The Santa Fe
and Taos Colonies

The Santa Fe and Taos Colonies

AGE OF THE MUSES, 1900-1942

By Arrell Morgan Gibson

UNIVERSITY OF OKLAHOMA PRESS
Norman and London

BY ARRELL MORGAN GIBSON

The Kickapoos: Lords of the Middle Border (Norman, 1963)
The Life and Death of Colonel Albert Jennings Fountain (Norman, 1965)
Fort Smith: Little Gibraltar on the Arkansas (with Edwin C. Bearss) (Norman, 1969)
The Chickasaws (Norman, 1971)
The Canadian: Highway of History (New York, 1971)
Wilderness Bonanza: The Tri-State District of Missouri, Kansas, and Oklahoma (Norman, 1972)
(editor) *Frontier Historian: The Life and Work of Edward Everett Dale* (Norman, 1975)
The West in the Life of the Nation (Lexington, Mass., 1976)
America's Exiles: Indian Colonization in Oklahoma (Oklahoma City, 1976)
Will Rogers: A Centennial Tribute (Oklahoma City, 1979)
The American Indian: Prehistory to the Present (Lexington, Mass., 1980)
Oklahoma: A History of Five Centuries (Norman, 1981)
(editor) *American Notes: Rudyard Kipling's West* (Norman, 1981)
The Santa Fe and Taos Colonies: Age of the Muses, 1900–1942 (Norman, 1983)

Library of Congress Cataloging in Publication Data

Gibson, Arrell Morgan.
 The Santa Fe and Taos colonies.

 Bibliography: p. 291.
 Includes index.
 1. Santa Fe (N.M.)—Intellectual life. 2. Taos (N.M.)—Intellectual life. 3. Arts—New Mexico—Santa Fe—History—20th century. 4. Arts—New Mexico—Taos—History—20th century. I. Title.
F804.S25G53 1983 978.9'53 82-40452
 ISBN: 0-8061-1835-0
 ISBN: 0-8061-2116-5 (pbk)

"Native American Muses" (chapter 8) was adapted and published as an article in the *New Mexican Historical Review;* it is reprinted here with permission of the regents of the University of New Mexico and the editor of the *New Mexican Historical Review.*

TO
PATRICIA
FIRST BORN
WAR'S ORDEAL SHARED
HUMANIST-BUILDER

CONTENTS

ILLUSTRATIONS

PREFACE

SANTA FE and Taos, alpine New Mexican *vecino* towns, have functioned in several urban roles. Santa Fe served as provincial capital for Spain and Mexico for over two centuries; Spanish officials placed San Fernando de Taos near ancient Taos Indian Pueblo as a base to sustain peripheral colonial settlements. Both became support centers after 1821 for the flourishing southern Rocky Mountain fur trade and rich Mississippi Valley commerce. Each also figured prominently in the Anglo-American conquest that began in 1846 and was concluded by the Treaty of Guada-lupe-Hidalgo two years later, by which the Southwest became United States territory. America's postbellum Western settle-ment and development surge bypassed Santa Fe and Taos, and they went into urban hibernation until around 1900, when a new raison d'être evolved for each.

At the turn of the century the traditionally quiescent Amer-ican-muse community was smitten with restlessness, anxiety, even insurgency. Many painters were disenchanted with the Eastern or "Academic" art establishment for its strictures and exclusiveness, and both artists and authors increasingly were dis-tracted by the escalating din of America's predacious machine-age culture, which they claimed threatened creativity. Some concluded that their aesthetic salvation lay in exile to places of isolation, of peace, in the quiet of nature where a higher truth might be attainable; residing in that optimum environment, practicing a simple life-style, they might refine and exalt their creative prospects. Thus gathering in coveys away from the city became a popular response. Artists and writers formed a score of colonies across the United States—from Provincetown to Carmel; Santa Fe and Taos were among those chosen.

This is a study of Santa Fe and Taos as fine-arts colonies. Their uniqueness in this role—they had the most extended lon-

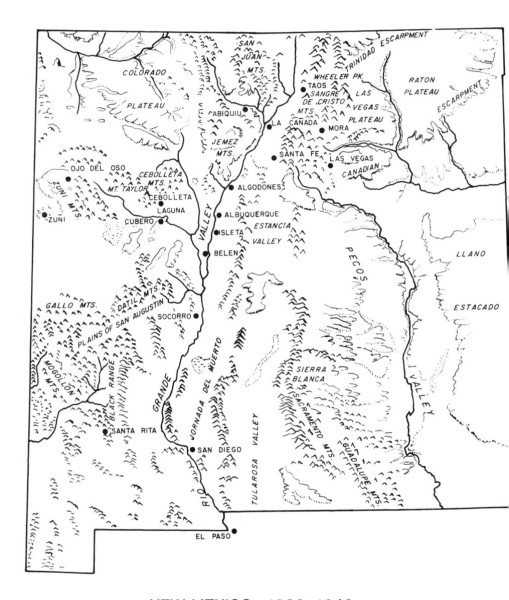

NEW MEXICO 1900–1942

gevity of the muse settlements, their colony population was the largest, they were pluralistic rather than specialized in their support of fine-arts expression, their ambience (natural, ethnic, and cultural environments) was the richest, and their outreach was the most generous of the colonies, in that they embraced Indian and Hispanic artists—will be explored.

This is not an analytical commentary or evaluation of the art, literature, music, dance, and drama produced in the Santa Fe and Taos colonies. Much has been written by professional critics about the art and some about the literature produced there. Occasionally I dare to venture an innocent, restrained descriptive comment on the character of the work where the context demands, but shun the esoteric realm of art and literary judgment and criticism.

The intent of this study is to present colony members not only as painters, writers, poets, composers, and dramatists responding to northern New Mexico's scintillating natural, ethnic, and cultural milieu but also as citizens sensitive to community concerns—their civic interaction, their proprietary, protective attitude toward the unique qualities of Santa Fe and Taos and their attempts to guard them against what they regarded as inroads of destructive twentieth-century "progress," and the extension of political action by colony members from municipal to state, regional, national, and, even occasionally, international matters.

Collecting materials on the Santa Fe and Taos colonies has been pleasant and productive in large measure because of the courtesy and assistance of staff members at Huntington Library; Beinecke Rare Book and Manuscript Library, Yale University; New Mexico State Museum Library; New Mexico State Records Center; University of New Mexico Library; University of Texas Humanities Center Library; and University of Oklahoma Western History Collections. For very special interest and attention to this enterprise, I wish to single out Glenda Morris, Terri Sampson, and Debbie Warren.

<div align="right">ARRELL MORGAN GIBSON</div>

Norman, Oklahoma

PART I

The Art Spirit

A SPRING SUMMONS

The willows at San Felipe
With their leaning branches
Have drawn the green of earth
up through the air.

— WITTER BYNNER

1 / ROCKY MOUNTAIN MUSES

AT the beginning of the twentieth century that portion of the American Southwest situated between the Pecos and Colorado rivers was a land of low esteem, the most scorned portion of the Great American Desert. Rugged mesas and towering mountains separated arid plains on the east from parched deserts on the west. By contemporary standards the Southwest was a desperate land, its principal value to the nation a geographic connective tissue that accommodated several transcontinental railway lines linking the Mississippi Valley and the Pacific Coast. The Southwest was the most sparsely populated portion of the American nation, its scattering of mining towns, stockraising and farming settlements, and Indian communities yielding such limited promise that it was the last of the contiguous continental territory to be organized into states. New Mexico and Arizona were not admitted to the Union until 1912.

Boomers, railroad builders, and townsite promoters had spectacular success throughout the nineteenth century in luring people and capital to the nation's remote regions. Their efforts, however, to coax these vital essentials of development to the Southwest were rarely productive; at the turn of the century the trans-Pecos territory remained the most underdeveloped, neglected section of the nation. Then, curiously, where boomers and speculators had failed, muses succeeded in making the South-

west attractive to the outside world, and, ironically, they became the unwitting evangels of "progress" for the region.

The very elements of the Southwestern milieu scorned by a materialistic, progress-obsessed, urban-industrial nation—awesome vistas, alluring and variant colors, intensity of light, sweeping spaciousness, multicultural communities, and precious isolation—were discovered around 1900 by the American creative community. Most of the literary-artistic immigrants settled in the remote northern New Mexican towns of Santa Fe and Taos, although they claimed the entire Southwest as their constituency. They demonstrated to a desensitized society the worth of this scorned land and, by developing an ever-broadening public interest, even infatuation with it. They were, in part, responsible for the Southwest's maturation and eventual acceptance as a coequal region of the nation.

The discovery of Santa Fe and Taos by artists and writers and the formation of humanistic colonies there around the turn of the century were the direct result of insurgency and change in the art world. New styles and techniques were evolving that influenced some painters to change their posture toward art, to move from the ideal or the real to Abstractionism, Expressionism, and Fantasy, the foundations for what is called "Modern Art." Increasing numbers of American artists were studying in Europe; they imbibed the heady doctrines of Impressionism and Cubism in France, Expressionism in Germany, and Futurism in Italy. And they responded variously. Some became ardent protagonists of European models. Others were eclectic and attempted to integrate several techniques and styles into an innovative synthesis. And there were artists who rejected European models, styles, and subjects and strove to "assert the importance of American life," to create a "vigorous realism" drawn from the American milieu—city streets; sweeping mountain, desert, and coastal landscapes; and vignettes illustrating the nation's cultural pluralism, an antecedent of latter-day Regionalism.[1]

This aesthetic ferment generated a revolt against the so-called Academy, an ultraconservative coterie of artists who peremptorily designated the acceptable form and style for American art and controlled the principal galleries in New York,

Philadelphia, and Chicago—traditional showplaces for the renderings of individual artists sanctioned by the Academy. Only by such favor could an American artist expect to succeed. Most young aspiring painters were excluded, with the result that there was no place of note for them to show their work.

Robert Henri, a Cincinnati artist who had studied at the Julien Academy and École des Beaux-Arts, in Paris, and a leader in the Santa Fe–Taos colonies, is acknowledged as the "most potent force" behind the movement to free American art from control by the Academy. Henri was an avante-garde aesthete who admonished painters to eschew arranging or rearranging subjects and capture the "natural attitudes and pursuits native to and typical of the people." He denounced the Academy for its arrogant exclusiveness, declared the right of artists to have a public judgment of their work, encouraged worthy painters, and helped to organize new exhibition sources. Through his efforts and those of other disenchanted American artists, the Academy's autocratic control of exhibition facilities was shaken and eventually destroyed.

The move for individual and group access to gallery facilities began in New York during 1908 with two "open" exhibitions, the Macbeth Gallery and Alfred Stieglitz's "291" Fifth Avenue rooms, which introduced the viewing public to heretofore Academy-excluded artists of ability and to new strains in the art world, including a declaration of "the importance of American life, and daily experience as themes of art." Both showings were surprisingly popular; at the Macbeth Gallery an estimated 300 people crowded the exhibition suites every hour for several consecutive weeks. The final blow to Academy domination of the American art world fell during 1913 at the nonpareil Armory Show, in New York. Of the 1600 paintings hung in the Armory Show, 1112 were by American artists, the remainder by Europeans, including works by Paul Cézanne, Eugène Gauguin, and Vincent van Gogh. The most notorious painting of the exhibition was Marcel Duchamp's *Nude Descending a Staircase*. Thus, among other things, the Armory Show introduced Americans to Modern Art.[2]

Change in art technology was another early-twentieth-

century art-world development that led to the formation of the Santa Fe–Taos colonies. While artists were touched by the exciting doctrines of the revolution in American art, most were faced with the imperative of making a living, which meant selling their work. The supporting crafts of illustrating, engraving, and portrait painting had been the common commercial resorts of artists seeking to become recognized and established as painters. Many artists worked through the day as commercial sketch artists, lithographers, portrait painters, and illustrators for *McClure's, Harper's Weekly, Collier's, Woman's Home Companion, Scribner's,* and *Cosmopolitan* magazines and painted evenings and on Sundays. By 1900, however, "bread and butter" portrait painting as a source of income for artists was declining; wood engraving for magazine illustrations, which had been the mainstay of support for many artists, had been displaced by photoengraving; and the demand for commercial illustrating had lessened. Thus, "painting, without a staple product that society wanted, had become an insecure, impoverished pursuit." Many aspiring artists were forced to leave New York and other Eastern urban centers where painters traditionally had collected and seek out places where lower living costs prevailed, which led to the formation of colonies.[3]

Pervasive ideological and stylistic change, including the rise of a pluralistic view of art—a tolerance among artists, a willingness to accept the work of those who differed in style, technique, and subject matter—also generated a spirit of independence among artists. Increasingly they refused to conform to the Academy's norms. They demonstrated a desire to experiment, and they expressed a refreshing self-determination and assertiveness through their art. Many courageously pulled away from the Eastern urban art establishment and sought out those havens where difference was cherished and where each would be tolerated to achieve his or her compelling fulfillment in art.

Flowing through the natures of many American artists and writers at this time was a dark disenchantment with industrialism and machines, a bitter contempt for progress, and a glowering impatience with society—to them an enlarging mute urban mass. They felt out of place, alienated, and bore resentment toward

their fellow citizens, who, in turn regarded artists and authors as impractical drones, their painting and writing not "respectable occupations for men," and who scorned their work as "really only play." Painters and writers felt threatened by these pejorative attitudes; they believed that the stridency and callousness of their complex materialistic world corroded their humanistic instincts. Thus they began to seek the peace of isolation—the quiet of nature where, many believed, a higher truth was attainable—that optimum environment and simplicity in lifestyle that would excite, refine, and exalt their creative prospects. Gathering in coveys away from the city became a popular response. There aesthetes could form a congenial and stimulating atmosphere for creative activity; it was reasoned that the "group can do more than an individual in a hostile world"; in colonies there was protection from the world's scorn.[4]

Most of the colonies were established in the East and on the West Coast near large cities convenient for artists and writers to market their works. Two of the first to be established were Woodstock, situated in the foothills of the Catskills, and Provincetown, on Cape Cod—both functioning during the 1890s. Others included Ogunquit Colony, in Maine; Gloucester Colony, in Massachusetts; Yaddo Colony, at Saratoga, New York; and MacDowell Colony, near Peterboro, New Hampshire—these patronized largely by artists and writers from New York. Chadds Ford Colony, on the Brandywine, and New Hope Colony, in the Delaware Valley, served Philadelphia artists and writers. Chicago artists and writers collected at Eagles Nest Camp, near Oregon, Illinois. And Carmel-by-the-Sea served as a haven for West Coast artists and writers. The most remotely situated colonies were Santa Fe and Taos, in New Mexico. Most of these colonies functioned during the summer, the artists and writers customarily returning to Greenwich Village, in New York; Vieux Carre, in New Orleans; Telegraph Hill, in San Francisco; and other intra-urban settlements where they worked at various jobs until the following summer.

Santa Fe and Taos were distinguished from the other humanistic centers in several regards. Besides being the most remotely situated, these Rocky Mountain havens, while popular

as summer resorts for writers and artists, differed from the others in that many settled permanently in one town or the other. Also, the Santa Fe–Taos colonies had the longest productive life of the aesthetic settlements, extending from approximately 1900 to 1942. Other unique features of these northern New Mexican enclaves included their location in an incomparable natural environment and a charming multiethnic society.

AUTUMN AT TAOS
Over the rounded sides of the Rockies, the
aspens of autumn,
The aspens of autumn
Like yellow hair of a tigress brindled with pine.

—D. H. LAWRENCE

2 / THE SANTA FE– TAOS AMBIENCE

SANTA FE and Taos attracted more creative folk during the age of colony building, 1900–1942, than any other area in the United States. A strong enticement was the low cost of living there, a consideration of great moment for struggling painters and writers, most of them on the threshold of poverty. But the strongest draw of Santa Fe and Taos was its anomalous environments—natural, ethnic, and cultural.

As indicated, the very natural conditions that made industrial-commercial developers shun the Southwest drew muses to it. Northern New Mexico, particularly, is a geological and botanical mélange—towering mountains, deep canyons, sweeping mesas, and desert flats. The Sangre de Cristo range, a southern spur of the Rocky Mountains, dominates the local landscape. Its snow-clad peaks, thrusting to nearly 14,500 feet, hover over awesome canyons; the deepest of these apertures in the earth's crust is the Rio Grande watercourse. Mile-high mesas connect the alpine chain with lowland deserts.

Highland climate, produced by the region's average elevation of 6,000 feet, yields stimulating, invigorating temperatures and a dry, antiseptic atmosphere, a milieu conducive to recovery for sufferers of tuberculosis and other respiratory diseases in an age when environment rather than drugs was used for healing these maladies. At lower elevations annual rainfall of ten to

9

twelve inches supports a surprising variety of vegetation that additionally enriches the landscape. Willow, cottonwood, sycamore, and salt cedar ornament the banks of streams and springs. Salt cedar locally is called tamarack; each spring and summer its feather-green branches are tipped by tiny light gray to pink blossoms. The desert flats sustain clumps of bear grass and several cactus types—including the picturesque ocotillo or candlewood, a plant reaching six to ten feet in height and, in season, laden with clusters of fragrant purple blossoms; the yucca with its familiar large white bell-shaped flowers; Spanish bayonet; amole or soapweed; and chamiso. From an eminence one can behold the gray-and-brown-tinted desert slashed by a twisting ribbon of green, the Rio Grande, principal drainage for north-central New Mexico.

Vegetative cover on the mesas includes chico, the greasewood; burro weed; silver and yellow sagebrush, purple when the light is low; patches of galleta, grama, buffalo, and porcupine grass; and the ubiquitous dark green piñon. On the mountainsides stands of wild grape, chokecherry, and hackberry are succeeded by belts of pine, spruce, fir, and aspen. Above the timberline alpine meadows enameled with larkspur, columbine, anemone, monkshood, poppy, gentian, and sedges reach to snowfields descending from cloud-impaling peaks.

Light is the dominating feature of the Santa Fe–Taos ambience. Artists found the sky there "so brilliant that it vibrates." The climate provided them a long painting season and clear, brilliant sunlight "under which the landscape as well as human beings assume definite contrast of light and shadow." To artists from other environments, the light intensity initially was overpowering; they rated the "brightness and clarity" of New Mexican light its most attractive features. Also this dazzling light intensity produced vividness of color; the high, dry atmosphere "tended to heighten the colors seen in the landscape and sky." It creates delicate color variants, marking changing aspects of the desert, and it conditions the effects of sunlight and rain upon sand and vari-tinted earths, the contrast of desert brown and gray with the Rio Grande valley's green, and the brilliance of the sky's vast blue dome hosting magnificent cloud formations. This same light

playing on mountain faces creates color moods that change from alpine rose to pure gold to soft pink. Julius Rolshoven, an internationally recognized painter who settled in northern New Mexico after a career in Europe, Africa, and the eastern United States, said, "I have traveled all over . . . in search of atmosphere, but nowhere else have I seen nature ever provide everything, even the conception, as it does in New Mexico."[1]

Mabel Dodge Luhan, a Taos-colony pioneer, said, "We who have lived here for a long time, maintain that there is an extra-sensory life in our surroundings, observable but not understood." Its essence was "strangeness as well as the beauty that causes the heart to contract sharply. Nature here is so strong that one has to be on one's guard not to be absorbed by it." She concluded, "The balance between . . . environment and the people is not even. Environment is the stronger as it does something more for the people than the people do for it."[2]

Until recent times, largely because of its rugged environment, northern New Mexico was perhaps the nation's most isolated region. Amy Lowell visited the area in the early 1890s as a tourist; in 1922 she complained to D. H. Lawrence, who resided at Kiowa Ranch, seventeen miles northwest of Taos, "In New Mexico you are almost as far away as in Australia." Northern New Mexico's near inaccessibility was a handicap, a deterrent to progress in the eyes of developers, but writers and artists found it sublimely attractive. Creative types claimed that they were threatened by the city's din of distracting and dehumanizing machine-age culture because it disoriented and alienated the individual and blunted his creative force. The isolation of Santa Fe and Taos provided them a refuge of infinite horizons, peace, and beauty, its "aura of innocence" uncorrupted by the material world.[3]

Santa Fe had access of a sort to the outside world over the Santa Fe Trail, a traders' trace running from Westport on the western border of Missouri to the Rio Grande, over a division of the Camino Real through Albuquerque to El Paso, thence to Chihuahua and several westward-bearing trails to the Pacific Coast. Until highways to accommodate automobiles became common across the Southwest, however, these were only rutted

wagon roads and dim trails fit only for horsemen, pack trains, heavy-wheeled freight wagons, and stagecoaches. The Atchison, Topeka, and Santa Fe Railway main line west reached Albuquerque in 1880; it had bypassed Santa Fe, situated sixty miles to the north. From Lamy, a water stop on the main line, crews constructed a spur into Santa Fe. The first train reached the town on February 9, 1880; this local line occasionally carried passengers, but it was used largely for freight. For the most part, passengers detrained at Lamy and were at first carried to Santa Fe by horse-drawn stage, later by motor bus.

Taos was even more isolated than Santa Fe. One observer stated that Taos is "where civilization fell asleep a thousand years ago—and has slept since." A traders' trace branched from the Santa Fe Trail at Cimarron Creek and crossed the Sangre de Cristos at Old Taos Pass, 9,000 feet altitude, into the valley settlements. A wagon road from southern Colorado threaded over lofty passes in the shadow of Wheeler Peak, by way of Valdez, thence to Taos. Also, a tortuous rocky trail north from Santa Fe along the Rio Grande fed into the ever-narrowing river canyon and ascended the side of the deep gorge south of Taos into the village. Local businessmen maintained daily stage service—at first a horse-drawn stage and later motor stage or bus— between Santa Fe and Taos, except when deep winter snows closed the passes and the treacherous trail along the narrow Rio Grande gorge. Travelers bound for Taos by way of Denver took passage on the Denver, Rio Grande, and Western Railway, locally referred to as the Dangerous and Rapidly Growing Worse, over its narrow-gauge line to Taos Junction, twenty-five miles west of Taos. This stop in the scrub pines of the San Juan foothills was a wooden station, likened to a large piano box placed on its side. The Long John Dunn Stage Line, using at first horse-drawn and later motor stages, made two runs a day to Taos. Passengers and mail ventured over this stage line at great peril down a threatening trail into the deep Rio Grande canyon and five miles of terrorizing ascent to the Taos mesa, the stage clinging to the edge of the cliff on a narrow shelf just wide enough for it.[4]

Most creative folk cherished Taos and Santa Fe's isolation.

One resident explained that "on account of its isolation in being side-tracked by railroads for fifty years, Santa Fe . . . escaped the flood of boosting standardization which makes the bigger and better Main Street in Minneapolis the same as the bigger and better Main Street in Dallas. . . . it has remained individual . . . the City Different."[5]

Another compelling feature of the northern New Mexican environment was its cultural age; to the sensitive, this land was imbued with an essence of great age, of timelessness. The region tributary to Santa Fe and Taos is one of the oldest and richest archaeological territories in the Western Hemisphere, reaching back several thousand years. The Anasazi and other ancestors of Southwestern Indians created the scintillating pre-Columbian Mesa Verde, Aztec, Chaco Canyon, Canyon de Chelly, Tyuoni, Puye, and Tsankawi communities. It has been claimed that these paleo-pioneer settlers "could as little escape the promptings of nature . . . the reaction of the environment upon the soul, as the artists of today can resist the inspiration that every day is new born in this surprising land of contrast, weirdness, beauty, and glory." The quality of the prehistoric art and architecture demonstrated these early peoples' fascination with their powerful milieu; the pre-Columbian heritage enlarges this environment's charm, and it flavors the Santa Fe–Taos ambience with an aura of mystery, charm, and great age. Writers and painters exulted in the discovery of this ancient race imbued with its pristine beauty, dignity, and nobility. It enabled many "Americans . . . to live down their national curse of newness," because in the Southwest's prehistoric chronicle they found the "fountainhead of a civilization older even than that of Europe" from which they have drawn their inspiration. No longer must the student seek out seats of ancient culture on the other side of the Atlantic.[6] Mabel Dodge Luhan, who exchanged the luxury of an Italian villa and a New York salon for a simplistic life in Taos, explained: "There is . . . the sense of an illimitable past. . . . An archaic past, still alive and ruling the ether."[7]

The Southwest's multiethnic population — the predominant Indian and Spanish-American, the late-arriving Mexican, a sprinkling of French, and the imperious Anglo-American —

comprises an "intoxicating mixture of races" and embellishes its social environment. The region was long held in colonial status by the United States Congress because of that body's low esteem, its scorn, for this region, derived in part from its multiethnic demography. Senator Albert Beveridge of Indiana best articulated this pejorative regard, referring to the Southwest as a "backward area" and "not equal in intellect, resources or population to the other states in the Union," the region's principal handicap that of its people—"stifled" by their Indian and Spanish heritage and therefore, not "sufficiently American in their habits and customs." But to refuge-seeking artists and writers this human mélange was "fresh material," a source of continuing interest, even fascination, providing charming subjects for literary expression and artistic rendition.[8]

The first, and most important, element to the creative immigrants in this multiethnic community were Indians. They were the original settlers. Those closest to Santa Fe and Taos were descendants of the incomparable Anasazi, called Pueblo Indians. They lived in self-governing, particularistic communities along the Rio Grande and its tributaries, sustained by irrigated agriculture and stock raising. The principal pueblos were Taos, Isleta, Jemez, San Juan, San Ildefonso, San Felipe, Santa Ana, Cochiti, Santo Domingo, Santa Clara, Pojoaque, and Zia. Pueblo Indians zealously retained their ancient ways, adopting with eclectic sophistication certain traits from the intruders' culture, notably those from the early-arriving Spaniards, including a veneer of the Roman Catholic religion that they blended with their native faith.

Native Americans served the Santa Fe–Taos aesthetic community in several ways, including changing the Indian image. The view of Indians held by most newcomers was drawn from reading muckraker magazine articles depicting them as defeated, debased aborigines concentrated on poverty-ridden reservations, or from witnessing their simulated forays as performers in wild-west shows touring the Eastern United States and Europe. Local Indians—often a lithe, stalwart figure clad in picturesque native dress of beaded moccasins, red headband, and flowing blanket, and of proud, even arrogant, carriage—serving as studio models

for immigrant painters denied this widely accepted libel. Most creative folk were surprised to discover in the Pueblo Indians "a people who had been able to maintain a position of dignity and a life intimately related to nature."[9]

Also, Indians, with their strong sense of connection with the natural world—each regarding himself as no less a part of a larger creation than the forest and sky—provided newcomers a fresh view of the universe. Many writers and painters found ideological comfort in this naturalistic stance, taking it as confirmation of their position that urban, industrial man once had possessed this identity with nature, but his increasingly materialistic culture had stripped it away.

Indian ceremonies and rituals centering on the dance further enriched the Santa Fe-Taos milieu. The Pueblo dance in its various forms was a prayer rendered as representational, symbolic ballet. Indians offered their kinetic prayers in supplication for rain in a desert land, for success in hunting, as thanksgiving and gratitude for achievements, to express kinship to brother animals, for healing, and in secret dances lasting several days as part of sacred rituals performed in the kiva, the ceremonial chamber in each pueblo. Most of the dances, however, were held for public view on each pueblo plaza. These celebrations at Christmas and other holy times were a mix of Christian and Indian ritual. The corn dance was the most important for community welfare. In the spring Pueblo people danced for germination of the corn, in the summer for maturation, in the fall for harvest. The color of the corn kernel, missed by the insensitive, was, like so many simple things, of importance to Indians. Corn was used for more than a staple food; it was also a sacred fetish. White corn was used for blessing a new home, blue corn for venerating the Pueblo governor's cane—his baton for ruling. Corn-kernel color also represented the six directions of the Indian universe: blue, north; red, south; white, east; yellow, west; pinto, above; and black, below.

While Indians served as models for artists, their art also came to be used as models. They, too, had responded to the aesthetic imperatives of the northern New Mexican environment by innovative renderings in textile, ceramic, costume, and

architectural design and color. Their sense of symbolism and the abstract was appreciated by the immigrant artists, and, in the late stage of the life of the Santa Fe and Taos colonies, Indian art influenced the shift there from realism to Expressionism and what is called "Modern Art."

Several artists and writers, attentive to the popular view that the Indian, because of drastic decline in population during the nineteenth century, was the Vanishing American, and intrigued with the value of many survivals of ancient lifestyle in their adopted environment, became committed to preserving and conserving what they judged to be a dying race and its culture. The irrepressible Mary Austin was chief protagonist of this cause. Clearly, Indians were much appreciated by most of the writers and painters, and to the newcomers Indians were "cordial and friendly and . . . amiably superior."[10]

The Spanish-American was another ethnic element of the Santa Fe–Taos social environment that yielded fresh, new material to the immigrant writers and painters. New Mexican culture contains a strong Iberian tincture that is derived from the role of the region as a northern outpost of the Spanish empire in the New World, a colonial extension of New Spain or Mexico.

Spanish settlement in New Mexico began in 1598 when Don Juan de Oñate, accompanied by his wife Doña Isabel, led a band of 130 families from northern Mexican settlements by way of El Paso del Norte into the Rio Grande Valley. Oñate's expedition included Franciscan padres commissioned to convert the Indians. The colonists brought herds of sheep, cattle, and horses into the new land.

Oñate established the capital for the province of New Mexico, at San Gabriel, near San Juan Pueblo. In 1609, Spanish colonial officials moved New Mexico's capital to Santa Fe, laid out the historic plaza, and erected the Governor's Palace, facing southward towards Mexico City, seat of the viceroy for New Spain.

Spanish colonists established farms and ranches in northern New Mexico, and in a simple way they prospered. Franciscan padres erected mission churches in the pueblos and attempted to convert the natives. Isolation of colonial New Mexico had

the effect of creating a virtual static culture. Just as Elizabethan culture and vernacular have survived in the isolated Anglo-American settlements of the Appalachian Mountains of the eastern United States, so have medieval Spanish vernacular, lore, and institutions survived in the isolated Spanish-American settlements in the Sangre de Cristo Mountains of northern New Mexico.

Northern New Mexico's Hispanic communities were not indifferent to the strength of their local environment. From earliest times, colonials paid tribute to their milieu. Gaspar De Villagrá composed an epic poem of thirty-two cantos depicting the vicissitudes of Oñate's column as it crossed the new land. And Marco Farfán is credited with composing and producing plays set in the new land with soldier-actors drawn from Oñate's guard.

Each year Spanish colonials observed several religious holidays and fiestas, and sponsored bailes, the village dances. They enacted popular medieval folk plays including *Coloquios de los Pastores*, *Los Tres Reyes*, and *Los Moros y Cristianos*. And they adapted Iberian arts and crafts to this land, drawing on local subjects and materials for sewing, embroidery, wood carving, furniture manufacture, and leather work. The isolation of each village required that it be virtually self-sufficient in food, textiles, and other needs. Environmental factors—the aforesaid isolation, compelling grandeur of nature, and abundant natural material at hand—provided Spanish-Americans with opportunities for aesthetic self-expression. They fashioned looms and handsome furniture—chests, cupboards with grilled doors for air circulation, beds, and tables. Cottonwood and pine were the favorite woods for carving and furniture manufacture. Textile colors were drawn from clay pigments, nut hulls, and vegetable dyes. The colonials did some of their most innovative work in religious art. Their lives mostly centered on religion and the church. They required *santos*, saint figures, and *retablos*, carved and painted panels representing religious events, to decorate their households and churches. Cut off from the supply source in Mexico City, *santeros*, local carvers, produced crude copies of *santos* and *retablos* from Spanish models. *Retablos* were usually placed in

churches while *santos* were found in both churches and homes. The Americanization of New Mexico, beginning around 1821 with the opening of Anglo-American trade with the Rio Grande towns over the Santa Fe Trail and accelerated following the Anglo-American conquest of New Mexico in 1846, had the effect of obscuring some colonial arts and crafts. Enough survived after 1900, however, to stir the interest of the immigrant writers and painters so that they sought to restore, conserve, and perpetuate them. Certainly survivals of Iberian culture enhanced the charm and color of the northern New Mexican social environment.

The other components of northern New Mexico's multi-ethnic population were Mexican, French, and Anglo-American. Each was overshadowed by the dominating Indian and Hispanic groups in the social environment. And the contribution of each to the region's cultural environment was proportionately less, although they add to the composite color and charm.

Soon after 1900, Mexicans, cultural and racial cognates of local Spanish-Americans, began to migrate from Mexico into the Southwestern United States seeking employment as section hands on the region's railroads and as agricultural laborers. They brought bits of more recent Mexican culture, by degree different from that carried into New Mexico by colonials from Mexico in the seventeenth century.

The French presence in northern New Mexico was a survival of the fur-trade frontier. Early in the nineteenth century French-Canadian trappers, many of them from Saint Louis and the upper Missouri River settlements, came to the southern Rocky Mountains to trap beaver. They settled at Taos and other tiny northern New Mexican settlements. Several married Spanish-American and Indian women and gave Gallic surnames to descendants—Devereaux, Charbonneau, Robideaux.

The fifth ethnic component of northern New Mexico's social environment was the Anglo-American. Beginning in 1821 with the opening of trade with the United States, American adventurers drifted into the Rio Grande towns. Mountain men trapped the highland streams during the fur-harvest season and wintered in Taos. Several established businesses there, including grain

milling and distilling, producing low-grade flour and the devastating "Taos Lightning." Anglos settled at Santa Fe as representatives of Missouri trading companies doing business with Spanish American settlements along the Rio Grande and into Chihuahua. Their influence over local Mexican officials was considerable, demonstrated by the bloodless conquest of New Mexico by the Army of the West in 1846. Always a minority, members of the Anglo community in Santa Fe and Taos dominated New Mexico's political and economic life following Mexico's cession of the Southwest to the United States in 1848 by the Treaty of Guadalupe-Hidalgo that concluded the Mexican War. While the resident Anglos regarded the emerging writer-artist colonies in Santa Fe and Taos with reservations, even misgivings, the newcomers indulged the former as a quaint anachronism of the Anglo-American frontier.

The quality of northern New Mexico's social environment was enhanced by its two ancient towns—Santa Fe and Taos. During the time of the Muses some of the artist-author immigrants settled in tiny mountain and canyon villages, but most of them chose Santa Fe and Taos; these towns became the recognized fine-arts colonies.

Santa Fe, a mountain town situated at 7,000 feet altitude and—in 1900—with a population of 5,000, is the oldest surviving capital city in the United States. The town was founded on the ruins of two aged pueblos that were occupied as early as 1200— Analco Pueblo, situated on the south side of the Santa Fe River, and Kwapoge Pueblo, situated on the site later occupied by Fort Marcy. In 1609, Spanish officials moved the capital of New Mexico from San Gabriel to the banks of the Santa Fe River, a tributary of the Rio Grande. There they directed construction of *El Palacio Real*, popularly called the Governor's Palace, as part of the *Casas Reales* or royal houses ordered built by the Spanish king at government centers throughout Spain's New World empire. The Governor's Palace, in Santa Fe, was laid out facing Mexico City, seat of the king's representative in New Spain, the viceroy. Its buildings clustered on a ten-acre tract containing parade grounds, a vegetable garden for the soldiers' table, rooms for officials, domestic quarters (including barracks), and stables

for cavalry mounts. The Chapel of Our Lady of Light, the military chapel for the presidial company of Santa Fe, was situated directly across from the Governor's Palace. A low-lying adobe settlement grew up around the Governor's Palace and its plaza situated on the south side of the government complex.

Santa Fe was primitive and appealing to writers and artists from their first glimpse of it. A picket fence flanked by hitching posts and rails enclosed the plaza. Benches along shady paths in the plaza-park area radiated from a Civil War monument marking the Confederate conquest of Santa Fe and its reoccupation by Union troops. The Conquistador band presented concerts each Sunday evening from the plaza bandstand, playing *Adelita* and other favorites for Hispanics promenading on the cobblestone walks fronting the business buildings and shops built around the plaza.

Local color included women, heads covered with black mantillas, hurrying to the cathedral just off the square, a reminder of New Mexico's link with Spain. Processions of burros, laden with packs of split cedar and piñon cut from the mountain canyons near the town by *leñadors*, shuffled down winding streets, pausing at dooryards for the vendors to deliver firewood to housewives. Soft-tinted adobe walls marked by rows of glowing hollyhocks enclosed gnarled orchards of apple, pear, and peach; these deflected piñon-scented winds streaming from nearby canyons, the quiet urban setting flanked by towering mountains, their snow-clad peaks thrusting into the clouds. Over all of Santa Fe was the aura of "romance." It "was woven about her like that of a beautiful woman, drawing men of every race with the desire to possess her."[11]

Taos, situated seventy miles northeast of Santa Fe and even more isolated, lies in an alpine valley fifteen miles long at an altitude of 7,000 feet and is enclosed on three sides by the towering Sangre de Cristos. During 1615, Spanish colonists established a settlement near the Indian village—Taos Pueblo—that they named San Geronimo de Taos. The Indian uprising in 1680 began at Taos Pueblo; insurgent Native Americans destroyed the Spanish town and drove the settler-survivors south to El Paso. In 1710, Spaniards rebuilt San Geronimo de Taos,

a cluster of adobe houses enclosed by protecting adobe walls guarded by vigilant sentries. Besides Taos Indians at the neighboring pueblo, the colonists had to contend with the threat of raids by Utes, Apaches, and Navajos. Also, Comanche and Kiowa bands from the eastern plains occasionally ventured up Cimarron Canyon to menace the Spanish settlement.

By 1750, Utes, Navajos, Apaches, Comanches, and Kiowas gathered annually at the Taos Pueblo trade fair to visit, dance, and traffic in skins, captives, guns, and blankets. Taos served as the winter home for French-Canadian and Anglo trappers and, during the days of the Santa Fe Trail commerce, Taos was a secondary trading point for the Missouri freight caravans.

Following the Anglo-American conquest in 1846, Taos consisted of three parts: Fernando de Taos, centered on a plaza surrounded by business buildings and dwellings; the Pueblos, two multistoried adobe structures housing the Taos Indians, northeast of San Fernando de Taos; and Ranchos de Taos, situated south of San Fernando de Taos. Taos's population, excluding the Pueblos was less than 1500 persons in 1900.

Taos's earthy primitiveness—dominating highlands, awesome desert sweeps broken by the valley's brilliant green of irrigated orchards and corn fields, and quaint earth-molded buildings—and its disparate human and cultural elements, made it a haven for those immigrants who found even simplistic Santa Fe too progressive, worldly, and threatening. Its natural and social environs yielded a plethora of unique, colorful, fresh subjects for literary and artistic interpretation that overpowered many of the émigrés. They confessed that so complete was their surfeit that it was weeks, ofttimes months, before they were able to elevate their creative consciousness to the level where they could command and use these environmental riches.

Writers and painters found in the Santa Fe–Taos social environment public attitudes that made northern New Mexico all the more attractive as a refuge from their threatening world. Added to the exotic atmosphere was a sustained "tolerance of differences in people." The "general politeness of the people . . . made it a congenial place to live and to work." And for the most part, writers and painters were accepted and permitted to

become a meaningful part of the community. John Sloan, an international art figure and a habitué of the Santa Fe–Taos colonies, said all across America artists were treated like "cockroaches" in kitchens; they were "not wanted, not encouraged," and fellow artist Robert Henri commented that in Santa Fe and Taos creative people were "treated with that welcome and appreciation that is supposed to exist only in certain places in Europe."[12]

This supportive public attitude may be accounted for in part by the fact that Indians and Hispanics predominated in the local population. They "regarded these newcomers with friendly or indifferent eyes. . . . They did not condemn any man who painted all day long." Rather they "embraced" the émigrés "in friendly nonchalance."[13]

Ernest Block, who composed portions of his symphony *America* in Santa Fe, exulted in this supportive social environment: "In New York people rush from subway to subway; in Chicago they tear from Elevateds to taxis; in Los Angeles they race through the air in planes; but in Santa Fe I see people who do nothing; they leave me alone so that I can work. They sit and talk here or they just sit. Thanks be to God that I have found a place in America where men can do nothing."[14]

Northern New Mexico's environment—an awesome, nearly overpowering natural setting and a colorful, simpatico social milieu—besides serving as an enlarging source of literary and artistic interpretation, also became a popular subject for comment, both by artistic émigrés and by a growing body of visitors. Robert Henri stated that the Santa Fe and Taos colonies were "wonderful locations" for artists. "The painters are all happy. The climate seems to suit well both temperaments—to work or not to work." Andrew Dasburg reached Taos in 1917 at the behest of Mabel Dodge Luhan who sent him a train ticket with the telegram message: "Wonderful place. You must come." Dasburg arrived there "at sunset on a snowy day. Taos valley seemed like the first days of creation. But though it seemed lonely and far from the world, he felt an immediate sense of belonging." Dasburg remained there for the rest of his life.[15]

When Leo Stein reached Taos as the guest of Mabel Dodge

Luhan he raptured "that he had never known such beauty on earth except in early Chinese paintings, and that he had never believed it could live outside of art." Anthony Anderson, art critic for the *Los Angeles Times*, wrote that the Taos and Santa Fe colonies show "the world that we have an art native to our soil. . . . The Indian and his pueblo are subjects well worthy of exploitation." Anderson added "history will be richer with the pictorial preservation of Indian life by these artists." And a *Christian Science Monitor* writer stated that "No matter how fixed an artist may have been in his way, he comes back from New Mexico a more or less changed man."[16]

By the beginning of the twentieth century this alterative force in northern New Mexico's milieu had begun to attract substantial numbers of writers and artists. These pioneers formed a subculture nucleus in Santa Fe and in Taos, which, in a decade, had become a functioning, productive fine-arts colony in each town.

SPANISH JOHNNY
The big stars, the blue night
The moon-enchanted plain;
The olive man who never spoke,
But sang the songs of Spain.

—WILLA CATHER

3 / THE PIONEER AESTHETES

THE Taos and Santa Fe colonies were founded around 1900, but, fifty years before this, northern New Mexico's scintillating vistas were attracting the attention of creative folk. The first to come were artists. During 1846–47, John Mix Stanley, America's frontier painter, sketched northern New Mexican scenes. A year later, Richard H. Kern, the artist-cartographer of the Frémont Expedition, visited Taos. Portrait-painter Worthington Whittredge sketched northern New Mexican subjects in 1865, and, beginning in 1880, Thomas Moran, the internationally famous landscape artist, regularly visited the Rio Grande valley to paint pueblo scenes. Montgomery Roosevelt, the portrait painter and cousin of Theodore Roosevelt, visited Taos in 1881. About the same time, Colin Campbell, Henry R. Poore, Alexis Compere, Frank Sauerwin, and G. H. Bentley sojourned in Santa Fe and Taos rendering paintings of landscapes, villages, churches, and natives. F. H. Lundgren used Santa Fe as a base to draw Hopis, Navajos, and other Indians of the region. Frederic Remington sketched northern New Mexican scenes several times in the period 1880–95 and in 1902 spent the best part of a year at Taos painting.

Each visitor was struck with northern New Mexico's nonpareil natural beauty and ethnic charm. Several predicted that the region could become a haven for disenchanted artists and writers. Frederic Remington, in referring to Taos, stated: "Amer-

icans have gashed this country up so horribly with their axes, hammers, scrapers and plows that I always like to see a place which they have overlooked; some place before they arrive with their heavy-handed God of Progress."[1]

Taos was the first New Mexican community to become a colony. Initially it served as a refuge for painters; writers settled there later. Joseph Henry Sharp is credited with being the major influence in its founding. Sharp, from Bridgeport, Ohio, studied at the Cincinnati Art Academy and at Academy Julien, in Paris. He first visited Santa Fe and Taos in the 1880s during a wide search across the West for new scenes and subjects, "fresh material" for his compositions. Sharp returned to Taos in 1893 and spent several months there, painting scenes set in the Pueblo and the Hispanic settlement. During 1895 at Academy Julien he shared with two young American artists—Bert Greer Phillips and Ernest L. Blumenschein—his fascination for the place and his view of its prospects for becoming an ideal place for painters.

Phillips and Blumenschein returned to New York where they resumed their work as illustrators for *McClures, Century, Harper's*, and other national magazines, but, eager to visit the places Sharp had described so alluringly to them, they set out during 1898 on a sketching tour of the Southwest. They approached New Mexico by way of southern Colorado over a dim traders' trace threading the southern Rocky Mountains' lofty passes and deep canyons, finally reaching Taos, where they repaired their battered wagon. Sharp's superlatives for the region, particularly Taos, were verified; Blumenschein and Phillips, too, were mesmerized by the miniature village, its plural ethnic character, and awesome natural setting. Blumenschein reluctantly returned to New York to continue work as a magazine illustrator but Phillips remained at Taos, taking a job as ranger in nearby Carson National Forest until he could devote full time to painting. Blumenschein visited Phillips and Sharp at Taos each summer for several years before moving there permanently.

Rather soon these three were joined by five other artists. The eight formed a coterie called *Los Ochos Pintores*. Oscar E. Berninghaus, a New York artist, heard of Taos from Blu-

menschein and Phillips; he first visited Taos in 1899. He, too, was an illustrator who hoped for the day that he could paint full time. Irving Couse, from Michigan, while studying art in Europe, met Sharp and Berninghaus, who told him of Taos. Couse arrived there in 1902. W. Herbert ("Buck") Dunton studied at the Students' Art League in New York; he learned of Taos from his teacher, Blumenschein. Dunton reached Taos in 1912. Victor Higgins, another New York illustrator, arrived in Taos two years later. Walter Ufer, born of German parents in Louisville, Kentucky, studied engraving and painting in Germany. He settled for a time in Chicago, a protégé of the Munich School, and worked for a time as an engraver, illustrator, and portrait painter. Ufer visited Taos in 1914 and eventually moved there permanently.

Los Ochos Pintores were well educated for the times, and, except for Dunton who was just beginning his career in art, were keenly experienced as commercial artists. For example, Blumenschein had studied in Paris on four different occasions. Certainly these men brought to Taos a fresh, surging spirit of creativity and an elegant cosmopolitanism.

For a time most of Los Ochos Pintores spent their summers in Taos painting, returning to illustrator jobs in the East during the winter; however, each had the dream of settling in Taos to paint full time. Sharp joined Phillips as a permanent resident, establishing a home there in 1902. Each of the other Pintores eventually made the move to Taos; Berninghaus moved there in 1925 and Couse was the last, making Taos his home in 1927.

In the early life of Taos colony each of Los Ochos Pintores followed a more or less different style. Several specialized in particular subjects, but all of them focused on the Taos environment and used the all-powerful nature of northern New Mexico as the stimulus for their creative work. Initially the paintings of each artist showed the influence of "academic realism," and critics claimed that in the early years their work bore the influence of their cognate careers in illustrating. Also, in the early years, the stream of dogma and doctrine issuing from the European and American art worlds had little effect on the emerging colony. This came later. For the time being,

each artist was striving to be creative and innovative and at the same time make a living by selling his paintings.

Couse primarily painted Indians. While his work became stereotyped from the art-critic viewpoint, he was immensely successful in sales because he painted what the public desired. His paintings depicted "Indian innocence," and portrayed the "fanciful and poetic ideal associated with the concept of man's goodness when existing in a state of primitive freedom." Sharp has been characterized as ethnological in his aesthetic interpretation because of his devotion to detail and the authenticity in his Indian paintings; and he emphasized the theme of "nobility of man living close to nature." Dunton exploited an interest in the Anglo-American frontier, painting Western scenes and figures, particularly cattle ranges and cowboys. Ufer painted local subjects and scenes with the exactness and heavy color of the Munich School; his work was popular both with museum curators and the general public. Berninghaus, Blumenschein, and Higgins were less traditional in their treatment of subjects in the Taos milieu. Blumenschein was the most plastic of *Los Ochos Pintores*, increasingly applying the exotic Cubist and Impressionistic techniques to his paintings.[2]

While aesthetes cherished the isolation of Taos, it had its handicaps. A principal one was remoteness from galleries in cities where artists could exhibit paintings for peer judgment, critic evaluation, and marketing. And tourists, who later became a major source of painting sales, rarely reached Taos in those early days of the colony.

To resolve this problem *Los Ochos Pintores*, in 1912, formed the Taos Society of Artists, its purpose "to develop a high standard of art among its members, and to aid in the diffusion of a taste for art in the general public." Officers of the society were responsible for collecting paintings from members and arranging an itinerary for spring and autumn exhibitions. Each exhibition season began with a showing of Taos artists' works in the Palace of the Governors, at Santa Fe; from there the exhibit moved by rail express on a circuit of major cities.[3]

During the society's early years, women's clubs were the most reliable sources for gaining access to display space in

local libraries and public halls. By 1915, largely because of the society's traveling exhibitions, the Taos painters were well known across the nation, their paintings had become increasingly popular, and museums and galleries in the major cities welcomed Taos Society of Artists' exhibitions. The semiannual exhibition circuit, beginning at Santa Fe, proceeded to New York; then moved back west to Detroit, Pittsburgh, Chicago, Minneapolis, Kansas City, and Denver; then to San Francisco, Los Angeles, and San Diego; and on to Honolulu, Shanghai, and several Australian cities.[4]

Taos Society of Artists' members gradually achieved national, even international, acclaim. Couse, Berninghaus, Blumenschein, Ufer, and Higgins won the coveted Altman Prize, the most sought-after award presented by the National Academy; and Blumenschein, Ufer, Higgins, and Berninghaus became National Academicians.[5]

Taos Society of Artists' by-laws permitted enlargement of membership from the original eight with the requirement that candidates must have worked in the Taos area for three successive years and received a prize in a national exhibition. And eventually the society's membership was increased to eleven (E. Martin Hennings, Catherine C. Crichter, and Kenneth M. Adams). In addition, the Society of Taos Artists' roster contained what the by-laws identified as nonactive members and honorary members. As the colony at Santa Fe grew, the Taos Society of Artists' exhibition program was expanded to include in its traveling displays paintings by certain Santa Fe artists; by 1922 the Taos Society of Artists' exhibition might contain the work of from fifteen to forty artists.[6]

The northern New Mexico aesthetes stressed art for art's sake and disclaimed any overriding concern for material return on their work, declaring that their primary interest was the peer judgment and critic evaluation that their work received during these itinerant exhibitions. Be that as it may, several Taos Society of Artists members became wealthy from sales of paintings. Couse and Ufer were the top money-makers in the society. At the peak of his career, Couse often received $20,000 a year from the sale of paintings, which, for the time, was an afflu-

ence-level income. Members dissolved the Taos Society of Artists in 1927 because they believed its aims had been achieved — Taos artists were recognized by critics, museums, galleries, and buyers; most were selling successfully; and individual marketing of paintings had become so successful that society officers found it increasingly difficult to collect enough paintings for the semiannual exhibition tours.

Taos artists became nationally known through the traveling exhibits, their success drew attention to Taos, and the number of artists venturing to the northern New Mexican village increased each year after 1912. During the summer of 1915 over one hundred artists appeared in Taos, taxing the limited local facilities. Most of the newcomers remained to paint during the summer months; many returned each painting season for a period of several years; and some of the newcomers became permanent residents. The Taos environmental draw was a widely acknowledged motive for this inpouring of creative people, but several also came because of the enlarging war in Europe.[7]

The more notable artists in Taos at this time included Maurice Sterne, painter and sculptor, and, at the time, husband of Mabel Dodge; Julius Rolshoven, a native of Detroit but an itinerant painter who had lived in Düsseldorf, Munich, Florence, and Paris before settling in Taos; Leon Gaspard, a Russian artist searching for a place to recover from war wounds and to paint; Marsden Hartley, a pioneer of the modern art movement in America; Grace Ravlin, who was committed to paint people and scenes as she found them rather than to compose or rearrange, who was also regarded as an ethnologist or comparative analyst, and, having studied and painted the peoples of Morocco, was drawn to Taos to paint the people of the Pueblos; Bert and Elizabeth Harwood, Paris-trained artists; John Younghunter, painter of portraits and landscapes; John Sloan, eminent New York painter; and Andrew Dasburg, who was to become the strongest and most influential artist in both the Taos and Santa Fe colonies.

Initially the founders of Taos colony regarded its rapid growth with satisfaction. Ufer, who frequently served as the executive-secretary of the Taos Society of Artists and therefore

its spokesman, exulted in the expansion of the Taos colony
with the prophecy: "Here, some day, will be written the great
American opera, the great American novel, the great American
epic! . . . This country will never be painted out . . . for it has
an infinite variety of moods and types." And whether the artist
be "conservative or an ultra-modernist, finds what he is look-
ing for." And all this will bring about "a new and more virile
epoch in American art."[8]

Ufer miscalculated the halcyon surface calm at Taos, be-
cause, as events progressed there, the influx of artists brought
new dogma, design, and style that threatened *Los Ochos Pin-
tores*, challenged this coterie's domination of the community,
created some disunity, and had the effect of driving away some
of the newcomers. Most took up residence at the growing colony
at Santa Fe. Hartley and Sloan, in particular, scorned the con-
servative, realism-type painting produced by most of the Taos
Society of Artists' members, and reportedly detested them as
persons. And *Los Ochos Pintores* regarded the former as "ego-
tistical" and condemned them for their "superior attitude." After
a time Hartley and Sloan moved down to Santa Fe. Rolshoven
and Dasburg joined them, but they eventually returned to Taos.[9]

Santa Fe became an aesthetic colony later than Taos. The
ancient village was larger than Taos and less primitive in its
amenities, but it had the same natural and social environmental
draw that had made Taos so attractive to creative persons—
isolation; a 7,000-foot elevation producing cool summers; co-
balt-blue sky trimmed with silver-edged cloudlets; brilliant light;
narrow, crooked streets; and hollyhock-flanked walls guarding
patios with flashing fountains and adobe *casas*, domiciles for
the colorful tri-ethnic cultures.

And Santa Fe expressed the same simpatico stance. Robert
Henri, one of America's foremost painters, commented when
he found Santa Fe: "There is a place in America—and that place
is Santa Fe—where an artist can feel" that he is welcome. And
Hartley, the modernist painter who first settled at Taos and
subsequently moved to Santa Fe, added:

I have heard before of the hospitality of the people of Santa Fe toward

artists. . . . It is so seldom that the artist is considered in the scheme
of things, that it sounds like a miracle. That is the attitude in Europe,
even in the uttermost parts; the artist is looked upon as something
worth having and holding, and he is respected for his talents and
devotion to an idea, which I am sorry to say in our country is not
felt as well as I hope it will be in the not far future. Artists are
useful citizens, despite the tendency among laymen such as merchants
and other money-makers to count them as idlers.[10]

Artists appearing in Santa Fe on the eve of the founding
included Warren Rollins, an established painter from San Ga-
briel, California, who, in 1900, spent the summer in northern
New Mexico and visited Santa Fe to show his work. At the time
the town had no exhibition space, and the local archaeological
society arranged for Rollins to display his paintings in the Gov-
ernor's Palace. The exhibit was enthusiastically received by
townsmen. While Rollins was in Santa Fe, Carl Lotave, the
muralist, was decorating the walls of the Governor's Palace,
and Charles Rawles, artist and lecturer, painted in his studio
in Seña Plaza.

The founders of the Santa Fe colony were Carlos Vierra and
Kenneth M. Chapman. Vierra, a native of California, studied
painting in San Francisco and New York. He also became a
skilled photographer. Stricken with tuberculosis while in New
York, Vierra came west seeking a high, dry climate. During
1904 he was a patient at Sunmount Sanitarium, in Santa Fe;
he recovered and resided in Santa Fe for the rest of his life.
Vierra painted landscapes and historical subjects; he was fas-
cinated with adobe structures—mission churches and public
buildings. He came to be called the "scenic architect," and was
a passionate advocate for preserving and restoring old-style
adobe buildings. His work drew the attention of artists in the
East and on the West Coast to Santa Fe.[11]

Chapman was a successful New York illustrator before
coming west in 1889 to teach art at New Mexico Normal (High-
lands University), at Las Vegas. Edgar L. Hewitt, president of
the institution, moved to Santa Fe in 1907 as director of the
newly founded Museum of New Mexico and School of Ameri-
can Archeology (later the School of American Research), both

housed in the Governor's Palace. Chapman followed Hewitt to Santa Fe and became a museum staff member. He continued sketching and painting and developed a strong interest in Indian art; he brought to public attention the then unrecognized Pueblo Indian art, and he published several books on Pueblo pottery design. Above all else, Chapman popularized Santa Fe as an artists' haven through his writings on art in *El Palacio*, publication of the Museum of New Mexico, and in national art magazines.[12]

Shortly, Vierra and Chapman were joined by other artists in numbers sufficient to comprise a nucleus for the gestating Santa Fe colony, its principal pioneers Gerald Cassidy, Sheldon Parsons, Paul Burlin, Olive Rush, William Penhallow Henderson, Gustave Baumann, and Robert Henri. Most of the immigrants became permanent residents of Santa Fe.

Like Vierra, Cassidy was a sufferer from tuberculosis who left a successful commercial-artist business in New York to seek a cure in the West. During 1912 he first settled in Albuquerque, then moved up to Santa Fe. After achieving a recovery, Cassidy continued as a commercial artist, painting Western scenes that were reproduced on postcards and on Santa Fe Railway travel posters, but he also worked as a serious painter of northern New Mexican vistas. His paintings of landscapes and Indians were of striking quality, received critic approval, and were purchased by many museums, including the New York Museum of Art. Cassidy received international recognition in 1915 when his murals for the Indian Arts Building of the Panama-California Exposition, in San Diego, were awarded the grand-prize gold medal.[13]

Parsons, a portrait painter from New York, joined the Santa Fe colony in 1913. In the northern New Mexican milieu he concentrated on landscapes, rendering them in impressionistic style. Parsons became director of the new state art museum, at Santa Fe, in 1918.[14]

Burlin—New York artist, Armory Show exhibitor, and Cubism-Expressionism advocate—also arrived in Santa Fe during 1913. Burlin was strongly influenced by European Modernists; he painted traditional New Mexican subjects in impres-

sionistic and semiabstract style. He also was influenced by abstract elements in Indian art and introduced them into his work. Until Hartley moved from Taos to Santa Fe in 1917, Burlin was the avant-garde painter of the colony. He left Santa Fe in 1920, moving to Europe where his "increasingly modernistic style was considered less revolutionary than in the Southwest." He carried to Europe elements of Indian art that he integrated into his work.[15]

Rush, from Indiana, reached Santa Fe in 1914. She painted there summers until 1920 when she established a permanent home in Santa Fe and became a leading member of the colony. Rush applied what she called "liberating forces" of Expressionism to the New Mexico environment to produce her semiabstract work, identified by the "geometric forms and bright light."[16]

Henderson, a nationally prominent portrait painter and teacher at the Chicago Academy of Fine Arts, came west with his wife, Alice Corbin Henderson, the writer, who was suffering from tuberculosis. The couple settled in Santa Fe during 1916, where she recovered at Sunmount, then resumed her literary career; Henderson became the most versatile member of the Santa Fe colony. As an artist he is best known for his paintings of New Mexican landscapes. In addition, he designed furniture and worked as an architect. The Museum of Navajo Ceremonial Art, in Santa Fe, is regarded as "the best evidence of his architectural originality." The Hendersons settled in a house on Corral Road that had been renamed Telephone Road because the telephone line into town followed it. Henderson renamed it Camino del Monte Sol, a street that became famous for the artists and writers living along it.[17]

Baumann, born in Germany and trained in Munich and Chicago, was among the last of the Santa Fe–colony pioneers, arriving there during 1918. He painted in oils but received primary recognition in the Santa Fe colony and the world of art as a printmaker, specializing in exquisite colored woodcuts. In his studio on Canyon Road, Baumann produced, on a press, color prints dealing with New Mexican subjects. He rendered his best-known work, including the incomparable reproduction of the "Deer Hunt" fresco,[18] from paleo-Indian cave drawings

at Rito de los Frijoles, a prime archaeological site near Santa Fe. Henri was the Santa Fe–colony pioneer most responsible for enlarging its membership and expanding its recognition and respect around the nation and world. During 1914, Henri met Hewitt in San Diego and expressed an interest in painting Indians. Hewitt invited him to Santa Fe; he arrived there in 1916 and became one of the colony's most productive and dedicated members. Unlike most of the other colony pioneers who established permanent residences in Santa Fe, Henri lived elsewhere during the winter months and returned there each summer. Henri gloried in the brilliant light, color, and variegated landscapes of northern New Mexico, he exulted in Santa Fe's "wonderful climate and colorful subject matter," and, when away from the place, he pined for it: "I'm really hungry for the sun, the feel and the look of Santa Fe." As an internationally prominent painter and teacher he influenced many pupils and friends to join the Santa Fe colony. Some became permanent residents, others became affiliated as summer painters. Among students and friends drawn there by his enthusiastic urging were George Bellows, Leon Kroll, Randall Davey, and John Marin, the last rated by critics during the 1920s as the most consistently strong and productive artist in America. Also, somewhat through his influence, his former pupil and close friend John Sloan moved from Taos to Santa Fe. With these men in its constituency, the Santa Fe colony could boast of two of the nation's best-known and highly regarded painters. Sloan returned to Santa Fe every summer until his death in 1951, becoming the dominating figure in the colony.[19]

Isolated like the Taos colony, the Santa Fe colony also faced the problem of exposing colony members' work to the world for peer judgment, critic evaluation, and markets, although to a lesser degree because in the early years Santa Fe was not quite as isolated as Taos. The town had relatively more direct access to the outside world, and an important future source of sales for New Mexican artists—the tourist—was coming to Santa Fe in increasing numbers before 1920. As indicated, the Taos Society of Artists permitted some Santa Fe painters to include their works in the very successful traveling

exhibits. Also, local citizens worked to promote interest in art produced by the Santa Fe colony. Beginning in 1915, officers of the Santa Fe Women's Club called for an intensive effort to expose the region to art and literature. Phoebe McCulloch, head of that organization's Art and Literature Department, stated that "In working together along the lines of beauty there is a specific benefit" for the community. And the State Federation of Women's Clubs, working with art-curator Olive Wilson, influenced establishment of the New Mexico Museum of Art, first in the Governor's Palace and later in a separate adjacent building, the facility containing both studios for artists and display space for paintings. Other efforts to promote paintings by Santa Fe–colony artists included the opening of a print shop in Seña Plaza during 1917 by Alice Corbin Henderson and Marjory Smith, and organization of the Santa Fe Art Club to sponsor exhibitions of Santa Fe colony paintings locally and in surrounding towns and in cities across the Southwest.[20]

The formative period for the Santa Fe and Taos colonies extended from about 1900 to 1920. By 1920 these two northern New Mexican settlements were flourishing artistic communities, recognized nationally, even internationally. While the colonies had, for the most part, attracted persons of considerable ability, and would continue to do so, in the formative years two persons dominated—Ernest L. Blumenschein, at Taos, and John Sloan, at Santa Fe.

Blumenschein's paintings came to be exhibited in and were purchased for museums in Paris, Venice, Budapest, Berlin, and in several cities in Australia, New Zealand, Canada, and South Africa. The prizes he received for painting excellence included the Chicago Art Institute Palmer Gold Medal, the National Academy of Design Altman Prize, the Isador Gold Medal, and the National Arts Club Medal. He was a high-ranking member of the National Academy of Design, the Arts Club of New York, the Society of Illustrators, the American Society of Painters, Sculptors, and Gravers, the Salmagundi Club of New York, a Fellow of the Grand Central Art Galleries, and a National Academician, one of the highest honors for American painters. This recognition and these honors were derived from his Taos-

colony experience and from exploiting the northern New Mexican natural and social environmental elements. In addition to being the acknowledged leading artist of the colony during the formative years, he was also its catalyst and principal internal critic and, according to reports, he "relished his reputation as an eccentric and even a difficult man."[21]

Sloan was the overpowering personality in the Santa Fe colony. His paintings were a mix of New York sidewalk scenes and northern New Mexican subjects, but he surpassed Blumenschien in recognition from the art world, eminence among critics and peers, prizes awarded for paintings, membership in status professional organizations, and distribution of works in museums and private collections. Like Blumenschein for the Taos colony, Sloan was catalyst and internal critic for the Santa Fe colony. His colleagues there rated him "perpetually inquisitive," and a "humorous, acid and violent child of art. . . . He whipped young men's minds with his extreme statements, his humor, his theories, his paradoxes, and his novelties. He was Irish, combative, never dull, pugnacious, sincere. His company was electric and always fun."[22]

During the formative years of the Santa Fe and Taos colonies, painters were stimulated by the northern New Mexican milieu, which they also drew on for subjects for painting. They concentrated on Indians, Spanish Americans, village scenes, landscapes, and other environmental subjects. The traveling exhibitions and the increasing numbers of paintings by Santa Fe and Taos artists purchased by tourists, private collectors, and museums had the effect of permitting the viewing public to discover the Southwest.

The quality of work produced during the formative period by Santa Fe and Taos artists varied; some paintings were of considerable merit, others were attractive but neither "pictorially perplexing" nor "intellectually challenging." Artists producing this latter class of paintings pandered to the public, which expected pictures "thematically pleasing and colorfully decorative." They quickly learned that there was a ready market for paintings that presented the uniqueness of New Mexico, with the result that many became stereotyped, notably landscapes depicting different seasons showing snow-covered mountain

peaks or Pueblo Indians with pottery. Much of the work by Ufer and Couse fell in this class. Ufer, a painter of great ability but pressed financially, sold a reported $150,000 worth of paintings in three years, his model a stereotyped Taos Mountain, an Indian on a white horse in the foreground. Blumenschein, Berninghaus, and Sloan studiously avoided this; yet, they were successful professionally and modestly successful financially. Cassidy was able to produce drawings for railroad posters promoting tourist travel in the Southwest and still do magnificent, critically acclaimed paintings, his *Juan Pino* an example.[23]

During the formative years the Santa Fe and Taos colonies differed from other colonies around the country. Most aesthetic communities were short-lived; the Santa Fe and Taos colonies, well established between 1900–1920, maintained a vital life until 1942. These colonies also differed from most of the others in that the artist often settled as a permanent resident or he established a second home in Santa Fe or Taos and used it during the summer painting season. And pioneer members of the Santa Fe and Taos colonies just did not behave as the public expected of creative people. Rather than being permissive, reckless, uncommitted, and nonconformist, they were remarkably stable in their family life. At that stage in colony development there was little of the "romanticized Bohemianism" and Greenwich Village behavior. The local muses were generally free of "temperamental eccentricities" that in other colonies created "notoriously difficult" situations and expressed themselves in "communism, scandal and disaster."[24]

Another difference that distinguished the Santa Fe and Taos colonies from fine-arts settlements elsewhere was that, at the time, there was no school of art (that is, coterie of artists obsessively committed to a particular aesthetic dogma or thematic philosophy) in either colony. Rather, the Santa Fe and Taos colonies were simply communities of creative persons, each largely independent, following his or her personal conviction and penchant.

But if Santa Fe and Taos aesthetes were independent in their art, they were dependent otherwise. Propinquity in awesome isolation required cooperation. Thus in each colony there evolved a sense of community, drawn from the natural environ-

mental fact of remoteness, but also from the social environmental models provided by Indians in the cooperative pueblos and Hispanics in their tightly knit family communities. Most colony members developed a sense of community that tempered their individualism and competitiveness, at least in their social relations. And it became a conspicuous characteristic of both colonies, particularly after 1920 when the aesthetes became regularly involved in local civic and ethnic causes.

As indicated, while the natural environment was the dominating influence in colony members' activity and response, the multiethnic social environment was a factor of no little consequence. Artists brought with them their preconceptions of art, methodology, and style, and applied them to local subjects. Indian and Hispanic art appealed to them and influenced the work of several. The Indian's abstract values and expression in his art were adopted by many of the later-arriving painters. Also, it was comforting for the immigrant artists to find a place where artists were not treated as pariahs, where many male Indians and Hispanics were practicing artists and were not scorned (as was the lot of creative persons in the industrial society of the East) but rather were honored by their communities.

The Taos and Santa Fe colonies had been accepted by the world of art as places where creative persons could find fulfillment apart from the pernicious distractions of the age. One advocate for northern New Mexican artistic settlements emoted that in either place one would find "the quaintest and most picturesque community in all of America. . . . It is simply too good to leave. It's the best stuff in America and has scarcely been touched. . . . It is the variety, the depth and breadth of it, rooted in aeons of time which explain the secret of its infinite charm."[25]

In 1920 the Santa Fe and Taos colonies prepared to enter the second half of their near half century of life. Before describing that productive and fast-changing epoch, it would be well to examine the supporting elements that enhanced the colonies' chances for success.

CAMPO SANTO AT SAN JUAN

Sit here by the Cacique's *house*
And watch Lupita plastering a wall
With dust that was some mother's son,
Mixed with the rain that fell, how many times!
As women's tears.
This was their life;
A wind that rose and struggled with the dust
And stilled to dust again.

—MARY AUSTIN

4 / THE NORTHERN NEW MEXICAN SOCIAL ENVIRONMENT: DISCOVERY, RESTORATION, INTERPRETATION

THE increasing strength and vitality, and the longevity, of the Santa Fe and Taos colonies were due in no small measure to the encouragement and very tangible support immigrant artists and writers received from persons and agencies in the two communities. In the fashion of Renaissance patrons several affluent residents of Santa Fe and Taos provided food and shelter to painters and writers until they became established. And there evolved strategic support agencies in both towns that additionally sustained the aesthetes and strengthened the colonies. Most important of these was the Museum of New Mexico, in Santa Fe; its assistance extended to the Taos colony and eventually made it a satellite of the Santa Fe colony. By 1920 the Museum of New Mexico had become the patron agency for both colonies and, through its outreach, increased their stature and reputation around the nation and world.

The evolution of the Museum of New Mexico demonstrates the intimate tie between art and archaeology, the latter bringing to public view the art of past cultures. And like the colonies themselves, the museum, in part, grew out of the nearly overpowering mystique of the paleo-Indian epoch of northern New Mexico's social environment.

Two persons are primarily responsible for creating the Museum of New Mexico—Edgar Lee Hewett and Frank Springer. Both were endowed with driving energy, an insufferable curiosity, and broad humanistic vision. They met at Las Vegas, situated seventy miles east of Santa Fe, while Hewett was president of the normal school there. Springer was a lawyer from Iowa who had prospered from land deals in the Cimarron region of northeastern New Mexico. While at Las Vegas, Hewett and Springer became interested in New Mexico's prehistory as well as its history during the Spanish period, and they fashioned twin goals—to excavate the potentially rich and revealing paleo-Indian settlement sites in northern New Mexico, particularly in Pajarito Park, situated thirty miles west of Santa Fe, and to recover and restore evidence of Spanish culture in northern New Mexico. Springer provided funding for these archaeological and historical projects and was an active participant in both. Several archaeological surveys of the Southwest had been made, including those carried out by Adolph Bandelier, who explored the region's paleo-Indian sign beginning in 1880, but by 1892 his interest and work shifted to Mexico and South America. Also, Alfred V. Kidder had pioneered in Southwestern prehistory excavations; however, excavations of habitation sites in northern New Mexico by the School of American Research staff would be the first intensive archaeological effort there.

Hewett and Springer began with preparations to restore the much-abused and often-altered Governor's Palace, on the Santa Fe plaza. In 1907 the territorial legislature designated it the Museum of New Mexico, to be a center for restoring, preserving, and displaying the archaeology, ethnology, history, and art of the Southwest. The venerable adobe structure would become available for remodeling into a museum when new quarters for the legislature and a residence for the governor

were completed. Also in 1907, Hewett founded the School of American Archeology, later named the School of American Research, a privately financed, nonprofit organization with headquarters in the Governor's Palace, in Santa Fe, and an affiliate of the Archeological Institute of America. Its purpose was "to promote and carry on research in the archeology and related branches of the science of man and to foster art in all its branches through exhibitions and by other means which may from time to time be desirable." Hewett served as director of the Museum of New Mexico and School of American Research until 1946.[1]

Hewett and Springer were responding to the currents of nationalism running strong in the pluralistic American Movement to which artists, writers, and other creative persons had already reacted. Just as the aesthetes were looking inward for roots and themes, so were these two humanist promoters. Up to that time, archaeological emphasis and interest in the United States had been directed to extracontinental sites—American archaeologists customarily worked ancient sites in Athens, Rome, and Jerusalem, as well as locations in Egypt and China.

Several persons served as staff members for both the Museum of New Mexico and the School of American Research, including a number of artists from the emerging Santa Fe colony. Springer hired Kenneth M. Chapman, one of the founders of the Santa Fe colony, as artist-illustrator. Chapman was becoming widely known as an authority on Pueblo Indian art, particularly pottery design; he was also a skilled writer and served as publicist, his articles in national magazines explaining the mission of the Museum of New Mexico in archaeology and art, stressing prehistoric art and Native American residuals in contemporary art expression. Springer engaged Carlos Vierra, another founder of the Santa Fe colony, to sketch and paint the Franciscan missions at the nearby pueblos, and to research Indian and Spanish colonial adobe construction.

Additional staff members who served both the cause of art and archaeology were Paul A. F. Walter and Jesse Nusbaum. Walter came to Santa Fe in 1899 as a reporter for the Santa Fe *New Mexican*, and in 1908 became owner of the paper.

Later he was appointed associate director and secretary for the museum; he founded *El Palacio* in 1913, the New Mexico Museum magazine containing articles on Southwestern art, archaeology, and history, a publication that achieved a national circulation. Jesse Nusbaum, another Las Vegas Normal staff member who followed Hewett to Santa Fe, subsequently developed an international reputation in anthropology and archaeology for his excavation work at Mesa Verde and other regional prehistoric sites. At the time of the founding of the School of American Research, Nusbaum was assigned the task of directing the remodeling of the Governor's Palace. His prodigal energy, enduring enthusiasm, and attention to detail were of great importance in the successful founding of the Museum of New Mexico and the School of American Research.[2]

In 1909 the buildings for the territorial legislature and the governor's residence were completed and the Governor's Palace was turned over to the Museum of New Mexico. Vierra and Nusbaum began the remodeling that year. Vierra examined adobe design and structure in every detail; he photographed, sketched, made field notes, and fashioned models from excursions across northern New Mexico, studying Pueblo and colonial Spanish-American architecture. From his work Hendrickson Associates drew the remodeling plans. Nusbaum directed the actual renovation work on the Governor's Palace, while Vierra supervised its aesthetics. Workmen removed the superficial interior and exterior overlay of territorial and Victorian architectural modes, and restored the aged structure as closely as possible to what Vierra and Nusbaum determined was its appearance at the time of its original construction nearly 300 years before. Thus when the work was completed in 1915, these two had created a model for what came to be called "Santa Fe style" architecture.

Just as artists from the Santa Fe colony were engaged in remodeling the Palace of the Governors and converting it into the Museum of New Mexico, they were also beneficiaries of its facilities. In part to fulfill its function as a patron of Southwestern art, the restored Governor's Palace included, besides laboratories for archaeologists and anthropologists, studios for

painters, sculptors, designers, and architects. Hewett stressed that the practice of offering studio facilities to artists was prac- ticed only in certain European cities. Gerald Cassidy, William Penhallow Henderson, Marsden Hartley, Julius Rolshoven, Paul Burlin, Robert Henri, Sheldon Parsons, John Sloan, and other Santa Fe–colony members received working space in the Gov- ernor's Palace. A large part of the building was converted into exhibition space for Santa Fe–colony artists to show their work; the galleries were also open to Taos-colony artists. This became an increasingly valuable resource for northern New Mexican artists as the number of tourists reaching Santa Fe increased, many of them buyers of their art.

Springer, sensitive to the tie between prehistory and its in- terpreters — archaeology and art — commissioned Carl Lotave to render murals in the American archaeology exhibition room of the Palace of the Governors, illustrating reconstructions of pre- Columbian communities that the School of American Research field staff had excavated on the Pajarito Plateau. Springer also provided cash advances to destitute artists in the colony, taking their paintings as repayment and placing them in the permanent collections of the New Mexico Museum.[3]

Artists from the Santa Fe colony also participated in the field work of the School of American Research. Its archaeologi- cal ventures, largely supported by Springer, extended across the Southwest and into Yucatan and Guatemala; however, Springer and Hewett's primary interest was northern New Mexico's pre- historic legacy and Spanish period. Some of the most exciting work performed by the School of American Research took place in the Chama valley, at Jemez Hot Springs, Puye, and along Rito de los Frijoles. The museum outreach program included an annual summer-school session conducted by the School of American Research, accredited by the American Archeological Institute — with visiting faculty (anthropology, archaeology, his- tory, and art) from the University of New Mexico and other institutions — and permitted to grant academic credit. Field staff for each summer session included Pueblo Indian workmen, pro- fessional archaeologists, artists, writers, and students; each ex- cavation team consisted of four diggers and a staff assistant

whose duty it was to analyze artifact material. A frequent expedition member was Charles F. Lummis, who wrote *Land of Poco Tiempo*, a classic on the region's environment and one of the first books to form the latter-day literary tradition for northern New Mexico's aesthetic colonies.[4]

Roots of the paleoartistic tradition survived in the artifacts exposed at these sites. Functional household items embellished by the prehistoric artist demonstrated how his skilled hands and creative spirit expressed his dreams and visions of beauty. Artist expedition members often were awed by these rich manifestations of indigenous American art and architecture, some of it over a thousand years old, discovered by the field crews. And they noted a strong continuum of these ancient aesthetic values and styles in the textile and pottery decorations applied by contemporary Pueblo Indians.

Several Santa Fe–colony artists, particularly those with a fondness for the emerging abstract and modern mode of artistic expression, found in these archaeological revelations compelling models for expression. Field crews exploring 400 caves in one canyon along Rito de los Frijoles discovered 196 frescoes graven in the soft tufa walls. They photographed and made plaster casts of these ancient works of art. Baumann and several other artists used these copies of paleo-art as models; Baumann's exquisite woodcuts of Rito de los Frijoles art became internationally recognized and esteemed.[5]

Clearly the Museum of New Mexico was primarily an agency for exploring, conserving, and interpreting the region's nonpareil environment—natural and social—and evoking respect for its age and essence. Response to its programs in archaeology, art, history, and literature exceeded Hewett and Springer's most extravagant expectations. Summer field sessions of the School of American Research had yielded such an abundance of rich and communicative prehistoric materials that space in the Governor's Palace for storage, laboratories for analysis, and museum display quickly was exhausted. And artists requesting studios far exceeded the facilities available, as did display space in the museum galleries for their paintings. And during summers, tourists were coming in ever-increasing numbers,

which severely pressed museum accommodations. Thus the two began to consider plans to expand the Museum of New Mexico beyond the crowded Governor's Palace.

The model for the new museum and the initiative for its approval and construction came in 1914 when New Mexico officials accepted an invitation to participate in the Pacific Exposition, in San Diego, celebrating the opening of the Panama Canal the following year. Hewett, Springer, Vierra, and Nusbaum were placed in charge of the New Mexico exposition building. These men developed a building design, compatible with the "Santa Fe style," embodying the features of six Franciscan Pueblo-mission churches, the Ácoma mission balcony and towers dominating the exterior architecture.

State committee members fitted the structure's interior with exhibits of paintings by Santa Fe and Taos-colony artists, state products and enterprises, and a display prepared by the School of American Research modeled after prehistoric communities excavated in northern New Mexico. The Pueblo "apartment houses" fascinated viewing "city dwellers who thought their own communal dwellings were uniquely modern." Lectures by Hewett on New Mexico history, culture, and art added to the exhibition appeal. The New Mexico building and exhibit were rated the "most popular" of the state exhibits and received first-place award for most-original state building.[6]

The enthusiastic reception of the exposition exhibit caused New Mexico political, business, and professional leaders, newspaper editors, and chamber-of-commerce officers to regard the state's art, history, and culture as potentially profitable resources that could be exploited for commercial and political purposes; with support and promotion these enterprises would draw more tourists, increase local and state income, and attract permanent residents to this sparsely settled state. And because they regarded the New Mexico Museum as the primary agency to accomplish this improvement in the young state's economy (New Mexico had been admitted to the Union finally in 1912), it was relatively easy for Springer and Hewett to obtain state support for museum expansion.[7]

The enabling legislation for the new museum required that

it be an annex to the Palace of the Governors. Springer provided half of the cost of construction and donated land for parking; the remainder of the land and funding for the new museum came from city and state sources. Vierra and Nusbaum composed a construction design calling for erection of a replica of the San Diego Exposition model, to be situated directly across the street and west of the Governor's Palace. Its adobe exterior extended two stories high and was supported by heavy exposed timbers, *vigas* and *corbels*—hand-dressed, carved, and decorated by native craftsmen.[8]

Broadly, the new structure was to commemorate the martyrdom of Franciscan missionaries in New Mexico. Its interior included a community hall, library and reading room, reception room, and studios for artists and galleries for displaying their work, all furnished in Spanish-style furniture designed by Chapman. The community hall was to be named Saint Francis Auditorium. Springer commissioned Donald Beauregard, a gifted young painter from Utah, to render six murals depicting the life of Saint Francis and Franciscan missionary scenes in the New World from the conversion of Saint Francis, to Franciscan missionaries preaching to the Mayans and Aztecs, to the founding of missions in New Mexico. Beauregard died while the mural work was in progress, and Vierra and Chapman, working from his sketches and color instructions, completed the group. Galleries for the Museum of New Mexico's permanent collections were to display paintings purchased by Springer from Santa Fe– and Taos-colony artists, or donated by them.[9]

A statement in *El Palacio*, the museum's publication, explained that the new structure embodied

the distinctive and salient points of New Mexico mission architecture which owes its character in part to the material employed in the construction, the environment, and to Pueblo workmanship and traditions. In a way it is the only American architecture in this country, because it has virtually grown out of the soil, shaped by the environment, and is based upon natural development going back many centuries.[10]

Ceremonies and observances for the new museum began on November 26, 1917, and extended into 1918 because of the

exigencies of World War I. Hewett and Springer, among others, delivered dedicatory addresses before the opening-ceremony gathering in Santa Fe of 1200 persons. Hewett commented that the Archeological Institute of America had given its sanction to the erection of the building along authentic lines. The editor of the *Santa Fe New Mexican* grandiloquently stated that the New Mexico Museum was a

Magnificent Monument. . . . Entirely without exaggeration . . . there is nowhere else in the United States the equal of the New Mexico State museum. It has been a marvelous revelation to Santa Fe people no less than to Santa Fe guests. . . . it is an institution without parallel in the country and a prize whose value the city and state are just beginning to realize. . . . That the art gallery ranks with the Carnegie Gallery in Pittsburgh, the Chicago Art Institute, the Corcoran Gallery in Washington and others, no one who has had an opportunity for comparison will deny.[11]

Congratulatory messages came to museum officials from all over the art world. Victor Higgins, Taos-colony pioneer and an internationally acclaimed painter, provided one of the most treasured notes:

It is an important step in the assimilation of an art by a democracy which is America's problem. Too long have we been led to believe that art was a thing that lived and died in Rome or Greece or some far away place. To see a new building erected that embodies the finer phases of art that a people purchased from within themselves and from the masterly handling of materials at hand is an innovation for America who has been anxious to array herself in European finery.[12]

In keeping with the revolutionary spirit in the American art world of breaking with the Academy—including its highly restrictive, exclusionary, even punitive, policy of controlling exhibition facilities—Hewett applied to the new museum the daring "open door policy," or free exhibition access to artists. He explained it thus:

America is eminent in material ways, and poor in esthetic culture. Therefore it would seem that particular encouragement should be extended to the workers in the field of creative esthetics. . . . The Museum extends its privileges to all who are working with a serious

purpose in art. It endeavors to meet their needs for a place of exhibition and as far as possible offers studio facilities, as tables are furnished to visiting writers. . . . The Museum thus becomes a forum for free artistic and intellectual expression, and must accurately reflect the cultural progress of our time.[13]

Artists were quick to praise Hewett for the announced "open door policy" for the Museum. Sharp, the Taos-colony pioneer, wrote: "Encouraging all schools and 'isms' in your exhibitions is most commendable. It gives something tangible for those who are interested enough to praise or criticize as the case may be." Olive Rush, the Santa Fe–colony pioneer, added:

Many of us came out here to find ourselves. I know of no institution anywhere better tuned to help an artist to do that very thing than the Museum of New Mexico, and none so well tuned to its own environment of great spaces. . . . Some may prefer that you should copy the Academies and put hobbles on the artists, but they are not of those who seek the light. Seekers have no patience with hobbles. The Air . . . and Freedom of Action . . . we fled the East for them.

And Oscar Jacobson, head of the School of Fine Arts, University of Oklahoma, declared: "I congratulate you . . . and I especially hope that your museum will always be a liberal institution, an inspiration and encouragement to those now living and with no terror for the new and unusual, as well as a dignified depository of the art of the ancients."[14]

The museum's inducements to creative persons had a predictable effect. During 1917, the year of its opening, museum officials reported a "phenomenal" increase in applications for studio and exhibit space. At least "forty artists, American and foreign," were in Santa Fe for the summer painting season, and exhibits of their work were held almost without interruption into late autumn. And by 1920 the number of artists working in Santa Fe and using museum studio or exhibit facilities, or both, had increased to nearly eighty.[15]

Also, the museum at Santa Fe increasingly was becoming a regional fine-arts nerve center, a coordinator for an enlarging

range of aesthetic, scientific, literary, and civic activities, even to directing the annual Santa Fe Fiesta. The museum served as an intellectual guardian for the Southwest, stressing right of freedom of inquiry and expression in their various forms for all persons. And museum staff often were business agents and brokers for both Santa Fe– and Taos-colony artists. The Museum of New Mexico became the first stop for the Taos Society of Artists' twice-a-year traveling exhibitions, and museum staff gradually took over shipping and watching over the movement of these paintings on their circuit from Santa Fe to New York, thence back west to various cities, with the tour generally concluding in Honolulu.[16]

By 1920 the Santa Fe and Taos colonies were well established. Intensive application by pioneers to northern New Mexico's hauntingly rich natural and social environments had yielded paintings of considerable quality. The painters had been nurtured by supportive persons and institutions auspiciously appearing on the northern New Mexican scene to meet their peculiar needs. During the formative years of the Santa Fe and Taos colonies, 1900–1920, resident artists had attracted considerable attention from the art world and general public by their traveling exhibitions. The Pacific Exposition at San Diego had exposed tens of thousands of persons to Santa Fe– and Taos-colony art. And the increasing number of tourists visiting northern New Mexico, many of them purchasers of paintings by local artists, and several national newspaper and magazine articles featuring the colonies and painters further popularized the region. Additional painters from the nation and around the world were attracted to northern New Mexico, as were other creative types—sculptors, poets, writers of fiction and nonfiction, playwrights, musicians, architects—forming a muse galaxy of such magnitude as to assure that the period from 1920 to 1942 would truly be the Golden Age of creativity for the Southwest and, in some respects, the nation.

CABEZON PEAK

At Cabezon there rises a mountain
And it might well be that the will of God
Bade this vast column of granite stand upright
As a witness to his power.
The Indians believed that, once,
And the Spanish peasants of today
Looking out from their doorways,
Believe it still.

—ARTHUR DAVISON FICKE

5 / THE GOLDEN YEARS AT TAOS COLONY (1920–1942)

TAOS in 1920 had changed but little from the remote alpine village where, in the late 1890s, Joseph Sharp, Bert Phillips, and Ernest Blumenschein founded the art colony. The Taos environment—awesome landscapes, brilliant light, exotic color, aura of timelessness, and intriguing multiethnic society—was the same as it had been at the turn of the century. Its population, excluding the Pueblo (less than 1500 in 1900), remained stationary until the Depression years when it declined slightly.

Through most of the Golden Years' epoch there was little change in the Taos urban character. The journalist Ernie Pyle visited Taos in 1938, only four years from the close of its life as an aesthetic colony. He wrote that artists lived in Taos

because of the landscape, the Indian, and the isolation from bothering influences. The village straggles out from the plaza for a few blocks. Most of the houses are adobe, some of them falling down. The streets are hard clay when dry, deep mud when wet. There are three hotels, all small. . . . There are a few "show places" around Taos; mansions built by rich people or artists. But not many. It's just as fashionable to live in an adobe shack. Taos hasn't changed much over the years.

. . . Until three years ago the village had neither running water nor electric lights. Even now the streets are not lighted and you walk around at night with a flashlight. . . . The artists try to keep things as nearly as they were for they want the picturesqueness.[1]

If Taos's natural-social milieu remained unchanged after 1920, the character of its colony changed substantially. Old-timers, *Los Ochos Pintores* (Ernest Blumenschein, Bert Phillips, Joseph Sharp, Herbert Dunton, Walter Ufer, Irving Couse, Oscar Berninghaus, and Victor Higgins) continued to dominate the community, but they were regularly challenged by the late-comers.

The Taos and Santa Fe colonies had been formed around 1900 as part of a secession movement by creative persons seeking refuge from what they regarded as the stifling power of the Eastern artistic and socioeconomic establishment. A second out-pouring for similar reasons occurred in the post–World War I era. Artists, writers, and other creative types, disillusioned by the apparent failure of Allied wartime goals to erase chaos and tyranny across the world and threatened by what they described as their suppressive, predatory industrial society, exiled themselves from the great urban centers of America to France, to Italy, to the South Sea islands, and to established colonies within the United States. By 1920, Taos was well known as a Muse haven and it received a large number of these postwar émigrés. The first wave to reach Taos between 1900 and 1920, the pioneers who founded the colony, consisted largely of painters; the second contained a majority of painters but it also included sculptors, musicians, playwrights, poets, and writers.

As indicated, several painters arrived at Taos Colony just before 1920—Bert and Elizabeth Harwood, John Younghunter, Grace Ravlin, Maurice Sterne, Julius Rolshoven, Leon Gaspard, Marsden Hartley, John Sloan, and Andrew Dasburg. Of these, Sterne, momentary spouse of Mabel Dodge (Luhan), worked briefly with Indian models at Santa Fe and Taos before completing divorce negotiations with the erstwhile New York salonist and returning to the East. Sloan and Dasburg soon moved to Santa Fe colony, but Dasburg returned to Taos where, ex-

cept for summer teaching stints at Woodstock colony, he resided for the remainder of his life.[2]

Dasburg, born in France in 1887, quite early came under the influence of French Impressionists and Cubists. A cogent interpreter of art themes, he explained why he used the abstract approach in his paintings: "all design lies in the intuitive mind of the artist. . . . every forceful creative idea . . . will shape its own means of expression in a manner inseparable from the man without the use of that which is independent of him"; and "A work of art is a metaphor and not a computation of visual facts." Commentators observed that Dasburg "never paints what he sees, but what he feels." By 1913, when he displayed three paintings and a piece of sculpture at the Armory Show, Dasburg was well established in the Eastern art community, prepared to spend a comfortable career of teaching each summer at Woodstock colony, and to enlarge his reputation as an avant-garde painter. That was until Mabel Dodge Luhan introduced him to northern New Mexico; its dazzling light, awesome vistas, strong, distracting colors, and charming social environment so mesmerized him that he soon made preparations to settle there permanently. For several years after 1920, Dasburg painted during the winters at Taos, returning summers to teach at Woodstock colony. After 1930 an increasing number of young artists came to Taos to study Dasburg's modern-art techniques and style. Eventually he displaced Blumenschien as the dominating force in the Taos colony.[3]

Artists streaming to Taos after 1920 included Howard Norton Cook, painter, muralist, printmaker, teacher of art, and magazine illustrator. His work was much influenced by the local social environment—the Indian and Spanish American essence which, he explained, determined his aesthetic response, less in an "identifiable way" and more as "a communication of the spirit." The great power of this essence was its "purity" and "directness of insight into life." Cook's etchings received high critical acclaim and appeared in exhibitions as well as permanent collections of the Metropolitan Museum and the Whitney Museum, in New York, and museums in Paris, Berlin, London, and Mexico City.[4]

Other painters of note surfacing above the crowd of artists who collected at Taos colony in the post-1920 era, particularly during the summer months, included E. Martin Hennings, Joseph Imhof, John Ward Lockwood, Thomas Benrimo, and Kenneth Miller Adams. Hennings had studied at Chicago Art Institute and at academies in Munich and Paris. His promise as a painter attracted the attention of Taos Society of Painters officers who inducted him into their elitist coterie. Hennings eventually was invited to display his work in the leading exhibitions of the United States and at London and Paris, receiving several prizes, including the prestigious Paris Salon award.

Imhof, from New York, studied at Brussels, Paris, and Munich, and painted abroad for several years before reaching the Southwest in 1904. Eventually he settled in Taos where he specialized in painting New Mexican landscape.

Lockwood studied at the University of Kansas, the Pennsylvania Academy of Fine Arts, and Academy Ranson, in Paris. An internationally acclaimed teacher, he held appointments on the faculties of the University of Texas at Austin and the University of California at Berkeley. Lockwood declared that he preferred the Taos colony because he found artists there "more exploratory" than in other colonies.

Benrimo, from San Francisco, studied at the Art Students' League in New York and for several years designed and painted theater scenery and illustrated for *Scribner's, Forum,* and *Fortune* magazines. Benrimo subsequently became a surrealist painter and taught at Pratt Institute for four years, then he turned to abstract style, which he rated a "more personal form of expression." Benrimo discovered Taos during the 1930s, and in that rich, pulsing milieu his work became an "inner reflection to the fascinating New Mexico landscape."

Kenneth Miller Adams, a Dasburg student, also studied at the Art Students' League in New York and at academies in Europe. He has been characterized as the foremost artist of the later generation of Taos painters, a congealing link between early and later aesthetes of that colony. He became professor of art at the University of New Mexico in 1940, and director of the University of New Mexico Summer Art School, at Har-

wood Foundation, in Taos. Adams's paintings, lithographs, and murals have been identified by critics as "figurative, abstractionist, and representational."[5]

Women painters figured prominently in the Taos colony. Catherine Crichter, a portrait and landscape painter from New York, was among the early immigrants to Taos. She was the first woman to become a member of the Taos Society of Artists. Blanche Grant, from Kansas and a Vassar graduate, studied at the Boston Museum School, Pennsylvania Academy, and the Art Student's League in New York, and for a time was professor of art at the University of Nebraska, Lincoln. She arrived in Taos during 1920. Her specialization was portrait painting, but, once settled in Taos, she also produced paintings and murals of Southwestern landscapes.

Lady Dorothy Brett, daughter of Lord Esher, who had been presented at court, preferred fine arts—music, dancing, and painting—to regal society. She studied art at Slade School, in London, before World War I and, by 1920, had become an established painter in Great Britain. During 1924 she accompanied the D. H. Lawrences to the United States, settling with them at Kiowa Ranch, near Valdez in northern New Mexico. Except for occasional trips to Mexico, the eastern United States, and Europe, Brett spent the remainder of her life at Taos. Her main painting interest there was the Indian and his rituals. She stated that her goal was to "paint the inner life of the Indian," portray "his reverence for the earth, the world that feeds him and keeps him alive," and to present the Native American "as he sees himself rather than the way we see him." Critics evaluate her paintings as largely symbolic and fanciful, and either modernist abstractionism or modified surrealism.[6]

Another Englishwoman at Taos during the Golden Era was Rebecca Stroud James. She reached northern New Mexico in 1926 and, like Brett, became so enamored of the dominating landscape and charming ethnics that she committed herself to a lifetime of interpreting the region through art. A self-taught artist, she painted mostly on glass; her work received popular approval in exhibitions in New York, Philadelphia, and San Francisco.

Best known of the women artists working at Taos during the Golden Era was Georgia O'Keeffe. She studied at the Art Students' League, in New York, and taught art in Texas public schools and at West Texas State Normal College, at Canyon, Texas. Her paintings, rather than of people and landscapes, focus on a single item—a bone, skull, black cross, or a flower, particularly the black iris, jack-in-the-pulpit, or morning glory. Her first New York showing was at Alfred Stieglitz's Gallery 291. Her paintings won critical approval; and she won a mate, in that Stieglitz and she were married. O'Keeffe first arrived in New Mexico in 1929; to "interpret the land and its elements." She lived first at Taos, then Santa Fe, and after that at nearby Abiquiu. O'Keeffe's "discipline never allowed her life to be one thing and her painting another. . . . To her art is life; life is painting. Her monoform paintings have consistently received high critical acclaim, reviewers commenting that her art is addressed to an 'inner seeing.'"[7]

Taos received the reputation of an international center during the formative period when several Europeans worked there. They included Leon Gaspard and Maurice Sterne, from Russia; John Younghunter, from Scotland; and Andrew Dasburg, from France. During the Golden Era of the Taos colony following World War I, the stream of foreign artists to northern New Mexico continued. They came from Europe and Asia, including Japan. Best known of the postwar émigrés, besides Brett and Stroud, were Joseph Fleck, Emil Bisttram, and Nicolai Fechin.

Fleck, from Austria and a student at the Vienna Academy of Fine Arts, was a versatile and widely acclaimed painter of portraits, landscapes, and genre, receiving many awards for painting excellence in Europe, before departing for the United States. Fleck reached Taos soon after 1920. His work there, based on northern New Mexican subjects, was widely collected by museums in the United States and Europe.

Bisttram, born in Hungary, studied painting at the National Academy of Design, the Art Students' League, and with Diego Rivera, the Mexican muralist, before settling at Taos in 1931. Initially he demonstrated a strong interest through watercolors in Southwestern Indian ceremonial dances. His credo was to

paint not so much for the sake of art as "for the spiritual insight he gains from the act of creation." Art for him was a "quest for unity of expression through the synthesis of Idea, Shape, Color, and Form." Eventually Bisttram became what he called a nonobjective abstractionist and an advocate of Dynamic Symmetry, which he incorporated into his work. Bisttram was active as a teacher of young artists studying in northern New Mexico; he established the Taos School of Fine Arts in 1932.[8]

The Russian painter Fechin was one of the most popular painters to reach Taos. He studied at Kazan Art School and the Imperial Academy, in Saint Petersburg, before venturing to New York in 1923; he arrived in Taos the following year. Fechin is best known for compelling genre painting and portraits where he demonstrated consistently the very special ability to capture the character and mood of his subject.

Other foreign painters visiting the Taos colony after 1920, attracted by its enlarging international reputation, include Adrian Barnouw, the Dutch painter, poet, and philosopher; Berger Sandzen, the Swedish artist; and two Danes, Knud Merrill and Kai Gotzsche. These young artists settled for a winter on a ranch near Taos and became close friends of the English novelist D. H. Lawrence and his German wife, Frieda. Their painting mode was stylized abstract form.

Painters at Taos colony in the formative period had largely been realist traditional-type painters. Although the work of several of the pioneer artists was of considerable merit, most was rarely "pictorially perplexing" or "intellectually challenging"; yet it was "thematically pleasing and colorfully decorative," and thus popular and marketable. As indicated, Blumenschein and Berninghaus were receptive to new themes and styles in art, but most of the early painters at Taos hewed to the traditional.

In the new order commercialism continued, and for many Taos artists painting was profitable. Improved roads and popularization of the automobile broke some of Taos's isolation; increased numbers of tourists reached Taos each summer after 1920, and many of the visitors purchased locally produced art.

The Santa Fe Railway Company assiduously promoted tourism across the Southwest with emphasis on northern New Mexico, providing artists passes on the line and purchasing their work for display in waiting rooms and restaurants along the line. Railway officials subsidized artists because they had found that a favored tourist attraction was viewing painters at work in their studios rendering colorful New Mexican landscapes and Pueblo scenes.[9]

Purist painters in the colony scorned this class of artists and charged that they pandered to "uncritical tastes" of tourists. Couse was regarded as the most commercial of all of the New Mexican painters; Blumenschein claimed that in a national competition for a calendar-illustration contract Couse "painted an Indian squatting before a buffalo hide on which he was drawing. That painting won the competition, made him famous, and he has been painting the same squatting Indian ever since."[10]

Regardless of quality, most of the paintings at Taos colony had become stereotyped in style (largely realist-traditional) and in subject matter (northern New Mexican landscapes and Pueblo Indians). Thus, for the sake of the colony's vitality and longevity, it was timely that new styles, modes, and techniques be introduced. It will be recalled that some modernist impulse was present at Taos toward the close of the formative period, but it had been overpowered and held in abeyance by traditional domination. Modern-art advocates Marsden Hartley and John Sloan had felt compelled to move down to Santa Fe colony to escape scorn from the Taos-colony majority for many of the ideas in art they espoused.

The stream of artistic change issuing from Europe and the Eastern United States finally reached Taos and Santa Fe in strength soon after 1920; the carriers were the new immigrants. Just as the Taos colony grew in size after World War I, it also was the scene of considerable diversification in style and technique. The newcomers brought fresh aesthetic dogma, design, and style. Conservative realism-type painting by the colony's old-guard members was gradually displaced as the dominant force, and by 1930, Taos had achieved the reputation of being the most exploratory of the American art colonies. However,

still no "school of art" (that is, coterie of artists obsessively committed to a particular dogma or thematic philosophy) formed.

For some time the colony remained as before, simply a community of creative people, each largely independent, following his or her aesthetic conviction and penchant. During 1920 a commentator for the *Taos Valley News* declared that the increased number of artists gathering at the colony marked the beginning of a new age there. He said that people "now painting at Taos are congenial yet independent. Each artist goes on his way, selecting what most appeals to him, and not interfering with the work of his colleagues. The group is made up of strong individuality and there is no idea of any particular cult or theory of art models."[11]

Another observer who detected this lack of a "school of art" at Taos stated:

The trouble with artists' colonies . . . is that they tend to become self-indulgent. There is too much gazing in the mirror, too much inbreeding. One might argue, why shouldn't artists cluster together as do the glassworkers of Murano? . . . But artists are not artisans! Between them lies the magic gap. Artists who spend most of their time with other artists run the risk of creative incest; their work thins out, becomes derivative, lacks the individual contour. . . . Taos consists of a group of individualists who just happen to be living together. They do not share ideas as much as they compete as free entrepreneurs in an open market. There is no School of Taos, [unlike Paris] where collective artistic thought and activity have traditionally run strong there.[12]

Harvey Fergusson, the native New Mexican author, explained that there was no solidarity among Taos artists: "They were split along many lines of cleavage, maintained by mutual aversion. The high-brow painters despised the low-brow painters, who painted only for money. There were men in Taos to whom art was a religion and others to whom it was a trade. But the high priests of art were also split into . . . factions."[13]

Thus in the early stages of the Golden Era at Taos colony, most painters developed as individuals, "trusting to their own intuitions, forming their own style out of the influences and

ideas boiling in the teeming atmosphere of their milieu." John Collier was of the view that in the Taos colony there was no "utopia" and by no means did it "hint of a cooperative commonwealth. A rather severe individualism prevails."[14]

The northern New Mexican environment continued to be the prime determinant of creative activity at the Taos colony. Like the pioneers, artists arriving there after 1920 found it to be a place "strong enough to actually dominate its painters." For the new aesthete generation, Taos still maintained an aura; the mystique of exotic land and native people continued to conquer émigrés. While pueblo Indians and landscapes persevered as popular subjects for artistic rendition, however, they no longer were a virtually exclusive choice. But, as had the pioneers, the latecomers drew on the nature stimulus and creative spirit evoked by the northern New Mexican environment.

Some aesthetes continued to use elements from the local natural and social milieu as subjects to which they frequently applied modern art values—drawing on what they called the techniques and styles of Modernism, Ultra-Modernism, Impressionism, Post-Impressionism, Expressionism, Cubism, and Abstractionism—to produce the multi-viewpoint perspective. Thus when exploiting northern New Mexican themes, most of the new painters expressed their work in a manner less of what they saw and more of how they felt about each subject; rather than recording "visual reality" as had been the predilection of Taos colony pioneers, the newcomers "sought to put down on canvas subjective, intuitive reality."[15]

Also, in the new order more of the Taos-colony artists painted nonlocal scenes—graphic vignettes of Eastern and European city-street scenes, landscapes of Corsica, Morocco, and Tunis, and seascapes, but drawing on the northern New Mexican ambience to stir the artistic spirit. In addition, there was a growing immigrant-painter appreciation for Indian art. Many Taos-colony painters found its abstractionist character a compelling model for enriching their work.[16]

During the 1930s another aesthetic strain—Regionalism— joined the expanding art universe at Taos. Regionalism is genre painting that stresses local or parochial rather than universal

themes. In a sense the Realist-Traditionalists at Taos had been doing Regionalism-type painting for some time, and its advent as an identifiable art entity brought renewed popularity for many of their paintings. The Great Depression's malaise and disillusionment encouraged enlarged adoption of Regionalism as an art form. Also, many painters were attracted to Regionalism because they could draw some personal comfort and aesthetic fulfillment from working in themes and subjects close and familiar to them.

At the same time some Taos painters advocated an extreme Modernism, perhaps the ultimate in nonobjective painting—Surrealism—defined as "art without an anchor in space or time, resting on nothing except the artist's own self-consciousness." An outgrowth of the Surrealist surge at Taos was the so-called Transcendental Movement. During June, 1938, Raymond Jonson and Emil Bisttram founded the Transcendental Painting Group, the closest to a "School of Art" (a group of creative persons committed to a single theme, style, technique, and/or art philosophy) ever formed at Taos. Its membership ranged from twelve to thirty members. Members of the Transcendental Painting Group often worked as a group, and frequently met and dined together to discuss Transcendental philosophy in art. They displayed their paintings at several galleries across the nation during the 1930s, particularly at the Museum of Modern Art, in San Francisco, and the Solomon R. Guggenheim Foundation Museum, in New York.

Members of the Transcendental Painting Group held that one achieved artistic fulfillment only by going "outside of or beyond the realm of experience or sense impression." They based aesthetic knowledge "on a spiritual intuition of reality, surpassing the bonds of sensical experience." Applying this to painting, their aim was to "leave past traditions and embark on new concepts of consciousness." Bisttram and Jonson explained that the aim of Transcendentalism in art was "to express the spirit of form rather than form itself." Bisttram added that art for him had become a "quest for unity of expression through the synthesis of Idea, Shape, Color, and Form." His goal as a leader in this movement was "to create forms that were cos-

mic, universal, and timeless." While one could not ignore sub-
ject matter, one had to concentrate on "intangible qualities of
the mind" for aesthetic guidance.[17]

The tradition for radical activity at Taos colony continued
to the very close of the life of the colony in 1942. One of its
manifestations was the founding of the so-called Conceptualism
School by John Winchester and Scott S. Edmonds, at Taos,
in 1942. Called a "new radical school of art," it really was
more of a community of avant-garde artists drawing from the
stream of Ultra-Modernism which infected Taos through most
of its later years, the members seeking to produce a cosmic
synthesis.[18]

By the 1930s, Taos-colony artists had access to a number
of local exhibition facilities to display their work. It will be
recalled that northern New Mexico's isolation during the pioneer
period led local painters to form the Taos Society of Artists,
which organized traveling exhibitions of local painters' work.
Also Taos artists displayed their work at the Museum of New
Mexico, at Santa Fe, and, as the fame of several of the Taos
painters grew, some negotiated for individual shows in galleries
and museums across the nation. As the Taos art colony became
better known and as the number of tourists reaching Taos each
summer increased, colony leaders formed marketing organiza-
tions and established local display facilities.

Taos's first gallery was at Harwood Foundation. Bert and
Elizabeth Harwood, both Paris-trained artists, came to Taos in
1918. When he died in 1923, his wife prepared the Taos resi-
dence and grounds as a memorial to him, naming it the Har-
wood Foundation, for use by Taos citizens and on her death
to be administered by the University of New Mexico, at Al-
buquerque. The residential compound included a large gallery
for displaying works by Taos artists, studios, a public hall,
meeting rooms, and a library for use by Taos citizens. Foun-
dation officials followed the "open door policy" of the Museum
of New Mexico, at Santa Fe, for showing local artists' work.
Besides annual displays of paintings by Taos artists, the foun-
dation also sponsored several handicraft exhibitions.

As tourist traffic to Taos increased, there evolved a local

market for paintings, and colony artists formed organizations to display and manage sales of their paintings. One was the Taos Art Association, its members a mix of Realist-Traditionalist and Modernist painters, which met monthly at Harwood Foundation. Taos Heptagon Gallery Group was made up of Modernist devotees. Later, the Ultra-Modernist painters at Taos led by Emil Bisttram formed the Taos Institute of Cultural Orientation. Members of the marketing organizations displayed their paintings at several galleries in Taos. Besides Harwood Foundation, there was the Spanish and Indian Trading Company Art Gallery, and a small gallery in the Don Fernando Hotel, on the Taos Plaza. During 1939 a gallery opened in the new La Fonda Hotel, situated on the Taos Plaza. Perhaps the most popular local display center was the Heptagon Group Gallery situated in the rear of the Rio Grande Drug Store, adjacent to the Plaza. Its members assessed viewers a small admission charge.[19]

During the Golden Years at Taos colony its artists also continued to display their work outside New Mexico, and several received national and international recognition and awards. Galleries in New York, Philadelphia, Boston, Chicago, Pittsburgh, Kansas City, Dallas, and San Francisco regularly displayed paintings by Taos artists. Blumenschein was appointed to the American Selection Committee for the 38th Carnegie Institution International Exhibition of Modern Paintings. Dasburg received several national and international awards, including first prize from Carnegie Institution Exhibitions, at Pittsburgh. His paintings received special recognition at the Whitney Museum Exhibition of Abstract Painting in America (1938), and he—with Ufer, Hennings, Blumenschein, Higgins, Berninghaus, Bisttram, and Adams—was feted at the 14th Annual Exhibition of Contemporary American Oil Paintings, at Corcoran Gallery, in Washington. Kenneth Adams received one of the top awards from this exhibition. Paintings by Blumenschein and Higgins were featured in the Canadian Exhibition of American Art in Toronto, and, in 1932, Higgins's painting *Winter Funeral* received the Altman Prize from the National Academy of Design. Adams, Blumenschein, Berninghaus, and Couse were

among nine Taos artists featured in the Century of Progress Exhibition, at Chicago, in 1934. During 1938, Blumenschien and O'Keefe were honored by critic approval of exhibitions of their work in Paris, and in the same year at Venice, Italy, paintings by Blumenschein, Fechin, and Ufer were featured in that city's International Exhibition.

The number of resident artists in the Taos colony varied during the Golden Years from nearly 50 in 1930 to 25 in 1940; however, the artist population increased substantially each summer, ranging from 100 to well over 150 each painting season. Also, tourists in increasing numbers were attracted to Taos after 1920, with the result that the village became crowded during the summer months when a gala, even carnival, air (dominated by art interest) pervaded the place. A writer for a national magazine declared that during the summer "the art spirit" infected everyone there: "The spirit of the place is to make something. Artists affect everyone and everyone affects artists, until Taos is now a whirlpool of self-expression. . . . All Taos is art conscious. Everybody talks art, sees pictures, compares painters, learns that art can be more important than business. Pictures hang in curio shops, in hotels, in the banks, in a gallery." The human pace at Taos slowed in autumn; the tourists had departed, and most of the visiting artists were preparing to return to their homes, most of them situated in the Eastern United States. Around October 15 of each year there appeared an editorial comment in the *Taos Valley News* that the "artist colony is fading away for the winter."[20]

During the Golden Years, Taos drew many celebrities other than painters and writers, in part because of the social outreach of Mabel Dodge Luhan. Her hospitality was legendary, her compound generally overflowing with interesting guests from all over the United States and Europe. Ralph Pearson, an etcher, settled near Taos and "found a civilization that was producing native art as a matter of course." He rented an adobe house and fifty acres for $125 a year, and started raising purebred hogs to keep him in food so that he could etch, but he said "it turned out that I had to etch to support the hogs." In the six years he lived at Taos he "saw more important people

from all parts of America and Europe than he did during his entire stay in New York."[21]

There were those in the Taos community, largely Anglo business people, who had been comfortable with the "moral stability" of the Taos colony during its formative period; they had pointed with some civic pride to the "remarkable record among the artists in maintaining family stability as opposed to over-romanticized Bohemianism." But in the new age aborning in the colony they had become increasingly uneasy over the influx of aesthetic émigrés with permissive lifestyles. Many Taos townsfolk called the newcomers, with their shaggy hair, unconventional dress, shocking language, and free love advocacy, "a bunch of nuts"; but begrudgingly tolerated them because they found them good for business in that the colony's enlarging Bohemianism titillated the tourists. For several years *Taos Valley News* published a column called "Artists Corner" that gave special attention to the creative crowd; later the column title was changed to "Gossip from the Artist Colony." This paper also regularly carried special feature articles about its resident, as well as visiting, artists and writers.[22]

Taos artists and writers had an active social life. Events that were much anticipated were the annual Christmas, New Year's, and Valentine's Day dances; the event of the year was the Society of Taos Artists costume ball. Also, Taos artists and writers regularly entertained. Their large home enabled the Blumenscheins to receive as many as 100 guests at a time; on the evening of July 27, 1920, 75 persons gathered there for a lecture on Southwestern Indians by J. A. Jensen of the Bureau of American Ethnology, followed by a buffet supper and dancing. Aesthetes occasionally formed auto caravans for trips to local points of interest, to the Pueblo dances, a visit to friends in the Santa Fe colony for a Sunday evening "Bohemian Party," or supper and a debate on the issue of "Ultra-Modern Art and Academic Realism." One excursion of Taos artists, after attending a Pueblo corn dance, proceeded to Abiquiu to view the art of visiting Russian painter F. I. Sacha. According to reports, his work reflected "an unusual talent, an emotional and colorful temperament," and demonstrated that "he is emancipated

... so that he can paint as his aesthetic emotion dictates."[23]

While relations generally were cordial between the Taos and Santa Fe colonies, Taos partisans were quietly contemptuous of the "more sophisticated dwellers" in Santa Fe because they demanded "the comforts of civilization—baths and street cars. . . . They feel ever so slightly superior to their neighbors in Santa Fe, because, seeking the primitive life for the artist, they are willing to live in a primitive way in the adobe houses that boast no [other] modern convenience than perhaps a fireplace."[24]

Actually, Taos-colony members were dependent in many ways upon Santa Fe. The New Mexico Museum there was vital for displaying their work and distributing it to galleries and museums across the nation. In truth, Taos colony eventually became a sort of satellite of the colony to the south. Several artists who had become permanent residents and property owners at Taos developed a more traditional community view, acknowledged this dependence, and urged increased cooperation between the two colonies for their mutual benefit, including working together to promote tourism. Ironically, Blumenschein, the practicing art purist and nonmaterialist of Taos colony and spokesman for its conservative faction, confided to Edgar Hewitt, chief impresario for the Santa Fe colony, that Taos artists were "pleased to be associated with the . . . Museum of New Mexico. By the labors of us all we are incidentally helping New Mexico to a reputation that may aid her in an economic way."[25]

In the life of the Taos colony, each member's raison d'être was to create works of art that would pass peer and critic judgment and be avidly sought by private collectors or find a place in the permanent collections of the nation's galleries and museums. In addition, for some there was a sense of mission, even obligation, to pass on the muse tradition through the teaching of art. Thus, there evolved in the Taos colony several art schools (institutions for the teaching of art as distinguished from "Schools of Art"—coteries of creative persons following a certain style, technique, and art philosophy). Individual artists often served as tutors; best known and most successful in producing distinguished artists was Dasburg who, early in his pro-

fessional career, had been an instructor at Woodstock colony and at other Eastern art centers. The two most important art schools to evolve from Taos colony were the University of New Mexico Taos Field School of Art and the Taos School of Fine Arts.

The Taos Field School of Art was founded on the initiative of the New Mexico Art League, a group of public-spirited citizens committed to increasing interest in art. Its members sought to establish a museum for the University of New Mexico at Albuquerque and each year purchased several paintings for the future museum; also they promoted a school of art at Taos. The Taos Field School of Art, founded in 1930, functioned each summer during June and July for an eight-weeks session at the Harwood Foundation, with a curriculum containing courses in sculpture, painting, architecture, and commercial art. Well-known Taos artists—including Higgins, Imhoff, Ufer, Lockwood, Dunton, Blumenschein, Adams, Berninghaus, and Phillips—served as instructors. First enrollment in 1930 was 120 students.[26]

Bisttram established the Taos School of Fine Arts in 1932; he held classes both winter and summer in his Taos home, where he stressed Abstract and Transcendental Art, presented around the theme of Dynamic Symmetry. Bisttram's curriculum consisted of four major forms of creative expression—art (painting and drawing), dance, music, and drama. His faculty eventually included Alice Sherborn, former student of Martha Graham, pioneer in the "creative dance." Bisttram told his students, who came from all over the United States, as well as Canada, Australia, and New Zealand, that they must be primarily concerned with space relationships, that "no true art is imitative," and that "only in stimulating the creative faculties" could "results be obtained that are truly contemporary. For this reason, Abstract Art, so-called, plays a significant part in instruction."[27]

The Great Depression had considerable negative effect on the Taos colony. Artists who lived in Taos and were, in part, dependent on the tourist traffic for sales found that the number of visitors reaching northern New Mexico declined steadily each

year after 1930. And paintings they sent to exhibition centers in major cities attracted fewer and fewer buyers. Several resident artists left New Mexico for other parts in search of employment. And many visiting artists, rendered destitute by the national economic decline, were unable to make the annual trip to Taos for the summer painting season. Those artists who remained at Taos faced a grim future. Then, beginning in 1933, the federal government, as a part of its relief and recovery program, the New Deal, established an arts-subsidy plan that sought to mobilize the nation's painters in a public arts program.

New Mexico was allocated five times the amount of funds for artist subsidy in proportion to population as any other state because of its large aesthetic community. Even so, it was claimed that at Taos and elsewhere "there are more painters registered . . . than there are jobs or money to pay for them." Taos artists were employed under federal grants to paint murals for courthouses, post offices, schools, and other public buildings across the Southwest.[28]

A number of the artists at Taos colony became uneasy over the government's entry into the arts; they feared that federal funds would bring public control of artistic expression. However, national administrators for the program assured them that "Artists on Uncle Sam's pay . . . will remain artistically free."[29]

These assurances did not convince Bert Phillips, one of the founders of Taos colony, who had been assigned a post-office mural. He withdrew from the project, then attacked the federal arts program:

I am not at all sure that the government's PWA projects for the relief of artists will be of value to either [the artist or the public]. Under government subsidy or relief we see a Modernist claiming to know the West, do a picture . . . representing Indians raiding and killing. For this work he receives praise and a prize. . . . All over the country public schools, and other buildings are being handed over to artists for decoration regardless of the artist's capability. This new arrangement by the government to help artists is bound to result in confusion in the layman's mind. Too many will accept the idea that a mural is good because the government is paying for it. Experienced artists

whose names are linked with the highest standards of achievement will have to lower their prices to the starvation level.[30]

The troubled 1930s drastically reduced the resident- and visitor-artist population at Taos colony, but several remained, and some, in spite of the Depression, maintained the colony's high reputation in the nation's art community. The outstanding painter at Taos colony during the Golden Era, 1920–42, and one who persevered there as the premier painter model was Andrew Dasburg. Without question, Ernest Blumenschein surpassed all other artists at Taos colony for quality work in its formative period, 1900–1920. During the 1920s, however, Dasburg displaced him. Dasburg is credited with being "one of the few Americans, and certainly among the very earliest, truly to absorb and understand Cezanne, Matisse, and Cubism." And he was among the first to introduce these revolutionary styles into the Taos colony. He and his many students applied them to the northern New Mexican natural and social milieu; they challenged and eventually displaced the domination of the Realist-Traditionalist mode for rendering the powerful and ever-popular local-environment subjects. His tribute as an international art figure includes the rating of being the "greatest landscape draughtsman since Van Gogh."[31]

The sister colony at Santa Fe underwent somewhat the same vicissitudes as Taos colony, except that it was larger and more exposed to the nation's main currents. It too changed, substantially after 1920, also experiencing a Golden Age, but on a grander scale. As at Taos colony, however, the northern New Mexican ambience continued to awe and to nourish the colony, both as a stimulus to creative expression and as a rich source of subjects for artistic rendition.

DESERT SONG

When I came on from Santa Fe,
The desert road by night and day,
The desert wilds ran far and free
Beneath the wind of desert sea.
.
And wakeful all the night I'd lie
And watch the dark infinity,
And count the stars that wheel and spin,
And drink the frosty ether in;
And I would hear the desert song
That silence sings the whole night long.

—JOHN GALSWORTHY

6 / THE GOLDEN YEARS AT SANTA FE COLONY (1920–1942)

SANTA Fe, as host for northern New Mexico's second aesthetic colony, experienced substantial alteration in urban character after 1920, compared with Taos where little change was evident. Santa Fe's population in 1920 was about 8,000, increasing to 12,000 in 1930, and nearly 21,000 in 1942, the concluding year of the colony's Golden Age of aesthetic life. On the other hand, Taos's population remained about 1,500 until the Depression years when it declined slightly. At Taos the colony was the major "thing" and, with the nearby Taos Pueblo, provided the principal identity for the village. But, while the colony at Santa Fe maintained its status as a glamorous fixture in the urban galaxy, it had to share the civic stage.

First, Santa Fe was the capital of New Mexico, home of the governor and state bureaucracy. The regular convening of the state legislature was a matter of some moment for the town.

Also, Santa Fe had become the banking and trading center and livestock market (cattle, sheep, and horses) for northern New Mexico.

Moreover, Santa Fe was less isolated than Taos; improved roads and increased use of motor buses and automobiles and occasional rail service connecting Santa Fe with the nearby Santa Fe Railway east-west main line, all contributed to bringing an ever-increasing number of visitors to northern New Mexico. During the 1920s tourism became one of the region's principal industries; Santa Fe became its center. Most tourists traveling to northern New Mexico came first to Santa Fe. A few ventured on to more-isolated Taos; of every ten tourists reaching Santa Fe, perhaps three proceeded to Taos and other parts of northern New Mexico. Thus each summer aesthetes in the Santa Fe colony were exposed to a greater number of tourists.

Santa Fe colony during the period 1920–42 also differed from Taos colony in size, both in resident and visiting artist population; as many as seventy-five artists made Santa Fe their permanent home. And more visiting artists, from 150 to 250, resided in Santa Fe during the summer painting season. Also, Santa Fe colony was more varied in its creative components. As indicated, in the formative years both colonies consisted almost exclusively of painters. After 1920, Taos colony attracted writers, poets, and sculptors, but painters continued to be the most numerous in the colony. At Santa Fe colony, painters also outnumbered all other aesthetes, but there were more sculptors, writers, and poets, as well as a few architects and composers there; several were permanent residents.

This increase in population at both Taos colony and Santa Fe colony after 1920 was owing to the outpouring following World War I; artists, writers, and other creative types sought asylum from threatening postwar American industrialism, exiling themselves to Europe (particularly Paris), to the South Seas, and to isolated refuges in the United States, including the Santa Fe and Taos colonies. And Santa Fe was part of the same stunning milieu which pervaded Taos, the principal draws for that colony being its awesome landscapes, brilliant light, exotic color, aura of timelessness, and intriguing multiethnic society. Santa

Fe, however, was less primitive and provided immigrants most of those "creature comforts" they had come to expect.

The newcomers joined colony founders Carlos Vierra, Kenneth M. Chapman, William P. Henderson, Frank Applegate, Gerald Cassidy, Sheldon Parsons, Olive Rush, Robert Henri, and John Sloan. Henri left Santa Fe in the early 1920s in search of a new painting locale, but Sloan continued to reside there summers, the premier painter and teacher, until his death in 1951. He dominated the colony and played the leadership role for it that first Blumenschein then Dasburg provided for the Taos colony. Vierra persevered in his personal causes of architectural restoration in Santa Fe and painting New Mexico mission churches, demonstrating a continuing zeal for linear accuracy and an abiding concern with color and design. Applegate maintained his status as landscape watercolorist of considerable ability; he also fashioned decorative tiles from local clay, which he fired in a special kiln he had constructed. Cassidy, Parsons, Chapman, Rush, and Henderson continued to perform industriously and creatively, regularly receiving critical acclaim for their work.[1]

Some of the painters arriving at the Santa Fe colony after 1920 included B. J. O. Nordfeldt, Randall Davey, Alfred Morang, and Cady Wells. Nordfeldt, from Sweden, was a leading etcher and painter. He spent a number of years at the Santa Fe colony. Critics said of his work that he was "so faithful to the modernist school that the primitive trees and hills might be as well in southern France or northern Italy." Davey, one of America's best-known painters, was perhaps the most extensively eulogized artist in the Santa Fe colony in terms of awards and honors received. Morang was a recent immigrant to the Santa Fe colony who, after Sloan, surfaced as a leader for the group. He was a versatile fine arts performer—musician (violinist of some reputation), writer, and landscape painter. He became best known as a Santa Fe–colony member through his service as a teacher of painting in the local Arsuna School of Fine Arts and as a columnist for the *Santa Fe New Mexican* and other newspapers of the region, commenting on Santa Fe–colony activities. Wells, a Dasburg student, lived in nearby Jaconita but was re-

garded as a member of the Santa Fe colony. He exhibited his paintings widely in the United States and Europe and consistently received critical acclaim.[2]

Several women painters joined Olive Rush in the Santa Fe colony during the Golden Years, and each won national distinction as a painter. They included Helen Stevens, a landscape and portrait artist, and Gina Knee, a modernist like Rush. The Denver Art Museum director credited Knee with inventing a "Fresh Idiom" for painting northern New Mexican scenes.[3]

One of the most innovative artists to reach Santa Fe colony during the Golden Years was Raymond Jonson, an abstract painter from Iowa, called by Charles Morris, of the University of Chicago, the "towering figure of contemporary America." Jonson was a charter member of the Transcendental Painting Group, and he was acknowledged as the artist playing the most substantive role in "broadening the interests and approaches of the artists in Santa Fe." Jonson was distressed by the generally negative public attitude toward modern art, and he lectured widely across the Southwest and the nation, making a vigorous attempt to interpret and popularize it. He "urged audiences to be liberal in view," that is, more tolerant and understanding in judging modern art. It was explained that Jonson's murals often related to rhythm and plane in relation to interplay between two dimensions and an emotional sensation of the third.[4]

Perhaps the most colorful painter in the Santa Fe colony during the Golden Years was Howard Coluzzi, who called himself "the artist of the people." Coluzzi lived in a tumbledown adobe on Garcia Street and was considered an artistic and literary recluse who refused to be interviewed. Famed for his masks and murals, Coluzzi occasionally emerged from his refuge to help build a house, decorate a wall, or to make a model in clay for some large building or residence. Otherwise he remained in his cloister painting and studying Greek and Roman classics. One of his most-talked-about commissions was the assignment to render a painting of Lady Godiva for a Bernalillo bar.[5]

Without doubt the most interesting painters to reach Santa Fe after 1920 were five young artists of "varying styles and backgrounds"—Fremont Ellis, Wladslaw (Walter) Mruk, Joseph

Bakos, Willard Nash, and Will Shuster—who, soon after they reached the colony, formed an association called *Los Cinco Pintores*. Ellis, from Montana, studied at the National Academy and Art Students' League and was much influenced by the work of American Impressionists. He was an ardent nature advocate and found the northern New Mexican milieu the ultimate place. Mruk, from Buffalo, studied at Albright Academy and under John Thompson, in Denver, then traveled through the West, where he was employed as a forest ranger, newspaper cartoonist, and artist before he discovered Santa Fe. At first he painted local scenes in Impressionistic style, but later he turned to Expressionism and Cubism. Bakos, also from Buffalo and a student at Albright Academy and of Thompson, taught art at the University of Colorado at Boulder, then joined Mruk in Santa Fe soon after 1920. He too painted northern New Mexican scenes in Impressionistic style, eventually turning to Expressionism and Cubism. Besides working as a painter in the colony, Bakos taught art at Santa Fe High School. Nash, from Detroit, was a Modernist who was strongly influenced by Dasburg. Through the years at Santa Fe colony he increasingly applied abstract techniques to his painting. Shuster, who was from Philadelphia and had trained as an electrical engineer, served with the American Expeditionary Force, in France, during World War I. Gassed in combat, he came to Santa Fe to regain his health; there he met and became associated with Ellis, Mruk, Bakos, and Nash. Shuster experimented with semi-Abstract techniques, but his style remained literal and representational.

Los Cinco Pintores were bound together by their awe for the northern New Mexican environment. They were fearful that "progress"—urban and industrial encroachment—threatened it, and they felt a sense of "desperation . . . to record something that was here, but would soon pass." And they formed a compact to bring art to "the common people," particularly art derived from this refreshing New Mexican milieu. Their collective position was that "art is universal. . . . it sings to the peasant laborers as well as to the connoisseur." This coterie was committed to "awaken the workers to a keener realization and appreciation of beauty, thus helping to develop the art instinct which lies latent

in every human mind. . . . They believe that individual expression is the most prolific source of creative art." Thus *Los Cinco Pintores* "banded together to increase the popular interest in art, to develop individual expression, and to protect the integrity of art by combining their resources." To introduce the "common man" to art, to bring "art to the people," *Los Cinco Pintores* bought land on Camino del Monte Sol on the southeast edge of Santa Fe, built adobe houses and studios on their common property, and painted each in his own way. Ellis, Mruk, Bakos, Nash, and Shuster consigned their paintings in traveling exhibitions for showings at mills, factories, mines, in farming towns—wherever workers labored. Their peers in Santa Fe acknowledged that *Los Cinco Pintores* added "variety and vigor" to the colony.[6]

As at Taos colony, Santa Fe–colony painters continued to bask in the powerful northern New Mexican natural and social environment. And, as in the formative period, artists in both colonies used this environment as sources of inspiration and stimulus for creative effort—as well as subjects for aesthetic rendition—but, in the new order, less as a source for scenes. Thus Santa Fe–colony studio output increasingly included paintings set in Corsica, the Riviera, Paris, Tunisia, Algeria, the South Seas, or the streets of New York.[7]

Also, as at Taos, Santa Fe–colony members demonstrated an increasing tendency to cluster into mutual-interest groups, sometimes as marketing associations, but more and more in groupings based on painting philosophy and style. In 1920, Sloan, Davey, Jonson, Baumann, and Nordfeldt organized the Santa Fe Art Club as a counterpart to the Taos Society of Artists to sponsor exhibits of members' paintings around the country. Three years later, Applegate, Baumann, and Nordfeldt formed the Society of New Mexico Painters, representing the "Progressive or Radical Conservative Element in art today" in Santa Fe. This organization also sponsored traveling exhibits of member paintings.[8]

The Transcendental Painting Group was popular in Santa Fe during the 1930s. Another Modernist covey, *El Escuelita* Group, formed by New York artists Jim Morris, Chuck Barrow, and Hal Temple, established their studio in *El Escuelita*, the

little abandoned schoolhouse on upper Canyon Road. *El Escuelita* Group functioned for over a year. Besides painting, each also had mastered "the violin and are heard playing together on some evenings."[9]

In 1930, Gina Knee and Cady Wells led in the formation of the Rio Grande Painters, a school of artists committed to Regionalism. The members stressed that Rio Grande Painters was "not a social unit." Rather, they were "joined together by nothing more than the quality of the Southwestern landscape and the people that inhabit it." Their traveling exhibits were very popular and well received in the Eastern United States; painting subjects included Penitentes, Navajo dancers, Southwestern landscapes, and winter scenes in Taos and Santa Fe. Critics said of the Rio Grande Painters that "the country in this section of the world is strong enough to actually dominate" these Regionalists "whose work is definitely shaped and molded after the original."[10]

The Depression forced formation of several additional organizations for marketing Santa Fe–colony art at a time when sales were exceedingly slow. The Society of Independent Artists was formed in Santa Fe during 1932 as an agency to barter members' paintings for food, shelter, and services. The Santa Fe Artists Guild, established in 1933, sought to promote sales of member paintings by promotion and price setting. In 1936 colony members formed the Santa Fe Art Association to protect rights of artists, solicit exhibit bookings, and promote art sales.[11]

Art styles changed at Santa Fe just as they had at Taos. The Realist-Traditionalist mode continued for some, but the new styles—Impressionism, Expressionism, Cubism, Abstractionism, and Transcendentalism—gained. New Art devotees, however, found the general public either opposed or indifferent to their renderings. Several civic groups were on record opposing Modern Art; some denounced it as "subversive." The General Federation of Women's Clubs "romped on Modernism." This group's Division of Art charged that Modernism was "art gone wild." Also several critics opposed Modernism and regularly wrote pejorative discourses; one called the new painting strain a "millstone and not a milestone in art."[12]

Modern Art protagonists attributed this opposition to lack of understanding, and they sought to overcome the public's continuing preference for Realist-Traditionalist paintings and to create an appreciation and wider acceptance of their work. They did this through advocacy writings in newspapers and magazines, and public lectures. Sloan, Jonson, and others from the Santa Fe colony lectured to women's clubs and civic groups in Dallas and other Southwestern cities on the "Spirit of Modernism," attempting to popularize the new aesthetic mode. They stressed that men and women working in it were "building upon foundations of the old masters." Sloan assured them that Modern Art "is not dead," people were "less shocked" by it; "modern art is being assimilated." They also formed Modern Art Clubs in several towns and cities across the Southwest. Olive Rush served as chairman for the Santa Fe Chapter of Modern Art.[13]

The most ambitious effort to explain Modern Art to the Southwestern public occurred during 1938. The United States Bureau of Education sponsored a forum on the arts in several cities of the region on the theme of "Abstract Art in the Machine Age." In Santa Fe the program extended over twelve weeks, a lecture each Monday evening. One of the featured speakers was Leide-Tedesco, composer, conductor, and critic of the arts.[14]

In spite of public apathy, even antipathy, toward Modern Art, several Santa Fe–colony artists received regional, national, and international acclaim for certain of their paintings. Cassidy's Navajo paintings were awarded special distinction at the Chicago Exhibit of 1929. Rush received several painting awards at the Chicago Exhibition of 1931. Davey was appointed to the Selection Committee of the Carnegie Institute's International Exhibition of Modern Painting during 1931. The Century of Progress Exhibition (Chicago, 1934) included paintings by ten Santa Fe–colony artists, and the following year Santa Fe artists were featured at the Whitney Museum Exhibition of Abstract Painting in America. At the National Exhibition (New York, 1936) paintings by Rush, Jonson, Davey, and Bakos received special recognition, and their work won critical acclaim on the West Coast from showings at Seattle, San Francisco, Los Angeles, and San Diego. Davey was elected to the National Academy of

Design in 1937 and the following year Nash won acclaim at the
Los Angeles Exhibition for his New Mexican scenes. The Inter-
national Exhibition of 1938 at Venice, Italy, included paintings
by Davey and Sloan, and the Exhibit of American Art, in New
York during the same year, featured paintings by Davey.[15]

The attitude of the town of Santa Fe toward the colony
varied, although for the most part it was that of approval.
Principal local support for the colony came from the Museum
of New Mexico. During the formative years of the Santa Fe
colony, its preoccupation had been with archaeological explora-
tion of local prehistoric sites by School of American Research
staff and with servicing the growing aesthetic community. It had
promoted the work of artists by maintaining the "open door
policy" of providing free exhibition space to members of the
Santa Fe and Taos colonies and managing the traveling exhibi-
tions. The Museum galleries had mostly exhibited New Mexican
scenes primarily because, in the formative period of the colony,
these were almost the only subjects receiving attention by local
painters. After 1920, however, the museum gradually enlarged
its program, altered its exhibition policy, and continued to be
the voice of the colony for freedom of expression, which, to
accomplish this guardian role, sometimes involved the staff in
controversy.[16]

The museum continued to provide studios for colony artists
and to show their work, and after 1920 its displays differed
from those of the formative period. The nearly exclusive New
Mexican settings for paintings were challenged for exhibition
space by the works rendered by colony artists of Corsica, Al-
geria, Morocco, the South Seas, and Paris and New York street
scenes, as well as nonperceptual abstractions of the artist's sub-
jective meanderings. The museum also expanded its exhibition
constituency beyond showing work by Santa Fe– and Taos–
colony painters to occasionally displaying work by artists from
other parts. Thus in 1922 the Museum of New Mexico spon-
sored the Exhibition of Western Artists Paintings, consisting of
work by seventy-eight artists, only ten of whom were from the
Santa Fe and Taos colonies (including Parsons, Henderson, Nash,
Sloan, and Shuster). The exhibit had been organized under the

auspices of the Western Association of Museums, of which the Museum of New Mexico was a member, and was on tour in the larger Western cities. This exhibition, scheduled for a month-long showing in Santa Fe, afforded the "people of Santa Fe and New Mexico their first opportunity to compare the work of the ten local artists represented in the exhibit with that being done in other art centers of the West."[17]

The ubiquitous Hewett, ever the impresario, seemed obsessed with making the museum the very center of Santa Fe life. Among the several civic enterprises he brought under museum aegis was the Santa Fe Fiesta, held around September 1 of each year. Several thousand visitors gathered in Santa Fe for this multiethnic and historical pageant. Art received a prominent place in the fiesta tableaux by exhibits in the museum as well as street displays featuring paintings and exhibits of pottery, textiles—including colorful hand-loomed blankets, wood carvings, embroidery—and metal and leather work. For the fiesta of 1923 the museum received the work of 71 Santa Fe- and Taos–colony artists, each showing from one to four paintings; the fiesta of 1932 featured the work of 125 artists, making the museum and streets about the Plaza a "blaze of color."[18]

Hewett worked assiduously to get the Museum of New Mexico and the Santa Fe and Taos colonies into the mainstream of American art. He affiliated the Museum of New Mexico with several associations, including the American Federation of Arts. Hewett regularly attempted to entice the American Federation to Santa Fe for its annual meeting, but each year he received a polite rejection—a mild confirmation of Eastern art-establishment parochialism, reflected in the Federation's determination to concentrate its annual meetings in cities east of the Mississippi River. Thus in response to his invitation to hold the 1925 meeting of the Federation at the New Mexico Museum, in Santa Fe, the organization's executive secretary told Hewett "I can not imagine anything more delightful than to have a meeting of the American Federation of Arts in Santa Fe, but at the meeting of the Board held in New York . . . it was decided by the officers Cleveland over Santa Fe"! [exclamation mark mine][19]

For the most part the Museum of New Mexico staff, led by Hewett, guarded freedom of expression for artists and writers in the Santa Fe and Taos colonies and, by extension, the general public. Thus Hewett and the Museum of New Mexico became involved in the great theology-science debate of the 1920s. One of the critical issues of the time was human origin, which pitted religion against the Darwinian theory of evolution. Hewett, speaking for the scientific branch of the Museum of New Mexico, supported the Science League of America's position to protect freedom of inquiry by keeping "Evolution in the Schools," the supposition being that, should science be limited and suppressed, then art and literature might well suffer the same fate.[20]

The Santa Fe community continued its openness during the colony's Golden Years, for the most part maintaining the well-established "friendly nonchalance," derived from the multiethnic character of the population and the fact that artistic expression was an honored activity among Hispanics and Indians. Later, as the Anglo population increased, aesthetes were tolerated, even indulged, largely because it was good for business—artists and writers were a strong tourist draw.[21]

Occasionally, certain civic leaders expressed anxiety over manifestations of "Bohemianism, via Greenwich Village via the left Bank" (deviant dress, free love, shocking personal habits and language, and political radicalism) that had "made some appearances" in the colony. One observer commented that Santa Fe indeed has some writers and painters of the "Greenwich Village stripe" but most of them "really work."[22]

The town newspaper, the *New Mexican*, generally supported the colony and, up to a point, defended it against any local scorn for its unorthodoxy. One of its editorials admitted:

Santa Fe has many eccentricities. She has some notoriously or famously eccentric persons in her population. We fight over fairies. . . . But we are in the main a Little Group of Ernest Workers. . . . The output of painting hereabouts is perhaps not to be dismissed as the vagaries of long-haired affectionists with flowing neckties. . . . You can count on one hand's digits the number of Santa Fe residents who are trying to make a noise like Greenwich Village or masquerading as conventional

poets or near-sculptors of smug intellectuals. There are a few . . . but they are the exception, and furnish some innocent amusements to the rank and file laborers in the vineyard.[23]

The *New Mexican* regularly published responses by artists to local criticism. Sloan was a frequent defender. In one rejoinder he ventured: "Artists aren't nuts, they're logical. . . . its the rest of the world that's cockeyed." He then pointed to the "illogical behavior of business people who pile up more money than they can use," often at great personal and social cost. The *New Mexican* also carried feature articles on colony members and their work, particularly publicizing their accomplishments and honors. Alfred Morang wrote a fine-arts column for the *New Mexican* titled "Ferris Wheel." An additional local publicity source for the colony emerged in 1933 with the advent of *El Artesano*, a magazine devoted to arts and crafts in northern New Mexico. Four local businesses—Old Mexico Shop, Spanish and Indian Trading Company, Spanish Chest, and Clark's Studio—supported its publication. The cover for the first issue, June 7, featured a painting by Shuster.[24]

Artists and writers clustered in residential cells about Santa Fe. The first and oldest concentration of homes and studios was along Canyon Road. The second was Camino del Monte Sol, a rising road "with its far-reaching view of snow-clad mountains, and volcano scarred plain, sweeping over it all a refreshing breeze of pure air." As the colony grew during the 1920s, several additional enclaves developed; Ellis started one at Rancho de San Sebastian, a 300-acre tract on Las Vegas Highway, ten miles south of Santa Fe. Most artists' and writers' homes and studios were of simple adobe construction. A visiting writer in 1926 observed "I learned to distinguish an artist's house from a Mexican's by only one fact; both were yellow-red mud; both indulged in bright blue door and window frames; but the Mexican usually had a goat tethered by the front door and the artist didn't."[25]

Entertainment—dances, excursions to the Pueblos, and "Bohemian" parties, where for an evening artists and writers dressed and acted like, perhaps, the public expected them to —was much like the entertainment popular with Taos-colony

members. The Easter Week Artists' Ball was the highlight of the colony's social year. Surrealism was the annual theme for this event during much of the 1930s. Witter Bynner, the poet, was the social leader of the Santa Fe colony. He customarily gave teas—which might be teas or, in some instances, a Prohibition Era euphemism to screen cocktail parties—to introduce visitors and newcomers to the colony, or to celebrate an award received by a member. Also, the Rio Grande Painters and other art schools in the colony held teas to present members' works to the colony and the public. Artist-publisher Nicholas Roerick and his wife, from Petrograd and New York (committed to "bind the world together through art") sojourned in Santa Fe. They frequently hosted teas feting visitors and local artists and authors. Santa Fe–colony members also established the practice of setting aside one day each week as "open house" for tourists to visit their studios; artists' wives served as hostesses. Perhaps more than the creative folk themselves, it was the colony's hangers-on, habitués of colony parties, teas, and receptions, who were responsible for much of the public scorn for Bohemianism. Thus at one tea given by the Rio Grande Painters, "In striking contrast to this strangely assorted group was Long John Dunn of Taos, overalled and with a cigar at rakish angle, along with a tourist lady whose most conspicuous feature was a bulbous rear elevation in closely fitting breeches, and Pecos Bill and Nell, all of whom of course formed a homogenous group."[26]

Several Santa Fe–colony artists, like those at Taos, felt a sense of mission, even duty, to pass on the muse tradition through the teaching of art. Some served as teachers of art in the Santa Fe elementary and secondary schools. Also they formed two art schools there.

First was the Santa Fe Summer School of Painting, later called the Santa Fe Art School, founded in 1928 by Cyril Kay-Scott. The *New Mexican* announced that "the school was so successful this summer that it will become a permanent part of Santa Fe life." It received the support of local individuals, state and city officials, and the Chamber of Commerce, which agreed to send out publicity to promote the school. During 1929 an advisory board consisting of Mary Austin, Applegate, Bynner,

Bronson Cutting, Dasburg, and E. R. Wright was formed to assist the Santa Fe Art School. From a first enrollment of 6 students, the school grew in a year to over 100 students from fourteen states and foreign countries. The curriculum included lectures from several prominent colony members, including Bynner who, besides being a poet, was an internationally recognized sinologist; his lecture was titled "Chinese Poetry and Painting." Classes also were held for patients at nearby Sunmount Sanitorium. Beginning in 1932, the Santa Fe Art School became affiliated with the University of Denver Art School (with Kay-Scott as dean) and was certified to offer normal-school–level work for teachers in methods of art instruction.[27]

The second art school to function in Santa Fe as an extension of the colony was Arsuna School, opened during June, 1938. Faculty included Kenneth M. Chapman who offered courses in Indian art, Bisttram in Dynamic Symmetry, Louie and Morrie Ewing in crafts, Reginald Fisher in anthropology, Hewett in archaeology, Jonson in advanced painting, Maurice Lichtman in piano, Datus Myers in painting and drawing, Morang in short-story writing, Dorothy Morang in piano, Raymond Otis in novel writing, Laura Brooks Secrist in speech and dramatics, and Dorothy Thomas in short-story writing. At its opening ceremony at the Fine Arts Center, Arsuna School faculty entertained guests and students with a tea and reception; 400 attended.[28]

As at Taos, the Santa Fe colony suffered drastically from the Great Depression that set in across the nation after the economic debacle of 1929. And, as at Taos, many members of the Santa Fe colony were dependent on the tourist traffic for painting sales, and the number of visitors reaching New Mexico declined steadily each year after 1930. Also, paintings that were sent to exhibiton centers in major cities attracted fewer and fewer buyers. Several resident artists left New Mexico for other parts in search of employment, and many visiting artists were unable to raise the money to make the annual trip to Santa Fe for the summer painting season. As at Taos, those who remained in Santa Fe faced a grim future.

The New Mexican reported "hard times" in the colony be-

ginning in 1930. Those who remained in the colony sought to find solutions to their economic plight through their collective energies and resources. They held "artists have to eat" shows; they formed guilds and associations to promote sales of their paintings and to seek out exhibit locations; they slashed prices; they bartered their work for food and shelter; and they exchanged paintings for furniture and other essentials.[29]

Aesthetes received some help from the community. The Chamber of Commerce and other civic groups provided relief for destitute artists. The *New Mexican* consistently aided colony members with reminders of their importance to the community, accounts of their ordeal, and urged people to "Buy a picture, take advantage of the opportunity to get good art work, support artists who in Santa Fe are hard working and among the most public spirited people in town."[30]

Then, beginning in 1933, the federal government—as a part of its relief and recovery program, the New Deal—established an arts-subsidy plan that sought to mobilize the nation's painters in a public-arts program. The regional committee to direct the public-art program in New Mexico and Arizona consisted of Jesse L. Nusbaum, chairman; Kenneth M. Chapman, secretary; and Bronson Cutting, John Gaw Meem, Mary Austin, and Caroline Thompson, members. Gustave Baumann served as field agent and coordinator to determine public-building space to be used for murals and other artwork.[31]

Painters from the Santa Fe colony were recruited to do murals in state and federal buildings (government schools, post offices, federal buildings, courthouses, and armories) across the Southwest and in Washington, D.C. WPA administrators emoted over the prospects of the art program, predicting that it would bring "art education appreciation" to the people; they saw the federal program as "a national art school," and they argued for the "lasting value of the project." Collectively it produced the so-called New Mexico Art Project. This consisted of murals and paintings for various state and federal buildings in New Mexico, including those on the University of New Mexico campus. It also produced works for the Coronado Cuarto Centennial, headed by a state commission that, besides sponsoring pageants and

writings on this epochal event, also supervised the production of much commemorative art.[32]

Both Santa Fe and Taos colonies nourished other aesthetes. Next to painters, writers (poets, playwrights, and authors of fiction and nonfiction) were the most numerous. The literary segments of the Santa Fe and Taos colonies will receive subsequent and separate extended treatment. In addition, the northern New Mexican refuges attracted sculptors, architects, musicians, and cinema people. These added to the luster and charm of the Santa Fe and Taos colonies.

PART II

Aesthetic Outreach

INDIANS

They wear squash-flowers cut in silver
And carve the sun on canyon walls;
Their words are born of storm and calyx,
Eagles, and waterfalls.

They weave the thunder in the basket,
And paint the lightning in the bowl;
Taking the village to the rainbow,
The rainbow to the soul.

—HANIEL LONG

7 / CREATIVE FLAIR IN THE TAOS AND SANTA FE COLONIES

THE *Santa Fe New Mexican*, principal chronicler and interpreter of the northern New Mexican aesthetic refuges, observed in 1929 that the region had become "symbolic of expression. Its themes, motifs, rhythms, or by whatever else termed, are being taken over by painters, poets, writers, musicians, as images for creative work." True, painters were the most numerous in the Santa Fe and Taos colonies; writers were next. But the tantalizing draw of New Mexico's natural and social environment attracted other creative types: those from the designing arts—sculpture, architecture, and furniture-making—and those from the performing arts—music, dance, cinema, drama, and the forum. Curricula of the Fine Arts School, at Taos, and the Arsuna School, at Santa Fe, confirmed this creative flair; students at both institutions were instructed in painting and writing, as well as music, dance, and dramatic arts.[1]

Closest to painters were sculptors; some painters of the Taos and Santa Fe colonies also sculpted. Mahonry Young, from California, was the first full-time professional sculptor

to settle in northern New Mexico during the Age of the Muses. He became nationally known for his Indian and cowboy figures. Young worked in a studio in the Governor's Palace when that building was the only structure of the Museum of New Mexico. Shortly after the new art museum opened in Santa Fe during 1917, Caetano Scarpitto, an Italian sculptor, arrived. He worked in terra-cotta and bronze. Young and Scarpitto were joined by Allan Clark, Grace M. Johnson, Bruce W. Saville, George Blodgett, Clare Dieman, Eugennie Shonnard, and Emilio Padilla; all settled in Santa Fe.[2]

Johnson did bronze and terra-cotta Indian figures. Saville won distinction for his small bronze figures of Indian ceremonial dancers and life-sized busts of prominent New Mexicans. Blodgett produced high quality bronze busts of Pueblo and Navajo Indians. Dieman taught sculpture in Cyril Kay Scott's School of Fine Arts, in Santa Fe. And Padilla, a gifted, imaginative sculptor, worked in wood.

Of this group, Clark and Shonnard achieved the widest recognition. Clark's pluralistic subject-matter interests and attention to delicate detail applied to his stone and bronze figures brought him continuing critical acclaim. Later he established his studio in Jaconita, New Mexico.[3] Shonnard, a sculptor from New York and a student of Emil Bourdelle and Auguste Rodin in Paris, spent 1925 in the Santa Fe colony modeling Indian figures. She became a favorite of Hewett; he served as her principal advocate and sponsor in Santa Fe. The following year Shonnard proceeded to Paris to show the work done in her Santa Fe studio. One of her letters to Hewett explains the rapturous hold of the northern New Mexican natural and social environment over her total being—"New York is dark and rainy, not blessed with a radiant sun as is our little Santa Fe, so I have to dream here of things I must accomplish." After the Paris showing she promised "you will see me in Santa Fe. There I shall build a house, and start my life's dream in sculpture, a dream to work among the Indians of the Southwest, for I know that I see and feel the highest part of their natures which are very sensitive and spiritually alive—and natures which are full of the love of the beautiful." Shonnard's moderate impres-

sionist work in cedar and stone, produced in her Santa Fe studio, became popular among collectors both in the United States and Europe.[4]

Architectural design became a matter of abiding concern and keen interest quite early in the life of the Santa Fe and Taos colonies. Northern New Mexico's social environment contained many compelling elements, not the least of which was the local architecture—Pueblo Indian and Spanish-colonial styles. Both were constructed of adobe, local clayey soils mixed with water and sun-dried into hard, durable building material. Besides its functional application, an adobe dwelling was imbued with a metaphysical essence for the spiritually motivated, nonmaterialistic Indians—it symbolized earth the mother, with the sun, the source of life; thus, residing in an adobe dwelling, one abided in the comforting maternal embrace. Also adobe symbolized the irrefutable progression of life—born from the earth mother, sustained by her during life, and returning to her at death.

Pueblo Indian and Spanish-colonial architectural styles joined the condominium cliff-dweller models of paleohistory and the geodesic-dome and quonset-hut styles of Eastern Indians as true American architecture.

Another class of structures in northern New Mexico were the Franciscan mission churches, situated among the Pueblos. During Spanish-colonial times, Franciscan friars and Indian laborers had erected several adobe sanctuaries, constructed in a style amounting to a fusion of Pueblo Indian and Spanish-colonial architecture. A number of these ecclesiastical structures survived in the twentieth century, were extant places of worship, and became popular subjects for aesthetic attention by members of the Taos and Santa Fe colonies.

The Anglo-American advent during the 1840s brought architectural change to Santa Fe and Taos, considerably more so to the former than to the latter. The newcomers razed many old adobe business buildings in both Santa Fe and Taos, replacing them with structures erected in what came to be called territorial style. Workmen replaced the quaint rounded tops of adobe walls with flat cornices of brick, increased window and

door openings, and coated the walls with lime stucco. Then late in the nineteenth century, responding to the imperatives of "progress," Anglo business leaders had Santa Fe platted as a conventional city. Engineers surveyed the streets and workmen paved several streets, placing curbing and sidewalks in front of red brick houses with porches cast in the Victorian mode— thus making Santa Fe increasingly uniform and nondistinctive, like any other American community in the East or the West. Business buildings in downtown Santa Fe were fitted with Corinthian columns and false fronts. Anglo business leaders, obsessed with "modernization" of the "Ancient City" next planned to tear down those surviving historic buildings on the Plaza, including the Governor's Palace.

At this juncture, Carlos Vierra, a founder of the Santa Fe colony, emerged as the principal guardian and conservator of those surviving old-style buildings. He sought to preserve existing structures and urged that new buildings reflect the historic mode. In 1909, Vierra won his first contest in the campaign to restore the historical style to Santa Fe buildings when he was permitted to supervise the restoration of the Governor's Palace as the Museum of New Mexico. When the work was completed in 1915, it was believed to appear as it did at the time of its original construction nearly three hundred years before, and Vierra had created a model for what came to be called "Santa Fe style" architecture. Its popularity was demonstrated by the enthusiastic reception of the New Mexico Building in the Pacific Exposition, in San Diego, during 1915. It was constructed in the Santa Fe style, embodying the features of six Franciscan Pueblo-mission churches. Observers rated the New Mexico Building and exhibit the "most popular" of the state exhibits, and it received first-place award for the the most-original state building. This substantially advanced the cause for architectural restoration, because shortly the New Mexico legislature authorized the construction of a new building for the Museum of New Mexico across the street from the Governor's Palace, to be erected as a replica of the San Diego Exposition model.

Vierra's cause of architectural restoration was furthered

by the artist Edgar Spier Cameron, who visited Santa Fe in 1917. Cameron made a public statement on behalf of preserving the uniqueness of Santa Fe in its distinctive architecture, and worked with Vierra to develop the theme "City Different." Cameron insisted that the historic architecture was "beautiful" and he urged the city to adopt an ordinance requiring all new buildings to have at least an adobe facade to maintain the old style of architecture. "The restoration of a charm which must have formerly existed in the city would unquestionably bring handsome returns. The simple adobe cottage with its projecting vigas and perhaps a portal will attract more people to Santa Fe than a pretentious brick box surmounted by the most elaborate galvanized iron cornice that money can buy."[5]

Clearly Vierra's zeal precipitated the renaissance of the Santa Fe style. Guarding Santa Fe's architectural integrity became a cause for the artist. His "anger was pronounced whenever he saw going up a structure in Santa Fe which did not conform in every particular to the principles he had formulated. He would denounce buildings which strayed from these principles and would declare them monstrosities. He was always active in protecting old Santa Fe landmarks and grew indignant whenever an old cottonwood was cut down."[6]

And the restoration was assured by application. Through his influence and the help of Cameron and others, the city of Santa Fe adopted an ordinance restricting buildings to no more than three stories to protect vistas in all directions. And the Santa Fe style was applied to residences along Canyon Road, Camino del Monte Sol, and other subdivisions developing in Santa Fe. Vierra bought land along Buena Vista Loma and sold lots only to builders who pledged to erect houses in the Santa Fe style. William Penhallow Henderson, the painter and architect, worked with Vierra in designing residences in this mode; he also maintained a construction company that built many of them.[7]

The local press, sensitive to the tourist appeal of the "City Different" and the prospect of enlarged income for local businesses, supported Vierra. Frequent editorial comment favored the architectural renaissance and denounced those who opposed

it: "Their provincial minds couldn't grasp the fact that the development of Santa Fe as an artistic center of the Southwest would be followed by a business boom. They did not realize that they had a native architecture more sound and adequate and vastly more fitting to the place than any of the modern complications of foreignness which they sought to embody in homes, stores or factories."[8]

Between 1846 and 1920 some architectural transformation occurred at Taos, but colony members there had less reason to protest against alteration because the amount of change was much less than at Santa Fe. Artists, writers, and others in the Taos colony adopted the native architectural style as their domicile preference. The editor of the *Taos Valley News*, however, believed that entirely too much tampering had occurred with the ancient mode and, like the editor of the *New Mexican* at Santa Fe, urged complete restoration:

If Taos is to be and remain the Mecca for renowned artists, tourists and a business centre, we must preserve the ancient style of architecture. To command the admiration of these gifted men, who come from all quarters of the globe to portray Taos, New Mexico in canvas, we must also beautify the Plaza streets, the park, and our roads. To do so means a string of dollars rolling continually in our safe and pockets. Boost or get out. Beautify Taos or Santa Fe will put us out of business as a center of world attraction.[9]

Civic leaders at Taos heeded this editorial admonition by maintaining a vigilant oversight of new construction, urging that it conform to the Santa Fe style. Two excellent representations of this mode in Taos were the buildings of the Harwood Foundation Compound and the several houses built by Mabel Dodge Luhan between 1923 and 1939.

Architects and designers were active in the life of both the Taos and Santa Fe colonies. Most spent summers in northern New Mexico; a few settled there permanently. John Gaw Meem, devotee of the Santa Fe style, became the premier architect of the Santa Fe colony. His most distinguished work, rendered in the Santa Fe style, is found in several buildings on the University of New Mexico campus, in Albuquerque, and the Labo-

ratory of Anthropology and El Cristo Rey Church, in Santa Fe. As the Santa Fe style became more widely accepted and popularized, it, or variations of it, took on other names including "mesa architecture."

A functional outlet for the aesthetic impulses of Taos- and Santa Fe–colony members was handcrafting fine furniture. Several persons in both colonies designed and fashioned exquisite household pieces. William Penhallow Henderson was the best known of the furniture makers; his work was most popular with tourists who ordered pieces or sets of furniture from his workshop for delivery to points all across the nation. Craftsmen used Spanish-colonial models to fashion couches, chests, beds, tables (round or rectangular tops and scroll or straight legs), chairs, coffee tables, as well as *trasteros* (storage cabinets with doors, sometimes fitted with hutch or bookshelf top), and *amarios* (tall shelf units resting on low-lying cabinet bases fitted with doors). A distinctive furniture style evolved in each colony —the Santa Fe sofa, Santa Fe chair, Santa Fe bed, and Santa Fe dining table; and the Taos table, Taos chair, Taos bench, and Taos desk. Most popular of all furniture produced in either colony was the Taos bed, a functional cross between a couch and a bed. Santa Fe style differed from Taos style in that furniture produced in the former mode was delicately turned. Taos style, with its massive, straight profiles, has been characterized as an extension of adobe architecture, conceptually embracing the smooth lines of adobe buildings with their thick walls and functional design.

Music was the first of the performing arts to appear in Santa Fe and Taos as a manifestation of the colonies' creative flair. Granted, public interest in music as well as dance and other performing arts would have evolved in Santa Fe and in Taos (as it did in towns and villages all across America during the forepart of the twentieth century) had the aesthetic communities not formed there. What the predominantly painter-author communities did was abet, enlarge, additionally enrich, and strengthen these cognate art forms. This was in part because most of the colony members had a taste for quality music. Several of the artists and writers were also musicians—Ernest

Blumenschien was a music-conservatory graduate and former symphony violinist, and Randall Davey played the cello in Sinfonietta, a Santa Fe chamber music ensemble; and in several instances family members were performers. Marina Dasburg, a popular vocalist, presented recitals in Taos and Santa Fe.[10]

In addition, music as an extension of the art spirit of the place elicited strong and sustained civic interest. Musical organizations made their appearance quite early in Santa Fe; in 1910 residents of Santa Fe formed the Santa Fe Operatic Drama Company, which held weekly meetings to practice for performances. The New Mexico Museum sponsored lectures on music. One, in 1928 by Mrs. Edgar Stillman Kenney, of Music Clubs of America, led to formation of a chapter in Santa Fe. Several musical groups emerged from this sponsoring organization, including the Santa Fe Trio and Sinfonietta, both chamber music ensembles.[11]

An indication of civic interest in music was the support residents of Santa Fe extended to concert performers. These included sponsorship of vocal and dance performances by Cameron M'Lean; the Gannon-Habes concert group, featuring concert violinist Maria Gannon and pianist Karl Habes; Tsianina, the Creek-Chickasaw dancer and mezzo-soprano, performing the opera *Shanewis;* and vocal concerts by Rafael Delgado, presenting songs of Spain, Cuba, Argentina, and New Mexico.[12]

Like artists and writers, musicians found New Mexico's natural and social environment a stimulating, productive place to compose. Ernest Bloch, a nationally prominent composer, was a favorite with the early-day members of the Santa Fe colony. Hewett provided him a studio with piano in the Museum of New Mexico. Bloch commented that "It struck me particularly, as I have not yet broken with my European traditions, to find a place in America, where rush is unknown, where people do their work and enjoy it. . . . The people of Santa Fe had more real music than we have in our artificial cities. . . . Then the Indians! What an extraordinary impression they made upon me with their beautiful music." Bloch claimed that he did his best work in Santa Fe. During 1924 he completed seven works there, and he exulted "my symphony is all

permeated by motifs which I heard at a 'corn dance' at Tesuque Pueblo."[13]

Isador Berger, a young composer from Chicago, came to Santa Fe in 1915 to complete an American opera built on themes drawn from the exotic land and people of northern New Mexico. Hewett also assigned him a studio with piano in the Museum of New Mexico. Berger was mesmerized by Pueblo lifestyle, particularly the Indian dances. A. B. D. Clark, a popular composer during the 1920s, was another musician who found Santa Fe a charming place to create.[14]

Musician interest in Santa Fe was also reflected by the music schools founded there. Members of the aesthetic colony organized the Santa Fe School of Music during 1931; within a year it was functioning with an enrollment of 126 students. Most of the teachers were spouses of colony members. Then in 1935 colony members formed Eidolon (Image of an Ideal), a cooperative school offering instruction in dance and music; its enrollment averaged 50 students a year. And Arsuna School, founded three years later, included music in its curriculum.[15]

Music was also a part of the creative flair of Taos-colony life. Aesthetes there were patrons of music, if on less a scale than in Santa Fe. Artists and writers formed local musical groups; painter W. Herbert Dunton was a leader in organizing a small orchestra for community concerts. They also pressed local and visiting musicians for presentations of classical and semiclassical community concerts. Most of the performances were held in Harwood Foundation auditorium. Most-popular local vocalists were Marina Dasburg and Eduardo Rael, the latter a baritone who specialized in Spanish songs. Visiting musical artists who performed in Taos, some of them appearing virtually every summer, were Ruth McBride, pianist; Thelma Given, violinist; John Sekus (from Holland), pianist; the Tallen family (from Finland), cello and piano; Lundeen Langston, soprano soloist; and Maurice Litchmann, pianist. These concerts were public benefits for such causes as the American Red Cross and for local causes, including the purchase of books for the public library in Harwood Foundation and the purchase of a piano for Harwood Foundation auditorium to avoid the expense and

trouble of renting and moving the instrument for each concert.[16]

Composers also found Taos and its environs simpatico for producing innovative works. Composer Thurlow Lieurance spent 1915 in Taos making phonographic records of Indian music that he transcribed and harmonized. Then he toured the nation's cities interpreting Indian music in concert. Natalie Curtis, Laura Bolton, and John Candelario established themselves in Taos to transcribe Spanish-American and Indian songs. Best known of the composers visiting Taos was conductor Leopold Stokowski. He was a frequent guest of Mabel Dodge Luhan. During the 1930s, for several summers running, Stokowski recorded and transcribed Indian music at Taos. In 1937 he made the decision to build an adobe house in Taos.[17]

As at Santa Fe, there was sustained interest in the teaching of music at Taos. Teachers, most of them spouses of artists and writers from the colony, gave private lessons in voice and on instruments. They also helped form the Taos School of Fine Arts, which included music in its curriculum, and the Willem Van Giesen School of Music. Van Giesen's students presented regular recitals in Harwood auditorium. Eduardo Rael, baritone, was Van Giesen's most distinguished pupil.[18]

Another art form from the creative flair of the Santa Fe and Taos colonies that additionally enriched the life of the two communities was ballet and modern dance. Performers at Santa Fe included Irene Emory, from the original Martha Graham dancers; Jacques Cartier, the European dance impresario; Catherine Rapp Ferguson; Besse Evans; and Mrs. Thomas Wood Stevens. Isadora Duncan's protégé Anna Duncan visited northern New Mexico in 1932 and appeared on a program in Santa Fe with Witter Bynner, she to dance, he to read poetry, which the *New Mexican* rated a "great success." Writer Mary Austin was a consummate modern dance advocate. During 1932 the great Martha Graham was a guest in Austin's home on Camino del Monte Sol, in Santa Fe. Austin presented her eminent guest to colony members and civic leaders with a tea on August 6, 1932.[19]

Taos-colony members also supported dance to enlarge the arts in their community. The Taos Community Fund sponsored

regular, free, dance concerts. The program included perfor-mances by Jacques Cartier and Mary Binney Montgomery, who came to Taos in 1937 as the guest of painter Lady Dorothy Brett.[20]

Both colonies supported schools for instruction in ballet and modern dance. Dance was included in the curricula of art schools in both towns, and separate dancing schools offered ballet and modern-dance instruction. Also several nationally prominent dancers who spent winters in Taos and Santa Fe gave private lessons. Irene Emory from the Martha Graham group was the best known of these teachers.[21]

Just as composers studied Pueblo Indian music, dancers studied Pueblo terpsichorean routines in search of fresh, inno-vative motions, rhythms, movements, beats, and style to add to their stage repertoire. Cartier, Stevens, and Evans spent con-siderable time at Taos Pueblo observing native dancers. The mysticism and symbolism of Native American dance fascinated many of the observers, particularly the explanation that the In-dian dance rhythm follows the beat of the human heart. Martha Graham, as Mary Austin's guest, observed the Santo Domingo Pueblo corn dance and was awed at the powerful nativistic spectacle.[22]

Drama was another extension of the creative flair from the Santa Fe and Taos colonies. Interest in dramatic arts developed earlier at Santa Fe than at Taos. In the formative years of the colony, 1900–1920, Santa Fe had two theaters; both were re-ported to be models of "up-to-dateness and enterprise." Mem-bers at Santa Fe founded a local dramatic group called the Santa Fe Players during the 1920s and produced plays written by colony members — as well as published, established dramas.[23]

This group presented a regular schedule of plays to local audiences, as well as to nearby towns. Their best-received pro-duction was the old favorite *Charley's Aunt*. Proceeds were dedicated to public causes, including the Red Cross, and to the Santa Fe Players Fund.[24]

In 1929 the Santa Fe Players presented Witter Bynner's *Cake: An Indulgence*, rated as a satirical verse play. *Cake*, it was claimed, already produced by the Pasadena Playhouse and

the San Francisco Players, had been rejected by New York producers out of fear of censorship for its allegedly racy lines. Thus it was billed as "Santa Fe to see the play that Gotham feared." Of the actors drawn from the colony, artist Frank Applegate was the favorite, and he had a lead in *Cake*. Artist Raymond Jonson produced the stage set and lighting; Cyril Kay Scott's art students prepared posters advertising the show; and Una Fairweather, a popular singer and actress, assisted Bynner in directing *Cake*. It played to packed houses for both performances at the Rialto Theater, July 13 and 14. The *New Mexican* rated it the "outstanding society event of the season"; the "play started the most radical conflict of strongly-held opinions ever aroused by dramatic presentations here."[25]

A second Bynner play, the one-act *Night Wind*, also directed by Bynner, was presented two years later by the Santa Fe Players on a bill with three other one-act plays. One was *Red Rust*, a Russian play rated as "snappy"; the Santa Fe Players obtained performance rights to it through Bynner's contacts and efforts. A critic said of the Bynner play, "it is different and makes you shudder."[26]

Other locally written plays acted out by the Santa Fe Players included Mary Austin's *Golden Bough*. And Anna Nolan Clark, a teacher at the United States Indian School, in Santa Fe, authored a play built around the theme of problems faced by Indians returning from school to their homes. It was presented to Santa Fe theatergoers with roles played by Indian students from the school. Olive Rush, the painter, presented the playwright and the cast to Santa Fe society with a tea.[27]

During the 1930s reading plays was popular in Santa Fe. Lynn Riggs, a member of the literary section of the colony and one of the nation's foremost playwrights, was a popular performer at public readings sponsored by the Santa Fe Players. His plays *Rancour, Domino Parlor,* and *Knives from Syria* were particularly well received. The Santa Fe Players also presented Riggs's *Rancour*, in December, 1931.[28]

The plays, dramatic productions, musical compositions, operas, and dance routines—conceived by Santa Fe colony members, or by outsiders, and produced there—were popular attrac-

tions not only for colony members and their families and the general public of Santa Fe and environs but also, during the summer months, for tourists who streamed to Santa Fe in increasing numbers each year until the Great Depression. Hewett, the constant impresario and Santa Fe booster, sought to derive additional civic benefit from these productions with enlarged, modern facilities. During the early 1920s, Hewett began to promote the concept of an open-air theater, built in the circular pattern of the Pueblo kiva, with a seating capacity of 7,500 and benefiting from the natural cooling of alpine temperatures and extended dry pleasant weather. Several design and architectural authorities favored his plan. One replied: "It seems to me that the inspiration from a point of design is a very happy one and could be worked out into something remarkably well-fitted for its purpose, but at the same time, preserving the character of the Pueblos with the Kiva motif for, what I presume to be, the dressing rooms." This phase of Hewett's plan for fine-arts enhancement at Santa Fe was deferred, but consummated finally in the grand open-air Santa Fe Opera facility.[29]

Taos-colony members expressed an interest in dramatic arts more slowly than the Santa Fe community. Some small touring stock companies stopped at Taos before 1920, but the community's isolation discouraged most of the larger ones. Dramatic groups from Santa Fe and Las Vegas presented plays there. Then, as the colony enlarged during the early 1920s, there evolved a demand for locally produced plays, causing aesthetes and civic leaders to band together and form the Taos Dramatic Club; the actor-members were called the Taos Players. They occasionally presented a play at Harwood Auditorium or the Montaner Theater.[30]

Belatedly, the national Little Theater movement caught on in Taos; it dates from October 31, 1934, when playwright Ed Stevenson, of Santa Fe, spoke on the movement at the Taos County courthouse. Helen Blumenschein, wife of one of the leading artists in the colony, was the prime mover in the formation of the Taos Little Theater; its production agency was called the Taos Drama Club; the actors, the Taos Community Players. Officers included Alexandra Fechin, Marion Bisttram,

and Mary Ufer. The Taos Little Theater cast first presented *God's in His Heaven.* An initial success encouraged the group to present a schedule of plays for the year. They opened in 1935 with two one-act plays, *The Neighbors* and *The Star Gazer,* and their renditions were rated a hit. "Most of the audience attended the performance of the two plays in order to make fun of their friends, but ended up enjoying the plays." In 1937 the Taos Drama Club changed the name of its performers from Taos Community Players to Taos Village Players.[31]

As at Santa Fe, a popular form of dramatic rendition was reading plays. Helen Merriam Golden was a regular performer before Taos audiences; her first reading effort was Euripides' *Medea;* others included *The Trojan Women,* the Soviet play *Squaring the Circle,* and T. S. Eliot's *Murder in the Cathedral.* Alexandra Fechin also was a popular reader of plays; her best-received efforts were ancient Russian legends.[32]

New Mexico's stirring vistas and ethnic riches also drew professional photographers and cinema makers as a part of the two colonies' creative flair. Throughout the 1930s both Santa Fe and Taos and their environs served as settings for still-life photography and motion-picture production. Mary Austin was a strong advocate of graphic media and frequently served as an arranger for filming local subjects and a guide to locations for both documentary and entertainment films. Floyd Crosby, H. W. Rodakiewicz, and Howard Steiner were among the film directors who worked there. Also, Lynn Riggs produced a film on Santa Fe and several colony members.[33]

Another peripheral reflection of the creative and intellectual interests of the northern New Mexican colonies were public-affairs programs organized and promoted by colony members. The most successful of these was the Taos Open Forum, which provided music, entertainment, and information programs for the community.[34]

Two additional manifestations of the creative flair from the writer-artist colonies at Taos and Santa Fe need be examined — the percolation of the modern aesthetic into the Indian and into the Spanish-American communities of northern New Mexico. Ancient expressions of the creative spirit in painting,

sculpture, textiles, ceramics, carving, costume, dance, music, and folk epics—which had been largely screened from the view of intruders, passed over, or ignored in the callous Anglo-American rush to develop the Western land and its resources—began to surface in the supportive Muse milieu created at Taos and Santa Fe after 1900 by the aesthetic émigrés. In a sense, Indian and Spanish-American artists also joined the colonies.

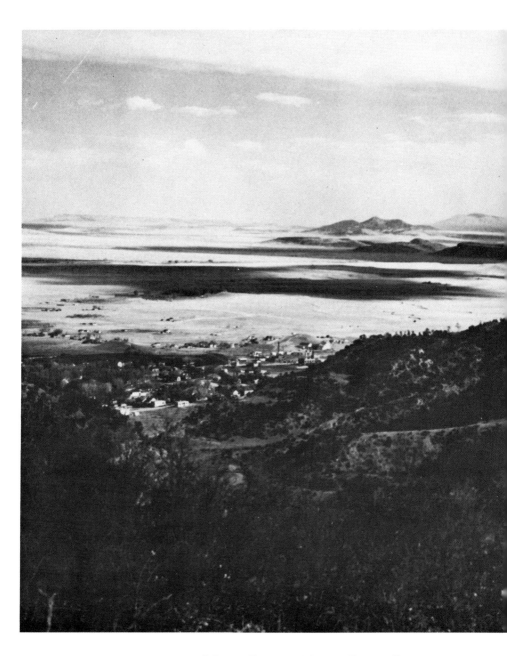

A panoramic view of Santa Fe. New Mexico Tourist Bureau, 1918. Library, Norman.

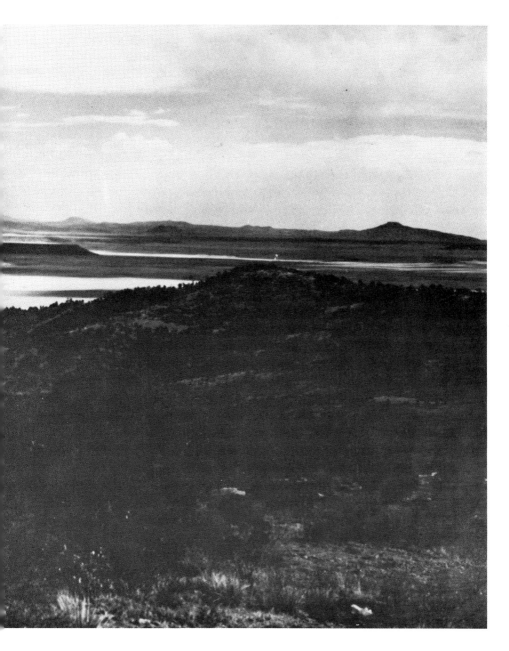

Courtesy of the Western History Collections, University of Oklahoma

103

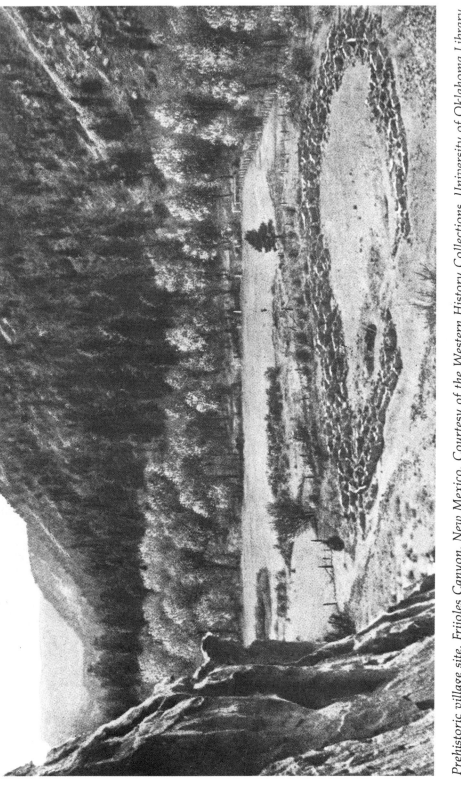

Prehistoric village site, Frijoles Canyon, New Mexico. Courtesy of the Western History Collections, University of Oklahoma Library.

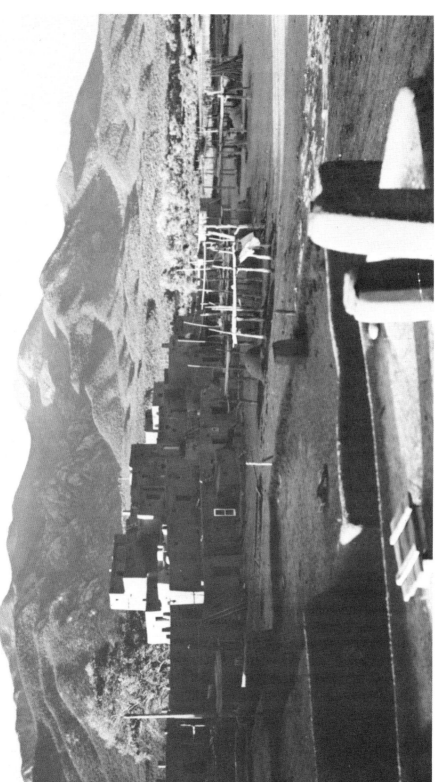

Taos Pueblo, New Mexico. Courtesy of the Western History Collections, University of Oklahoma Library.

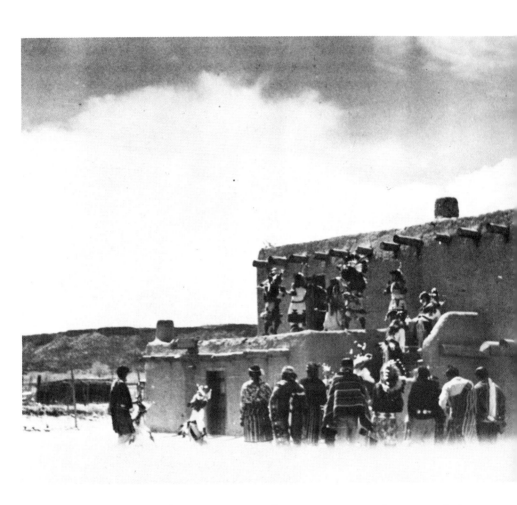

Deer Dance, San Ildefonso Pueblo, New Mexico. Courtesy of the Western History Collections, University of Oklahoma Library.

East edge of Santa Fe, New Mexico, in the 1930s. Courtesy of the Western History Collections, University of Oklahoma Library.

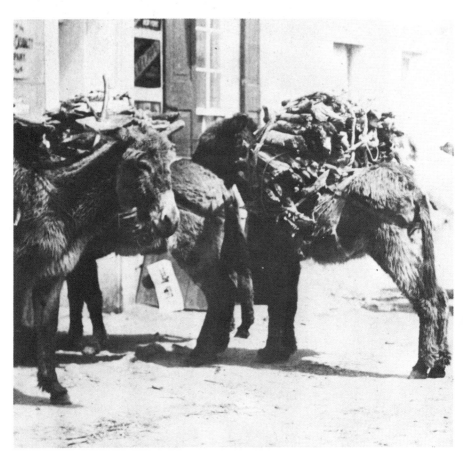

Leñador burros delivering wood to Santa Fe households. Courtesy of the Western History Collections, University of Oklahoma Library.

Governor's Palace, Santa Fe, New Mexico, before restoration. Courtesy of the Western History Collections, University of Oklahoma Library.

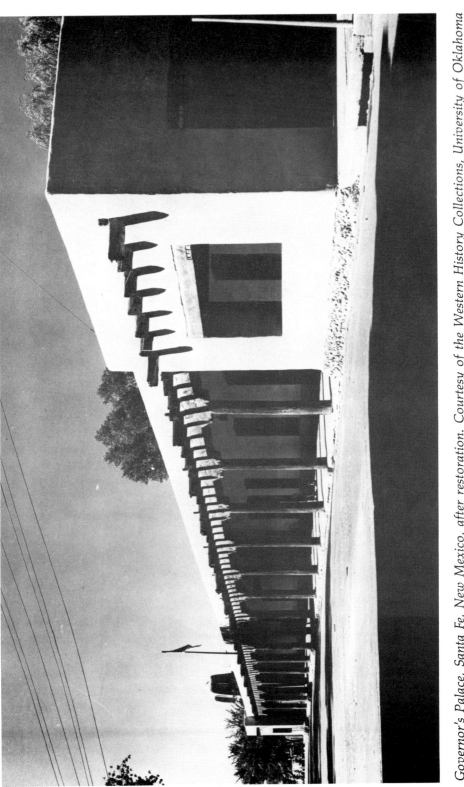

Governor's Palace, Santa Fe, New Mexico, after restoration. Courtesy of the Western History Collections, University of Oklahoma Library.

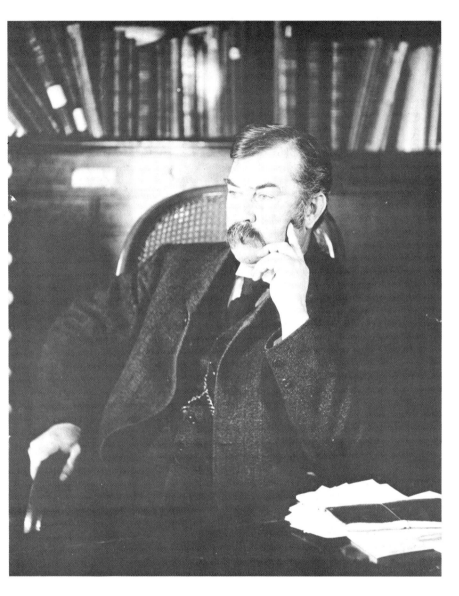

Frank Springer. Courtesy of the Museum of New Mexico, Santa Fe.

111

Edgar L. Hewett. Courtesy of the Museum of New Mexico.

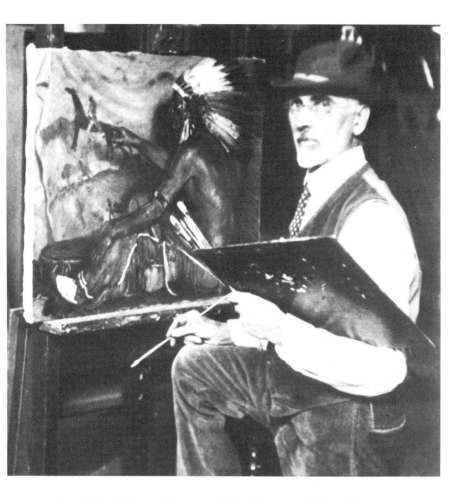

Joseph W. Sharp. Courtesy of the Museum of New Mexico.

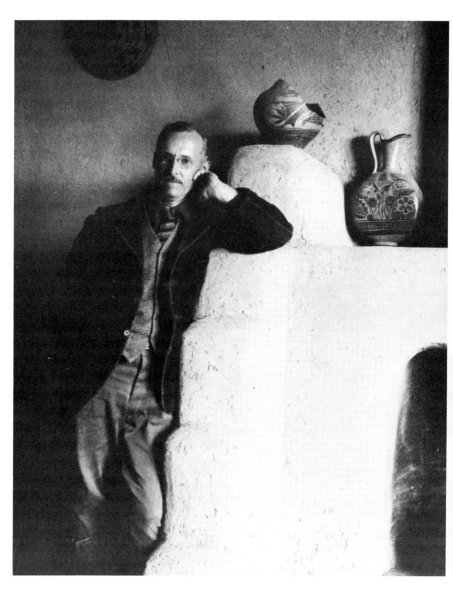

Ernest L. Blumenschein. Courtesy of the Museum of New Mexico.

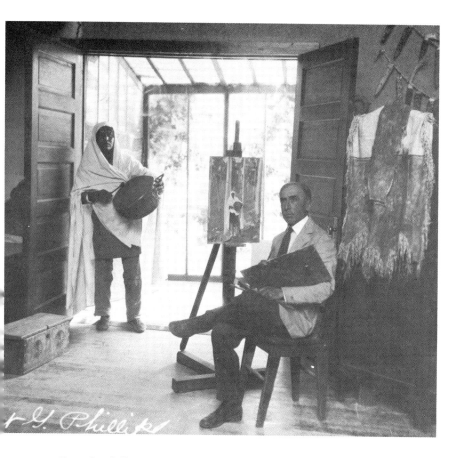

Bert G. Phillips. Courtesy of the Museum of New Mexico.

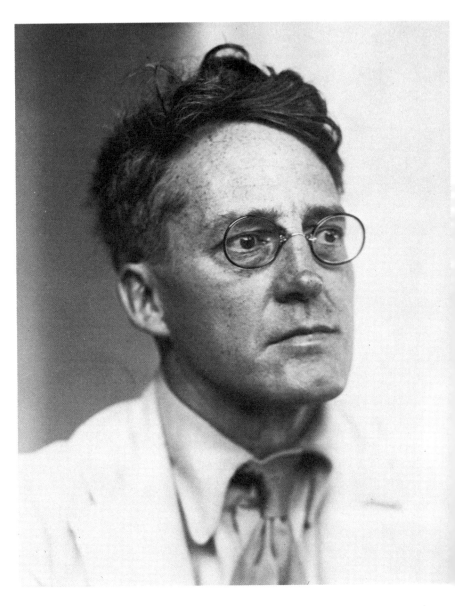

John Sloan. Courtesy of the Museum of New Mexico.

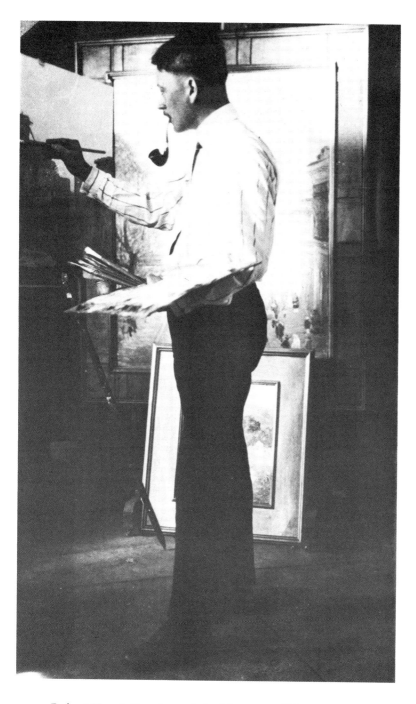

Robert Henri. Courtesy of the Museum of New Mexico.

Gerald Cassidy. Courtesy of the Museum of New Mexico.

Carlos Vierra. Courtesy of the Museum of New Mexico.

Alice Corbin Henderson and William Penhallow Henderson. Courtesy of the Museum of New Mexico.

W. Herbert Dunton. Courtesy of the Museum of New Mexico.

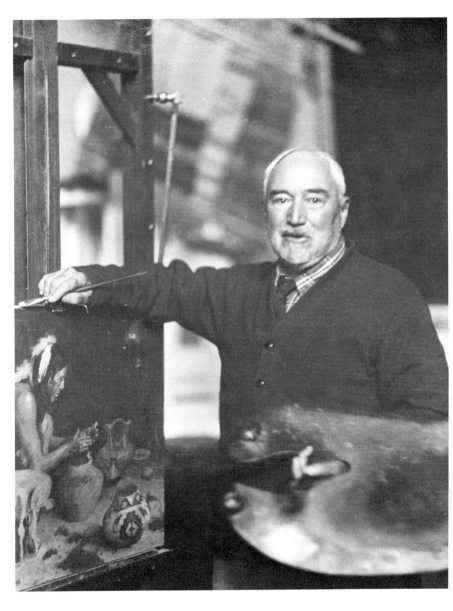

E. Irving Couse. Courtesy of the Museum of New Mexico.

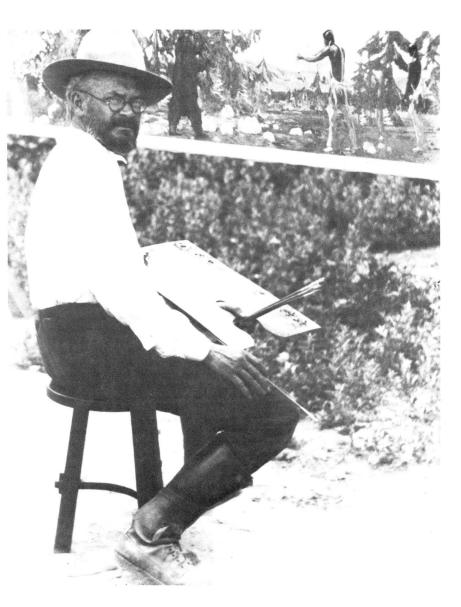

Walter Ufer. Courtesy of the Museum of New Mexico.

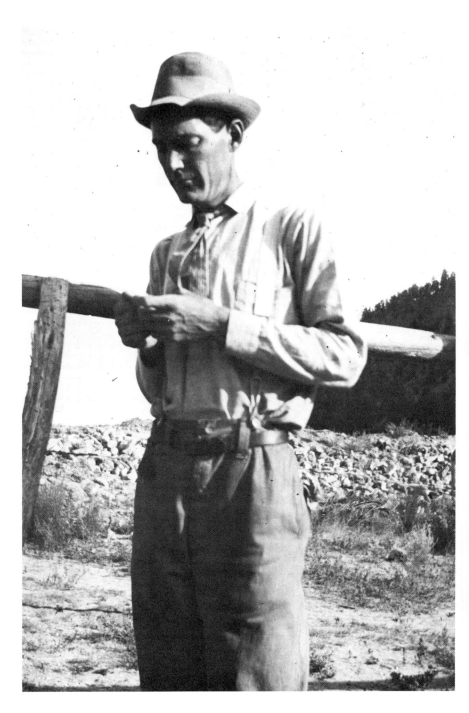

Kenneth Chapman. Courtesy of the Museum of New Mexico.

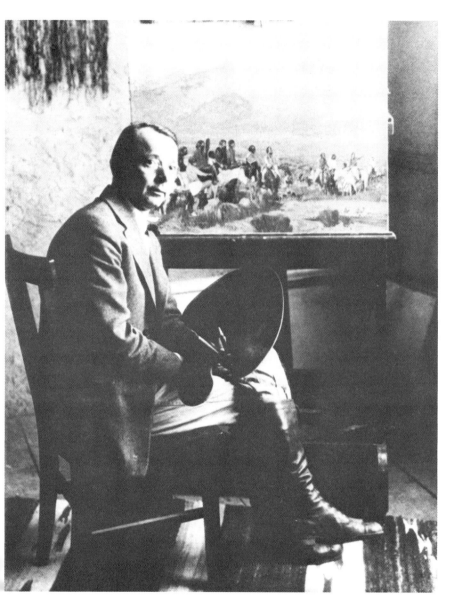

Oscar E. Berninghaus. Courtesy of the Museum of New Mexico.

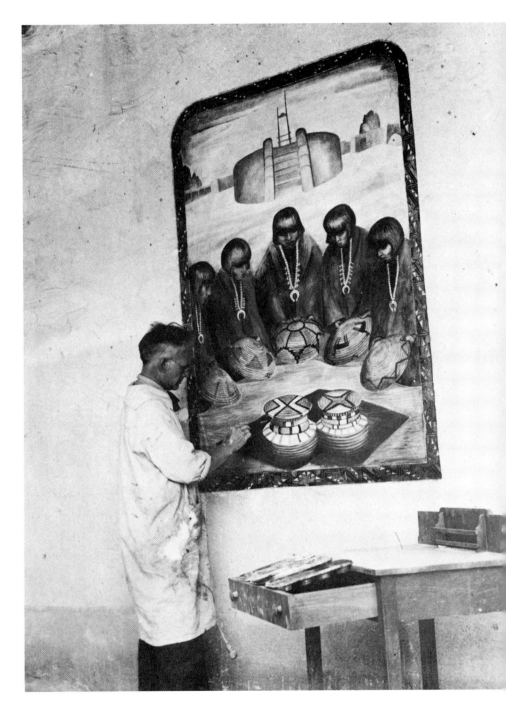

Will Shuster. Courtesy of the Museum of New Mexico.

126

Sheldon Parsons. Courtesy of the Museum of New Mexico.

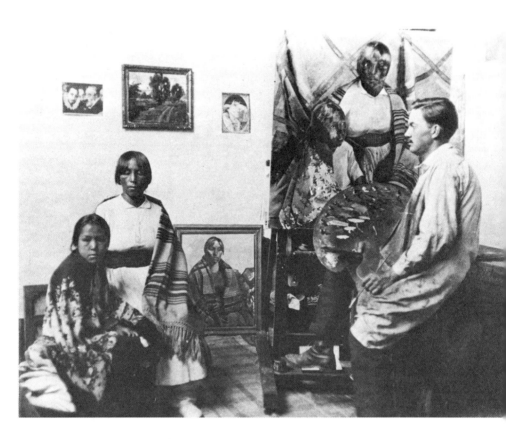

Kenneth Adams. Courtesy of the Museum of New Mexico.

Fremont Ellis. Courtesy of the Museum of New Mexico.

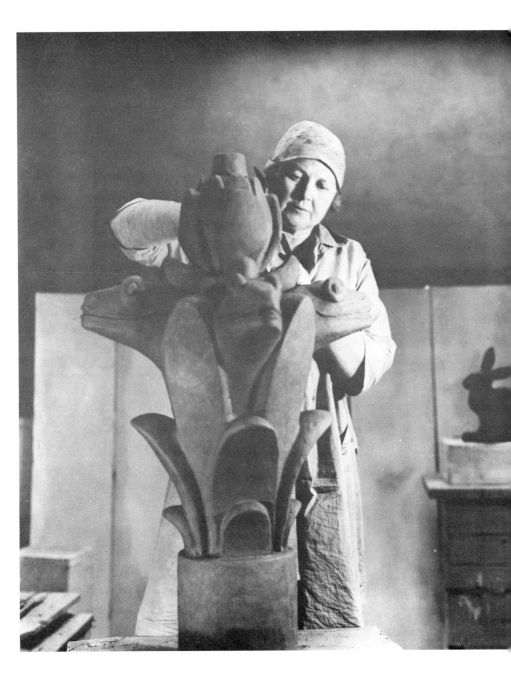

Eugenie Shonnard. Courtesy of the Museum of New Mexico.

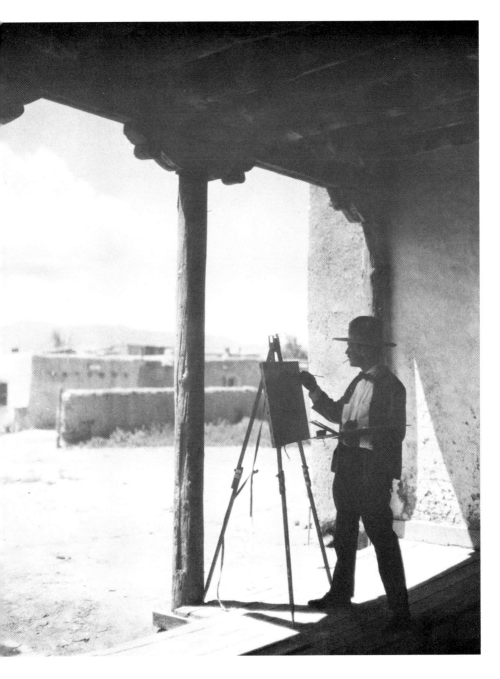

Victor Higgins. Courtesy of the Museum of New Mexico.

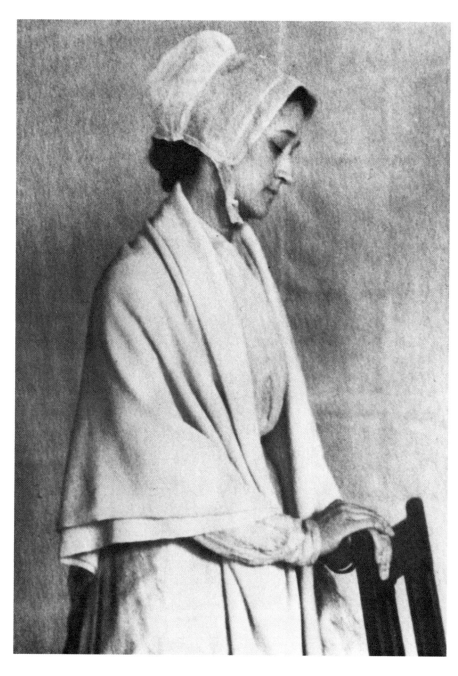

Olive Rush. Courtesy of the Museum of New Mexico.

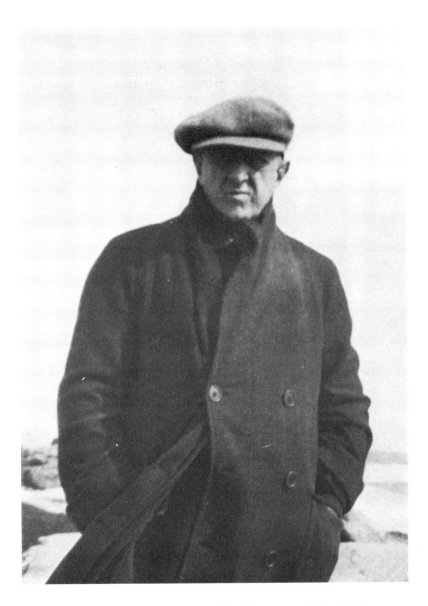

Marsden Hartley. Courtesy of the Museum of New Mexico.

Andrew Dasburg. Courtesy of the Museum of New Mexico.

Randall Davey. Courtesy of the Museum of New Mexico.

Lady Dorothy Brett. Courtesy of the Museum of New Mexico.

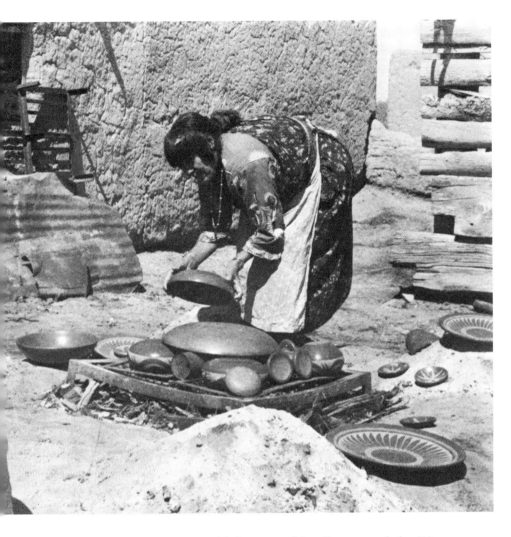

Maria Martinez, potter of San Ildefonso Pueblo. Courtesy of the Western History Collections, University of Oklahoma Library.

137

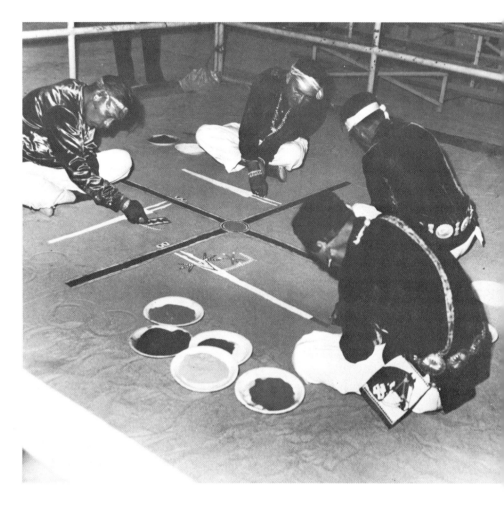

Navajo sand painters. Courtesy of the Western History Collections, University of Oklahoma Library.

Zuñi metalworker. Courtesy of the Western History Collections, University of Oklahoma Library.

Charles F. Lummis. Courtesy of the University of New Mexico Library, Albuquerque.

Witter Bynner. Courtesy of the Museum of New Mexico.

Mary Austin. Courtesy of the Museum of New Mexico.

Willa Cather. Courtesy of the Museum of New Mexico.

Mabel Dodge Luhan. Courtesy of the Beinecke Rare Book and Manuscript Library, Yale University, New Haven, Conn.

144

D. H. Lawrence. Courtesy of the University of New Mexico Library.

145

Lynn Riggs. Courtesy of the Western History Collections, University of Oklahoma Library.

Oliver La Farge. Courtesy of the University of New Mexico Library.

RAIN IN THE DESERT

The huge red-buttressed mesa over yonder,
is merely a far-off temple where the sleepy
sun is burning,
Its altar-fires of pinyon and toyon for the day.
The old priests sleep, white-shrouded,
their pottery whistles lie beside them, the
prayer-sticks closely feathered;
On every mummied face there glows a smile.

—JOHN GOULD FLETCHER

8 / NATIVE AMERICAN MUSES

FROM the earliest days of the Taos and Santa Fe colonies, painters had employed Pueblo Indians as studio models. These slender, lithe, supple-muscled natives became familiar figures in genre-type paintings that enjoyed sustained popularity. But Indians of northern New Mexico, besides being subjects of art, were, in addition, creators of works of art. They too were caught up in the art spirit that dominated this region between 1900 and 1942; and they also contributed to the legacy of the Taos and Santa Fe colonies.

Indians of the Southwest had a noble ancient tradition for aesthetic expression, confirmed by the abundant evidence archaeologists and anthropologists were exposing in the prehistoric ruins of northern New Mexico. During three centuries of Spanish rule the Indians of northern New Mexico had endured periodic suppression of lifestyle, religion, and art, but, by cautious sub rosa application, they were able to preserve their muse techniques and tradition.

Soon after the United States absorbed this land in 1846, it began to attempt to transform the natives into hybrid Anglo-Americans. Managers of the Americanization program believed

that, to accomplish this, it was essential to erase all sign of Indianness. Aboriginal lifestyle, religion, and art were regarded as pagan and thus were forbidden. Indian children, coerced into attending government schools, were taught that tribal ways were inferior, that American ways were superior.

Artists and writers in the Taos and Santa Fe colonies challenged this federal policy of suppressing aboriginal culture. They had come to cherish their Pueblo neighbors; they found them charming, useful, and instructive; useful to painters as models, to writers as sources of inspiration for verse and as the substance for fiction and nonfiction composition. Increasingly painters found Indians instructive in art forms. For several years most artists in the Taos and Santa Fe colonies followed the conservative, traditional path of painting style, but after 1920 they increasingly searched for "fresh artistic forms and symbols." This led them away from dependence for guidance on the European and Eastern art establishment to more exotic sources. Several artists turned to "primitivism" on the assumption that there was strength in primitive art "because it was believed that 'savage' peoples created and responded to art more intensely than did their 'civilized' counterparts."[1]

The symbolism and structured form found in survivals of Indian art greatly influenced Andrew Dasburg, Olive Rush, Paul Burlin, and other leaders of the Abstract, Cubist, and Expressionist movements in the Taos and Santa Fe colonies. They acknowledged the aboriginal influence on their art. Burlin disclosed that "his rugged, direct quality" in painting was "due in part" to his "study of the abstract elements in Indian art. . . . this source had a direct bearing on his early, semi-abstract style."[2]

The artists and writers of the northern New Mexican colonies also adopted a protective stance toward their Indian neighbors. One of the purposes of the Society of Taos Artists was "to preserve and promote the native art." Ernest Blumenschein and Bert Phillips, founders of the Taos colony, believed "the effort to standardize" the Indian "is resulting in a discouragement of racial customs which will eventually destroy their wonderful art."[3]

Robert Henri, international art figure and Santa Fe colony pioneer, lamented that because of sustained and suppressive federal pressure on the Indians,

Materially they are a crushed out race, but even in the remnant there is a bright spark of spiritual life which we others with all our goods and material protections can envy. They have art as a part of each one's life. The whole pueblo manifests itself in a piece of pottery. With us, so far, the artist works alone. Our neighbor who does not paint does not feel himself an artist. We allot to some the gift of genius; to all the rest, practical business. Undoubtedly, in the ancient Indian race, genius was the possession of all; the reality of their lives. The superior ones made the greater manifestations, but each manifested, lived and expressed his life according to art. . . . Here in New Mexico the Indians still make beautiful pottery and rugs, works which are mysterious and at the same time revealing of some great life principle which the old race had. Their work represents the pueblo and stands for their communal greatness. It represents them, reveals a certain spirituality we would like to comprehend."[4]

Until about 1920, Indian art functioned as a fugitive enterprise with some work being done by Native Americans, primarily in ceramics and textiles. But they worked under considerable handicap, as federal agents assigned to the Pueblos and tribes along the Rio Grande enforced the Americanization program by maintaining an unrelenting pressure on these hapless aboriginal wards. As late as 1919, George Vaux denounced the Taos art colony, accusing it of having a "deleterious and undesirable effect upon the Pueblo Indian in that it encourages him to retain his immemorial manner of dress and spoils him by offering him easy money to pose for paintings when he might be better employed at the handles of a plow. . . . painters are merely clogging the wheels of progress by making the Indian lazy and shiftless."[5]

Kenneth Chapman, Frank Applegate, John Sloan, Mary Austin, and Edgar Hewett were primarily responsible for mounting a defense for Native American creativity against the obscurantism of the federal Americanization program, and for generating the renaissance in Indian art. In their analysis of the character and content of Indian art they found that natives

used sand, bark, stone, clay, wood, bone, skin, quills, beads, metal, fibers, rushes, and wythes as media for aesthetic expression. They ground roots, bark, leaves, minerals, hulls, berries, and animal substances, such as gall, to produce red, yellow, blue, green, and brown pigments. Indians fashioned exquisite ceramic pieces without the benefit of the potter's wheel. And they created masks and costumes, regarded as characterizing supernatural beings, to achieve "personation." They wore these masks and garments at dances, festivals, and rites to personate the supernatural beings. Also the natives carved deity figures, (icons called kachinas) from cottonwood, then painted them and fitted them with feathers. Hopis were the premier kachina makers. The Southwestern Indians drew on a multitude of symbolic designs, some over 4,000 years old, to embellish their art, each an "abstraction of the cosmos of New Mexico—sun, and storm, lightning, thunder, rainbow, swelling rain cloud, rising fog, the stepped earth-altar outline of the hills, subtending the down-stepping arrangement of the storm cloud, the infiltrating rays of light and falling rain." The mythical thunderbird dominated the design galaxy. Natives painted in flat, stylized manner, "perspective and volume . . . suggested by the overlapping planes," on drum heads, pottery, their bodies, and walls of dwellings and kivas.[6]

Austin and Sloan became the publicists for Indian art; they did much to introduce it to the Eastern United States and to develop an interest in it. Sloan was particularly concerned that the "primitivism" surge among artists had generated an appreciation for Inca, Aztec, Mayan, and African art, but the art of the Southwestern Indians was assigned to natural museums as ancient curios. He urged that their dances, rituals, ceramics, textiles, icons, and other aesthetic compositions be recognized as art, concluding that theirs was "the only 100 percent American art produced in this country."[7]

The renaissance of Indian art began in 1902. Chapman, on a field trip searching for variant pottery types, discovered Apie Begay, a Navajo, composing tribal scenes in crayon and pencil. About the same time he learned that Elizabeth Richards, a young Anglo teacher at the San Ildefonso Pueblo school, was encour-

aging her students to draw pueblo-life scenes and paint them with watercolors.

Begay's natural ability manifested in his drawings, and the expressive renderings of the San Ildefonso Pueblo students caused Chapman to encourage Indians to paint. By 1915 several had advanced to the stage that he believed they would benefit from studio experience. At his urging, Hewett brought several San Ildefonso painters to the School of American Research, Museum of New Mexico, and assigned them studios. In the groups were Awa Tsireh and Crescencio Martinez.

Their successes attracted other young San Ildefonso artists to studios in the Museum of New Mexico, at Santa Fe. The San Ildefonso painters "strongly influenced each other and developed a group tradition" that fused into the so-called San Ildefonso School of Water Colorists. "Their visual goals were initially illusionist, representational, and realistic." Sometime after 1920, Richard Martinez led "a major shift toward abstract decoration."[8]

Aspiring painters from Tesuque, Taos, Hopi, and Zia Pueblos joined the San Ildefonso artists at Santa Fe and were assigned studios in the School of American Research, Museum of New Mexico. Taos painters of note included John Concha, Alberto Martinez, and Raphael Pando. Fred Kabotie from Hopi and Ma-Pe-Wi from Zia emerged as the outstanding young artists. Kabotie, whose compositions emphasized Hopi ceremonials, came to be rated the "most versatile and accomplished of the early pueblo painters."[9]

Indian painters from other parts also were attracted to Santa Fe and Taos. They included F. Overton Colbert, Chickasaw; Monroe Tsotoke, Kiowa; and Acee Blue Eagle, Creek-Pawnee— all from Oklahoma. Besides painting, Blue Eagle lectured on Indian art at Arsuna School, in Santa Fe.[10]

Native artists faced two supreme risks. One was the possibility of failure to produce compositions that met their aesthetic expectations or those of their painter peers and the art-buying public. The other was the possibility of provoking civic wrath, ostensibly for revealing secrets of kiva ritual and ceremony in their paintings. Ones accused of pueblo blasphemy faced trial

before the council of elders and a sentence of public whipping or even expulsion from the pueblo. Several Indian artists reportedly were so accused and banished, and the threat of peremptory punishment intimidated some artists, either conditioning their artistic response or causing them to abandon a career in painting. Notwithstanding these risks, Indian art came to flourish in the simpatico milieu fostered by the Santa Fe–Taos colonies. The range of recognized Indian art form expanded beyond painting to include work in clay, fibers, wood, metal, and sand. This development was a response to the pervading art spirit of the Santa Fe–Taos colonies, as well as an extension of the already established painting ventures by Indians, and it also was linked to the escalating tourist population. Each summer after 1920 more and more people visited northern New Mexico. An additional attraction for them was the growing Indian-arts enterprise.

Along with Indian paintings, pottery was the most popular art form with the buying public. Several pueblos developed distinctive pottery styles. Picuris and Taos pottery had a micaceous gold-clay cast; San Ildefonso and Santa Clara pottery was either luminous black or "earthy red." Santo Domingo and Cochiti pottery characteristically was "creamy Buff" with "bold geometric designs." Zia potters decorated their ceramics with deer, birds, flowers, and seeds. Zuñi pottery has been described as "cold red with brown and white designs that unite complex triangular figures with rotund whorls"; Acoma pottery was identified by its "close-knit geometrics," and Laguna pottery by its "accurate cross-hatching of fine-line work."[11]

Maria and Julian Martinez of San Ildefonso Pueblo were the potters ultimate in the Southwest. In 1921, Maria Martinez discovered a means of scribing designs on a polished black background. Julian and Crescencio Martinez decorated unfired pottery, using yucca-fiber brushes dipped in containers of vegetable or mineral color.[12]

Weaving baskets, bowls, hampers, and mats from sedges, wythes, and fibers—each embellished with symbolic designs set in contrasting colors, a time-honored art—also became a profitable enterprise for Southwestern Indians. In addition, they carved icons and fashioned drums from cottonwood and aspen

trunks, covering the heads with tightly stretched elk hide, and worked traditional figures and designs with beads and quills on soft, bleached buckskin.

The most popular weaving art form came from Navajo looms. Natives of this populous Indian nation had learned the technique of fiber selection, color and design application, and loom construction from their Pueblo neighbors. Spanish innovations included sheep for wool fibers and improved loom technology. Well before the aesthetic colonies were founded in northern New Mexico, Navajo serapes, blankets, and rugs were esteemed trade items at the annual Taos fair. Indians from Canada to northern Mexico knew of Navajo textiles and sought them. With the renaissance of Southwestern Indian art and the rise of the tourist market, both Pueblo and Navajo weavers concentrated on producing rugs for the visitor trade.

Indian metal art began with the Spanish advent. From Spaniards natives learned silversmithing. Pueblo, Navajo, and Apache Indians melted Spanish silver coins and fashioned them into ornamental pieces—conchas (flat silver shells) strung on a leather strap and worn about the waist, buttons, bracelets, rings, harness pieces, and squash-blossom necklaces. During their captivity at Bosque Redondo, 1864–1868, the Navajos were introduced to brass and copper wire, which they hammered into bracelets. After 1900, Indian metalsmiths began to fit turquoise, the precious stone of the Southwest, to silver pieces.

Sand painting was an ancient Navajo art form. Native artists produced intricate, exotic designs with colored sand, and used their composition for healing, contemplation, and aesthetic fulfillment. Traditionally, the paintings in sand were destroyed by sunset of the day during which they were made. Gradually the sand-painting art became commercialized as Indian designers adapted religious symbolism to tourist demand. During the summer months Navajo artists presented sand-painting demonstrations for visitors. One huge sand painting, fifteen feet square, was struck in the lobby of La Fonda Hotel, in Santa Fe. For the tourist trade, native artists spread glue on the surface of small rectangular pieces of masonite or plywood and perma-

nently cast varicolored sand into attractive patterns and symbolic figures.[13]

As interest in Indian art grew during the 1920s and the native-painter population working in the New Mexico Museum studios increased, Hewett, Applegate, Chapman, Sloan, and Austin solicited support for them. Contributions of $5, $50, and occasionally $100 came from donors as far away as New York and California to further "Indian art in the Southwest."[14]

A most important development in Indian art occurred around 1930 when federal officials began to relax the 150-year-old policy of eradicating Indian culture, including tribal art. A few daring teachers in the Indian schools of New Mexico had permitted native children to express themselves freely in art. During 1929 pupils of the second grade of Santo Domingo Pueblo school exhibited their drawings at the Museum of New Mexico, in Santa Fe; however, the Indian artists surfacing during the 1920s were mostly self-taught.[15]

Mary Austin was largely responsible for the change in public policy concerning Indian art. She insisted that the humane and intelligent policy for the federal government was to lift the rule against expressing Indianness. Her position was that the most effective way to renew the Indian was to permit him self-determination rather than requiring him to follow the white man's road. And the suppressed Indian arts, so vital to tribal as well as national culture, could be saved only through education. Austin became acquainted with officials in the Bureau of Indian Affairs and the Department of the Interior, and pressed them for favorable action. Finally in 1930 she received from Secretary of the Interior Ray Lymon Wilbur a guarded promise to consider changing the federal policy of Americanizing Indians. At his direction, W. Carson Ryan, Jr., director of education for the Bureau of Indian Affairs, surveyed Indian schools for the purpose of implementing a plan to add native art to the curriculum. This changing federal posture led to the development of The Studio, an Indian art center in the United States Indian School, at Santa Fe.[16]

There, during 1932, Superintendent Chester E. Faris asked

Olive Rush, a leading artist in the Santa Fe colony, to decorate the walls of the school's new dining hall with murals. She countered with the proposal that Indian painters do the work under her supervision. Faris agreed. The call went out for Indian painters and twelve responded; they organized themselves into the Fresco Guild. Until that time the native painters had only done small watercolors. Thus it was essential that they readjust their ideas to scale. But the "Indian instinct for placement, trained through generations of adjusting complicated designs to the surface of native pottery, came readily into play here, so that it was not more than a few days before the whole difficulty of scale and relative proportion was overcome." Indians and non-Indians came to watch the Fresco Guild at work. The project became for the Indians "a universal source of pride and the swelling of self-respect."[17]

This success encouraged school officials to form an art department at the United States Indian School, at Santa Fe, called The Studio. It opened in September, 1933, with Dorothy Dunn in charge. Dunn had been a student at the Chicago Art Institute. From research classes at nearby Field Museum and lectures in anthropology she became interested in Indian art. Dunn arrived in New Mexico in 1928 where she "found more art than I ever dreamed of in Chicago."[18]

Dunn taught two years at the Santo Domingo Pueblo school and one year in the Navajo schools. After becoming acquainted with Chapman, she worked in the basement of the Art Museum in Santa Fe on an enlarging collection of Indian art that would become the Indian Arts Fund Collection. Also she attended Indian ceremonials and worked with archaeological crews on several prehistoric site excavations.

Rush, Gustave Baumann, and F. H. Doyles of the Denver Art Museum assisted her in establishing The Studio. For several years during the 1930s, The Studio enrollment averaged 130 pupils studying composition, drawing, design, and painting. Initially, Dunn had only one student helper to assist her in instructing eight classes of from fifteen to thirty-two pupils. Elizabeth Willis DeHuff later taught art there. Students became teachers of art in the Indian schools of the Southwest, were

employed as muralists, as illustrators and commercial artists, and some became free-lance painters.[19]

Most of The Studio students were from the Southwestern Pueblos and the Navajo nation, although some came from Oklahoma, the old Indian Territory. These included Allan Houser, Fort Sill Apache; George Keahbone, Kiowa; Allan Bushyhead, Cheyenne-Arapaho; and some Indian students who had studied under Oscar Jacobson during the 1920s at the University of Oklahoma School of Art. The success of The Studio in Santa Fe led to an academic spread of Indian art; for example, in 1935, faculty of Bacone College, in Muskogee, Oklahoma, an Indian institution of higher education, established an Indian art department.

One of the most successful Indian artists to study at The Studio was Oscar Howe, a Yanktonai Sioux from the Crow Creek Reservation, in South Dakota. He arrived at Santa Fe in 1933 at the age of eighteen to study commercial art, but natural talent refined by The Studio training led to a full-time career as a painter. Howe "explored time honored precedents of the Plains Indians together with a study of certain modern media and techniques." He presented several one-man shows in the Museum of New Mexico, in Santa Fe, which were rated as "exciting displays of regional themes from the Great Plains—rich and vivid in color—dynamic in composition." And he is credited with introducing "elements of European experimentation into Indian graphic arts."[20]

Other Indian art-instructional facilities in Santa Fe and Taos were Arsuna School—its curriculum included courses in native aesthetics—and Seton Village. Ernest Seton-Thompson, the naturalist, established Seton Village, near Santa Fe, and formed within it what he called the "College of Indian Wisdom," a four-week summer term, based on the proposition that the Indian "possessed a transcendental view of the world. Rather than seeing themselves as superior to other creatures and attempting to dominate and change the world, Indians sought harmony with all things around them." The teaching schedule included lectures by Seton-Thompson on environment and art, instruction by Ina Sizer Cassidy in Indian basketry, pottery design and

symbolism by Chapman, and a pottery-making course taught by Indians from the Santa Clara and San Ildefonso Pueblos. Enrollment for 1932 in the College of Indian Wisdom included Indians and non-Indians from New Mexico, California, Missouri, New Jersey, Iowa, Oklahoma, Michigan, and Illinois.[21]

Initially, the display of Indian art posed a problem similar to that which confronted the Santa Fe- and Taos-colony pioneer painters. And the problem was resolved in a similar fashion. Each year Museum of New Mexico staff formed displays of Indian art and sent them on an exhibit circuit that began in Santa Fe and Taos and proceeded first to the East Coast, then westerly to the Pacific Coast. Sloan, Hewett, Rush, and Austin were chiefly responsible for maintaining contacts with gallery and museum officials and arranging for the showing of art produced by local native artists. Eventually they joined with Mrs. J. D. Rockefeller, Jr.; Mrs. Dwight Morrow; Oliver LaFarge; Witter Bynner; Alice Corbin Henderson; and Amelia and Martha White to form the Exposition of Indian Tribal Arts, an organization that promoted the production and exhibition of native art.

As early as 1920 the Museum of New Mexico established an "Indian Alcove" to display native drawings hailed as "new art indigenous to the soil." In 1922 the museum staff began to sponsor the Southwestern Indian Fair featuring native art in connection with the annual Santa Fe Fiesta. Through the years the Museum of New Mexico and the Harwood Foundation Gallery, at Taos, showed combined native-art exhibits as well as one-person shows featuring the work of Allan Houser, Gerald Nailor, Eva Mirabal, George Keahbone, Vicente Mirabal, Pop Chalee, Awa Tsireh, Crescencio Martinez, Quincy Tajoma, Narenco Abeyta, Fred Kabotie, Ma-Pe-Wi, Tonita Pena, and Oqwa Pi.[22]

In 1920 collections of Indian paintings, pottery, basketry, textiles, and metalwork began to move from Santa Fe and Taos to the East Coast. In that year Sloan arranged for a showing of New Mexican native works at the Independent Art Show, in New York—the occasion marked as "the first time that American Indian paintings had ever been exhibited as Art." Also in

1920, Austin was able to schedule an exhibit of Indian paintings at the Museum of Natural History.[23]

During the 1920s, Indian art gained a wider public acceptance. Galleries and museums in the East, the Midwest, and on the West Coast, particularly San Francisco, Los Angeles, and San Diego, increasingly accepted exhibits of native art from northern New Mexico. Thus in 1931, Sloan staged the largest collection of Indian art ever assembled, works by painters from thirty tribes that filled seven large rooms and included the "marvel of sand painting," in the Grand Central Palace Gallery, in New York. The following year Rush exhibited work by Indian students from The Studio at Rockefeller Center, in New York; Cochrane Galleries, in Washington, D.C.; and in Chicago at the World's Fair Galleries. Also, after 1930, Indian art from northern New Mexico often proceeded from East Coast exhibitions to galleries in Geneva, Venice, Budapest, Prague, Paris, and London. By 1941, Indian art from New Mexico was accepted for display in the New York Museum of Modern Art.[24]

Critics and writers on art were attracted to these exhibitions. The *New York Times* art critic was struck by Awa Tsireh's work: "His drawings are in their own field as precise and sophisticated as a Persian miniature. The technique that has produced pottery designs as perfect as those of an Etruscan vase has gone into his training."[25]

Equally as vital to Indians as exhibition of their art was marketing. Resourceful natives sold paintings, metal work, pottery, and textiles to summer tourists at stands along major highways crossing their lands, in the Pueblos, and in Santa Fe, Taos, and other northern New Mexican towns. Civic leaders made several attempts to establish a native market in Santa Fe until Hewett set up a sales place under the portico of the Governor's Palace, on the Santa Fe Plaza.[26]

Colony members also aided in native-art sales. On lecture trips to Broadmoor Art Academy, in Colorado Springs, Alice Corbin Henderson carried portfolios of Indian paintings. One season she sold fifty-seven pieces. Mary Austin, on trips to New York to meet with her publisher, also carried Indian paintings

that she sold to acquaintances. Besides paintings, the most popu-
lar native-art item was pottery. The nonpareil ceramics of Maria
Martinez, of San Ildefonso, were featured in New York Fifth
Avenue shops.[27]

Sloan became concerned that tourist patronage might in-
fluence Indian art "for the worst." Most of the time Indians, near
poverty and perennially in need of money, could be driven to
produce at an unbecoming level. Also manufacturers in Massa-
chusetts and other Eastern states were producing and marketing
jewelry and blankets with the claim that they were Indian made.
To guard against commercialism and corruption of native art,
and alien competition, he, Austin, and other native-art advocates
in the Santa Fe and Taos colonies urged government officials to
guard genuine Indian creativity. The Federal Trade Commission
moved to ban the misrepresentation of native goods, and offi-
cials in the Department of the Interior issued an order that only
authentic items made by individual Indians could be sold in the
national parks. Also, agents of the Bureau of Indian Affairs
established three schools for Indians to receive training in weav-
ing and metalwork — one at Santa Fe, one at Albuquerque, and
one at Fort Wingate.[28]

Another agency that sought to guard the integrity of native
art was the Laboratory of Anthropology. Its foundations were
established during 1922 in the School of American Research,
Museum of New Mexico, when Chapman, Austin, and other
members of the Santa Fe colony formed the Indian Arts Asso-
ciation. Its basic purpose was to encourage the native artist to
shun the growing tourist pressure for curios and to produce only
the best, consonant with traditions of ancient Indian art. Mary
Austin explained that collectors, museums, even tourists, were
buying up the old pottery and there was the fear that

soon there would be nothing left by which the Indian Pueblo potters
could refresh their inspiration and criticize their own output. With
nothing to feed the stream of living tradition (as things were bought
up), it became quickly evident that the decorative quality of native
design would grow thin, lose interest and value. So . . . the artist
friends of the Indians, in the desire to preserve . . . the treasure of . . .
living and authentic art, the Indian Arts Fund . . . appeared.

Pieces of pottery came from the abandoned Pecos Pueblo, from Pojoaque, Isleta, and other settlements. "Local collectors turned in what they had in the way of pottery, even curio dealers cooperated." The pieces were temporarily placed in the basement of the Museum of New Mexico.[29]

The Indian Arts Fund received donations from friends of the cause, most ranging from $5 to $100, and gifts of Indian art. Then during 1928, John D. Rockefeller, Jr., presented $270,000 to the fund. Thereupon Indian Arts Fund trustees incorporated in 1929 to form the Laboratory of Anthropology; its collection was enlarged to embrace the best examples of native textiles, bone and wood carvings, metal art, and paintings. Architect John Gaw Meem designed a building compatible with the Santa Fe style and, when completed, provided a structure for storing, analyzing, and exhibiting the native-art collection.[30]

Through the years its holdings were increased by gifts and purchases. Trustees purchased a textile piece, rated the "finest Navajo blanket seen in the West" from a Denver woman for $2,500. The collection, which contained over one thousand pieces of fine pottery in 1929, was enlarged by the purchase of the Alice Corbin Henderson collection of native ceramics by Mary Austin, who gave it to the Indian Arts Fund. The Laboratory of Anthropology program included publishing and teaching; in cooperation with the University of New Mexico it presented a course each year in Indian art taught by Chapman, offered especially for teachers in the schools of the Southwest and for employees of the United States Indian Service.[31]

During the Depression native artists became involved in the federal Public Works of Art Project, the Treasury Relief Arts Project, and several PWA projects. Local Indians were employed to apply murals to new state and federal building interiors, including the New Mexico state capitol building and Indian Department building, in Santa Fe, and several post offices, courthouses, and schools across the Southwest. Also they were assigned to PWA projects to produce baskets and bead, metal, and textile work.[32]

The creative flair of the Santa Fe and Taos colonies helped to liberate Southwestern Indians from the suppressive federal

Americanization program, precipitated a renaissance in native art, and provided Indians the means to achieve aesthetic fulfillment. And one writer contends that the interaction of Anglo and Indan artists also ameliorated the long-standing Indian-white alienation and hostility; he explains, "The red man and the white man for so long a time were on such bad terms and their relations at best were so strained." Particularly in northern New Mexico, however, "the Indian has become a friend of the white man," this "due in no small measure to the artists, whose sympathetic understanding of human nature has helped to create an 'entente cordiale' in many Indian communities."[33]

The creative flair of the Santa Fe and Taos colonies also involved Spanish-Americans. They, too, contributed to the fine-arts legacy of northern New Mexico.

AN ADOBE HOUSE

A house born of the brown earth
and dying back to earth again,
Without any desire to be more than earth
and without any particular pain,
Beside an acequia *bringing water*
to corn not yet tall.

—WITTER BYNNER

9 / HISPANIC MUSES

DESCENDANTS of Spanish colonials also became involved in the life of the Santa Fe and Taos colonies. Indeed, their very presence seasoned the northern New Mexican social environment, casting upon it an Iberian patina of exotic style, liquid language, and quiet charm. Like Indians, Hispanics served as models for painters and subjects for writers of prose and poetry. And they too were caught up in the art spirit that dominated this region between 1900 and 1942, and also contributed to its fine arts legacy. Hispanics, however, became involved late in the life of the colonies, and their art surge had a shorter span of time than that of the Indian and Anglo contributors.

The same persons responsible for the restoration of Indian art—members of the Santa Fe colony, particularly Mary Austin, Kenneth Chapman, and Frank Applegate—motivated by the desire to conserve extant Hispanic art and encourage its renaissance, in 1923 formed the Spanish Colonial Arts Society. Interest in this class of art began quite early in the life of the Santa Fe colony. Chapman, Gerald Cassidy, and other local artists frequently went on sketching expeditions to outlying villages. There they saw the survivals of earlier, but now inactive, Hispanic art forms, most of it in wood—delicately carved

doors, windows, corbels, and roof beams, elaborately contrived *armorios* and *trasteros;* tin lanterns and candelabra; and a rich array of religious art (the *santos, bultos,* and *reredos*). They collected these art pieces to furnish their adobe homes in Santa Fe. Other colony members took this up. Then curio dealers, collectors, and tourists took a fancy to these items; during the 1920s it became fashionable for many households to contain accent pieces of colonial art from northern New Mexico.

An enlarging traffic in these art pieces created in several colony members a proprietary concern for the loss of Hispanic history and culture through its export to homes and museums across the nation. Thus they formed the Spanish Colonial Arts Society, an organization housed in the basement of the New Mexico Museum, at Santa Fe, and committed to conserve local Hispanic art and encourage its resumption. Many members of both the Santa Fe and Taos colonies became involved in the society's conservation work because they regarded Spanish colonial art as largely indigenous to the northern New Mexican environment. Also, it comprised a form of primitivism and, thus, like local Indian art, provided attractive simplistic models.

From their studies of Hispanic art, Spanish Colonial Arts Society members learned that early-day Iberian settlers in New Mexico applied their aesthetic talents to fibers (weaving blankets and rugs, and rendering elaborate crochet and embroidery work called *colchas*); to architecture; only limitedly to ceramics; to wood carving; to furniture making (of high craftsmanship but imbued with an art flourish, too); to metalwork; and to painting. While the art spirit infused Hispanic households, public buildings, and personal dress of colonials in northern New Mexico, most of their art had a religious basis and application. Also, their isolation was a determinant of art style, technique, and medium. One Santa Fe–colony member characterized Hispanic art as derived from "quasi-medieval folk culture with a good deal of peasant subsistence economy, preserved by extreme isolation."[1]

The northern New Mexican villages of Chimayo, Truchas, and Cordova were weaving centers. Colonial weavers produced handsome blankets and rugs on looms situated in their homes.

Wool from flocks of sheep that flourished on highland meadows in the Sangre de Cristos was carded, spun, and dyed as a cottage industry. Dyeing the yarn to produce the strong, contrasting colors and designs characteristic of colonial weaving required keen skill and an artful eye. Dye material came from several sources. Chihuahua traders brought to the northern New Mexico weavers cochineal, a pure red dye; brazilwood, which yielded rose and other shades of red; and indigo for blue. But most reliance for dyestuffs was placed on local vegetable and mineral sources—elder produced pink dye, larkspur yielded azure, copper sulphate furnished turquoise shades, and yellow dye came from the golden flowers of the chamiso. Mixing chamiso blossoms with indigo produced green. Roots of the dock plant yielded yellow, and stone lichens and apple bark, yellow-green. Also, colonials derived brown from juniper bark and walnut hulls, and black from sumac leaves. Colonials wove these colored yarns into sharp, contrasting, eye-catching designs that made practical bed and floor coverings and at the same time were rough tapestries of striking color and simplistic beauty. Colonial women executed delicate crochet and embroidery called *colchas* with cotton and wool threads, applying this artful work to coverlets, dress and shirt sections and other clothing pieces, as well as leggings and footwear. They applied their most skilled *colchas* work to embellish home and church altars. These included altar cloths with scalloped borders struck in religious designs. They also crocheted large panels containing esteemed religious figures, including our Lady of Guadalupe.[2]

Colonial building was an art form, too. From years of frontier experience, exposure to Pueblo Indian models, and Iberian creativeness, Spaniards in northern New Mexico evolved a distinctive architecture for home, public building, and church construction—the adobe. In its perfected form the adobe consisted of walls of sun-dried mud blocks, broken with heavy carved timbers, corbels, and lintels to form ceiling, door, and window supports, and roofed with heavy spaced timbers, *vigas*, covered with saplings placed in an attractive herringbone pattern. Its interior was simply furnished with a traditional corner fireplace, *nicho* for placing holy objects, and ofttimes the cir-

cular torreon, a defensive tower situated on one corner of the dwelling. Yard fixtures included an outdoor oven, the beehive-shaped *horno*. The adobe, blending in color and form with its surroundings, was a product of northern New Mexico's natural environment; certainly it also became a trademark of the region's social landscape, imparting to it an additional quality of distinctiveness, of uniqueness.

Chapman, Applegate, and Austin found in the inventory of Spanish-colonial arts little evidence of work in ceramics. This was more than likely because the pottery of Pueblo Indian neighbors was of such high quality and could be obtained so readily that there was little incentive for Spanish pioneers to take up pottery making. But in woodcrafting they excelled, elevating it to the level of an art form. Colonists used local woods, primarily pine and cottonwood, joining pieces with the tedious mortise-tenon-glue joints to strengthen the soft woods. Their creative array included handsome tables and chairs, chests (each carved with figures of birds, flowers, and animals, and fitted with descriptive panels), and high cupboards (with panels and grilled doors).

Artisans learned the qualities of local woods other than the widely used pine and cottonwood. Piñon, a dwarf pine of slow growth yielding hard, resinous wood, was ideal for table legs and saddletrees. Juniper, with its tough, straight grain, had several uses, including "teeth" for the weaver's comb, and aspen with a "live quality of resonance," was used for making drums, guitars, violins, and other musical instruments. Glue, vital for joining wood pieces with dowels and mortise and tenon joints in the absence of nails or screws, they made from boiled animal hooves, which produced a strong adhesive substance. Tools on the northern New Mexican frontier were few and primitive, largely consisting of the knife, adz, saw, axe, and chisel, and sometimes a plane and brace and auger bit.

Metalsmiths also contributed to the galaxy of Spanish-colonial arts. They were itinerants, going from village to village seeking work; and they were versatile, working in iron, tin, brass, copper, silver, and occasionally in gold. As blacksmiths they met the mundane needs of each settlement—from iron

they made locks, hasps, spearheads, axes, knives, and shoes for horses, and mended copper kettles and brass fixtures. As artists they made tin lanterns, candleholders, mirror and picture frames, and small tin boxes with painted glass side-and-top panes. From melted silver coins Hispanic metalsmiths contrived crosses, rosaries, earrings, buttons, necklaces, and bridle and saddle ornaments. Their ultimate in aesthetic application came in the mastery of filigree work—drawing silver and gold into metal strands and fashioning birds, fish, flowers, pear-shaped ear pendants, and tall combs.

Members of the Colonial Arts Society found that the highest forms of Hispanic art were devoted to religious subjects. Iberian settlers of northern New Mexico were uniformly devout Catholics. They were committed to otherworldly concerns of judgment, salvation, and eternal life. Religion was a pervasive force in their lives, and a community of saints served as daily companions and intercessory agents for them. Thus with paintings and icons of the suffering Christ, the Virgin, Ysidro (patron saint of agriculture), and others of the Christian pantheon close by in their churches and homes, it was believed that they vicariously shared the settlers' mortal suffering and privation on the northern New Mexican frontier. Much colonial art, then, was an extension of the settlers' celestial preoccupation—their all-abiding interests and concerns—and of their religious values.

Hispanic religious art went through several stages. In the early days of the Spanish regime in northern New Mexico, missionary priests placed copies of Spanish renaissance paintings of the Virgin and other divine figures in the churches. Local artists copied these to supply the demand for home display. They painted on buffalo and elk hides and small pine slabs shaped with an adz and smoothed with several coats of locally mined gypsum, called *yeso*. Some paints were imported from Mexico, but increasingly they resorted to vegetable and mineral colors used by Pueblo Indian artists.

During the Pueblo Revolt in 1680, Indian insurgents destroyed most manifestations of Spanish culture in New Mexico, including churches and religious objects. After the reconquest interest from Mexico in the religious welfare of the northern

colony declined. This led to a second phase of religious art. The otherworldly emphasis continued and local artists set out to replace the vandalized iconographic art. But they abandoned European models; they "strayed from tradition, and they relied more on their own conceptions, drawn from environment. The saintly images became primitive in feeling and technique. A local school of art developed, with its own style and in the native mediums. It was an art of passionate extremes, sensual, yet morbidly ascetic and stoical. It was a folk art, adapted to its environment with simplicity of design."³

The Hispanic art that evolved during the second phase, however, was not a homogenized expression. Northern New Mexico's natural environment—a twisted, tumbled alpine relief of towering ranges—isolated the tiny colonial settlements situated in the narrow valleys, and caused local differences and distinctiveness in art styles. These included the "dramatic painting of the Truchas-Santa Cruz area, the architectural deviations of Sandia and Manzano villages, and the preponderance of large, facile sculpture types in the neighborhood of Valencia and Tome."⁴

Hispanic aesthetics in this period were dominated by an artist type called the *santero*, who specialized in producing *santos*, defined as "New Mexican religious portraits in any medium—painting, sculpture, or print." *Santeros* were skilled in carving and painting. Customarily they traveled from village to village selling *santos* and taking commissions to do additional ones. Their *santos* consisted of three types: *bultos, retablos*, and *reredos*.⁵

The *bulto* is a wooden sculpture of a religious principal carved generally from a cottonwood root and varying in size from a small piece suitable for placing in the household *nicho* to a life-sized icon placed in the local church and carried in religious processions. The favorite representations of holy persons were carvings of the Christ figure, the Holy Mother and Child, the Lady of Guadalupe, and San Ysidro, the farmers' patron saint. Most *santos* were single figures, although *santeros* sometimes prepared a tableau for the spring planting festival consisting of San Ysidro and yoked oxen complete with plow

and harness and a guiding angel. The *santero* infused the *bulto* with the honored medieval ascetic suffering and emaciation, particularly the Christ figure, consistently cast as a man of pain and sorrow. The Hispanic artist painted *bultos* in several colors, using powdered mineral and vegetable tints mixed with egg yolk to form a tempera that he applied with a yucca-fiber brush. The ultimate in *santero* art was creating and carving a crucifix, which conveyed agony and anguish on the face and body of the Christ figure.

The *retablo* is a two-dimensional painting on a rectangle of wood composed of representations of holy persons or a religious scene. A household *retablo* might average fourteen inches by twenty-one inches; a larger *retablo* for church use, perhaps three feet square, made up of several smaller boards joined with pegs and glue. Commonly the *retablo* painting represented the local patron saint surrounded by other saints popular in the community.

The *reredo* is a tall altar back that might cover the entire wall above and behind the altar. The *santero* designed the *reredo* by joining several *retablos*, each serving as a panel depicting a holy scene and integrated into a larger wooden mural.

Perhaps the *santero's* most difficult task was preparing the plaques of wood for composing and painting the *retablo* or *reredo*. The surface of the slabs of adz-hewed pine was rough and uneven. To smooth it the Hispanic artist covered the surface with several coats of wet gypsum *(yeso)*. On the hardened white surface he painted with mineral and vegetable tints, mixed with egg yolk for tempera quality, and applied them with a yucca-fiber brush.

While most of the *santero's* work was in wood, occasionally he used stone or tin, painting on it much as he did on wood. The largest stone *reredo* (carved from limestone quarried near Pojoaque) consisting of seven panels of religious portraits in bas relief, thirty-nine feet high and eighteen feet wide and tinted "in beautiful old fresco colors" originally was sculpted for the *Castrense* or military chapel of Santa Fe. It was later placed as an altarpiece in Santa Fe's El Cristo Rey Church.

The vitality and popularity of *santero* creations declined

soon after the Anglo commercial advent on the Rio Grande, beginning in 1821; by 1885 the second phase of Hispanic art had come to a close. *Santeros* were unable to compete with the mass-produced holy relics and pictures—saintly statues in tinted plaster of paris, Currier and Ives prints, and European lithographs depicting favorite holy persons. In the new order it seemed "there was no place for the professional *santero*." The exception was in the Penitente communities of northern New Mexico. Members of this ultraconservative order refused to accept the importations and "their *moradas* contain many of the original *retablos* and *bultos* safe from collectors."[6]

Members of the Santa Fe colony who had formed the Spanish Colonial Arts Society learned from their study of Hispanic art that it had moved from "imitative beginnings to a robust individuality, followed by a decadence and a forgetting." Their purpose, then was two-fold—to conserve extant Hispanic art, and generate among Spanish-Americans of northern New Mexico a renaissance of interest and participation in their aesthetic legacy.[7]

It was well that the Spanish Colonial Arts Society became concerned about conserving Hispanic art objects because during the 1920s these items became popular among collectors and tourists. Curio dealers in Santa Fe and Taos hired Spanish-Americans to scour the northern New Mexican communities for art pieces. These agents entered churches and carried off religious objects, even the carved doors, and they solicited householders for genuine *santos*. Modernist priests often scorned the old holy objects and attempted to dispose of them. The priest at Santa Cruz sold the church's bells, cast in colonial times, to a curio dealer.[8]

Also the Spanish Colonial Arts Society worked to preserve public buildings and churches constructed in the early Hispanic style. Because Carlos Vierra already had succeeded in halting modernization in Santa Fe and preserving certain historic buildings there, society members turned their attention to structures, particularly churches, in peripheral villages. John Gaw Meem, a distinguished Santa Fe architect and member of the Spanish

Colonial Arts Society, provided professional guidance for restoration of colonial structures.

The roof of the church at Cordoba leaked and the priest wished to replace the flat adobe-style roof with a new gabled tin roof. He also wanted a standard-height kitchen door installed because the old, solid, carved panel door was lower than his head and he had to stoop to pass. He only visited the church once a month to say mass. The Cordoba parishioners opposed the changes and appealed to the society for help. Applegate protested to the archbishop who directed that the Cordoba church be restored in its original style. Meem advised the people at Cordoba on completing the restoration, other colony members raised funds for materials, and Cordobans did the work.[9]

Willa Cather, the novelist, took a special interest in the cloister at Acoma. As a member of the Society of Colonial Arts she helped to raise the sum of $5,000 required for its preservation. She wrote articles about the cloister and the need for prompt conservation attention and spoke on its behalf.[10]

Society members raised money for other Hispanic art-conservation purposes. These included restoration of the mission church bell tower, at Acoma; repair of the mission-church interior, at Trampas; and extensive structural restoration of the historic chapel of *El Sanctuario*, at Chimayo. Meem supplied the professional-design counsel for the restoration of *El Sanctuario*. Mary Austin was the indefatigable fund raiser for the society; she solicited money from Santa Fe– and Taos-colony writers and artists, from townspeople, and from lecture appearances before Eastern audiences, always including in her remarks an appeal for support of Hispanic and Indian needs. Also the society was aided in its restoration attempts by grants from the Society for the Preservation of Missions and by the Fred Harvey Company; to the latter, restored missions were important tourist attractions.[11]

Members of the Spanish Colonial Arts Society also strove to generate a revival of pride among Hispanics for their aesthetic legacy and a desire to resume activity in it. Courses in

Hispanic art were offered at Arsuna School. Also William Penhallow Henderson, the Santa Fe–colony artist, constructed a workshop adjacent to his studio for Spanish-Americans to receive instruction and experience in producing traditional furniture with modern tools. Society officers established an office in Santa Fe's Seña Plaza to coordinate their Hispanic-art renaissance attempt, and hired a field worker to encourage Spanish-Americans in art activity.[12]

Witter Bynner, the poet, and Andrew Dasburg, the artist, determined what antique Hispanic art pieces should be purchased for the society's collection as representative models. The Museum of New Mexico provided space in its basement for housing the art objects collected by the society and hired a full-time curator to manage it. In addition, museum officials offered studio space to aspiring Hispanic artists.

Interest in the society's efforts to restore work in the colonial arts spread across the state. The New Mexico State Department of Vocational Education came to provide instruction and training in Hispanic-art courses including wood sculpture, painting, cabinet making, leather work, weaving, and embroidery. At the San Jose School and several other state vocational institutions, Spanish-American students studied antique pieces of religious art, furniture, and textiles, or photographs of these items and used them as models for their work. In 1932 faculty at the University of New Mexico began to study Spanish-colonial art pieces and the practicality of certain types for modern use.

The Spanish Colonial Arts Society also provided display and sales assistance to newly discovered Hispanic artists. Officers of the organization opened the Shop of Spanish Arts, in Seña Plaza. Hispanic artist recruits responded to this outlet for their work, and by the late summer of 1930 the shop was reported to be "brimming with blankets, carvings, embroideries, furniture, and many other things." Sales were largely to tourists who came to northern New Mexico each summer in increasing numbers until the deepening Depression substantially reduced the visitor traffic. Also the society promoted sales by arranging for display of Hispanic art at the annual fiesta, and it increased Hispanic artist interest and participation by offering a cash

prize for what was judged to be the best art in each class. In addition, artists with quality work were assured sales from the tourist crowds who came each year to Santa Fe for the fiesta. The fiesta sales of 1930 included carved doors purchased by visitors from Pennsylvania and California.[13]

Harwood Foundation Gallery, in Taos, also displayed wood sculpture, *colchas, serapes*, blankets, tin work, and furniture by Hispanics as a part of the Native Arts and Crafts Show, which opened in late May each year. The exhibits were sponsored by the Taos Guild, counterpart to the Santa Fe–based Spanish Colonial Arts Society.

Mary Austin and other society members sought to promote Hispanic art by extending display and sales opportunities beyond Santa Fe and Taos. Through their wide contacts, they were able to persuade galleries in New York, Boston, Chicago, and Kansas City to show work by Spanish-American artists from northern New Mexico.[14]

While, during the 1930s, there was a wide response to the Hispanic-renaissance movement, most of the Spanish-American wood sculptors, painters, weavers, metalsmiths, woodcrafters, and other artists either have been only momentarily recognized or have become virtually anonymous. Those receiving most public and critical acclaim during the period of renewed Hispanic participation in the arts—the decade of the 1930s—were wood sculptors Jose Dolores Lopez, of Cordova; Patricino Barela, of Taos; and Celso Gallegos, of Agua Fria.

Lopez's forte was the execution of exquisite nature figures —flowers, birds, and animals. Some of his work was purchased by the Museum of Modern Art, in New York. Lopez's daughters and son George also were acclaimed wood sculptors. Gallegos has been characterized as the last of the *santeros*, the only prominent latter-day Hispanic artist who eschewed secular subjects and worked in the classical mode of sacred themes. Barela became the most popular of the new generation of Hispanic artists.[15]

The WPA and other Depression recovery programs that assisted Anglo and Indian artists of northern New Mexico also aided Hispanic artists. Local officials of the WPA provided

funds for training aspiring Hispanic artists and assisted them in displaying and marketing their work. Barela was a recipient of WPA support in the early years of his artistic career. One of the most notable WPA ventures in Hispanic art was commissioning Juan Sanchez, a young Hispanic sculptor, to produce a large number of *bultos* and *retablos* for museum and general public-exhibition use. Sanchez's sculpture and painting imitated "the picturesqueness of the older pieces" of extant sacred art.[16]

Members of the Spanish Colonial Arts Society, particularly Mary Austin, were also interested in Hispanic literature and the performing arts of music, dance, and drama. Austin assiduously collected Hispanic traditions, proverbs, and stories, and by 1933 had accumulated a reported "thousand gems of Spanish colonial literature." She published several in anthologies. Austin also encouraged Hispanics to write; she influenced Nina Otero Warren to compose *Old Spain in Our Southwest*, which was rated as an authentic picture of Spanish New Mexico.[17]

In every Hispanic village music for entertainment was provided by handmade fiddles, guitars, harps, drums, and flutes. Singing was popular among Hispanics; their songs were of two classes—*canciones* (lyrical ballads) and *alabadas* (sacred songs). Hispanic dance was both secular and religious. Most of the dancing for entertainment was of Aragonese origin. Dance also was a part of some religious pageants, observances, and celebrations, the best known being the *matachina*, a generic name applied in Spain to an old type of ballad dance; in northern New Mexico it became a mix of European and Indian elements. Dancer costumes were modeled after Catholic ecclesiastical robes and headdresses, with three-branched wands for the Trinity. When Indians performed the *matachina*, the wand also represented the "fruitful corn mother." Customarily the *matachina* was performed at Christmas and Easter.[18]

Mary Austin was a dedicated student of Spanish-American drama, another popular form of the performing arts among Hispanics in northern New Mexico. By tradition, drama was introduced to the region in 1598 by the performance of *Los Moros y Los Christianos* by a Spanish cast on horseback. Austin found that virtually all of the Hispanic plays have a religious

theme, the most popular ones being *L'Aparición de Nuestra Señora de Guadalupe*, presenting the miraculous appearance of the Virgin to an Indian, and a series depicting the life of Christ —*Los Pastores, Los Reyes Majas, El Niño Perdido*, and *La Pasión*. A popular secular play is titled *Querneverde* or *Los Comanchos*, which recounts with actors on horseback the exploits of the Comanche chief Querneverde who raided the Spanish settlements of northern New Mexico, capturing the two daughters of a prominent Spanish family. Austin found in her study of Hispanic drama that in the northern settlements were dramatic societies in which membership had become hereditary. Parts in the plays as well as costumes and stage property were handed down, often from father to son, and "in many cases passed from generation to generation without once being written down."[19]

The Hispanic contribution to the fine-arts legacy of the Santa Fe and Taos colonies is substantial, and in some respects is similar to the Indian and Anglo elements of the trinity of aesthetic achievement there. For example, its strong tradition, historical performance, and latter-day renaissance fed the Santa Fe– and Taos-colony propensity for conservation of art by ethnics through establishment of a separate museum, as had been the case for Indian art. The discovery by the Spanish Colonial Arts Society of the vitality, color, and substance of Hispanic art, and its conservation of extant art pieces and attempts to involve Spanish-Americans in art production is said to have influenced Mary Wheelwright to found the International Folk Art Museum, in Santa Fe, to house her extensive collection, gathered by her from around the world; Hispanic art came to comprise a major portion of the museum resources. But Hispanic art differs from the Anglo and Indian art in many respects, too. It was the last of the three classes of art to surface, to receive recognition, and to flower, and it had the shortest life of the three. Also, much of its value as art was retrospective, that is, the tradition and survivals in the antique *bultos* and *retablos* are a more substantive part of the Hispanic contribution to the Santa Fe and Taos colony artistic legacy than the production of latter-day Spanish-American artists.

PART III

Euterpe's Issue

NEW MEXICAN MOUNTAIN

Indians dance to help the
young corn at Taos Pueblo. The Old men
squat in a ring
And make the song, the young women with fat
bare
arms, and a few shame-faced young men, shuffle
and dance.

The lean-muscled young men are naked to the
narrow
loins, their breasts and backs daubed with
white clay,
Two eagle-feathers plume the black heads. They
dance with reluctance, they are growing civilized;
the old men persuade them.

Only the drum is confident, it thinks the world has
not changed; the beating heart, the simplest of
rhythms. . . . only . . . the strong Tribal
drum, and the rockhead of Taos mountain,
remember
that civilization is a transient sickness.

—ROBINSON JEFFERS

10 / THE LITERATI

WRITERS were captivated by the same spirit of revolt and
sense of restlessness that swept the artistic community soon
after the turn of the century. The literati also were seeking
new models and modes of expression. Poets experimented with
freedom of form, vers libre, and exploited the concrete, the
sensory—they called themselves Imagists. Increasingly concepts
were expressed by implication. Moralizing was taboo for many
of the poets of the new age aborning. Like the artists, they drew
aesthetic substance from inner feelings and expressed it in a de-

liberate effort to stir the senses. Writers of fiction and nonfiction increasingly eschewed romanticist imperatives and applied realist techniques; critical biography became popular. Also, because it was a time of uncertainty, of threatened chaos on a world scale, many writers, again like the painters, sought moorings through attention to more manageable regional themes and guidance from the alleged superior wisdom of "primitive peoples."

Like the painters, writers felt endangered by what they identified as America's corrosive materialism and civic hypocrisy. They believed that their increasingly industrial society stultified creativeness, and they developed a familiar secessionist intent, a will to separate from the greater American society and settle in a refuge where their aesthetic energies would be safe, and where they could express them freely. In their quest, some writers went to Europe, while others searched across the United States for a haven—to Carmel, to Provincetown; several authors followed the artists to Santa Fe and Taos.

Like the pioneer artists before them, writers found the northern New Mexican environment awesome. The popular poet Don Blanding explained that

Taos is Carmel-by-the-Sea moved to the desert. . . . There are piñon and juniper trees instead of live-oaks and cypress; the mountains are more stark and savage, the mesas are like modernistic stylized waves rearing from a sea of sage and sand. Taos, like Carmel, has an enchantment [for] the hearts and imaginations of those who live in it and know it well. . . . New Mexico is a land of Cruel Beauty, fascinating, frightening, and at once earthy and mystical.[1]

The literary émigrés used the northern New Mexican milieu variously. Some drew on it to stir their creative energies and to inspire them to write but dealt in subjects and themes from other parts. Other writers also depended on the natural landscape to stimulate their creativity, but they exploited it additionally by fashioning its elements into literary compositions, much as the artists had done with their paintings. Thus the northern New Mexican ambience became the subject of poems, environmental studies, and natural-history compositions, and

the setting for countless fiction and nonfiction works, plays, even operas.

Writers venturing to Santa Fe and Taos also became enamored with northern New Mexico's social environment, particularly its tricultural society. The Hispanic and Anglo experiences in this primal land were subjects of considerable interest to them but, of this variegated milieu's three components, it was the Indian who became a never-ending source of wonder. And for Mary Austin and several other literary immigrants he became the stimulus for ongoing interpretation, narration, and lyrical rendition as they sought to plumb his mystical nature and alluring life-style. As it was for several painters at Santa Fe and Taos, writers there also explored the Indian as a living specimen of "primitive man" or "natural man", the symbol of innocence, a promising source for resolving modern industrial man's uncertainties and for revealing fresh themes and life-style alternatives.

During the nineteenth century the Indian as a literary subject had been popularized as the "noble savage" in America by James Fenimore Cooper's Leatherstocking tales and in Europe by Karl May's Winatu books. Several Santa Fe and Taos authors, through their writings about Indians, produced a renaissance of interest in Native Americans. Southwestern Indians became a rich and productive source of literary adaptation by Austin and others who assiduously collected, annotated, and published their folk tales, drama themes, legends, and epic narrations. Even sophisticated, Harvard-educated Witter Bynner, poet, sinologist, and a Santa Fe–colony pioneer, was captivated by the affluent aboriginal cultural display. Bynner's favorite month in his adopted Southwest was December when he recounted "tall mountain gods, escorted by fire gods . . . come down from their caves to bless the people" in a ceremony that he found fascinating and so "eerily a spectacle."[2]

The Santa Fe and Taos colonies also appealed to writers because, like the artists, most were virtually destitute, and at the time the northern New Mexican settlements probably had the lowest cost of living in the nation. During the "halcyon days" of the 1920s it was explained that a writer could rent a

two- or three-room adobe house in Santa Fe or Taos for less than ten dollars a month. Many of the colonists "kept their horses in the dooryard, their butter in the well . . . and heated their small adobe rooms, hung with dusky saints . . . with piñon and cedar burned in small oval adobe fireplaces."³

The region's literary tradition is centuries old, beginning with Captain Farfán, the playwright who marched up the Rio Grande with Oñate's column in 1598. During the nineteenth century, northern New Mexico received the attention of several writers; they produced works of enduring quality, worthy models for the authors who settled in the Santa Fe and Taos colonies after 1900. George Frederick Ruxton, an Englishman, visited the upper Rio Grande valley in 1846 and wrote two books describing his experiences there—*Life in the Far West* (1847) and *Adventures in New Mexico and the Rocky Mountains* (1848). Lewis H. Garrard, a young traveler from Cincinnati, explored northern New Mexico in 1846–47 and recounted his adventures in *Wah-to-yah and the Taos Trail* (1850). William H. W. Davis, United States attorney for New Mexico in early territorial days, wrote *El Gringo or New Mexico and her People* (1857). General Lew Wallace completed his novel *Ben Hur* during 1880 in the Governor's Palace while serving as New Mexico Territory's chief executive, and his wife Susan wrote of her experiences in New Mexico, which she published in 1888 under the title *The Land of the Pueblos.*

Northern New Mexico's prehistory has been a popular subject for writers. Archaeologists have been the principal source for opening this vista, which later influenced Santa Fe and Taos colony artists in form and design, and writers there in subject matter. Archaeologists also contributed to northern New Mexico's literary tradition. Adolph Bandelier studied Pueblo cultures, then wrote *The Delight Makers* (1890). It provides in fictional form a charming reconstruction of prehistoric Indian culture in the Southwest centering on the ancestors of the modern Pueblo Indians who, according to Bandelier, were dominated by a powerful secret society called the Koshare or "Delight Makers." Charles Francis Lummis was the most widely read author working with northern New Mexican subjects at the turn of the cen-

tury. For several years Lummis lived there; his *The Land of Poco Tiempo* (1893) has become a classic for the region.

The writers of the Santa Fe and Taos colonies produced poetry, fiction, nonfiction, and dramatic text. Several authors, like Mary Austin, wrote poetry, fiction, nonfiction, and plays. Their literary production ranged from biography, history, and nature studies to works of the so-called mystery, adventure, romance, and children's literature categories. Many Santa Fe and Taos colony authors also wrote articles and short stories for popular periodicals—*Saturday Evening Post, Collier's, Esquire,* and *New Yorker*—and commentaries and interpretive essays for *Forum, Atlantic Monthly, Scribner's, New Republic, The Nation,* and *Saturday Review of Literature.*

A few writers appeared in Santa Fe and Taos nearly as early as the pioneer artists. One of the first of the literati to reach Santa Fe, and an acknowledged founder of the author section of the colony, was Alice Corbin Henderson. She was from Chicago and an editor of *Poetry Magazine;* her writer friends were legion and included Carl Sandburg, Vachel Lindsay, John Gould Fletcher, and Witter Bynner. Stricken with tuberculosis, Henderson, accompanied by her artist husband William Penhallow Henderson, traveled west during 1916 in search of a place to recover. They settled in Santa Fe and acquired an adobe dwelling on Telegraph Road (the future Camino del Monte Sol), which became a residence center for Santa Fe–colony artists and writers, much like nearby Canyon Road. Alice Corbin Henderson became a sustaining influence in the colony. Her wide correspondence reporting the environmental charisma of northern New Mexico drew several nationally known writers, including John Gould Fletcher and Witter Bynner, to the region. The Henderson home on Camino del Monte Sol became a popular place for writers to gather to read poetry, essays, and synopses of novels for peer evaluation. Besides building the author section of the colony, Henderson provided leadership in the formation of several literary and civic enterprises beneficial to Santa Fe. Her best-known works are *The Sun Turns West, Red Earth,* and *Turquoise Trails.* She also wrote *Brothers of the Light: The Penitentes of the Southwest,*

a sympathetic, supportive study of this much-maligned sect. And she collaborated with Mary Morley to produce a collection of children's songs.[4]

Other pioneer writers in the Santa Fe colony were Ina Sizer Cassidy, Frank Applegate, and Ruth Laughlin Barker. Cassidy, from California and Colorado, arrived in Santa Fe with her artist husband Gerald Cassidy about the same time as the Hendersons. She, like Alice Corbin Henderson, drew material for literary expression from the northern New Mexican milieu, casting her impressions into verse, short stories, and feature articles. She also worked as editor for regional publications. During the 1930s, Cassidy served as a project editor for the New Mexico volume of the WPA-sponsored guide to the states. An enduring advocate of preserving the ancient charm and style of Santa Fe, she was a leader in the Old Santa Fe Association. For many years Applegate served as a member of the Museum of New Mexico staff. From his study of Indian and Hispanic cultures he wrote treatises on pottery and textiles that have become classics. Applegate collected and published Indian and Hispanic folktales, and wrote plays based on local lore, including the popular one-act *San Cristobal's Sheep*. Barker, a native of northern New Mexico, wrote authoritatively on the region's culture and history. Her best-known work is *Caballeros: The Romance of Santa Fe and the Southwest*.

Literary successes of the author-pioneers in the Santa Fe colony attracted established writers from other parts to northern New Mexico, with the result that by the mid-1920s it was claimed that they had eclipsed the artists as the colony's most productive and prestigious component. Oliver La Farge, the Pulitzer Prize–winning novelist, commented on the competition between writers and artists for preeminent recognition in the colony. In the 1920s

which was the high period of the artists here in Santa Fe, Santa Fe was in fact more of a poets' and writers' colony than a painters.' This tends to be forgotten. I have found elsewhere that where there are painters, it is the public's tendency to think of them as the principal element in an art colony, regardless of what else there may be. I remember in the French Quarter in my time we had Sherwood

Anderson, Bill Faulkner, and myself as well as a number of others who then or later produced books of merit. Before us there had been such people as O'Henry and Lafcadio Hearn. As far as I can remember, the French Quarter produced only one painter who was worth a hill of beans, and as a matter of fact he was in the French Quarter very little. Yet the general assumption even among members of the colony itself was that we were above all a collection of painters.[5]

During this intermediate period of the colony's literary evolution, several writers of note became permanent residents of Santa Fe; others lived there during the summer months. Permanent settlers included Witter Bynner, Haniel Long, Oliver La Farge, and Mary Austin (see chapter 11 for an account of her role in the Santa Fe colony). Prominent writers residing in Santa Fe during the summer months included John Gould Fletcher, Arthur Davison Ficke, Ben Botkin, Stanley Vestal, and Willa Cather.

Bynner shared with Alice Corbin Henderson the leadership position in the Santa Fe colony. A Harvard-educated Phi Beta Kappa, Bynner was catholic in interests and bonhomie in disposition. He began his literary career as an editor for *McClure's Magazine*, then served as professor of literature at University of California, Berkeley. Before arriving in northern New Mexico, Bynner had acquired recognition as one of the nation's leading poets. In addition he had developed an interest in Chinese culture, mastered certain of the Chinese languages, translated Chinese writings, collected Chinese art, and was rated an expert sinologist. His best-known translation of Chinese poetry was published under the title *The Jade Mountain*.

In 1921, Bynner first arrived in Santa Fe as the guest of Alice Corbin Henderson. Infatuated with the natural beauty of the place and the mystic charm of Indian culture, he confided to his poet friend Robinson Jeffers, "I have sent my roots of instinct into the earth. . . . the beauty of the earth has made us beautiful too and had made us, if only for a moment, do beautiful things."[6]

Sometimes writing under the pseudonym Emanuel Morgan, Bynner produced twenty books including *Indian Earth*, rated

as "a saga of race that has never been expressed," a new volume of poems concerning "traditions still warming the soil of New Mexico." He also composed several plays—*Cake, Red Rust,* and *Night Wind.*[7]

Bynner was independently wealthy and generously shared his good fortune with others. He aided struggling literature students, and presented an annual national poetry prize of $150, a substantial sum for the 1920s, to promote college-student interest in poetry.[8]

Bynner's warm, prodigal hospitality was legendary; for over twenty years he was the acknowledged premier host of Santa Fe. His afternoon entertainments—before 1933 euphemistically called tea parties, after repeal of national prohibition called cocktail parties—were given to honor writers, painters, visitors, or for any other good reason for having friends in, the number of guests often running as high as 150 for a single gathering.[9]

Above all else Bynner's vitality, strong personality, personal charm and natural leadership provided social cement that held the Santa Fe colony, in all its disparate elements, together and converted it into a functioning community for promoting creative activity and the quality life. Bynner was obsessively protective of the canons of unfettered personal expression and consistently guarded the colony's pluralism and general immunity from civic censors. The novelist Harvey Fergusson recalled that Bynner contributed much to the sense of community in Santa Fe, and rated him as "One of the most distinguished . . . human catalysts." His parties, which drew aesthetes from both the Santa Fe and Taos colonies, contained guests from all groups and cliques. "I have never seen a host work so hard and yet so joyfully to entertain guests who had nothing in common except that they were fascinated by Bynner. He sat down at the piano and played and sang out of an enormous repertoire . . . which brought youth back to life in all kinds of people and brought them together."[10]

Haniel Long, professor of literature at Carnegie-Mellon University, in Pittsburgh, for fifteen years, came west in 1928 on sabbatical leave to recover his health and to write. He was

summarily captivated by the restorative and inspirational essence of northern New Mexico and settled there permanently. Like Bynner, Long was a vital force in the Santa Fe colony, both socially and creatively. His best-known writings are *Piñon Land*, a charming ecological interpretation of his adopted region, and *Interlinear to Cabeza de Vaca*, cast in epic verse.

Oliver La Farge, Harvard-trained anthropologist, did not settle permanently in Santa Fe until 1941, near the close of the vital life span of the colony there, although throughout the 1920s and 1930s he spent most summers in northern New Mexico. He became a respected anthropologist and served as director of Peabody Museum expeditions in the Southwest, but his greatest recognition came as an author. His *Laughing Boy* received the Pulitzer Prize in 1929; additional writings include *Enemy Gods*, *The Mother Ditch*, and *Cochise of Arizona*. La Farge explained his approach to writing had "been instinctive rather than a thought out plan." On his style, he added, "I originally wrote in a very florid, periodic style and was cured of it by the influence of Indian myths which at one time I studied intensively, particularly the really remarkable literature of the Navajoes." La Farge, like several other members of the Santa Fe colony, was an activist for Indian policy reform, serving as president of the Association on American Indian Affairs.[11]

During summers of the early 1920s scores of authors, some established but most of them aspirants, came to northern New Mexico to write. John Gould Fletcher and Arthur Davison Ficke, classed as neoromantic poets, were the best-known temporary colony members during this period. Both Fletcher and Ficke fashioned environmental sensations into their verse, the former in his *Breakers and Granite* and *Burning Mountain*; the latter in *Mountain against Mountain*. Each summer, from the University of Oklahoma, at Norman, came Ben Botkin and Stanley Vestal (Walter S. Campbell). Botkin collected and annotated regional folklore and verse that he published at the University of Oklahoma Press under the title *Folksay*. Vestal, a poet best known for *Fandango*, also was a writer of fiction *(Santa Fe Trail)* and biography *(Sitting Bull)*.

The premier writer of the summer-visitor group during the

intermediate period of the Santa Fe colony was Willa Cather. Cather journeyed summers from her eastern home to the Southwest on a regular basis beginning in 1912. She customarily resided in Santa Fe but on occasion spent some time in Taos. Mabel Dodge Luhan, leader of the literary section of the colony there, was her host, providing Cather "a peaceful life in the little house" in her residential compound that she had constructed for D. H. Lawrence. During her stay at Taos she visited Lawrence at his ranch on nearby Lobo Mountain. But Santa Fe was her favorite place, she receiving hospitable welcome each season from Mary Austin and other members of the colony.[12]

Already a nationally acclaimed writer for *O Pioneers* and *My Antonia*, Cather searched the Southwest for fresh subject matter, but for a time it was denied her because, as she explained, the region "was too big and too various. But it gave me more pleasure than any other part of the continent." Cather's friends claim that her "discovery of this region was the principal emotional experience" of her "mature life." Then, during the summer of 1925, two experiences combined to yield the literary guidance for her to produce a Southwestern classic. She recalled "I shall always remember the late afternoon I was sitting in a . . . spot up by Martyr's Cross, east of Santa Fe, watching the Sangre de Cristo Mountains color with sunset." It was there that she received the conviction that "the essential story of the Southwest was not," as most writers contended, "the ancient Indian civilization nor that of the Spanish explorers and martyrs. . . . The real story of the early Southwest is the story of the missionary priests."[13]

Related to this experience was the discovery in a Santa Fe bookstore of a copy of W. J. Howlett's *Life of the Right Reverend Joseph P. Machebeuf . . . Pioneer Priest of New Mexico.* Cather's interest was captivated by the powerful character described as an associate of Machebeuf—Archbishop Jean-Baptiste Lamy, a clerical reformer who served on the New Mexican frontier from 1858 to 1888. Lamy became the very soul of her literary interest and attention; his life provided the basis for *Death Comes for the Archbishop*—in a sense, a fictionalized biography of Lamy, whom she renames Archbishop Latour. Cather wrote the

manuscript during 1926; Knopf published it a year later; and at once it became a best seller.[14]

Between 1930 and 1942 scores of authors came to Santa Fe, some to settle permanently, others for a summer or so. As with the artists there, the writers continued to draw on the milieu for inspiration; some also exploited it for subject matter, but increasingly they dealt with nonlocal themes. In this final stage of colony life authors continued to produce some quality work in poetry, fiction, and nonfiction, but more and more they keyed their writings to the popular market, often at the sacrifice of their literary convictions. Some of those writers who were successful in marketing their manuscripts were Frances Cary, a children's literature specialist; Frances Crane, a mystery writer; Emily Hahn, later a biographer but during the 1930s a writer of romances, including *Affair;* Mavis Hall, author of "gutsy, earthy books" like *Cannery Anne;* and Eric Kelly, a writer of juvenile stories who found the Indian a popular subject for readers and said Santa Fe was a "rich field" for his interests.[15]

Novelist Raymond Otis, a young writer from Chicago, drew on several local subjects for *The Little Valley*, a sensitive portrayal of small Hispanic communities, and *Fire in the Night*, the first book to deal with the Santa Fe social potpourri. Elizabeth Shepley Sergeant, essayist, literary critic, activist, and biographer of Willa Cather, spent most summers during the 1930s in Santa Fe. Sidney Peterson, a San Francisco newspaperman, came to Santa Fe to compose *Into the Evil* and other books because he found that the awesome landscape and stimulation from creative persons in the colony made Santa Fe a "good place to write."[16]

One of the outstanding poets to appear in the 1930s was Thomas Wood Stevens; his *Westward Under Vega* was rated by critics a composition of "rich beauty." Clergy became involved in the literary community too. Fray Angelico Chavez composed and read poetry Sunday evenings at the New Mexico Museum, in Santa Fe. And Roark Bradford, a gifted short-story writer and playwright from New Orleans, spent some time in Santa Fe. His writings, largely based on Negro life, included *Ol Man Adam an' His Chillun* (dramatized by Marc Connelly as *Green*

Pastures), *This Side of Jordan*, and *John Henry*.[17]

Lynn Riggs ranks as one of the most popular and productive writers in the Santa Fe colony during the 1930s. An English instructor from the University of Oklahoma, Riggs became acquainted with Witter Bynner when the latter presented a lecture on the Norman campus. Bynner invited Riggs to Santa Fe, and during most of the 1930s Riggs made his home there. His many plays included *Son of Perdition*, *Rancour*, *The Lonesome West*, *Cherokee Night*, *Russet Mantle*, and *Green Grow the Lilacs*, from which the musical *Oklahoma!* was adapted. Most of Riggs's plays were first read by the author to members of the Santa Fe colony for peer criticism, and several were presented on the Santa Fe stage before they were produced on Broadway. Eastern drama critics rated Riggs one of the "best playwrights of his generation." He was appointed professor in experimental drama at Baylor University in 1941; his course was rated as one of the "most stimulating on the campus."[18]

Several writers from across the Southwest occasionally visited Santa Fe to mingle with colony members. Up from the Tularosa country of southern New Mexico came Eugene Manlove Rhodes, author of *Pasó Por Aquí* and *Peñalosa*. Erna Fergusson, from Albuquerque and for many years a "courier chief" for the tourist industry of northern New Mexico, was in Santa Fe frequently on tourist business and as an author and was regarded a member of the colony. She was a popular writer of nonfiction, and her book *Dancing Gods*, describing Southwestern Indian ceremonials, was well received. Paul Horgan, librarian at the New Mexico Military Institute, at Roswell, and a close friend of Witter Bynner, regularly spent summers in Santa Fe, and his works, in part the result of time spent there, included *A Lamp on the Plains*, *Conquistadors*, and *Great River: The Rio Grande*.[19]

The evolution of the writer segment of the Taos colony resembled that of the Santa Fe colony except that the author population at Taos was not as large as that of the southern colony. The pioneer period for the Taos colony's literary segment extended from about 1917 to 1925. Mabel Dodge Luhan was its founder (see chapter 12 for an account of her role in

the Taos colony). She performed a formative function for the literary segment of the Taos colony like Alice Corbin Henderson for the founding of the Santa Fe colony; like Henderson, Luhan drew writer friends from other parts to Taos. These included D. H. Lawrence and Robinson Jeffers. Writers of this stature provided a patina of prestige and awe that attracted other writers.

Several authors reached Taos after the Mabel Dodge Luhan advent. Sarah Roberts Wallbaum, from Chicago and a writer of short stories and poems, spent several summers there beginning in 1918. And Blanche Grant, an artist and writer, settled permanently in Taos in 1921. The following year she became editor of *Taos Valley News*, developed an interest in the history and culture of northern New Mexico, and thereafter divided her time between painting and writing. Grant's books include *One Hundred Years Ago in Old Taos, Taos Today*, and *When Old Trails were New*.[20]

Joseph O'Kane Foster, a Chicago newspaperman, arrived in Taos during 1921 and became a permanent resident. He was one of the few persons in the Taos area accepted as a friend by the difficult-to-get-acquainted-with D. H. Lawrence. His writings include *The Great Montezuma, In the Night Did I Sing*, and *D. H. Lawrence in Taos*, an account of his experiences with the great English novelist. One of the few writers in the Taos colony born in New Mexico was Peggy Pond Church; she lived at Taos and Santa Fe and was well regarded in both colonies. Church became a poet of national reputation for her *Foretaste* and *Familiar Journey*, which express the spirit of the country. Her *House at Otowi Bridge* is a saga in human travail, courage, and determination in adjusting to a fierce land.[21]

Probably the most colorful writer of the Taos colony was Willard ("Spud") Johnson. While a student at the University of California, Berkeley, he published *Laughing Horse*, an underground newspaper, as a "horselaugh" on what he considered "dull and conventional campus publications" and the arid "intellectual climate" at Berkeley. Soon *Laughing Horse* carried articles by writers of note, including Upton Sinclair and D. H. Lawrence. University officials banned *Laughing Horse* from the

campus on the charge that it published obscene material. At about this time Witter Bynner invited Johnson to Santa Fe; he arrived there during 1922 and moved to Taos the following year. Johnson moved back to Santa Fe several times to carry out various writing, editing, publishing, and bookselling ventures, but he spent most of his life in Taos.[22]

Johnson published a highly rated book of poems titled *Horizontal Yellow*—taken from the name given by Navajos to the West—and a satire on the Santa Fe colony titled *The Ballad of Santa Fe*. Also Johnson continued to publish *Laughing Horse*, issuing a total of twenty numbers by 1938; his contributor list was prestigious—Carl Sandburg, Mary Austin, Sherwood Anderson, Alfred Knopf, Miguel Covarrubias, Lincoln Steffens, John Dewey, Carl Van Vechten, and D. H. Lawrence. Johnson also published several works in hand-set type on a small hand press in his adobe shack in Taos, including a play by D. H. Lawrence, a short story by Lynn Riggs, poems by Idella Purnell, and drawings by Paul Horgan. In addition he served as an editor for the *New Yorker* and editor of the *Taos Valley News*. Ernest Blumenschein, the opinionated artist doyen of Taos, commented that Johnson's function in the Taos colony was to "stir up mild forms of irritation." Others described him as "the intellectual conscience of Taos," consistently the "watchdog of intellectual integrity," as well as "the voice of reason raised against ideological extremes." As an editor he was regarded as a "gentle crusader, the mildly buzzing, persistent gadfly."[23]

After 1925 writers came to Taos in increasing numbers, some to settle permanently, others as summer residents. Of the permanent Taos-colony writers, some spent winters in Honolulu, Carmel, Pasadena, or Phoenix. Don Blanding, the "peoples' poet," resided in Taos during the 1930s where he wrote *Memory Room* and *The Rest of the Road*, but left Taos each October for Carmel or Honolulu. Joining Blanding at Taos were Myron Brinig, who published an average of a book a year (*The Sisters* was his best known work); Paul Annixter (H. A. Sturzel), a writer of natural history and animal stories, highly regarded for his *Wilderness Ways;* and his wife Jane Comfort (daughter of California-author Will Comfort), who published several novels

written at Taos, including *From These Beginnings.* The Annixters wintered in Pasadena. Other permanent author residents were Lola Ridge, poet, who published *Dance of Fire;* Mrs. John Evans, who wrote *The Island* and was the daughter-in-law of Mabel Dodge Luhan; Alonzo S. Burt, author of *The Water Devil;* and Lorraine Carr, a writer on nature subjects. Her novel, *Mother of the Smiths* received high critical acclaim. Alexandra Fechin, wife of painter Nicolai Fechin, had contributed stories and verse to Russian magazines in prerevolutionary Russia. She continued writing after settling in Taos and during the 1930s published Russian folktales and a book, *March of the Past.*[24]

D. H. Lawrence influenced three writers to come to Taos: his wife Frieda, Dorothy Brett, and Aldous Huxley. Frieda wrote *Not I, But the Wind,* an account of her life with Lawrence. Brett, the English artist who accompanied the Lawrences to Taos and painted charming northern New Mexican scenes, also wrote and published *Lawrence and Brett,* an account of her experiences with the noted English author, dedicated as she said to this man whom "every woman and most men loved." Both Dorothy Brett and Frieda Lawrence became permanent residents of Taos. Aldous Huxley was the third person attracted to Taos because of the Lawrence connection. He arrived there after Lawrence's death, but had known Lawrence in Europe and had heard much about the place from both D. H. and Frieda Lawrence. Huxley had used Frijoles Canyon and the Los Alamos mesa country as the setting for the Native American scene in *Brave New World.* During 1937, Huxley and his wife Maria stayed with Frieda Lawrence at Kiowa Ranch, on Lobo Mountain, near Taos, to complete *Ends and Means.* Later Maria Huxley told Frieda Lawrence that the ranch setting on Lobo Mountain had changed their lives. They searched for a similar place of solitude and natural beauty and found it on a ranch in the southern California interior.[25]

Persons of literary consequence arriving in Taos near the end of the colony's life in 1942 included Harold Hawk, Dick Covel, and Frank Waters. Waters, an engineer from Colorado, settled in Taos and wrote several books built around northern New Mexican themes, including the highly praised and widely

read *The Man Who Killed the Deer* (an account of a young Pueblo Indian searching for a place in either the conflicting Pueblo world or the confusing Anglo society) and *People of the Valley*, which depicted the vicissitudes of Hispanics in small mountain villages threatened by Anglo progress.[26]

Harvey Fergusson, from Albuquerque, did most of his writing in the East and California but returned now and then to northern New Mexico for material and renewal of literary inspiration. One of his early books, *Footloose McGonigal*, is described as "a Taos portrait gallery." Fergusson's *Wolf Song* tells of the early days in Taos and the surrounding country.[27]

Few of the summer authors writing in Taos could match the literary reputation of Robinson Jeffers. Mabel Dodge Luhan, accompanied by her Taos Indian husband Antonio and her secretary Spud Johnson, regularly spent winters in Carmel for "rest from the altitude" of Taos. There she met Jeffers and pressed him to come to Taos, much as she had pressed Lawrence and other writers to join her there. Beginning in 1930, Jeffers and his family spent their summers in Mabel Dodge Luhan's compound in Taos. It is said that the vitality of Jeffers's poetry heightened after his Taos sojourns.[28]

The quality of life in the Santa Fe and Taos colonies was enhanced by occasional visits of celebrity writers from other parts. Stephen Graham, an English writer on Russia and his "amiable friend" Wilfred Ewart came to Santa Fe and Taos in 1923 and visited Lawrence, Bynner, and other writers. Ewart reportedly had come to northern New Mexico for his health and the hope that "its calm might cure his stutter."

Vachel Lindsay visited Alice Corbin Henderson in Santa Fe during 1929. Characterized as a "resounding poet," he "thundered" at the tea Henderson sponsored for him. Thornton Wilder, author of *Bridge of San Luis Rey*, frequently visited friends in Santa Fe and Taos. During the winter of 1933–34 he was a speaker at the Taos Open Forum, and he returned the following summer as the guest of Mable Dodge Luhan. Also during 1935 novelist Edna Ferber was a Luhan guest.

In the same year the Santa Fe–colony writers, organized as Writers' Editions, sponsored a visit by Robert Frost, who

appeared on the stage of the New Mexico Museum auditorium on the evening of August 5. Henderson, Church, Long, Otis, Botkin, Bynner, Fletcher, Johnson, Riggs, Sergeant, and Erna Fergusson managed Frost's appearance. Over 200 persons attended the presentation, which was rated as "pleasing." In his introduction Frost was touted as a leader of the modern poetry movement with Vachel Lindsay, Carl Sandburg, and Edgar Lee Masters. Lynn Riggs's tribute to the honoree, who had received the Pulitzer Prize twice for poetry, expressed gratitude for the "compassionate, stirring things he says of the gracious earth, and its people."

And during 1938, Carl Sandburg came to Santa Fe to visit Alice Corbin Henderson. At her reception honoring him, Sandburg sang folksongs accompanied by his guitar.[29]

Writers of the Santa Fe colony formed several groups for mutual professional benefit and social intercourse. Writers from the Taos colony were members of these organizations. A writers' club, formed in 1929, was called the Rough Riders, its purpose to discuss writing problems, critique manuscripts, promote publication outlets, and entertain visiting writers. Members served as faculty for writing courses at the local Arsuna School and the University of Denver branch of the Santa Fe Art School, held in Santa Fe each summer. Its curriculum included courses on poetry and short story techniques taught by Ina Sizer Cassidy. Also, members helped with the annual Roundtable on Southwestern Literature at Las Vegas. Austin, Botkin, Fletcher, Otis, Barker, and Cassidy were regular participants.

During the Depression years of the 1930s several Santa Fe authors joined the American Writers' Union to enhance literary marketing, guard against "gouging publishers," and protect their literary interests. Mat Smith, of New York, was in Santa Fe in 1936 organizing a local branch of the American Writers' Union. Also, several Santa Fe and Taos colony writers joined to form the New Mexico Writers' Guild, an organization devoted to promoting author welfare.[30]

The most enduring and productive grouping of Santa Fe authors was the Poets' Roundup. Beginning in 1925, Alice Corbin Henderson entertained Santa Fe and Taos writers one

evening each week in her home for fellowship and reading of poetry. Bynner, Fletcher, Long, Vestal, and Austin joined Henderson in 1930 to turn the Poets' Roundup to social purpose— to raise funds for the New Mexico Association of Indian Affairs, a social-action group formed by Santa Fe– and Taos-colony members. Thereafter, the Poets' Roundup became an annual event held at McComb Hacienda and other places about Santa Fe large enough to accommodate crowds, often 200 persons paying one dollar admission. Late in the 1930s the Poets' Roundup became an annual August garden festival "whose spontaneity leads many into their first understanding of what this literary colony is about." Each writer was allowed five minutes to recite his or her work. Proceeds from the Poets' Roundup of 1936 were assigned to the Writers' Editions.[31]

Writers' Editions, founded in 1933 as a cooperative effort by Santa Fe authors to "free them from the dictates of Eastern publishers" and to improve publication opportunities for their manuscripts, was symptomatic of depressed national economic conditions during the 1930s. Through the years colony writers at Santa Fe and Taos had been published by major Eastern book concerns. In fact, publishers, editors, and literary agents— including A. Knopf (of Knopf Publishers) and Harold Latham (of Macmillan Company)—were frequent visitors to Santa Fe and Taos, negotiating with local authors for manuscripts. And their books were widely reviewed in *Saturday Review of Literature, New York Times,* and other regional and national periodicals and newspapers. The authors and their writings also received continuing notice in the *Taos Valley News, Taos Review, Taoseño,* and the *Santa Fe New Mexican;* each newspaper ran a special column detailing activities of the writers and artists. Dana Johnson, long-time editor of the *New Mexican* and of strong humanistic bent, was keenly interested in the colony and was its strongest local supporter; aesthetes regarded him as a member of the colony.[32]

Because the Great Depression drastically reduced the number of books produced each year by Eastern publishers, writers in northern New Mexico turned to local and regional publication outlets. Writers' Editions was an example of this trend; the

conviction of its executive committee—Alice Corbin Henderson, Erna Fergusson, Gustave Baumann, and Haniel Long—was that "regional publications will foster the growth of American literature." First releases of the Writers' Editions were *The Sun Turns West*, by Henderson; *Atlantides*, by Long; *Foretaste*, by Church; and *Peñalosa*, by Rhodes. This cooperative had published seventeen books by 1942. Walter Goodwin of Rydal Press, Santa Fe, designed and printed Writers' Editions books, imparting to each volume immense "style and beauty."[33]

Other publication outlets for northern New Mexican writers during the 1930s were *Folksay*, edited by Santa Fe–colony member Ben Botkin and published by the University of Oklahoma Press, and anthologies, including *North American Book of Verse*, which printed works by Bynner, De Huff, and Fletcher. Cyrus McCormick, an independently wealthy member of the Santa Fe colony and writer for *Esquire Magazine*, founded in 1936 the *New Mexico Sentinel*, a weekly newspaper devoted to "better New Mexico government." Its contents included a New Mexican writers' section, "a little magazine published every week in mid of the newspaper," consisting of poetry, prose, and criticism. Long, assisted by Bynner, Erna Fergusson, Paul Horgan, and Frieda Lawrence, edited the literary section. Also, in 1938 New Mexico Writers' Guild established a magazine, *Over the Turquoise Trail*, to accommodate poetry, stories, plays, and commentary by Santa Fe and Taos writers. And during the late 1930s several authors from the Santa Fe and Taos colonies, like the artists, were engaged in a federal relief program—WPA Writers Project. Ina Sizer Cassidy was appointed statewide director for New Mexico. Her staff of researchers and writers were to produce the New Mexico volume for the American State Guide Book Series.[34]

Just as Santa Fe– and Taos-colony artists increasingly were provided local galleries to show their paintings, authors eventually were provided local bookstores to show and vend their published works. Roberta Roby's Villagrá Bookshop, in Santa Fe's Seña Plaza, was the best-known author's outlet in northern New Mexico. Spud Johnson once managed the Villagrá. Other Santa Fe outlets included the Santa Fe Book and Stationary

Company. Authors' works were available in Taos at the Laughing Horse Bookstall and the Taos Book Shop.[35]

Authors commingled with artists and other creative types at Santa Fe and Taos to additionally enrich colony life. In the early years, writers, like the artists, were for the most part conservative and traditionalist in life-style and outlook and openly opposed the permissiveness commonly associated with communities of creative persons. In 1926 an observer wrote that most Santa Fe–colony writers were committed to the straight life. He added: "no one among them ever said, come now, let us have a western Greenwich Village. Such an idea is, in fact, distasteful to them." But as the author population of Santa Fe and Taos increased, there occurred a concomitant increase of nonconformists — daring in dress, flaunting in lifestyle, several rated as "kinky." Gay status became a common and accepted form of sexual choice in both colonies, albeit a subject of continuing ridicule in the press — a *Santa Fe New Mexican* "Village Gossip" column in 1931 stated: "Wanted, information leading to disclosure of the identity of the unprincipled person who sent Santa Fe's leading novelist a cake of Fairy Soap on Wednesday."[36]

Two of the most interesting and attractive writers of the Santa Fe colony were Marion Winnick and Phil Stevenson. Winnick, who had a Boston accent and was the author of *Juniper Hill*, rode horseback each day to La Fonda in downtown Santa Fe to lunch and to plan the rest of her trilogy. Stevenson, an award-winning playwright, composed *God's in His Heaven*, a social protest statement against "child tramps" forced into that type of life by the Great Depression. Stevenson was an unremitting activist; among the Santa Fe writers he was characterized as "the Communist and correspondent of *New Masses*."[37]

Of all the writers in both colonies, three surpass all others in creative force, plurality of literary interest, and enduring influence — Mary Austin, Mabel Dodge Luhan, and D. H. Lawrence. The contributions of the three to colony vitality and longevity are of such magnitude that each merits special attention.

RIO ABAJO

Once by this saguan's ruined arch
Music its walls absorbed gave back again,
As in the dusk guitars were playing,
And on the stamped adobe floor
The dance still swaying.
Still is the Alameda sweet
With sun-steeped petals strewn
Where late the twinkling monstrance passed,
Mid gold more lucent than its own,
To bless the fields again.

—MARY AUSTIN

11 / MARY AUSTIN: SANTA FE'S LITERARY DOWAGER

"GOD'S Mother-in-Law," as she was called (never to her face) by writer friends, first saw Santa Fe in 1918. By that time she was a well-established writer; Mary Austin's admirer H. G. Wells declared that her writings would live "when many of the more portentous reputations of today . . . become no more than fading names." Mary Hunter Austin was born September 9, 1868, at Carlinville, Illinois. A precocious youngster, she very early manifested an intensely subjective, near mystic, preoccupation. She graduated from Blackburn College, at Carlinville, and prepared to teach in the local school, but the death of her father in 1888 caused her mother to move the family to California, near Rancho El Tejon, to join an older brother in homesteading the arid lands of the San Joaquin Valley.

Mary Hunter taught school until 1890 when she married Stafford Wallace Austin, a teacher and farmer. The couple moved to Owens Valley, near Independence, California, where the husband became engaged in irrigation projects. To escape

199

the boredom of farm life and a marriage that she rated a "total disappointment," Mary Austin collected ethnic lore from local Indians and Hispanics and composed poems, stories, and articles for *Overland Monthly*, *Out West*, *Cosmopolitan*, and *Atlantic Monthly*. Her first book, *The Land of Little Rain*, an environmental study published in 1903, was hailed by critics as "an American classic."[1]

A retarded daughter issued from the marriage. Mary Austin cared for the child for several years then placed her in an institution, left her husband, and moved to coastal California, first to Los Angeles, then to San Francisco, and last to Carmel. At Los Angeles she came under the didactic domination of Charles F. Lummis, editor, critic, author of *Land of Poco Tiempo*, and the Southwest's premier publicist. Lummis for a time was Mary Austin's literary mentor and helped her place manuscripts with publishers. Subsequently Mary Austin moved on to San Francisco, seeking a fresh locale for literary development. Then she settled at Carmel in 1903, described at the time as a "bit of wild beach and many dunes," and was one of the founders of the aesthetic colony there. She came to know John Muir, Edwin Markham, Harry Leon Wilson, and Ambrose Bierce, and became intimate with George Sterling and Jack London. At Carmel she established a home and lived there permanently until 1912, thereafter returning periodically until 1924.[2]

In 1907, Mary Austin traveled to Europe and remained there for nearly three years. By this time she had acquired modest national recognition both as a writer and lecturer; thus she was in demand in England as a speaker on the subject of literature and life in the United States. She was accepted in several literary coteries and became a friend of H. G. Wells, George Bernard Shaw, and other writers of note. Mary Austin spent considerable time with the Fabians, an organization of English socialists, whose doctrine denied the Marxian imperative of proletarian revolution to accomplish change, insisting that society could achieve needed change by gradual reforms through "permeation" of existing institutions. Her intimate associates were Sidney and Beatrice Webb, Mary Stopes, and other English reformers; they quickened her social sensitivity and nur-

tured a reform impulse that continued throughout her life.

Soon after returning to the United States, Mary Austin settled in New York City, first at Washington Irving House, on Riverside Drive; next at the National Arts Club; and last at No. 10 Barrow Street, where she pursued busy and productive literary and activist careers. She published six books, including *A Woman of Genius*, and wrote stories and poems drawn from her Southwestern experience, particularly Indian and Hispanic lore, as well as articles of social commentary that appeared in *Atlantic, Harper's, The Bookman, New Republic,* and *The Nation.*

During the New York residence Mary Austin became a member of the popular provocative Mabel Dodge salon. Mabel Dodge, a wealthy social-cause impresario fresh from years of lavish exile in an Italian villa, entertained each week in her New York residence a clique of intellectuals and radicals often made up of Mary Austin, Bill Haywood, Emma Goldman, Lincoln Steffens, Max Eastman, Walter Lippmann, Elizabeth Gurley Flynn, Margaret Sanger, and John Reed.

Mary Austin expanded her range of friends in high places, entertaining them at the National Arts Club. These included the Herbert Hoovers, William Allen Whites, Sinclair Lewis, Willa Cather, and John Collier. Several of her guests—Gerald Cassidy, the painter, and Ina Sizer Cassidy, his author wife, to mention only two—were to be her neighbors in Santa Fe after 1924. Mary Austin and Ina Sizer Cassidy played prominent roles in the 1916 National Women's Suffrage meeting at Atlantic City. During one of her annual visits to California and Carmel, Mary Austin divorced Stafford Wallace Austin.

With the entry of the United States into World War I in 1917, Mary Austin's friend Herbert Hoover was appointed director of the National Food Administration to marshal the food resources and coordinate their equitable distribution to the nation's military and civilian segments. Hoover selected Mary Austin as a member of the propaganda corps. She already had been active in organizing community kitchens in New York. Following her appointment to Hoover's staff, she traveled across the United States, continuing the work of setting up community

kitchens and promoting victory gardens. Her reports to Hoover disclose that she threw herself into the war effort with that intensity of effort and consuming dedication that characterized her performance in all things. She told Hoover: "I am busy going about the country assisting at the opening of community kitchens. . . . What the women want, *what your whole movement needs* is a sense of social directions. That's what I'm doing with it. If *I can't do it with your approval*, I'm going to do it anyway." She reported on another occasion that she was "stirring up the country on the food problem," lecturing, writing for newspapers, magazines, preparing posters, "urging establishment of community gardens, community storehouses, community markets and kitchens. The community kitchen is now so well established. . . . The great problem to be met now is the accommodation of labor, the housing and feeding, not only of the people who have to be taken from one place to another to work, but the accommodation of families where both father and mother are now engaged in war work." She also pressed on Hoover her idea of a "woman's land army."[3]

As the war drew to a close, Mary Austin wearied of the rush and press of New York and, seeking solace and inner peace, she returned to Carmel; but she found "things were not as they had been" there in that tourists had discovered this "quaint place" and, in her view, were corrupting it. She determined to seek a new refuge, but meanwhile she had in mind to go to Mexico to gather material for articles and a book on the subject of social change among Hispanic and Indian peoples. Before the war she had interviewed Mexican revolutionists hiding in the towns of southern Arizona and New Mexico and got from them the feel for the possibilities of cultural change and Hispanic-Indian restoration in that strife-ridden nation. Sensitized to social change by her Fabian connection, she pointed to what she called "immense cultural activities going on up and down the great central plateau" that accommodated the Hispanic-Indian populations of Mexico and New Mexico, "and the importance of these matters for the whole Southwest. What I felt . . . was the possibility of the reinstatement of the hand-

craft culture and folk drama" in New Mexico "following the revival of those things in Mexico."[4]

As Mary Austin prepared to make this investigation, she received invitations from friends in northern New Mexico—the Cassidys, in Santa Fe, and Mabel Dodge Sterne, in Taos—to stop off and visit with them. Her patroness from the New York salon days had married artist Maurice Sterne and briefly joined him in Taos but had subsequently separated from him and was living with a Taos Indian named Antonio Luhan. In fulfilling these invitations, Mary Austin unknowingly was becoming acquainted with the place where she would settle and spend the rest of her life. But even as a guest, Mary Austin displayed her propensity for being the "fixer"—unsolicitedly solving other people's problems. When she arrived in Taos she found what she described as "more than a little small-town opposition to Mabel and Tony's affair, and the beginning of a cabal against them." In typical fashion, Mary Austin aggressively assumed command. She said, "I advised Mabel to return temporarily to New York, to make a beginning of a divorce, and to make an allowance to Tony's wife. Then I took pains to explain just what it would mean to Taos financially to drive her to abandon it. Things began to move forward and to settle down."[5]

During her visit to northern New Mexico, Mary Austin was engaged by a representative of the Carnegie Americanization Foundation to make a survey of the Hispanic population of Taos County, which she found was approximately the size of the state of Maryland in area. Accompanied by Mabel Dodge Sterne, Gustave Baumann, the artist, and Tony Luhan in a wagon driven by the latter "over winter roads," she completed the survey and prepared the required report. Also during her visit to Taos and Santa Fe she was entertained several times at teas and receptions sponsored by the Cassidys and Hendersons, in Santa Fe, and Mabel Dodge Sterne, in Taos. She also lectured several times on the subject "Relation of Literature to the Southwest," which was rated by local critics as "interesting" and in traditional Austin style "thoroughly presented." A final event of this extended visit to northern New Mexico was join-

ing the Cassidys for a tour of the southwest—Gerald Cassidy sketching, Ina Sizer Cassidy composing poetry, and Mary Austin gathering material for a book she had conceived to be titled *The Land of Journey's Ending.* Her enlarging circle of friends in Santa Fe and Taos urged her to settle there.[6]

Thereafter, for four years Mary Austin cast restlessly about seeking a refuge. Having discarded New York and Carmel, she returned to England in 1922 to try life there, but found the old charm and stimulation absent. She reported that in the course of her lecture tour, audiences were "sitting around me with their tongues hanging out, to hear about the great age of literature that is beginning in America. They wanted to hear something of the kind, life drags so just now in Europe. Indeed I think it likely that young intellectuals over there will resent" cynical American writers "taking away their hope in America."[7]

Finally, after several additional visits to northern New Mexico, Mary Austin decided in 1924 to settle in Santa Fe. She stated that her decision was based on a number of considerations, including the fact that the region consistently afforded the "delight of discovery." And in Santa Fe she noted that "One feels . . . strangely little responsibility for what ought to happen next, accepting the present gladly."

The richness of the natural and social environment was an added inducement for her. She found that the environs of Santa Fe had a landscape "even more attractive than the desert Southwest she already knew, more complex and satisfying aesthetically." She emoted, "there is the irreducible access to the continuity of beauty in the scene, the form and color and infinite variety of the landscape," which "affords that sense of participation in the immense activities of nature that are natural to countries at once open and mountainous. Its contours are noble and dynamic—sharp sky-reaching peaks, alternating with long, level stretches of brooding power." Mary Austin added that she had a penchant for sensing beginnings, the origins of art, culture, and social organization. These provided her "the key to an intensive understanding of the whole pattern of civilized society." Therefore, the Indian and Hispanic presence and rich tradition further embellished the local environment for her.

Mary Austin was fascinated by the pageantry of Indian dance and drama, the Hispanic fiesta, and church ritual. And as a writer she expected that "such an abundance of fresh, workable material of the quality of importance" would enable her to "avoid the effect of labored staleness which overtakes one in older localities." Above all else, she found Santa Fe a charming place to live because of the "simple pleasures inexpensively attained, such as gardening, the collection of folk art, and easy hospitality."[8]

During 1924, Mary Austin rented a house in Santa Fe, purchased a small tract at the foot of Cinco Pintores Hill on Camino del Monte Sol, selected a traditional adobe design, and hired a builder. The completed dwelling, furnished in compatible ethnic interior—Pueblo pottery, Navajo rugs, Hispanic icons, and paintings by local artists—she named *Casa Querida*. Income from literary royalties, several large magazine commissions, and a full lecture schedule assured Mary Austin sufficient funds to pay for the construction and furnishings of *Casa Querida*. Soon after its completion, her brother's daughter, Mary Hunter, came to live with her.

Mary Austin, already an international figure in literature and public affairs, further enhanced her professional status during the ten remaining years of her life that she spent in Santa Fe. Certainly she added much to the life of the colony. Many literati there were awed by her; the leaders—Alice Corbin Henderson, Ina Sizer Cassidy, Witter Bynner, and Spud Johnson (during his occasional residences in Santa Fe)—accepted and related to Mary Austin each in his or her own way. Although Henderson and Cassidy at times were appalled by her air of infallibility and imperious outlook, they indulged her because of their regard for her as an author. Bynner loved her as a friend and disputed her as a poet. Johnson related to her more in a familial sense, affectionately calling her "Aunt Mary" (with Mary Austin's approval).

By this stage in her life, Mary Austin's personality had coalesced into a complicated and eccentric profile; by all measures she had become one of America's most interesting and creative females. Above all else, Mary Austin's "destiny was

self-directed, and her choice self-made." She often despaired that she was regularly faced with the problem of finding her way in a world "densely populated with conformists and conservatives." She held views on all matters of the human condition; certainly on matrimony: marriage she contended "is a doubtful business at best, but I have a notion that any sort of marriage which is not degrading is better than no marriage at all." She was confident to the point of arrogance, a mystic, and a self-contained source of knowledge. A friend explained: "It was not largely from either books or documents that she got her knowledge. She never listened to nobody and nobody could tell her anything." As a mystic she steadily pondered "the world beyond and the world within." Her concentration was so intense that soon after arriving in Santa Fe she warned friends "please don't pay any attention to my actions when you meet me in the morning. I may not see you or speak to you. But it is because I am deep in my work, and when I am I never allow anyone to speak to me. It breaks up the whole day for me, if I do. Please remember this, and don't mind me."[9]

Mary Austin was contemptuous of certain discoveries ascribed to others. She claimed credit for conceiving the psychoanalytical method, but denounced its practice and interpretation by others:

Writing done along the line of Freudian psychoanalysis as practiced in the United States would command about as much respect from me as a horoscope cast by an astrologer. Not because I don't believe in the psychoanalytic method. I am not sure but I invented it. At any rate I was using it for the interpretation of myths as early as 1898, and between 1903 and 1906 I lectured on that method, as applied to art and social prejudice, in Universities and Forums in the West. The differences between my method and Freud's are largely in the approach. I approached along the normal line of psychic development. He approaches from the clinical along the lines of abnormal and neurotic development. He derives his knowledge of primitive life from books written very often by people who got them from other books. I had a long and intimate acquaintance with primitives. Also I have a concept of Mind some 25 years in advance of his. I mean it will be 25 years before psychologists of the Freudian type catch up with me."[10]

In her writing she explained that if she required "a description of a place I have never seen, I go into the subconscious for it, apparently getting nothing. Then a few days later I find myself suddenly supplied with a description, which, so far as I have been able to test it, is in every case reasonably correct. There is no emotion in either of these processes, except when the thing comes, a pale glow of exactly the same thing that accompanies religious ecstacy."[11]

Mary Austin explained her relation to God as "practical and absolute. I can imagine nothing happier than finding out what God wants and doing it. I do not go to God for little things. . . . God differs from the rest of my family in having no faults, so that I am never angry or resentful toward him. I never feel misunderstood nor ashamed before him. I have been unhappy sometimes because of griefs he has visited on me, but eventually come to understand that he could not do otherwise."[12]

She believed writing to be a form of spiritual fulfillment. She denied that a person really wrote, rather "it is the All-Knowing Intelligence that writes through you." And although reared a Methodist, she regularly went into a convent. This she found "absolutely indispensable" both for her literary continuum and spiritual well-being. She explained "I go into retreat for from three to seven days each year, and have spent many months in conventual life both in Rome and England."[13]

A life-long feminist-activist, Mary Austin believed "that women more than men carry the creative fire," but she "actually preferred the society of men, and depended on men for her deepest companionship." One of her favorites was Sinclair Lewis, who visited her several times in Santa Fe. She once confided to him, "I know I'm feminine, damnably feminine, and not ashamed of it, but I'm not ladyish. You can count on me behaving like a gentleman."[14]

In her later years she became obsessed with searching out what she called the American Rhythm, which she defined as life patterns that reveal verities of the human state. During a visit to Mexico she found a graphic model for the collective experience in Diego Rivera's murals. She concluded that her nation had become alienated from the American Rhythm be-

cause its material progress, industrialization, and urbanization had drawn the people from the land. She concluded that the Indian, because of his physical-spiritual attachment to the land, experienced the perfect life rhythm; thus from his experience would come the guidance for restoring the American Rhythm. Witter Bynner agreed that there was an American Rhythm, but denied Mary Austin's position, declaring that the true American Rhythm was paced to the "quick-stepping rhythm" of national existence—factories, automobiles, technology.[15]

Those seeking to understand her often were baffled by the flair of Mary Austin's intellect. Her publishers often debated (not in her presence) whether they were dealing with a "self-deluded crank or an authentic genius." *Commonwealth's* theological editor concluded that Mary Austin was "distinctly mystical in her searchings, even in her contracted searchings of the natural scene and remained evidently, at an insecure position to near, if not quite at, pantheism."[16]

Mary Austin, however, was never so preoccupied with the profound that she disregarded the picayune; commonplace and ordinary matters interested her, too. On occasional recesses from a frenetic schedule of writing, lecturing, and leading causes, she went to her *Casa Querida* kitchen to make jellies, jams, and pickles for friends. It is told around Santa Fe that, on an occasion when she entertained a group of friends at the National Arts Club and found the pie not up to her standards, she wrote the manager suggesting that he give the pastry cook a day off and she would teach him how to make a pie.[17]

After settling in Santa Fe, Mary Austin permitted herself no respite from the near frenzied course she had committed herself to twenty years before—writing books, articles, poetry, and plays; each year fulfilling a taxing schedule of public lectures in all sections of the country, speaking largely on subjects pertaining to the Southwest; resurrecting ethnic arts in northern New Mexico, first Indian, then Hispanic; and working for regional and national causes. Quite early in her residence at Santa Fe, Mary Austin developed a strongly protective attitude toward the ancient city and perennially sought its betterment.

In her poetry Mary Austin stressed environment as the foundation of verse elements. She concluded that there were at least two sources of poetic influence in any given region: first, the landscape—the shape, rhythm, and relief of the land itself; and, second, the racial quality of the people reflected in their response to the land—out of the civic body "the native verse proceeds." Certainly her interpretation of the art of poetic composition and her poetry had a regional fixation—the Southwest. She published verse in *Poetry, Saturday Review of Literature, Literary Digest,* and several anthologies.[18]

Mary Austin's articles ranged from popular presentations of Southwestern culture in *Ladies Home Journal, Collier's, Saturday Evening Post,* and other popular magazines to interpretive essays on literature and literary trends in *Saturday Review of Literature, Literary Digest,* and *Art and Archaeology.* Advocacy of causes and activist polemics she published in *New Republic, The Nation,* and *Survey Graphic.*

During her ten years in Santa Fe, Mary Austin wrote eight books, including *American Rhythm, The Land of Journey's Ending, The Children Sing in the West, Starry Adventure* (her only novel during this time), *Earth Horizon,* and *One-Smoke Stories.* Her most widely acclaimed works were those "of places, of the elemental experiences of people finding out about them, and of their living upon the primary resources they provide."[19]

So environmentally obsessed was she that critics found books like *Starry Adventure* "a novel in which the landscape itself is a spiritual force almost more important than the human beings motivated by it." Mary Austin's autobiography *Earth Horizon* revealed her feelings of "close identification with the spiritual life of the soil." One reviewer said of *Earth Horizon,* "Mary Austin's autobiography is an indescribable book. . . . what it conveys is life as Mary Austin feels it and knows it. Since she is a poet, prophet, mystic, and artist, her vision of life is not the usual one, and is not the accepted one." *Earth Horizon* was in his judgment "the most truly American and most original autobiography extant. It is, as the author says, "a true report. . . . A profoundly original interpretation of the American spirit."[20]

Quite early in her literary career Mary Austin wrote plays, virtually all of them based on American Indian themes. She completed *Coyote Doctor* and *The Arrow Maker* in 1911; a year later, *Fire*. A performance of *The Arrow Maker* in New York during 1911 was rated "highly artistic and successful." *Fire* was first performed at Forest Theater, in Carmel, in 1912. During her extended visit to Santa Fe and Taos in 1919–20, she advised and promoted the community-theater plan in both places with a view to producing her plays. Playwriting continued a primary literary interest throughout her life. Her *Golden Bough* premiered in Santa Fe during the summer of 1935, presented by the Koshare Players, of Las Vegas.[21]

As a professional public speaker Mary Austin was booked by L. J. Alber World Celebrities Lecture Bureau and other agencies. She first became well acquainted with northern New Mexico in 1919 by lecturing at Santa Fe, Taos, and other towns on the subject of "Southwestern Literature and the Common Life." She was particularly popular with audiences in the larger California towns; for several years she made an annual appearance at the Women's University Club, in Los Angeles. She also spoke on college and university campuses in the Eastern United States; she was a favorite at Yale University. During 1926, Mary Austin lectured on the Clark University campus as guest speaker for the Department of Psychology's "Symposium on Psychical Research."[22]

With no visible compunctions she commonly discovered a subject of engaging interest, developed a viewpoint on it, then presumed to speak on the subject as an expert. Thus during 1928 she became very interested in the phenomenon of the gifted child, and presented a series of lectures on that subject; she invited parents to bring child problems to the lectures for discussion. She also developed a rhythm test for children that became a lecture subject. Other lecture topics included "Primitive Drama" and "Genius and the Subconscious Mind." Popular lecture topics for teacher- and librarian-convention programs were "American Fiction and the Pattern of American Life" and "The Southwest — Scene of Coming Culture." During the summer of 1930 she was invited to Mexico City as the guest of

the minister of education to lecture before the Seminar on Latin American Cultural Relations. While there she spoke at the National University on "American Indian Art."[23]

Her efforts to resuscitate ethnic arts in northern New Mexico, first among Indians and later Hispanics, were successful. She had been a leader in the movement to preserve Native American art objects through the Indian Arts Fund. She also worked assiduously to recover and preserve Indian literature and drama and to generate respect and acceptance of it. To accomplish this, Mary Austin collected the published, model Indian stories; published essays on the origin and content of Indian literature and drama; and lectured widely on its rightful place as the genuine indigenous American literature. She explained:

Every one of the pueblos has a long epic account of their creation, tribal wanderings, and the origin of the most important of their ceremonials. It is poetic in form and of high literary quality. The poetic form is not uniform, but varies in particulars that suggests its composition over long periods of time. . . . Ten years ago these various epics were still intact, but there is reason to believe that they are now beginning to decay. Every effort should be made to preserve them. . . . as a common heritage of the American future in which the art of our own aborigines will be valued as the same thing is valued in other countries.[24]

Mary Austin was also largely responsible for the renaissance of Hispanic culture in northern New Mexico through formation of the Spanish Colonial Arts Society that concentrated on Hispanic artifacts, and because of her additional strong interest in their music, dance, literature, and drama. She studied Hispanic folk plays and wrote descriptive and interpretive articles on the origin and historical evolution of *Los Pastores*, *Los Reyes Mayos*, *El Niño Perdido*, and the Our Lady of Guadaloupe pageant. "Spanish-American Drama" was a popular topic for her lecture visits to Yale University. At New Haven she and Alexander Dean and his drama students produced Spanish plays adapted by Mary Austin from presentations she had witnessed at Santa Fe. She declared that "What I am trying to do is to

restore to the Spanish people the opportunity which they once made and we Americans stupidly destroyed. . . . What I am trying to do here at Santa Fe is to reinstate the original *Teatro de Corral*, an open air stage set up in one of the town's little plazas or *placitas*."[25]

Largely through her efforts, there did occur a revival of interest among Hispanics for their music and drama. A Hispanic troupe formed on the University of New Mexico campus, and in 1934 the members went to the National Folk Festival, at Saint Louis, to enact *Pastoreles* and present a concert of Spanish-American music, which were "well received."[26]

Mary Austin's interest in Hispanic music was well established before she became acquainted with northern New Mexico, but visits there heightened it. She began collecting Penitente tunes during her visit of 1919. Leandro Alvarez, of the Santa Fe band, did some of the transcriptions for her. She explained to writer-critic Louis Untermeyer: "The Penitente hymns . . . are authentically American as the Negro Spirituals, although their music is far inferior; just as Indian and even Spanish folk music are inferior in emotional content and even melodic range to the spirituals. This is because the Negro gains immensely in not having to fit his religious expression into a tight little mythology such as the Roman Catholic religion of the sixteenth and seventeenth centuries." By 1930, Mary Austin could claim with some justifiable pride in achievement that "The Spanish speaking group here is emerging after a long foggy period of Americanization with something of the force and freshness which we discover in Mexico since the Revolution."[27]

Mary Austin's literary life was interrupted from time to time by her involvement in causes. One of her earliest ventures into attempted social change concerned woman's suffrage. She explained in 1911 when that movement ignited the women of California that "I have been traveling in my own country and Europe for the past three or four years, and from being indifferent to Woman's Suffrage have become one of its ardent advocates. I should like to use such influence as my name may have for the cause in California in the way to make it count the most." Soon she joined the National American Woman's

Suffrage Association and served as its director of publicity and lecturer. She wrote pamphlets promoting suffrage for women in Nevada and other states; "she planned the pageant of the National Woman's Party on the east steps of the Capitol for the reception of the suffrage envoys from the West by members of the Senate and House in 1916." And she played a principal role in the suffrage convention of 1916, in Atlantic City. By this time she had become an intensely dedicated feminist "wanting women to have equal rights as women and not as 'imitation men.'"[28]

Mary Austin was instinctively suspicious of most American politicians and doubted their competency to guard the traditional rights of citizens, including freedom of expression, and she was ever vigilant for threats of censorship. Thus she worked with Senator Bronson Cutting, of New Mexico, to attempt to defeat a bill in the Congress delegating to agents in the Bureau of Customs authority to exclude books, pamphlets, and works of art into the United States that they deemed to be obscene. Mary Austin also held reservations about democracy. When John Galsworthy visited her in Santa Fe, he asked her what she thought about democracy. She answered, "I did not find it a success, but that I was glad to have been a part of it, as an experiment."[29]

Always the environmentalist, she felt a strong sense of mission to guard the Southwest's natural-social milieu from the juggernaut of Anglo-American progress. Her interest and influence in regional resource conservation was responsible for New Mexican officials in 1927 appointing her to the Seven State Conference on Colorado River Basin Development (which eventually led to construction of Boulder Dam). In her debates with delegates she affirmed that the Colorado River was a "national asset," and had implications of importance not only for the basin's member states but comprised an international issue, too, because Mexico had to be considered. Drawing on her early experience in California's Owens Valley, where Los Angeles interests appropriated the region's water for urban use, she flatly stated that California—particularly Los Angeles—was a menace to the region; Mary Austin pointed to the fact that

California contributed nothing to the flow of the Colorado but sought to take perhaps as much as one-half of the water available in the proposed impoundment, to the permanent disadvantage of the other basin member states. Her position of "fighting for the cultural future" of the Colorado Basin while her opponents were committed to the "economic present" became so difficult that she withdrew from the conference.[30]

Other causes attracting Mary Austin's attention included her opposition to attempts to introduce the Spanish American bullfight into the Southwest. She imperiously stated that it was "incongruous" and "has no place in the national experience." She spoke out against American womanhood's growing obsession with slimness. She, of figure heavy, even obese lines, claimed the "attempt to look young" indicated one's "refusal to grow up." And she lamented "there's no room for fat ladies."[31]

For several years Mary Austin urged federal officials to establish a national department of arts and letters (an antecedent for the present National Endowment for the Arts and Humanities). She conceived a plan for the agency and its mission that she circulated among government officials, pointing out that such a national program of aesthetic-resource mobilization would turn persons of creative ability from spending their time "struggling for place and honor among themselves" to "developing art of the people."[32]

Mary Austin's leadership in the cause for preserving Indian and Hispanic art and culture included restoration of extant structures of historical significance in northern New Mexico. The most important of these was the *Sancturario*, at Chimayo, which she declared was "the inalienable possession of descendants of Spanish pioneers." For centuries a sacred place to natives for worship and miracle healing, by the 1920s it was falling into disrepair, its religious fixtures vandalized, and title to the land and building in question. Joining Frank Applegate the anthropologist-writer and John Gaw Meem, the architect and president of the Society for Preservation and Restoration of New Mexico Mission Churches, she prepared to retrieve the *Sancturario* from threatened ruin. Meem provided professional direction for reconstruction, Applegate cleared the property's

title, and Mary Austin raised $5,000 from friends in the Eastern United States to pay the restoration expenses.[33]

Of all her causes, Mary Austin was most devoted to Indian welfare. She joined Santa Fe– and Taos-colony members to rally national support for defeat of the infamous Bursum Bill that would have deprived the Pueblos of vast tracts of agricultural and grazing land. And she contested Commissioner of Indian Affairs Charles H. Burke's order banning dances among the Pueblos. During 1923, Commissioner Burke, braced by missionaries, concluded Pueblo rites were "useless and harmful performances," and forbade "gatherings of any kind that take the time of the Indians for many days." Mary Austin was recovering from an illness at the time and read of Burke's action in the *New York Times;* that editor commented: "If religious liberty in the United States applies to everybody but the Indian" then Commissioner Burke "adds another disgraceful chapter to the history of Indian affairs in this country. Commissioner Burke might better leave the Indian ceremonial dances alone and philosophize a bit on the influence of the fox trot." Mary Austin's reaction was a strong letter to Burke accusing him of referring to Indians as "half animals," of interfering with "religious freedom of the Pueblos" and suggested that he was guilty of "suppression of native religious faith." The pressure that she and other members of the community brought to bear on federal officials forced Burke to relax his order banning Pueblo religious observances.[34]

To guard against further bureaucratic suppression of Indian culture, Mary Austin urged that Congress adopt laws guarding Native American rights. She stated that the "Protestant missionary has always insisted that Indian drama, Indian dance, Indian music, Indian poetry, Indian design, must be totally destroyed and their place filled with third rate expressions of these things, pieced together from various cultures of our European past. . . . Missionaries have taught young Indians that the religion of their parents was not only contemptible but ridiculous." She also worked for federal legislation to enlarge the place of Indian arts and crafts in the federal Indian-school curriculum, to set standards of quality for Indian products, and

to provide marketing facilities for them. Her reputation as a guardian of Indian culture and welfare led during 1930 to her appointment by the Mexican government as a consultant on that nation's effort to restore "its Indian arts and culture."[35]

In Santa Fe, Mary Austin became a veritable eye of the hurricane for local causes. She promoted the local public library and community theater, the preservation of the Santa Fe ambience against intruding "progress," and fought and defeated an attempt by Edgar Hewett and other civic promoters to establish an annual national chautauqua (a sort of popular culture center) in Santa Fe. With Frank Applegate she worked for introduction of art in the local public-school system. She also sought to improve instruction in Spanish language in the public schools of New Mexico. She enlisted the support of J. F. Zimmerman, president of the University of New Mexico, for this cause. In her appeal for university sanction of this attempt at curricular improvement, she explained "There is no question that the local school system needs improvement. . . . Once Spanish speaking New Mexico produced interesting and vital literature of its own. Public speaking was an art and the common people composed songs and poems of genuine literary merit. But in the struggle to acquire an English vocabulary, this literary expressiveness has been completely lost." Witter Bynner and she had worked with Hispanics in Santa Fe in language experiments and found that under the Anglo-dominated curriculum "not only had they not acquired an expressive vocabulary in English but the expressiveness had all been lost in their remaining Spanish vocabulary." A neighbor of Mary Austin's in Santa Fe has said: "Her courage in fighting for lost causes and local issues of various kinds was fabulous and partisan to the point of frenzy."[36]

The year 1934 was a difficult, terminal time for Mary Austin. Several chronic illnesses intensified and forced her reluctantly to a *Casa Querida* bed. Even there she continued writing and directing enterprises through friends. She petulantly referred to herself as "woman alone" and she admitted that she was contrary, headstrong (some called her "mulish"), imperious, and opinionated. Thus, she found it difficult to understand the devoted attention she received from admirers, even

when bedfast. She wrote that friends came for her with their automobiles and "nobody is put out if I am sick when I go about, not even the young men. If there is a party somewhere, I am taken along. It is expected that I will talk about whatever is in my mind."[37]

Mary Austin died on August 13, 1934. Earlier she had placed a mark on a creviced rock on Picacho Peak, situated east of her home in the foothills of the Sangre de Cristo Mountains. Her ashes were placed in the crevice and covered with cement. She had assigned most of her estate to one of her most cherished successes—the Indian Arts Fund.[38]

Tributes acknowledged Mary Austin's thirty-four books and many causes. Joseph Conrad and H. G. Wells declared her to be "among the most important writers" of her time. She was called the "Oracle of Santa Fe and Prophet-at-Large to America," and a person whose presence "created a stir in people." Carl Van Doren praised Mary Austin's writings as issuing "out of deep reflection, and from something even deeper than reflection, the unconscious instincts of the individual and the memories of the race." He added that she must be known as the "Master of the American Environment," whose books are like "wells driven into America to bring up water for her countrymen." William Allen White said of Mary Austin, she had a "tough-fibered brain, was vainer than a wilderness of gargantuan peacocks," and was "a strong, overbearing woman," and he and his wife "loved her and took her to their hearts." He rated her *A Woman of Genius* "one of the great American novels," and he recalled "always we left her presence feeling that our minds and hearts had been kindled with new energy and refreshment."[39]

Mary Austin's epitaph might well state:

I have seen that the American achievement is made up of two splendors: the splendor of individual relationships of power, the power to make and do rather than merely to possess, the aristocracy of creativeness; and that other splendor of realizing that in the deepest layers of ourselves we are incurably collective. . . . It is not that we work upon the Cosmos, but it works in us. I . . . rejoice that I have felt so much. As much as I am able, I celebrate the Earth Horizon.[40]

CUNDIYO

As I came down from Cundiyo,
Upon the road to Chimayo
I met three women walking;
Each held a sorrow to her breast,
And one of them a small cross pressed—
Three black-shawled women walking.

—ALICE CORBIN HENDERSON

12 / MABEL DODGE LUHAN: TAOS SALON-KEEPER

MABEL Ganson Evans Dodge Sterne Luhan, compulsive culture carrier and Taos-colony pioneer, was born at Buffalo, New York, in 1879, into the Ganson banking family. She inherited a fortune that she applied to gracious living and cultivation of the arts. Her first marriage yielded a son, John Evans, Jr., who later became a novelist. John Evans senior was killed in a hunting accident. With her second husband, Edwin Dodge, a Boston architect, she resided first in Paris then near Florence in a luxurious villa where she regularly entertained Eleonora Duse, Gertrude and Leo Stein, Alice Toklas, Pablo Picasso, Henry Matisse, Gordon Craig, and other aesthetes.[1]

In 1912, Mabel Dodge returned to New York, divorced Dodge, and established a residence at 23 Fifth Avenue that became a haven for intellectuals, artists, writers, and activists— a sort of salon; Mabel Dodge soon was known as the "American Madame de Staël." Here "society and anarchists rubbed elbows," and "the 'Nude Descending a Staircase' made her first appearance." In the residence's "stately drawing rooms Gertrude Stein began her writing, and Henry Matisse exhibited his paintings to America. . . . everyone who was interesting and had ideas gathered and talked. Every side of every question was

welcome and heard," and Isadora Duncan titillated the habitués with exotic dance. Mabel Dodge "had money and served excellent suppers. Art and aristocracy asked no more." Lincoln Steffens judged the happenings at Mabel Dodge's place as "the only successful salon I have ever seen in America."[2]

By her own declaration, Mabel Dodge rated each man by the sexual prowess he could demonstrate to her. In New York she successively gave Andrew Dasburg, the impressionist painter; John Reed, the revolutionist; and Maurice Sterne, the cubist painter, a trial. She married Sterne but periodically he fled from her, claiming that he felt that his matrimonial mission was that of a bull, that her erotic demands robbed his potency and suffocated his ability to create. On one desperate occasion he followed the suggestion of a friend that he seek the isolation of northern New Mexico where the serene lifestyle of Pueblo Indians might awaken in him the same sort of "creative outburst" he had recently experienced in Bali. Sterne reached Santa Fe during 1917 and visited the Rio Grande Pueblos on sketching trips.[3]

For some time Mabel Dodge had been restless. Expecting great things from her return to the United States, she had been disappointed. The weekly gatherings at 23 Fifth Avenue provided only momentary relief from the mounting boredom. And she was unable to derive any sustained satisfaction from her several liaisons. She bitterly admitted to her writer-critic friend Carl Van Vechten that "The melodramatic element in my life is getting very attenuated." Life here is "effete" and is a "striving and a striving and ending in nothing." Desperately seeking a place that might galvanize her flagging spirit, she decided to join Sterne in Santa Fe. Mabel Dodge arrived in Santa Fe in late December, 1917. After a short stay there she found the place crowded and undesirable and at her insistence they moved on to Taos.[4]

If Santa Fe was "the strangest American town" she had ever seen, Taos was even more so—smaller, more primitive, and haunting in its mystery. She withheld judgment on the place for a few days. Then she attended a public rite in the Taos Pueblo plaza. Mabel Dodge claimed that witnessing it

committed her to a life of residence at Taos to be near the transforming force that seemed to emanate from the Pueblo. She recalled that memorable day:

I heard the singing and drumming as soon as we reached the Pueblo, and it drew me strongly and I left the others and ran hurriedly towards it with my heart beating. . . . all of a sudden I was brought up against the Tribe, where a different instinct ruled, where a different knowledge gave a different power from any I had known, and where virtue lay in wholeness instead of in dismemberment. So when I heard that great Indian chorus singing for the first time, I felt a strong new life was present there enfolding me.[5]

Mabel Dodge's restless spirit was soothed by what others called "the Taos way," a potent, regenerative aura that loomed over the valley. She quickly became much attracted to northern New Mexico's natural beauty, but its social environment, particularly the Indian presence and his mystique—the indefinable conviction that he possessed vital life secrets—mesmerized her; she consciously sought to discover them and apply them to her own life.

Soon after arriving at Taos, Mabel Dodge first rented quarters in the Manby house. The United States had just entered the war against Germany. She had brought a German cook out from New York; her husband was Russian; and a stream of foreign-appearing guests visited her at Manby house. Thus townsfolk began to suspect that the wealthy woman from New York had formed a nest of spies in their midst. And her daily visits to the Pueblo to teach the women to knit was regarded as a move to incite the Indians. From that time on, for forty-five years, Mabel Dodge was a rich source of gossip for the town.[6]

Mabel Dodge purchased land near Taos Pueblo and had workmen construct a large residence, modeled after the Pueblo, and surrounded by adobe cottages for visitors. In this compound she lived until her death in 1962 in "simple but feudal comfort." Mary Austin, Mabel Dodge's iron-willed friend and mentor, had admonished her not to permit the place to become

a sort of dude ranch. She assured Mary Austin that she was maintaining her residence as a "creative center; not just a place for people to retreat into, or to go to sleep in, or to barge in for just a good time. I want people to use it freely but for creative purposes."[7]

During her visits to Taos Pueblo, Mabel Dodge met Antonio Luhan, a bronzed, handsome Taos Indian giant. That he was married and the father of several children were of no concern to Mabel Dodge. The strong feeling she harbored for him led her to drive Maurice Sterne away and to lure Tony Luhan into her compound. Later during a visit to Taos, Mary Austin observed the civic rancor Mabel Dodge had brought on herself by this blatant familial larceny, and took charge. She pointed out to town leaders the economic loss all would suffer if they drove Mabel Dodge away. Then she directed Mabel Dodge to divorce Sterne, pay Tony Luhan's wife a settlement, and, if her relationship with Tony Luhan persisted, to marry him. This Mabel Dodge did in 1923. She announced to Mary Austin, "everybody has been very pleased about it here. Tony and I are happier and feel very good about it." The pair was accompanied by Andrew Dasburg, Mabel Dodge's former lover, as a witness to the ceremony. Tony Luhan remained Mabel Dodge's mate to her death. She had found the man who, in quiet power, could if not dominate, at least satisfy her. And she claimed that she drew from him renewed will and creative force that fired her great energies to new enterprises, including writing.[8]

Mabel Dodge Luhan worked in the writing of seven books and scores of articles around a frenetic outpouring of involvement in other pursuits—serving as a leader of Taos colony, mounting civic and social causes, traveling with her Taos Indian husband, and drawing notables to Taos to embellish the colony and perform in the salon she maintained on an irregular basis in her compound. Her books—*Winter in Taos; Taos and Its Artists; Lorenzo in Taos;* and *Intimate Memories*, a four-volume autobiography (*Background, European Experiences, Movers and Shakers,* and *Edge of Taos Desert*)—confirm her "view of literature." She once commented:

I am interested in human documents. I don't care for . . . "literary" books. I like honest, self-observant, autobiography. I dislike false, common . . . ones. I am interested in any attempt to add to consciousness and dislike anything that seems to delay or obstruct that tendency. . . . I do not really like what we call civilization. . . . I believe the race to which I belong is disintegrating with ever-increasing momentum, and I believe the future of these continents lies in the fate of the Indian Americans.

Taos-colony elder-statesman Ernest Blumenschein said of Mabel Dodge Luhan as a writer that in her first book *Intimate Memories* she presented herself "frankly . . . as God made her." In later books "she shows signs of mellowing with richer art and deeper feeling."[9]

What manner of woman was this "modern Madame Récamiere" as she was sometimes called in Taos? Contemporaries have described Mabel Dodge Luhan as a "short vigorous person as restless as a flea" with flashing, intelligent, curious eyes, a dark, strong face, and gradually thickening figure; a woman of "considerable ego," who "operated always on her own terms," and who "was always in command." Blumenschein held a sort of twisted respect for Mabel Dodge Luhan but scorned her for her dominating, domineering ways. He pegged her as "a woman of means who buys whatever she desires. If she sees a husband better than the one she has, she buys him. . . . Her chief occupations, besides writing, seem to be building houses and upsetting plans." Among the Indians and Hispanics of Taos she was known as "The woman who married an Indian," and "the woman who wrote a book about [D. H.] Lawrence."[10]

Some colony members defended her. For a time D. H. Lawrence lived in the Mabel Dodge Luhan compound, then in a fit of pique moved to a mountain ranch nearby, and, reportedly out of spite over differences with her, he intended to write a "wicked book" about her. Bert Phillips, the pioneer founder of Taos colony, learned of this and sent word to Lawrence that if he wrote "a wicked book about an American woman whose hospitality he had accepted and taken advantage of, that a selected bunch from Taos would proceed up the mountain

and horsewhip him!" The local doctor reported that was why Lawrence moved rather quickly to Mexico.[11]

If Antonio Luhan was the one man who could satisfy her, Mary Austin was the one person who could dominate her. She showed unrestrained respect and affection for Mary Austin, and would generally do as the great environmentalist bade her do. Mary Austin recalled in her autobiography, *Earth Horizon*, that

while there is practically no likeness between Mabel and me, very little consenting approval, there is the ground work of an intelligent approach to problems of reality, and a genuine affection. There is about Tony a warm stability of temperament which makes him an acceptable third to all our intercourse, so that I count among the unforgettable experiences of New Mexico the journeys we have taken, journeys of exploration and recollection, laying ourselves open to the beauty, the mystery, and charm of New Mexico.[12]

That Mabel Dodge Luhan was a leader in the Taos colony and came to dominate it cannot be gainsaid. Her many projects for Taos provided regular employment for natives, and "spending her money freely" there was "a benefit to both Indians and white businessmen of Taos." She enlarged the colony's membership, both summer and permanent residents, by drawing on her wide range of acquaintances to recruit writers, painters, and musicians to the "exhilerating essence" of northern New Mexico. Even the fragile writer-critic Carl Van Vechten did not escape her summons; in 1920 she urged that he "come before its too late, and before its discovered, for it's going to get discovered. . . . Here the air is so keen that everything is stronger than anywhere else. . . . Here you see no silk stockings, but wool, wool, wool, wool!"[13]

Mabel Dodge Luhan participated in local and national causes. One of Taos's most critical needs was a health-care facility; she provided money for the purchase of the land and the construction and equipping of the Taos hospital. She generously supported local charity and welfare activities, and civic-improvement campaigns, such as the preservation of original Taos buildings and guarding the town against the march of

Anglo progress. For many years most of the books added to the Taos Public Library in the Harwood Foundation Building were purchased by her. While not an activist in the Mary Austin mold, she did have a broadly based consciousness—witness her view on the national condition expressed to Leo Stein: "The whole ghastly social structure under which we are buried . . . must be torn down, exposed, so those who follow us will have peace and freedom to make a different one."[14]

From her first days in Taos, Mabel Dodge Luhan supported Indian causes. It was her belief that "what is considered 'progress' by Americans means annihilation for Indians." Indian causes seemed to require continuing attention because of unremitting pressure by predacious business and agricultural interests on Indians for their lands, resources, and water, and bureaucrats regularly changing federal Indian policy to favor business interests to the detriment of Native Americans. Mabel Dodge Luhan provided money, influence, and time for Indian causes. She supported the campaign to defeat the Bursum Bill, defended and helped win the Indian's right to worship and dance in the traditional way, and she regularly traveled to Washington to appear before congressional committees studying Indian affairs. John Collier, a reformer who had attended her New York salon sessions, was a frequent guest in her Taos compound. During 1923 he formed the American Indian Defense Association (AIDA) and, until 1933 when he became Commissioner of Indian Affairs, served as its executive secretary. AIDA strategy sessions often were held in Taos at Mabel Dodge Luhan's place.[15]

Mabel and Tony Luhan spent the months of November, December, and January away from the blue winter cold of alpine Taos. She owned a country estate, Finney Farm, at Croton-on-Hudson, New York, where they occasionally wintered. Also they spent a winter now and then in San Francisco, Phoenix, or at Alcalde and other New Mexican towns situated at a lower altitude along the Rio Grande. She said this was always "good for a change" and she recommended it for "jaded Taos nerves."[16]

During the winter of 1939, Mabel Dodge Luhan returned to New York for prolonged treatment of a sinus condition.

While there her son John Evans, the novelist, persuaded her to restore the Gotham salon. She obliged at One Fifth Avenue, a "swank Greenwich Village tower." A *Time* writer recalled that in the old days she had been able to "startle, delight and dumfound the town"; she had "caught men between the eyes, held them magnetized, fascinated, charmed, as men will be by the allure of a woman's lively calling essence." Mabel Dodge Luhan hoped to capture the bloom of provocative evenings past, her guests—Roger Baldwin, civil libertarian; Thornton Wilder, novelist-playwright; A. B. Brill, psychiatrist; and John Collier, reformer—augured success. New York, however, had changed; the radiance she had known was gone. Mabel Dodge Luhan acknowledged defeat, emoted nostalgically for Taos, and commented, "The rumble of New York came back to me like the impotent and despairing protest of a race that has gone wrong and is caught in a trap."[17]

It was said that Mabel Dodge Luhan "collected people and arranged them like flowers." Some came at her bidding as visitors for a week or so, others came to stay for a season, some for several years, and a few for a lifetime. Throughout the 1930s, Robinson Jeffers, one of America's great twentieth-century poets, left his home in charming Carmel for summers in Taos as Mabel Dodge Luhan's guest. His explanation was, "Really, everything in New Mexico is more or less fantastic," and "here at Mabel Luhan's strange guests come and go from day to day." Celebrities who visited Mabel Dodge Luhan in Taos included symphony conductor Leopold Stokowski, novelist-playwright Thornton Wilder, stage designer Robert Edmond Jones, painter Georgia O'Keeffe, author Mary Austin, critics Carl Van Vechten and Leo Stein, and reformer John Collier. Watching the annual summer coming and going at the Mabel Dodge Luhan compound, "the rendezvous of bizarre and interesting people the world over," became a popular entertainment for the people of Taos.[18]

Certainly Mabel Dodge Luhan's most famous recruit for Taos was the English novelist D. H. Lawrence. His avant-garde writings on the human condition, particularly sex, his glowering protest to the late war, and his choleric confrontation of

British society led officials to ban several of his books from Great Britain. An enraged Lawrence with his wife Frieda chose a self-imposed exile to Italy. Avid reader Mabel Dodge Luhan came upon his *Sea and Sardinia*, published in 1921, and at once committed herself to "seducing his spirit" and enticing him to Taos to apply his singular interpretive powers to the northern New Mexican milieu. She maintained a year-long pressure on Lawrence, following him with letters and cables as he moved about from Italy to Capri, Sicily, Ceylon, then to Australia. Finally Lawrence assented to visit Taos. During September, 1922, he and his wife proceeded to San Francisco, where they were handed, compliments of Mabel Dodge Luhan, railway tickets for travel to New Mexico. Mabel and Tony Luhan met the Lawrences at Lamy and drove the British author and his wife to Santa Fe for an overnight stay with Witter Bynner before proceeding to Taos.

Mabel Dodge Luhan's first impression of Lawrence was that of a spindling, hesitant male dominated by an aggressively voluptuous female. She concluded that Frieda Lawrence "was the mother of the orgasm and of the vast, lively mystery of the flesh. But no more. Frieda was complete, but limited. Lawrence, tied to her, was incomplete and limited. Like a lively lamb tied to a solid stake, he frisked and pulled in an agony." She determined to liberate Lawrence from Frieda's suffocating embrace so that he could collaborate with her on a book about New Mexico; he also had shown some interest in writing a book about Mabel Dodge Luhan's life.[19]

They did work together in the compound for a few weeks, but Frieda's jealous fits made serious writing impossible. And it seemed that, as Frieda badgered Lawrence, he increasingly turned on their hostess with the result that Mabel Dodge Luhan had to deal with the neurotic outbursts of both. Finally Lawrence and Frieda moved to a ranch northwest of Taos where he believed the quiet would permit him to resume writing. Mabel Dodge Luhan wrote Van Vechten that she felt a deep sense of relief when they left, but she was concerned that Lawrence might punish her by assigning her a demeaning role in one of his books, as he had several of his former British friends. She

concluded, "D. H. is absolutely a 'mal hombre' as they say here and would do the worst. Completely unreliable and un-principled. He has tried to destroy every friend he ever had in his books. This is his aim."[20]

In the spring of 1923 the Lawrences left Taos for Mexico, where they were joined by Witter Bynner and Spud Johnson, both of whom had established a friendship with Lawrence. From Mexico, Lawrence and his wife proceeded to England. For a time he was intensely interested in establishing a colony in northern New Mexico populated largely by friends and ac-quaintances in England. Only one person, the painter Dorothy Brett, agreed to accompany Lawrence and Frieda on their return to New Mexico. During March, 1924, the three arrived in Taos. Old differences had been set aside, they were well received by Mabel Dodge Luhan, and the Lawrences and Brett settled in Mabel Dodge Luhan's compound, busily painting and writing each day. In no time at all, however, Mabel Dodge Luhan, Frieda Lawrence, and Dorothy Brett became involved in a bitter triangular contest for Lawrence's favor and attention. He de-spaired of finding peace in the compound and, desperate for a quiet place to write, asked Mabel Dodge Luhan for permission to move to Flying Heart Ranch, one of her properties situated seventeen miles northwest of Taos on Lobo Mountain. She offered the 166-acre ranch with several log cabins on it as a gift. Lawrence refused, then she offered it to Frieda who ac-cepted and, in return, gave Mabel Dodge Luhan the manuscript for one of Lawrence's books—*Sons and Lovers*. The Lawrences changed the name of the property to Kiowa Ranch, and con-verted three of the cabins into clean, comfortable dwellings— one for the Lawrences, one for Brett, one for Mabel Dodge Luhan, and the fourth they converted into a stable for Law-rence's cow Susan.[21]

Mabel Dodge Luhan visited the Lawrences frequently and before long the familiar conflicts—largely a three-cornered women's battle over Lawrence—tore them apart. Lawrence, egged on by Frieda, ungraciously joined the attack on their benefactor. Because he had not fulfilled the role she had cast for him—to write "the book" explaining northern New Mexico

to the world—Mabel Dodge Luhan denounced Lawrence as "a dismal failure as a writer. . . . He is such a mass of intertwined complexes as to be impossible to handle. We had a violent meeting and a violent sundering. . . . Frieda . . . is obtuse, retrograde, stupid spiritually and definitely hostile to anything spiritual. Lawrence has summed her up this way himself. Yet he is completely under her domination—and his life is ruled by her will."[22]

Finally, in the autumn of 1924, Lawrence, Frieda, and Brett closed up the ranch and went to Mexico, where he worked on the novel *Plumed Serpent*. Mabel Dodge Luhan explained their exile to Alfred Stieglitz, the art impresario, photographer, and husband of painter Georgia O'Keeffe:

I have had another break with Lorenzo. I finally couldn't stand his meanness and untrustworthiness any more and wrote him when he went to Mexico in October that he was *too* treacherous and unreliable, that he couldn't keep a friend when he once, finally, made one. . . . He's too dualistic. . . . He is very lovable and attractive when he *is* good —but really *too* horrid when he is bad. . . . He's too *damn* mean. . . . He has satisfied his sadism in a story called "The Woman who Rode Away." . . . It was about a white woman whom he makes sacrifice herself voluntarily to the Indians who finally cut out her heart in that cave above Arroyo Seco. And so they took back the power that passes from race to race and that man must always keep! But—as in dreams—he disguises my dark eyes in blue ones.[23]

The following spring the Lawrences and Brett returned to New Mexico, spent the summer at Kiowa Ranch, then toward the end of September, 1925, they left for Europe. By this time Lawrence was suffering from advanced tuberculosis. Distance cooled the heat of controversy between Mabel Dodge Luhan and Lawrence and they corresponded regularly. He showed genuine interest in her writing and provided criticism for manuscripts she sent to him. He could not shake the draw of Taos and each spring declared his intention to return to Kiowa Ranch, but his weakened state made travel to the States impossible. After his death in 1930, Mabel Dodge Luhan had to contend with his continuing influence at Taos through the presence of

Frieda Lawrence and Dorothy Brett, both of whom settled there permanently.[24]

With all of their bitter surface controversy, an indissoluble bond had been maintained between D. H. Lawrence and Mabel Dodge Luhan. Their relationship had mellowed with time and geographical separation. Certainly the emotional high he produced in her life diminished after his death, but never again was she able to rise to that level of exultation in companionship with an intellectual peer that had been her experience with Lawrence. During the late 1930s she felt increasingly alienated from the colony, and she became a near-recluse during the months each year that she spent in Taos. This disenchantment she shared with Brett: "I have given up going to the village unless I can't help it. Such a harried population accumulating here. Very low grade whites and awful looking. I don't know where they spring from." It is said that "there is a very strange melancholy pervading the village, that all the storekeepers, etc. are in a kind of doldrums. . . . I prefer to stay away from the town since I cannot see any way to help it."[25]

UNTITLED

Give me the moon at my feet
Put my feet upon the crescent, like a Lord!
O let my ankles be bathed in moonlight,
that I may go
Sure and moon-shod, cool and bright-footed
toward my goal.
For the sun is hostile, now his face
is like the red lion.

—D. H. LAWRENCE

13 / D. H. LAWRENCE AND RANANIM

JOINING Mary Austin and Mabel Dodge Luhan in the upper galaxy of writers in the Santa Fe–Taos colonies was D. H. Lawrence. Born September 11, 1885, at Eastwood, England, the son of a coal miner, David Herbert Lawrence attended lower local schools, studied at Nottingham University College, then was appointed teacher at Croydon. One of his instructors at Nottingham University College, Ernest Weekly, invited him to lunch at his home during April, 1912; Lawrence at once was smitten with Professor Weekley's German wife Frieda, a daughter of Baron Friedrich von Richthofen. The following month the lovers slipped away to Germany then Italy, and after a two-year delay her divorce from Weekley was completed and Lawrence and she were married.

During World War I the Lawrences lived in England in a state of virtual house arrest. Lawrence regarded war among nations as the most despicable form of public conduct and bitterly opposed England's participation in the conflict. Physically unfit (chronic bronchial congestion) for military service and an

avowed pacifist and outspoken war critic married to a German, Lawrence became a special source of surveillance by police and military intelligence agents. Both Lawrence and Frieda were suspected of being German spies and officials forced the couple to move from the seacoast where, it was claimed, they sent signals to German submarines surfacing near their beach, to a location where police could more easily watch them. Lawrence and Frieda lived on the threshold of poverty throughout the war; his novels *White Peacock*, *The Intruder*, and *Sons and Lovers* were not selling well, and the recently published *The Rainbow* had been seized and banned by British officials as "indecent." This further alienated Lawrence and increased his determination to exile himself from "meddlesome England," a society he claimed was corrupted by war-mongering industrialism. After the war, for a time Lawrence and Frieda restlessly moved about southern Europe, first to Italy, then Sicily, and on to Capri.

Lawrence dreamed of a place where he might establish a utopian colony surrounded by stimulating, interesting associates free of strident twentieth-century progress, supporting themselves by productive work in a simplistic and thus creative life-style. He called his contemplated refuge Rananim, from the Twenty-third Psalm suggesting "Rejoice!" but which Lawrence converted to mean "Colony of Lost Souls." For a time he thought that the place to establish Rananim might be the United States, perhaps in Florida. From Taormina during January, 1922, he wrote his publisher Thomas Seltzer: "I am tired of Europe — really tired to my bones. There seems to be no getting any forwarder. What I want in America is a sense of the future, and be damned to the exploited past. I believe in America one can catch up some kind of emotional impetus from the aboriginal Indians and from the aboriginal air and land, that will carry one over this crisis of the world's soul depression [World War I] into a new epoch."[1]

Mabel Dodge's letters and cables inviting Lawrence to Taos finally broke his indecisive drift; Frieda and he took passage to the United States by way of Ceylon and Australia early in 1922.

His first day in northern New Mexico, as a guest in Witter Bynner's Santa Fe home, for him was a time of galvanizing awe, of exultant revelation:

The moment I saw the brilliant, proud morning shine high up over the deserts of Santa Fe, something stood still in my soul. . . . so different from the equally pure, equally pristine and lovely morning of Australia which is so soft, so utterly pure. . . . in the lovely morning of Australia one went into a dream. In the magnificent fierce morning of New Mexico one sprang awake, a new part of the soul woke up suddenly, and the old world gave way to a new. There are all kinds of beauty in the world, thank God. . . . But for a *greatness* of beauty I have never experienced anything like New Mexico. . . . It is curious that the land which has produced modern political democracy at its highest pitch should give one the greatest sense of overweening, terrible proudness and mercilessness; but God! how beautiful.

And when he reached Taos he emoted, "I think the skyline of Taos the most beautiful of all I have ever seen in my travels round the world." He added that he was "quite overwhelmed. . . . It is high up, 7,000 feet, and I am just feeling a bit dizzy and sleepy, and feel as if my own self were trailing after me like a trail of smoke."[2]

If the natural environment transfixed Lawrence, certain features of the local social environment, in particular the Mabel Dodge compound, threatened him. Following their arrival in Taos during September, 1922, their hostess quartered them in what Lawrence described as a

very smart adobe cottage . . . built in the native style. It is just one story high, has four rooms and a kitchen, and is furnished with a good deal of "taste" in simple Indian or home-made furniture and Mexican or Navajo rugs; nice. The drawback of course living under the wing of the "padrona." She is generous and nice—but still I don't feel free. I can't breathe my own air and go my own little way. What you dislike in America seems to me really dislikeable; everybody seems to be trying to enforce his, or her, *will*, and trying to see how much the other person or persons will let themselves be overcome. Of course the *will* is benevolent, kind, and all that, but none the less it is other people's will being put on me and like a pressure. . . . and I despise it. People must be very insufficient and weak, wanting, inside themselves, if they find it necessary to stress themselves on every occasion.[3]

After a few days in the compound, tensions began to build between Mabel Dodge and Frieda, precipitated by Mabel Dodge's attempts to spend time alone with Lawrence ostensibly to help him fulfill the writing mission she had conceived for him—to write the ultimate interpretive work about northern New Mexico, and perhaps do a book about herself. Frieda's jealous rages Mabel Dodge answered in kind; she denied that she found any physical attraction in Lawrence, but she still felt compelled to have a physical relationship with him because in her view, "the body is the gateway to the soul." When she informed Frieda that she was not the right woman for Lawrence, Frieda scornfully invited her to try to win him, then "Try . . . living with a genius, see what it is like and how easy it is, take him if you can."[4]

Inevitably Lawrence was drawn into the contest and he obediently took his wife's side, although he did have a sense of fairness and occasionally attempted to quiet the contest for his favors by conciliation. Increasingly frequent encounters and escalating din and fury, however, made it impossible for him to write, and he sought a place to flee to. Mabel Dodge had purchased a small ranch on Lobo Mountain situated seventeen miles northwest of Taos for her son's use as a place to hunt. Lawrence had visited the ranch and rated it "an ideal retreat for a winter . . . several primitive buildings, a corral, a brook, some tall pine trees, and a breath-taking view over wide colorful plains far below, but no such conveniences as running water."[5]

A dispute with Mabel Dodge during the move from Taos to Lobo Mountain so enraged Lawrence that he refused to settle at the ranch. Rather he rented a cabin on the Del Monte Ranch, owned by Bill and Rachel Hawk and used during the summer as a dude ranch, situated two miles below the Mabel Dodge property. Soon after they arrived in New Mexico, Walter Ufer, the artist, introduced the Lawrences to two young Danish painters —Knud Merrild and Kai Gotzsche—who were traveling from New York to California in a Model-T Ford. Lawrence invited the Danes to join Frieda and him at the Del Monte Ranch for the winter; they accepted and rented a cabin near the Lawrences' from the Hawks.[6]

Life in the Lobo Mountain wilderness was primitive and physically demanding. Lawrence and the Danes cut firewood for the two cabins. Their food was simple—porridge for breakfast; salt meat, potatoes, and apple sauce for dinner; and porridge for supper, with occasionally the luxury of cabbage soup and fried rabbit when the Danes were successful as hunters. Lawrence was a skilled cook and made fine bread that he baked in a *horno*, the local beehive-shaped outdoor oven. They observed a daily tea; Lawrence brewed the beverage.

Lawrence's first winter in northern New Mexico was an intensely cold one; temperatures at the alpine altitude of upper Lobo Mountain often ranged between twenty-five and thirty degrees below zero. Witter Bynner said that Amy Lowell and other friends of D. H. Lawrence would have been as surprised "as we were by the resources and aplomb with which they [the Lawrences] faced simple isolated living . . . when a kitchen stove and a living room fireplace were all they had against winter and their mile of steep woods road, off the highway was almost impassable with snow." But Lawrence wrote some each day, worked about the cabin, and spent pleasant evenings with Frieda and the Danes basking in the cozy cabin's warmth around the fireplace.[7]

His joy in discovery of a place for Rananim intensified Lawrence's desire to establish a haven for friends who, like himself, were alienated from their mindless, progress-bent world. He urged them to join him in making "a real life" on Lobo Mountain where he planned to obtain land for the colony. "It is much more splendid, more real," he wrote. "And the rule would be, no *servants;* we'd all work. . . . No highbrows and weariness of stunts. We might make a central farm."[8]

As spring neared, however, and the prospects increased of the road from Taos being opened, a dread came over him; the improved road would bring people, including Mabel Dodge. He explained to his mother-in-law his difficulty of relating to Mabel Dodge (in a few months to become Mabel Dodge Luhan) and the damaging effect he found her presence had on his writing: "We are still 'friends' with Mabel . . . but do not take this snake to our bosom." To avoid the inevitable confrontation, he

decided to move on, and during March, 1923, Frieda and he entered Mexico, lingering in Mexico City, Cuernavaca, Puebla, Orizaba, and Chapala, as Lawrence sketched a novel to be titled *The Plumed Serpent*.[9]

Lawrence sorely missed northern New Mexico and his zealot's sense of mission to create Rananim there would not relent. Therefore, during late 1923 he traveled from Mexico to England, intent on mustering recruits for his projected Lobo Mountain utopia. As he went about England visiting friends, that old lung torment that had plagued him off and on for several years returned, and a melancholy gripped him. He told Thomas Seltzer his publisher, that he loathed "London, hate England, feel like an animal in a trap. It all seems dead and dark and buried. . . . I want to get back West. Taos is heaven in comparison."[10]

At London's Cafe Royal he entertained a group of friends whom he considered choice prospects. He gave a speech describing the wonders of Taos and explained "what he was attempting to accomplish in the world, and invited them all to come to New Mexico to help him in the task." He assured them that in the Lobo Mountain Rananim "They would struggle with the world in a new way . . . withdrawing their essential being from the common struggle and turning their strength into a new channel." Heavy with wine they pledged to do so and Lawrence cautioned, "Do not betray me."[11]

Lady Dorothy Brett, the painter, daughter of Viscount Esher, was the only person among those present at the Cafe Royal gathering who remained committed to Lawrence and Rananim. She accompanied the Lawrences to New Mexico; they reached Taos during late March, 1924. Mabel Dodge Luhan assured them a peaceful and warm reception and insisted that they settle in her compound. Lawrence and Frieda hesitantly accepted. His letters to friends exuded exultation over returning to northern New Mexico. "We are here again at the foot of the Rockies on the desert, among the Indians—7,000 feet up. I am glad to be away again. The winter in Europe wearied me inexpressibly. There seems a dead hand over the old world." And as the days of alpine spring advanced he explained to Seltzer: "Taos is looking very lovely, full spring, plum blossoms like

wild snow on the trails, and green, green alfalfa, apple orchards in bloom, the adobe houses almost pink in the sun. It is almost arcadian."[12]

In no time at all relations in the compound became seriously strained; old conflicts, complicated by the presence of a third woman—Dorothy Brett—surfaced, and Lawrence sought respite from the turmoil of the female trio battling like catamounts for his favors. Frieda and he concluded negotiations with Mabel Dodge Luhan for title to the Lobo Mountain ranch and the Lawrences and Brett, accompanied by Mabel and Tony Luhan and several Indian and Hispanic workers, went to Lobo Mountain to renovate the dilapidated cabins.

Lawrence was a model worker for his abbreviated Rananim. It was said that he "never asked the Indians . . . to do anything he wasn't willing to do himself." He constructed shelves and cupboards, cut firewood with Brett's help, irrigated the alfalfa field, baked exquisite bread in the *horno*, mended fence, and cared for a flock of chickens, three horses, and a cow that he milked twice daily.[13]

He explained to Mabel Dodge Luhan after completing a particularly difficult task, "I've done one of the hardest day's work in my life today—cleaning the well. All the foul mud of the Thames—and stank like hell. Now it's excavated and built in with stone." And he observed to his friend Earl Brewster: "One has to be so much harder, and more cut off here. Either one stands on one's feet, and holds one's own on the face of the land, or one is mysteriously pushed out. America has really just the opposite vibration from Asia—here one *must* act or wither; and in Asia, it seems to me, one *must* meditate. I prefer this because it is harder."[14]

The pace at Kiowa Ranch satisfied Lawrence—morning and evening chores, writing each day until noon, riding horseback over mountain trails during the afternoon, and perhaps entertaining guests up from Taos for the evening. Mabel Dodge Luhan came to Kiowa Ranch only occasionally, so a major source of conflict between Frieda and Lawrence diminished. Her place as a precipitant of Frieda's jealous rage was taken by Lady Dorothy Brett. She was blindly devoted to Lawrence. While she continued

to paint, she found time to serve Lawrence. She helped him cut firewood, make improvements about the ranch, care for the livestock, and typed his manuscripts. Increasingly during the summer Frieda and Lawrence quarreled over Brett's presence at the ranch.

Finally in disgust Lawrence decided to return to Mexico, but rather than leave Brett alone on Lobo Mountain, he insisted that she accompany them, and during October, 1924, he closed down the ranch and the trio traveled south. He soon repented Brett's presence, however, because Frieda gave him no peace, his writing suffered, and finally at Frieda's ultimatum he sent Brett back to Kiowa Ranch. While in Mexico, Lawrence became gravely ill with malaria and, in the course of receiving medical attention for this malady, the attending physician informed him that he was in the advanced stages of tuberculosis. During April, 1925, Lawrence finally recovered sufficient strength to travel and prepared to return to Taos. At the El Paso border crossing United States Immigration Service agents refused to admit him because of his tubercular condition. After several days' delay and appeals to British and American diplomatic officials in Mexico City, however, Lawrence was allowed to enter the United States.

Once the Lawrences were settled at Kiowa Ranch, Frieda refused to permit Brett to live in the cabin Lawrence had prepared for her, and she moved down the mountain to a cabin on the Hawk Ranch. A summer of Lobo Mountain crisp, dry, alpine atmosphere improved Lawrence's health a bit, and he informed friends that he was "up to the eyes in doing nothing" and "spent all the golden evenings riding through the timber."[15]

As autumn approached, Lawrence and Frieda planned to return to Europe, she to visit her children in England and her mother and sisters in Germany, and Lawrence, admitting a sense that the end was near, to see his homeland one final time. He persuaded Brett to precede them to Europe, promising to meet her in Italy.

Lawrence and Frieda stopped first in England, then Germany, before continuing to Italy. Near Genoa on the Italian Riviera, Lawrence rented the Villa Bernarda where Frieda and

he entertained old friends and made new acquaintances, including Captain Angelo Ravagli, who became Frieda's lover and eventually her third husband. Also the Lawrences traveled about Italy and the Mediterranean. Lawrence spent some time with Brett in southern Italy before she returned to Taos.

Lawrence continued writing—poems, plays, essays, and novels, including the notorious *Lady Chatterly's Lover*, and letters to Mabel Dodge Luhan and Dorothy Brett and many other friends. Each year as the spring season approached, he longed for Taos and the ranch on Lobo Mountain, but his physical condition progressively declined, and he knew that, because he was a carrier of tuberculosis, he could never make it past the United States Immigration Service authorities. In her letters to him Brett urged him to come to Canada where she would help him slip into the United States, thus avoiding Immigration Service examination and exclusion. Repeatedly he wrote her and Mabel Dodge Luhan, "I wish I were there," and until his death he regularly expressed the wish to return to New Mexico "where he was sure he would get well." In the last weeks of his life he pathetically tried to strengthen himself and "rest enough to go to New Mexico." In early 1930 as his condition steadily worsened, Frieda placed him in the Ad Astra Sanitarium, at Vence, France, on the Mediterranean. H. G. Wells, the Aldous Huxleys, and other friends came to visit, and sculptor Jo Davidson fashioned Lawrence's head. He became so uncomfortable in the sanitarium that Frieda moved him to nearby Villa Robermond; there D. H. Lawrence died on March 2, 1930, and was buried in the local cemetery, his grave marked by a headstone bearing the phoenix emblem, his symbol for Rananim.[16]

The D. H. Lawrence legacy, strongly tinctured by his northern New Mexican connection, is awesome from every standpoint. Aside from a scintillating list of fiction and nonfiction writings (novels, poems, plays, and essays) that places him among the greatest of all twentieth-century authors; aside from his titillating confrontations with censorship laws, both in Great Britain and the United States, which banned his books and paintings; aside from his innocently precipitated revolution in public attitudes

toward sex; aside from his singular mastery of his native language by which at times he created nearly sublime prose; there has been a surprisingly sustained reluctance to acknowledge his greatness. For ten years after his death the BBC refused to permit his name to be mentioned. The taboo on D. H. Lawrence and his writings is gradually dissipating, however; increasingly literary critics are speaking out for him. Frieda Lawrence's biographer Robert Lucas has stated that as of 1960, 800 books (biographies, critical analyses of Lawrence writings, and annotated editions of his novels, poems, essays, and letters) dealing with D. H. Lawrence have been published, and by 1980 Lucas ventured that the number would exceed 1,000. This led him to conclude: "No other writer of this century has been so thoroughly described, dissected, analysed, interpreted, praised and denounced by so many literary critics, sociologists and psychologists as D. H. Lawrence."[17]

What manner of man was this social iconoclast who raptured over northern New Mexico's milieu and sanctified its charm and natural beauty in verse and prose, and who esteemed Taos and its environs more than any other place he had ever seen in his wide travels? Lawrence struck people variously. Friends of long standing like Aldous Huxley found Lawrence's nature a shifting mix of charm, compassion, patience, tenderness, and petulance, volatility, impatience, harshness. Those close to him admitted that he was ultrasensitive to real and imagined wrongs, vengeful, even cruel, toward those he believed had misused him. Friends were embarrassed to find themselves caricatured in demeaning roles in his novels. Joseph Foster concluded that "much of his irritation, his pettiness, was despair," despair with his deteriorating physical condition and the apparent failure of the world to heed his jeremiads.[18]

One of his British admirers, Catherine Carswell, was stirred by what she described as his lithe grace, and a mystical "swift and flamelike quality. . . . I was sensible of a fine, rare beauty in Lawrence, with his deep-set jewel-like eyes, thick, dust-coloured hair, pointed underlip of notable sweetness, fine hands, and rapid but never restless movements." The Santa Fe poet Witter Bynner said when he met the British novelist, "Lawrence's appearance

struck me from the outset as that of a bad baby masquerading as a good Mephistopheles. I did not feel in him the beauty which many women have felt." Because of his thin frame and generally emaciated appearance, many persons have described Lawrence as a "scarecrow" but Bynner said he found less a scarecrow but "gangling, and his voice was occasionally like whistlings of the wind."[19]

The Indians at Taos were intrigued by Lawrence, seemed to like him, and called him "Red Fox"; Frieda they called "Angry Winter." For the most part Lawrence maintained an aloofness toward the Santa Fe– and Taos-colony members, regarding most of them as "arty" and "repulsive." The distance he maintained there caused some to scorn, even denounce, him. One colony member told Mary Austin, "A couple of weeks ago I saw D. H. Lawrence with Mabel Luhan. Lawrence is a most impossible looking person. He struck me as looking unwholesome. I am coming to believe that mediocrity is better than brilliance with a bias."[20]

Lawrence was not a recluse at Taos, however; he simply chose friends carefully. Frieda and he enjoyed evenings at Kiowa Ranch with visitors from Taos, Santa Fe, and other parts. Lawrence's editors and publishers came to the ranch, and Frieda's nephew from Germany, Friedrich Jaffe, spent some time with them. Witter Bynner, Spud Johnson, Andrew Dasburg and his wife-to-be Ida Rauh (the actress-activist), and Mabel and Tony Luhan called on the Lawrences. One of Lawrence's favorites was a young Taos writer named Joseph O'Kane Foster with whom he shared his views on several subjects, including the utilitarianism of the novel: "The great relationship, for humanity, will always be the relationship between man and woman. And the relationship between man and woman will change forever. The novel is the perfect medium for revealing to us the changing rainbow of our living relationships."[21]

Later Foster concluded:

Lawrence was a prophet. He changed my life. I was just out of college with a degree in philosophy when I met him. He made me see that it

was all garbage, what I had in my head—that I didn't know a goddam thing about anything. I started all over after I met Lawrence. As a thinker, as a philosopher, he was years ahead of his time. I honestly think that we're just beginning to catch up with Lawrence now, thirty-six years after his death. Today you can't possibly imagine the literary situation when Lawrence began to write. You never even used the *word* "passion" then, let alone trying to describe it. The whole world of male and female relationships was taboo in art—its as simple as that. Well, Lawrence changed all that, singlehanded; he broke through and he changed things, and didn't they hate him for it! That's something else you can't imagine—the incredible hatred, the vilification, the persecution. He came to Taos because of hatred. Sex wasn't all of it, though. They called him a sex writer, and of course he took up the challenge, but the real thing was class. Lawrence was forever attacking the English class system, mocking it, chipping away at it. Clifford Chatterly is England in a wheelchair.[22]

Lawrence believed that he had special insight into the human condition, and he freely shared his diagnosis and prognosis for modern industrial society:

Sex . . . was decaying, infected by the ethics of Victorianism, smothered by hypocrisy, made dull and apathetic by mechanical living. The sexual emotions, as psychologists had recently discovered, and artists always known, were inseparably related to creative activity. Dull them and you dull the man or woman. Warp them into mechanical responses and you turn civilization mechanical and prepare for its death. Our physical and intellectual welfare is, in this respect particularly, tightly linked to the functions of the body.[23]

Lawrence as the prophet had a message for America, too, and it was drawn from the perceptions he derived from life at Taos. He stressed "blood consciousness," akin to the Indian sense of nature's chain of being, as the motive force in the creative person. And his obsession with naturalness made him hate the machine; he believed that "handling machines made people machine-like." He admonished America to find its genuine and enduring foundations. "America . . . should leave off being quite so prostrate with admiration" for technical-industrial progress.

America must turn to America, and to that very America which has
been rejected and almost annihilated. . . . They will never draw it
from the lovely monuments of our European past. . . . America must
turn again to catch the spirit of her own dark, aboriginal continent.
. . . Americans must take up life where the Red Indian . . . left it
off. They must pick up the life-thread where the mysteries of the life
which Cortez and Columbus murdered. There lies the real continuity
. . . between murdered Red America and the seething White America.[24]

Just as Lawrence avoided most of the Taos- and Santa Fe–
colony members, he shunned the causes they mounted, except
those promoting improvement of Indian welfare. He worked for
the defeat of the Bursum Bill, and he advised Mabel Dodge
Luhan and others on strategy for furthering the local campaigns
to improve Indian status. He thought that John Collier was a
zealot, his actions often damaging for the causes he supported.
He reminded Mabel Dodge Luhan: "There is necessary a balance.
But you have gone so far to one side, it is really easier for you
to go over the edge than to return. Collier is utterly out of
balance. The Santa Fe crowd is perhaps seeking a little balance,
in its own way. Learn to modify yourself."[25]

Lawrence freely admitted that he had derived substantial
spiritual uplift from the New Mexican experience. Discovering
that his abiding principle—the life essence he called "the blood
force," the key to creativity—was a functional part of Indian
life and practice was a rapturous revelation for him. Certainly
the New Mexican phase of Lawrence's life enhanced his literary
career. There he completed several novels he had been working
on for some time (including *The Plumed Serpent*, set in Mexico),
revised and published others, and wrote essays, poems (includ-
ing the remaining verse for *Birds, Beasts, and Flowers*), and
novelettes. He used Lobo Mountain ranch as a setting for several
essays, poems, and novelettes. *Mornings in Mexico* is misnamed;
it consists largely of his writings about New Mexico. He wrote
the play *David* at Kiowa Ranch especially for Ida Rauh to act
out. *The Princess*, *The Woman Who Rode Away*, and *St. Mawr*
have New Mexican settings.[26]

Lawrence's writings had a metaphysical cast; he refined this
after exposure to northern New Mexico's generative milieu and

articulated it to mean "There is a dark core of being, there is a flame or a Life Everlasting wreathing through the cosmos for ever and giving us our renewal, once we can get in touch with it." And the subtle openness of Taos society, its broad tolerance, influenced his literary presentation of revolutionary subject matter, particularly as regards human sexuality. For this daring application to the novel he has been accused of pandering smut and pornography, and he has suffered public censure by having his books banned in Great Britain and the United States. Witter Bynner, however, who knew Lawrence better than most writer associates, declared that bawdiness irked Lawrence for several reasons, including the fact that its presence in writing often made it more difficult for authors like himself to apply the "free expression of decent candor" to their writings which, he stressed, was his resort and intent.[27]

The contest among the three women of Taos—Mabel Dodge Luhan, Frieda Lawrence, and Dorothy Brett—for Lawrence continued unabated for several years after his death. Mabel Dodge Luhan had been and continued to be a resident of Taos; Dorothy Brett remained there for the rest of her life; and shortly after Lawrence's death Frieda returned to Taos with Captain Ravagli, settled there, and eventually married him. During 1933 the *Santa Fe New Mexican* announced that the "battle over Lawrence is still a live topic in Taos." This was in reference to the trio's efforts, each to rush to print with a book describing her relation and her value to Lawrence: *Lorenzo in Taos*, by Mabel Dodge Luhan; *Lawrence and Brett*, by Dorothy Brett; and *Not I, But the Wind*, by Frieda Lawrence.[28]

Through the years the three Lawrence devotees, each living close to the other in the tiny town of Taos, mellowed, became what appeared on the surface to be warm friends, visited regularly, and looked after one another in their advancing years. Brett, nearly ninety, explained that "Of course, we all three wanted him all for ourselves. We wanted to have secrets with him, do you see? But once he was dead—once the bone of contention was removed—we women became much better friends than we had been."[29]

But Lawrence's ghost continued to condition relationships

among these women. Bitter resentment at Frieda for denying her access to Lawrence lurked strong in Lady Dorothy Brett's heart, and it occasionally surfaced. During 1961 a BBC representative visited Taos to tape interviews for a special television program on D. H. Lawrence. Brett is reported to have told an aging Spud Johnson that during her interview, when asked her estimate of Frieda Lawrence, "I suppose you all said she was a wonderful woman. Well, I didn't. I said she was a bitch, and she was."[30]

The three women of Taos pined for Lawrence, and finally in 1935 he returned to them. Up on Lobo Mountain near the Kiowa Ranch house Angelo Ravagli constructed a small adobe chapel, fitted with a crypt and guarded by a large carved phoenix figure. It commanded "a view of the entire slope of Mt. Lobo and of all of Taos Valley, as well as Truchas Peaks and the Jemez Mountains on the far horizon. The magnificent approach to it is flanked by a gateway composed of two giant pine trees." Ravagli then went to Vence, had Lawrence's remains exhumed, carried them to Marseille for cremation, then delivered the ashes to Taos.[31]

Frieda Lawrence scheduled the memorial service for the evening of September 16, 1935, at the chapel. Anglo, Hispanic, and Taos Indian friends—including his favorites Trinidad and his wife, Rufina—were present. Trinidad brought a group of dancers from the Pueblo to pay last respects to "Red Fox." Eulogies included reading selections from Lawrence's published poems *Pensees*. Then workmen sealed the container of Lawrence's ashes in the chapel crypt.[32]

Belatedly Lawrence had his heart's wish fulfilled; he had returned to Lobo Mountain, the place of his fondest dreams. His silent epitaph might well be the paean for nothern New Mexico that he had written for *Survey* shortly before his death, and which was published posthumously: "New Mexico was the greatest experience from the outside world that I have ever had. It certainly changed me forever. . . . it was New Mexico that liberated me from the present era of civilization, the great era of material and mechanical development. . . . For greatness of beauty I have never experienced anything like New Mexico."[33]

PART IV

The Muse Heritage

SPRING MORNING—SANTA FE

The first hour was a word the color of dawn;
The second came, and gorgeous poppies stood,
Backs to a wall. The yellow sun rode on:
A mockingbird sang shrilly from a nest of
wood.

The water in the acequia came down
At the stroke of nine; and watery clouds were
lifting
Their velvet shadows from the little town;
Gold fired the pavement where the leaves were
shifting.

—LYNN RIGGS

14 / THE COLONIES AND COMMUNITY

AROUND 1900 aesthetes began to settle in Santa Fe and Taos; in each town they formed a colony, a special interest community, where they expected that their interaction with other creative folk would foster greater individual performance and satisfaction. Many of the newcomers were sensitive to the dogma of the "cultural radicals" who stressed the need for alternative life-styles to replace the family and other community-forming elements that they believed were being destroyed by the enlarging and "predacious" technological-industrial entity. Thus the colony was, in a sense, a renunciation of modern culture with its nearly single-minded materialism, which many muse-types believed was a threat to their creativity. While most artist-author colonies were isolated enclaves in relation to the host towns or cities, those at Santa Fe and Taos became vigorous civic organisms, each grafted onto and functioning as a vital

247

part of the town. The colonies eventually served as a directive force, influencing local politics and, under the aegis of the larger community, even branching out to participate in national and, occasionally, international affairs. One observer commented that

other towns in this country have artists and writers, but no other town has them taking such active part in town life. In Provincetown, Carmel, and such places, they keep to themselves. In Santa Fe they run for office, decorate the public buildings, restaurants, and bars; they clamp down on builders who want to erect buildings out of keeping with the prevailing style of architecture; and they start most of the local movements to improve the town.[1]

Just as the nearly overpowering force of northern New Mexico's natural environment and charming social environment provided painters and writers continuing inspiration and creative vigor, the milieu also generated a sense of community among them. First, its isolation tempered the intensity of the muse émigrés' individualism, forcing them to a more cooperative stance that encouraged civic commitment. Second, the model of Indian and Hispanic cooperativeness was instructive for the newcomers. And, third, northern New Mexican society, for the most part, was an open one that permitted the newcomers to become involved in meaningful roles in community life, even positions of leadership.

As their sense of civil commitment grew, colony members at both Santa Fe and Taos increasingly gave of themselves to help others. They donated proceeds from the twice-annual artists' ball to local causes. In times of drought and depression they raised money for needy Indians and Hispanics. In the early days of the Great Depression, Mary Austin and other colony members went East to raise money from wealthy friends to succor hungry natives. Also artists and writers started a movement to help destitute health seekers find employment on federal relief projects in New Mexico. During 1937 artists and writers donated paintings and books and manuscripts for a sale to be held at the New Mexico Museum, in Santa Fe,

the proceeds to go to the Red Cross for aiding victims of the flooding Mississippi River.[2]

A favorite cause for Santa Fe– and Taos-colony members was Indian welfare and education. Writers and artists were among the founders of the New Mexico Association on Indian Affairs, formed to promote improvement of Native American status. Each year to support the association program, they conducted several fund-raising campaigns, including the Poets' Roundup held in the homes of Alice Corbin Henderson, Mary Austin, and other Santa Fe–colony members. The programs featured Paul Horgan, Lynn Riggs, Haniel Long, Thomas Wood Stevens, Witter Bynner, and others reciting poetry, presenting lectures, and reading plays. These events drew crowds of up to 200 persons.[3]

Several individual colony members also gave generously to civic causes. During the 1930s artists and writers at Taos started a drive for funds to construct a community hospital. Joseph Henry Sharp and other artists donated paintings to be sold, the proceeds to be placed in the hospital fund. Mabel Dodge Luhan gave the money for purchasing the land and constructing the hospital. She also started the Taos Public Library. During 1918 she gave several hundred books from her library, and she solicited from friends in New York books and money to purchase books. Matilda Hall sent twenty-four new volumes of fiction, history, and science, and every three months she sent twenty additional volumes. Also through the years Mabel Dodge Luhan added volumes to the Taos Public Library, which came to be quartered in the Harwood Foundation Building.[4]

Colony members became so much a part of the life of the two towns that they came to exercise considerable alterative and directive influence on the affairs of both. Oliver La Farge calculated that by 1925 the Santa Fe colony was the most influential single group in the town. Artists and writers at Santa Fe and Taos formed social-political action committees to promote civic improvement and at the same time to guard and preserve the ancient character and charm of each place. For several years aesthetes in the northern colony had used the

Taos Open Forum as an outlet to discuss and air public issues, then during 1935 they formed the Artists Civic Cooperative Association to work with leaders in local government and the chamber of commerce to advise them in dealing with civic problems and to help keep Taos attractive. The social-political action group in each town influenced the establishment of a fire department for Santa Fe and Taos, a public water supply for Taos, urged increased funds for public libraries in the two towns, campaigned to save a row of ancient cottonwoods threatened by a city-council plan to widen a road into Taos, and served as advisory committees to local school boards for curriculum improvement.[5]

The Santa Fe– and Taos-colony members also supported tourism which, until 1942, was New Mexico's most important industry, its focus the scintillating natural beauty of the Sangre de Cristos and their charming Indian-Hispanic enclaves. Tourism became the special concern of Edgar Hewett, director of the New Mexico State Museum and School of American Research, and officers of the Santa Fe Chamber of Commerce. They worked in close alliance with the Santa Fe Railway and the affiliated Fred Harvey Enterprises. Railway officials gave special transcontinental rates for tourists bound for New Mexico, and the Fred Harvey Enterprises fed and sheltered tourists at Harvey Houses along the route and at La Fonda Hotel, in Santa Fe. Tourists were transported from Lamy on the Santa Fe main line in buses called Harvey Cars to Santa Fe, Taos, and other points of interest.

Both the Santa Fe Railway and Fred Harvey Enterprises also supported those local activities with tourist implications. William H. Simpson, a Santa Fe official with a strong interest in art and literature, hit upon using Santa Fe and Taos artists and their studios and paintings to promote the region. Thus the Santa Fe Railway supplied artists with passes to come to New Mexico to paint, and Santa Fe Railway and Harvey Enterprises officials purchased paintings by colony artists that they displayed in ticket offices and Harvey Houses and reproduced on calendars and other advertising. Their advertising invited tourists to escape the stress of city life, as the artists and writers

had done, and join them in "Nature's Hideouts" in northern New Mexico. And Harvey Enterprises provided financial support for the Society for Preservation of Missions to protect the colonial missions from vandals and to restore them for tourist viewing.[6]

A competitor with the Santa Fe Railway–Fred Harvey Enterprises combine for northern New Mexican tourist business was Koshare Tours, managed by author Erna Fergusson. Koshare Tours provided tourist expeditions by automobile and on horseback to pueblos and isolated Hispanic settlements.

Artists and writers in the Santa Fe and Taos colonies supported tourism in various ways. Some actually held open house in their studios, permitting visitors to view them at work, and gave teas to provide tourists opportunities to meet other resident artists and writers. They often made personal appearances at receptions honoring them and their work at the Harwood Foundation Museum, in Taos, and the New Mexico State Museum, in Santa Fe, and they regularly showed up at the increasing number of galleries in Santa Fe and Taos that displayed their work. And several, particularly those who were permanent residents of Taos and Santa Fe and property owners who had adopted the more traditional material view on community welfare, regularly spoke out in support of the local tourist industry. Ernest Blumenschein, one of the founders of the Taos colony, was such an advocate. He assured Hewett that "By the labors of us all we are incidentally helping New Mexico to a reputation that may aid her in an economic way." And on annual trips to New York for showings of his works, he missed no opportunity to promote tourist visits to northern New Mexico. On his return from the exhibition tour of 1934, he was optimistic "of getting a big tourist business in the area this summer."[7]

The climax for the tourist season was observance of the annual Santa Fe Fiesta and Taos Fiesta. The Santa Fe Fiesta, generally held during the first week of September, was based on a colonial Hispanic observance, begun in 1712, to commemorate the reconquest of Santa Fe by Don Diego de Vargas in 1692. In the early twentieth century residents of Santa Fe

observed the De Vargas pageant only intermittently until around 1924 when Hewett and local chamber-of-commerce officials attempted to integrate it into the local tourist attractions, largely as a historical pageant presented on the plaza in front of the Governor's Palace in a palisaded pavilion. Viewers were charged admission, which had the effect of excluding the local principals—Hispanics and Indians—few of whom could afford the price of admission.[8]

Local colony members led by Carlos Vierra, Witter Bynner, Gustave Baumann, and John Sloan urged Hewett to enlarge and open up the pageant; he assented, and, mostly because of the interest and driving energy of these colony leaders, there evolved a pluralistic spectacle that became the ultimate showpiece of the tourist year for that part of New Mexico. Vierra set up an arts-and-crafts fair in the armory for Indian and Hispanic craftsmen. Sloan spent a large part of his time in Santa Fe each year designing floats and costumes for the Fiesta parade. Bynner composed tableaux of New Mexican historical episodes enacted on the hillside northeast of Santa Fe near the Cross of Martyrs where fifty-two Spanish friars were put to death by Indian insurrectionists in the uprising of 1680. And Baumann designed a parade figure—Zozobra, a huge papier-mâché figure depicting Old Man Gloom—whose destruction by fire symbolized the purging of the years' accumulated sadness and signaled prospects for happiness. Also colony members conceived *El Pasatiempo*, their "hysterical parade," to offset the serious historical pageant.[9]

The Santa Fe Fiesta of 1937 marked the most successful observance of this traditional spectacle. The goal of colony members to involve thousands of Hispanics, Indians, and local townspeople in the celebration, as well as thousands of visiting tourists, was achieved. That year's fiesta began on Saturday night with the burning of Zozobra: "This papier-mâché figure, some forty feet high, has been manufactured in recent years by an artist, Will Shuster, who fills the figure with firecrackers and sparklers, and manages to make Zozobra's eyes roll and terrific groans come from his lips as the flames lick his shins." There followed the conquistadores ball and Hispanic dancing

in the streets, all in costumes, with Hispanic bands scattered about the town, each playing to a group of celebrants. Sunday morning opened with the procession to the Cross of the Martyrs, followed by vespers in the cathedral and a concert by Hispanic musicians. On Monday, the final day of the Santa Fe Fiesta, the program included reenactment of the entry of De Vargas and his army of reconquest into Santa Fe, followed by *El Pasatiempo*—the hysterical parade. This lampoon on local people and their ways included floats satirizing dude ranchers, archaeologists depicted as "lugubrious bonediggers," an old-time western funeral with the corpse's feet protruding from the coffin, and a fake bullfight.[10]

The Taos Fiesta, also called San Geronimo Fiesta for the local patron saint, was a two-day festival held late in September or early October of each year to coincide with the conclusion of that region's harvest. The pageant included tableaux with colonization, missions, Popé and the Indian revolt, and reconquest themes and races, along with Indian and Hispanic dances and music. The Taos Fiesta attracted more and a greater variety of Indians—Apaches, Navajos, Cheyennes, Kiowas, Comanches—than the Santa Fe Fiesta. They camped near the Pueblo and visited, some for weeks before and after the fiesta. This Native American conglomerate comprised a kaleidoscope of color in grand festive beads, paint, and feathered finery.[11]

Local chamber-of-commerce officials turned the Taos Fiesta into a successful tourist attraction, and Taos-colony members were active in its production, but without the intensity of their counterparts down in Santa Fe. They planned exhibitions of paintings at Harwood Foundation Museum and at galleries in the village and sponsored a costume ball. And occasionally Taos aesthetes intruded to influence the direction of the fiesta as those at Santa Fe had done. Thus in 1929 when chamber-of-commerce leaders considered including a rodeo in the celebration, W. Herbert Dunton, a painter in the colony and former cowboy, protested saying, "Rodeos were all right in a cow country but Taos is not a cow country and never was."[12]

Colony members vigilantly guarded the towns against the intrusion of elements they regarded as threatening. They op-

posed bringing a week-long chautauqua to Santa Fe because
they said the town "didn't need to seek culture." Also they
regularly confronted what they believed were threats to the
unique New Mexican social environment. Mary Austin became
an ardent guardian of the local Indian and Hispanic heritage.
Thus she denounced Willa Cather, claiming that she had tra-
duced Santa Fe's Hispanic legacy. Austin explained that during
her extended hospital stay she had permitted Cather to live in
La Casa Querida, her Santa Fe home. While there Cather wrote
portions of *Death Comes for the Archbishop.* Austin later com-
plained that her guest "did not tell me what she was doing."
And when the Cather book was completed, Austin added:

I was very much distressed to find that she had given her allegiance
to the French blood of the Archbishop; she had sympathized with his
desire to build a French cathedral in a Spanish town. It was a calamity
to local culture. We have never got over it. It dropped the local
mystery plays almost out of use, and many other far-derived Spanish
customs. It was in the rebuilding of that shattered culture that the
Society for the Revival of Spanish Arts was concerned.[13]

Another instance of Santa Fe–colony members serving as
judges of what was best for the town occurred in 1927 when
the Daughters of the American Revolution prepared to present
the town a $10,000 "pioneer Madonna" statue marking the
terminus of the Santa Fe Trail. Colony members protested on
aesthetic and cultural grounds against city leaders accepting the
statue, which led to a heated public hearing attended by artists
and writers on one side and those favoring accepting the statue,
largely chamber-of-commerce and local D.A.R. members, on
the other. Frank Applegate and Mary Austin spoke for the
muses. Applegate said he had "canvassed all the artists and
writers in Santa Fe and that none of them wanted the monu-
ment here, that it was not artistic and Santa Fe did not want
something unloaded on it that it didn't want." Austin denounced
as "stupid" and "ridiculous" the attempt to place the statue
in Santa Fe. She added "the so-called Pioneer Woman monu-
ment did not represent the real pioneers of this region at all
. . . the real pioneers were Spanish people and that they had

not been consulted and were not represented at all."[14]

Leaders in both colonies mounted their most intensive protective campaign to defeat an attempt by Edgar Hewett and Santa Fe Chamber of Commerce officials to establish in Santa Fe the Center of Creative Arts and Culture, incorporated on April 26, 1926, under the laws of New Mexico as "Culture Center of the Southwest." The plan was to make the center a summer university with an educational, cultural, and recreational program. Hewett, as director of the School of American Research, committed his school's prestige and facilities to undergird the proposed center.[15]

Hewett had the plan for such a center in mind for some time. Beginning in 1915, he had organized several summer-school sessions under the auspices of the New Mexico Institute of Science and Education. Classes for the two-month term were held in the Governor's Palace until the adjacent state museum was completed. Curriculum included instruction in architecture; Spanish; music; anthropology; study of art exhibitions in the museum galleries; field trips to excavation camps of the American School of Research; visits to the pueblos to view Indian dances; and attendance at the Corpus Christi pageant; the De Vargas procession; and the native miracle-play presentation, Los Pastores.[16]

Ever the compulsive impresario, Hewett decided in 1926 to establish a permanent educational-cultural center in Santa Fe. He believed the center would serve several ends. Using the Santa Fe and Taos colonies as showpieces for the center, he could expose to the world the rich cultural resources of northern New Mexico and, of no little consequence, enhance the region's tourist draw. With strong support from the local chamber of commerce and the Santa Fe Railway Company, Hewett invited the Southwest Federation of Women's Clubs (Kansas, Louisiana, Missouri, Arkansas, Colorado, Arizona, Texas, Oklahoma, New Mexico, and Mississippi) to join with him to establish a cultural colony at Santa Fe. Federation officers accepted.[17]

When Hewett announced the plan for establishing the cultural center and sought a grant of public land from the city

of Santa Fe, local artists and writers denounced the project and petitioned the city council to deny Hewett's request for land for constructing the cultural center. In addition, on April 24, 1926, they formed the Old Santa Fe Association. Its purpose: "to work for the preservation of Old Santa Fe, and of guiding new growth and development and advancement in material welfare, in such a way as to sacrifice as little as possible of the unique charm and distinction of this city, born of age, tradition, and environment, and which are Santa Fe's most priceless assets."[18]

The cultural center issue "split Santa Fe wide open." Editor Dana Johnson, who resigned from the New Mexican staff because of his support of the Old Santa Fe Association's stand, lamented "The unity of spirit on which this city has prided itself has been blown up in a few days' time. If the proposition [cultural center] goes forward, this breach must inevitably widen. No one can predict the result. There is only one conceivable thing to do, and that is to drop it like a hot potato."[19]

Officers of the Old Santa Fe Association drafted copy for distribution to regional and eastern papers containing statements in opposition to the proposed cultural center. They sent clippings from the New Mexican and other regional newspapers containing statements of their opposition and telegrams reporting defections of members from the cultural-center support organizations to Federation of Women's Clubs officers. And they printed circulars for national distribution with such titles as "An Explanation of a Protest" and "An Open Letter to the Federated Club Women" which included the statement: "The position of the Old Santa Fe Association has been comprehensively stated in protests already published. To repeat: it regards the Culture Colony for Santa Fe a misplaced undertaking. . . . The incorporation of a new 'Culture Colony' in or near America's most seasoned town, is an obvious and deplorable incongruity."[20]

Mary Austin was the most active member of the Old Santa Fe Association. She had several hundred letters containing a statement of protest against the proposed cultural center printed and delivered to each Federation of Women's Clubs district and

state president and council member. She made many speeches before civic clubs and other local groups across the southwest seeking support for the stand of the Old Santa Fe Association. And she wrote several articles for *The New Republic* and other national magazines on this subject.[21]

The Old Santa Fe Association also mustered support from persons in other parts, drawing from them pledges of letters opposing the project to be sent to Santa Fe leaders. Percy Jackson, a New York lawyer and personal friend of Hewett, wrote the director of the School of American Research: "I cannot tell you how disappointed I am in the thought that there is a possibility of Santa Fe becoming just an ordinary American City. It is so unique and has been such an attraction for visitors. . . . I can see no advantage in having the city become a second Albuquerque, and that it would become in my judgment. . . . I do hope you will give this matter most thorough consideration before it is too late."

Ameila Elizabeth White, another ardent Santa Fe devotee from New York, wrote the leaders of the cultural center project that she was

inexpressibly shocked at the news . . . of the "Cultural Center" to be established in Santa Fe. . . . Santa Fe was the most interesting and delightful and *distinguished* spot in the United States where we could be sure of escaping from the intolerable crowds that infest Eastern resorts in summers. Now it seems that Santa Fe is to become much *like every other American resort.* . . . We are dreadfully distressed to find that Santa Fe for which we had such a great affection is to be so utterly changed and ruined.[22]

Hewett, city council members, officers of local civic clubs, the Santa Fe Women's Club, Woman's Board of Trade, and Santa Fe Railway Company spokesmen were appalled at this opposition to the cultural center that they insisted "would be of such immense economic benefit to Santa Fe." And they sought to counter it with letters, telegrams, and phone messages to regional Federation of Women's Clubs officers, reassuring them that the city of Santa Fe was unwavering in its commitment to provide the Federation of Women's Clubs land and civic

support for the proposed cultural center. The head of the Santa Fe Clubwomen's Committee for the Culture Center explained that this opposition was "the price paid by a community for having so-called 'creative minds' in their midst. . . . But with as worthy a cause at stake and with the combined forces of the Santa Fe Railway Company and the Federated Club workers, surely our objects can be attained ultimately."[23]

Hewett and other local cultural-center advocates explained that the Old Santa Fe Association was a "cuckoo organization" consisting of "a fanatical group of would-be highbrows" trying "to run the town and say who shall live here and who shall not. They do not represent the town." Hewett added that "Santa Fe is a bit in danger from a certain supercilious intolerance that is of recent origin. What attracted and anchored many of us to the place in the olden time was a fine graciousness, social and intellectual hospitality, that made it truly distinguished. This we feel we can not afford to lose." He added that the opposition to the cultural center "was instigated by Mary Austin and some of the artists and their satellites." He lamented that the work of this "influential minority in opposition" had the effect of putting "everybody, including the Santa Fe Railway, in a rather embarrassing position."[24]

This countercampaign only stirred the Old Santa Fe Association members to greater opposition effort, which caused A. C. Ater, passenger official for the Santa Fe Railway Company, to complain to Charles Doll, president of the Santa Fe Chamber of Commerce, that it threatened to defeat their plan for the culture colony. He warned that "unless some steps can be taken to prevent this propaganda from being spread all over the United States, by an injunction [from the courts] or otherwise, I am sincerely afraid that the entire project will fall by the wayside." Toward the close of 1926 the Federation of Women's Clubs withdrew their support from the cultural center, causing Hewett and other local supporters reluctantly to abandon the project. Thus the Old Santa Fe Association—the voice of the Santa Fe colony, with considerable support from the Taos colony —had triumphed.[25]

Sustained successes in local causes by Santa Fe– and Taos-

colony members strengthened their sense of community and encouraged them to take up state and national, even international, causes. Several vexing social questions nagged at Americans during the 1920s and 1930s, not the least of which was prohibition. Witter Bynner attempted, with some success, to rally northern New Mexican colony members to support repeal of the eighteenth amendment. This led him headlong into bitter controversy with local temperance forces who denounced him and his partisans in public debate and letters to the local newspapers for the threat, it was claimed, they posed to good public order. A citizen dry leader, Adela C. Holmquist, raged at Bynner, "People like you, if you had your way, do not care how much they disrupt the state or make it lawless, so they can get a drink." Bynner answered that "religious groups have unjustly and bitterly fought the right of the people to express its voice in this matter [repeal of prohibition]."[26]

After 1920 colony members became increasingly sensitive to public questions and committed to limited social change, and they saw political action as the means to accomplish their goals. Cyrus McCormick, a member of the writer section of the Santa Fe colony and independently wealthy, during the 1930s founded a weekly newspaper, *The New Mexico Sentinel*, which he claimed was to be devoted to the betterment of New Mexican government. In less than a year the paper had accumulated a reported circulation of 4,000. Several Santa Fe– and Taos-colony members helped McCormick edit *The New Mexico Sentinel*.[27]

Indian welfare became a continuing interest and concern for colony members at Santa Fe and Taos, and increasingly they resorted to political action to protect Native Americans from public and private exploitation and neglect. Their first success as guardians of Indian rights came during the early 1920s when they played a primary role in the defeat of the Bursum Bill which, if approved, would have stripped Pueblo Indians of thousands of acres of land and critical water rights for the benefit of Hispanic and Anglo squatters. This triumph led the New Mexico aesthetes to maintain a continuing interest in Indian affairs. John Collier, the activist-reformer and leader of

the American Indian Defense Association (AIDA), lived in Santa Fe and Taos much of the time between 1920 and 1933, when he became commissioner of Indian Affairs. Colony members supported his work as AIDA spokesman. After his federal appointment in 1933 they influenced his formulation of a comprehensive program for Indian policy reform that culminated in 1934 in the Wheeler-Howard Act (sometimes called the Indian Magna Charta or Native American Bill of Rights). It lifted the federal ban on Indian religion, language, and culture generally; extended a measure of self determination to Indians; and provided them support for economic improvement. Interestingly, even though most Santa Fe– and Taos-colony members sustained Collier in his Indian policy-reform efforts, several found him objectionable as a person. On one occasion Bynner took violent issue with the imperious Collier and raged to D. H. Lawrence that he was "acting like a filthy little monkey."[28]

Artists and writers in the Santa Fe and Taos colonies agitated for recognition of the artistic and literary contribution to American life by creation of a cabinet post of secretary of National Culture. Bynner, Mary Austin, and John Sloan regularly spoke on behalf of this cause and during the early 1920s it was reported that President Warren G. Harding was favorably disposed toward creating a Department of Fine Arts in his cabinet. The *Santa Fe New Mexican* noted that it was timely because, in part owing to the quality contributions of Santa Fe– and Taos-colony members, "America was enjoying a veritable art awakening."[29]

Santa Fe– and Taos-colony members were politically active, particularly during the economically troubled 1930s. Bynner, Ina Sizer Cassidy, Mabel Dodge Luhan, and Allan Clark, an artist from Pojoaque, formed the New Mexico Roosevelt League in 1932. By October of that year, when the league had a membership of ninety, its members joined with the New Mexico Young Democrats to present a combined minstrel and political fund-raising show. Bynner was principal speaker and in charge of the vaudeville section of the program. Clark drew cartoons to publicize the event, and Bob Hall, a professional actor, presented a satirical political speech as a mock politician. Through-

out the decade of the 1930s the league studied issues and en-
dorsed those candidates for state-party nomination who sup-
ported their positions on issues. One of their favorite candi-
dates was United States Senator Bronson Cutting who guarded
aesthetic interests; he was particularly vigilant for attempts at
censorship by the Congress.[30]

Painters and writers of northern New Mexico also applied
collective action to guard against what they regarded as threats
to quality of aesthetic performance, and freedom of thought and
expression. Thus during 1937, Sloan led a move to oppose the
spread of union art. The Union of Scenic Painters and Decora-
tors, an American Federation of Labor affiliate, had been engaged
to decorate interiors of World's Fair buildings with murals.
Sloan's protest included the warning that the murals would
make the World's Fair buildings a "chamber of horrors" because
AFL union painters were "tradesmen" and did only "common-
place work." And Bynner solicited support for Leon Trotsky,
the exiled Russian revolutionist, who had been granted asylum
by President Lazaro Cardenas, of Mexico—largely through the
intercession of painter Diego Rivera—and placed in Coyoacan,
a suburb of Mexico City, in one of Rivera's residences. Bynner
had first met Trotsky in 1917 in Greenwich Village, and he
met him a second time in 1937 during a visit to Mexico. An
eighty-member United States Committee for the Defense of Leon
Trotsky had been formed. Bynner, a leading member of the
committee, praised Trotsky as "one of two great leaders of
change in the world state," and urged that he receive a "Square
Deal."[31]

Several Santa Fe– and Taos-colony members provided
American radicals a haven in northern New Mexico. Michael
Gold of New York, former editor of *New Masses* and editor
of *The Daily Worker*, came to Santa Fe in 1936. After a visit
with the McCrossons who ran the Spanish Shop for the Spanish
Colonial Arts Society, he proceeded to Taos as the guest of
painter Walter Ufer. Ufer said Gold "slings the hottest column
in the United States."[32]

Colony members rallied to thwart local and national at-
tempts at censorship. Such was the case in 1929–30 when Con-

gress considered a tariff bill that contained a clause granting the collector of customs authority to exclude paintings and other materials he deemed "indecent." Colony spokesmen lobbied through Senator Cutting in an attempt to defeat this proposal.[33]

Santa Fe and Taos artists and writers joined aesthetes across the nation during 1933 to protest alteration of controversial murals by Diego Rivera in New York's RCA Building. The Rockefeller family had engaged the Mexican artist to do a group of frescoes. Critics objected to his rendition, which included Bolshevist flags and a Lenin figure joining the hands of a soldier, a worker, and a Negro, and they demanded that the radical themes be purged. Rockefeller family spokesmen asked Rivera "to change the face of the Lenin figure to that of an unknown person." Rivera refused and the Rockefellers contemplated destroying the murals. Andrew Dasburg, in New York for an exhibition of his paintings, learned of this and wrote Mary Austin. She mobilized the Santa Fe colony, and Mabel Dodge Luhan and Spud Johnson mobilized the Taos colony. They rushed petitions and telegrams protesting the plan to destroy Rivera's murals. Santa Fe's Stephen Watts Kearny Chapter, Daughters of the American Revolution, objected to the stand of the Santa Fe and Taos colony members and sent counterstatements in support of the Rockefeller position. Colony partisans lost this contest.[34]

Writers and artists at Santa Fe also supported a number of international causes. Their first extraterritorial venture occurred during World War I. Artists raffled and auctioned paintings and dedicated the proceeds to the local Red Cross chapter and the New Mexico Council for Defense. Also artists donated studio time several afternoons each week to paint huge canvas landscapes imitative of the French countryside. They were to be used at army training camps by officers to develop observation skills and for gunners to apply range-finding equipment. Later, during the Spanish Civil War, northern New Mexican artists and writers formed the Committee for Immediate Medical Aid to the Spanish Democracy and donated paintings, litho-

graphs, and books to be raffled to raise funds for suffering Spaniards.[35]

As indicated, the reception of colony members by the people of Santa Fe and Taos varied, but generally theirs was an attitude of support and quiet, if at times reluctant, toleration. Bynner related that a longtime resident told him, "At first we respectable residents of Santa Fe hated the way you artists and writers went about in any kind of clothes and no neckties," many in Navajo shirts and jewelry, "but you do afford interest and amusement to the tourists, and if you can stand it, I guess we can." Secretary of the Interior Herbert Work was piqued at Santa Fe– and Taos-colony members for their interference with his plan to Americanize Indians and their attempts to influence federal Indian policy. During an inspection tour of the Rio Grande pueblos in 1924, he stated that writers and artists from the two colonies "were a bunch of long-haired nuts who wanted to keep the Indians back in the dark ages of primitive savagery."[36]

The Santa Fe and Taos newspapers generally supported the colonies and guarded the members from interference or harassment, and, when local citizens became upset with artists and authors, editors reminded them that, while the creative ones "are temperamental" and "sometimes they are not entirely patient with the shortcomings of us non-aesthetics," yet "these people help to keep us lighthearted." In 1915, during the formative period of the two colonies, the *Santa Fe New Mexican* stated a position regarding censorship it generally followed through the years: "We have too many moral censors and the public is beginning to feel that there are too many laws regulating personal liberties and a sufficient number of regularly and self-constituted guardians."[37]

Writer Ruth Barker, author of *Caballeros* and one of the few native members of the Santa Fe colony, explained that the principal reasons these two northern New Mexican communities were so attractive to creative persons, besides environment, were the region's pluralism and tolerance. She concluded that most of the people there were "guided by . . . 'Live and Let

Live.' Not taking upon himself the role of his brother's keeper, it matters little to Santa Fe what his brother does. The placid and the passionate live as they please."[38]

While townspeople at Santa Fe and Taos indulged the colony members as curiosities and tourist attractions that brought economic benefits to both towns, many came to resent the aesthetes as the latter's sense of community and collective interest in civic welfare enlarged. The aesthetes seemed to become increasingly presumptive, even supercilious, about what was best for each town. On at least two occasions, civic leaders openly, even bitterly, differed with them, shattering the tranquil *pax civi* and threatening the very life of the colonies. The first confrontation, in 1920, grew from an imagined Bolshevist infiltration of northern New Mexico, the second, the cultural center battle of 1926.

Out of the chaos, political instability, and cataclysmic revolution of the post–World War I era, alien doctrines (including Marxian dialectical materialism) began to seep into the United States. Some of the principal carriers of this ideological virus were colony members seeking alternative life-styles. Several artists and writers settling in Santa Fe and Taos were influenced to some degree by the proletarian-centered dogma. By late 1920 paintings and literature, composed around what some citizens claimed were revolutionary themes, began to appear in the New Mexico State Museum and in local book stores. Business and political leaders expressed concern about these "aesthetically rendered political statements" and demanded that they be suppressed. The *Santa Fe New Mexican* had been the perennial protector of colony members, but this turn in art and literature style and theme shocked the editor; he denounced the works and their creators as "Bolshevist" and said that which was passing as "modern art" really was "lunacy." He added, neither

Santa Fe nor New Mexico wants any Bolshevism, on canvas or on street corners. . . .Three fourths of the official publicity out from the Museum of Art section has been labored propaganda for art extremism of the most absurd kind. We urge that it will be the part of wisdom to regain a proper balance on this subject and take every

precaution to see that the gallery is not regarded as a center of anything remotely connected with Bolshevist ideas in art or otherwise.

The editor added that at least two of the extremist artists from the local colony were openly preaching Bolshevism in Santa Fe.[39]

Alice Corbin Henderson led the aesthetes' counterattack against the suppressionists by scathing letters to the *New Mexican* editor. She charged that the editor was attempting to censor the works of Santa Fe and Taos artists and writers, warned against the "main street mentality" prevailing, and claimed she detected a compulsive desire to "wipe out the contributions of alien races and cultures in favor of a political amalgamation which may leave only a colorless conformity in its wake." And she attacked the editor's advocacy of a censor to determine what paintings should be shown at the state museum and what literature should be sold in bookstores. She concluded that "political doctrine has nothing whatever to do with art. To confuse political views with artistic aims is detrimental alike to politics and to art. . . . it is as little concern of an art museum to inquire into a painter's political views as it would be to inquire into his religion, his bank account, or his domestic affairs." Colony leader Robert Henri wrote Hewett from New York: "I have heard . . . that 'The New Mexican' has blundered into calling for an art censor at the Museum of New Mexico. I expected better things from them. I count on the west for fresh and modern and very American ideas, and above all on every one in Santa Fe, for since I have been there I have looked on Santa Fe as a hope." Interestingly, by the beginning of the tourist season of 1921, northern New Mexico's "Red scare" had passed.[40]

The contest between civic leaders and aesthetes over the proposed cultural center at Santa Fe was more intense, and the artist-author triumph so antagonized local business and political leaders that they determined to punish colony members by deliberately excluding them from civic affairs. Hewett protested that the cultural center was not an "ephemeral tourist enterprise but a substantial educational institution" that would

have added to "the resources and business of the city by way of the steady expenditures which reach every line of business in the city in a most substantial way." He continued, "that which has made Santa Fe what it is, namely, its social, intellectual and spiritual hospitality, can not be endangered by this new spirit of intolerance engendered by the colony members 'that is creeping in.'" He urged the mayor and other city leaders to "see that no one from this list of protesters gets on" the planning commission. Their actions toward the cultural center show "how extreme these people would be in attempting to dictate to prospective housebuilders as to style of architecture, etc. Such extremists as Carlos [Vierra], Henderson, Austin, or almost any of those who will aspire to be on that commission would immediately produce a revolt against the whole idea. As in most matters of this kind I am inclined to think that the practical, hardheaded layman is the most reliable." If the taint of Bolshevism on northern New Mexican aesthetes passed in a season, the cultural center controversy endured for years. And several civic leaders maintained their grudge against "meddlesome" aesthetes until the demise of the Santa Fe and Taos colonies in 1942.[41]

EL RITO DE SANTA FE

This valley is not ours, nor these mountains,
Nor the names we give them — they belong,
They, and this sweep of sun washed air,
Desert and hill and crumbling earth,
To those who have lain here long years
and felt the soak of the sun
Through the red sand and crumbling rock,
till even their bones were part of the
sun-steeped valley.

— ALICE CORBIN HENDERSON

15 / DEMISE AND LEGACY

VITAL life signs of the Santa Fe and Taos colonies began to deteriorate during the 1930s; for all intents and purposes by 1942 both artistic communities had expired. Their vigor had been progressively sapped by the Great Depression and United States involvement in World War II, deaths of colony leaders, increasing intracommunity tension at Santa Fe and Taos, community change, and value shifts in the artistic-literary world.

The fifteen years after 1930 embracing the Great Depression and World War II brought pervasive change to the nation and the world. Sustained economic decline following the stock-market debacle of 1929 had a chilling effect on the northern New Mexican colonies and created severe hardship for most of the muses there. Painting and book sales plummeted in the principal markets in Eastern and West Coast cities and to tourists as the number of visitors to the spectacular Sangre de Cristo country progressively declined. Losing their means of support forced many permanent artist-writer residents to leave northern New Mexico, and bleak economic prospects discouraged the number of creative types necessary to maintain colony popula-

tion from settling in Santa Fe and Taos. Also, regular summer residents as well as occasional artist and writer visitors found it difficult to raise the money for transportation and maintenance for a summer's work there. The journalist Ernie Pyle visited Taos in 1938 and observed that "Some of the artists feel that Taos is through as an art colony. There hasn't been a new arrival, settling there permanently, for nearly ten years." American entry into World War II had a further weakening effect on the colonies in that the so-called war effort drew artists and writers away for military service and employment in war industries.[1]

Deaths of several founders and sustaining members of the colonies during the 1930s produced additional attrition in colony population. The passing of their example, goals, standards, leadership and comradeship, the very lack of their presence, had a diminishing effect on colony vitality and force. They showed their devotion and debt to the northern New Mexican milieu, however, by having their remains placed there. Thus when Mary Austin died, her ashes were ensconced in a highland crypt overlooking her beloved Camino del Monte Sol. D. H. Lawrence's ashes were returned from Europe and placed in a memorial shrine on Lobo Mountain. And by Walter Ufer's request, his Taos Indian friend Jim Mirabal carried a small copper urn containing the artist's ashes to the mouth of an arroyo east of Taos and scattered them to the four directions to sift over the Taos valley.[2]

One of the unique characteristics of the northern New Mexican colonies was their functioning as a social-action community in Santa Fe and Taos, serving as an alterative and directive force, influencing local affairs to the point that they became the acknowledged "most influential group" in each town. While townspeople initially tolerated and indulged muses because of their potential economic value to the towns, primarily as tourist attractions, they came to resent their collective role of determining what was best for each town, which often was at variance with the civic will. Local politicians and chamber-of-commerce officials became so embittered at actions for "community betterment" by "meddlesome" aesthetes that they deliberately attempted to exclude them from the planning commission and

bodies. The towns were small enough
ccasional ostracism to be felt directly
rs in their business and social dealings
ainly escalating civic resentment alien-
ir morale, colored their perception of
l actually became a deterrent to main-
n.

cause at Santa Fe and Taos had been
mbience of each and guarding the local
ronment from twentieth-century indus-
ial "progress." That generation of art-
pendent on the quiet order and exotic
New Mexican milieu for subject matter
function creatively. Colony members
efforts, as in the case of the Vierra-
paign to preserve Hispanic architecture.
principal cause of environmental stress,
e axiom that what tourists cherish in a
stroy. Tourism had been a mixed bless-
s. For a time the summer visitors had
or their paintings and books, but at the
e distraction. And many tourists even-
tually elected to establish homes in Santa Fe and Taos, forming
a coterie of affluent hangers-on, basking in the charming aura
of the colonies.

Painters and writers at Santa Fe and Taos were regularly
reminded of what tourists had done to Carmel and other aes-
thetic centers, in that, once seasonal visitors discovered an art-
ist-writer refuge, they inevitably corroded its quality of creative
life. Mary Austin, a founder of Carmel colony, left it for Santa
Fe when tourists discovered the Pacific Coast haven. Her writer
friend Cary McWilliams kept her informed of the continuing
decline of Carmel as a fine-arts center owing to ever-mounting
tourist pressure, and she repeatedly warned her partisans in
New Mexico of the hazards summer visitors posed to their Sangre
de Cristo settlements. In 1927, McWilliams lamented to Austin
the progressive despoiling of the California seacoast around Car-
mel to serve tourism, and explained "What seems to have hap-

pened" is that "lovely and fragile things have been offered for sale to shoppers whose lust for possessions has taken no account of the evanescent quality of goods so snatched from hand to hand. . . . A very melancholy truth. . . . this earlier charm is already a lost radiance," a casualty of "the present spectacle of mad grabbing and looting of ocean frontage and the application of bargain-counter techniques to nature."[3]

Mary Austin regularly pointed to the approaching doom of Carmel as a muse center as instructive of what would probably happen to Santa Fe and Taos as tourist pressure increased in northern New Mexico: "The moment that rumors of Carmel's fame as an 'art colony' became general, the place was doomed. Bric-a-brac shops were established, along with exquisite tea rooms; costly homes were erected on the Highlands; hospital hotels were built for the benefit of rich alcoholics. . . . The noveau riche came in hordes and built . . . homes . . . determined to live the Bohemian life and to devote at least one afternoon a week to 'art'." Because of these changes, Carmel was "irretrievably lost" to artists and writers. Mary Austin explained that "the thing that destroyed Carmel destroys every effort made in the United States by creative workers to establish for themselves a place in which their creative work can be carried on under the most favorable conditions. It is the desire of people who are totally unable to understand the creative life and yet cannot resist the appeasement to their own egos which they find in exploiting it." The message was clear. Just as intruders at Carmel drove "creative workers away by imposing their own tastes and manners," they posed the same threat to Santa Fe– and Taos-colony members.[4]

Substantive changes in American artistic values also contributed to the demise of the Santa Fe and Taos colonies. These muse havens had been formed in response to a movement running strong among creative folk around 1900 who bore a bitter contempt for progress, a glowering impatience with the mute urban mass, felt threatened by technology, and regarded these as threats to their creativity. To guard their aesthetic values, they believed it necessary to become exiles, to gather in protective, self-interest settlements, author-artist colonies, often remote

from cities. The colonies at Taos and Santa Fe were created as a part of this general outpouring of muses seeking respite from the crunch of twentieth-century industrial culture, and by 1930 these northern New Mexican havens had accommodated two generations of artists and writers. By this time, however, they were less needed because increasingly artists and writers no longer felt alienated from the larger world, and their contempt for progress and bitter impatience with the mute urban mass in many cases was changing to respect for the one and sympathy for the other. They determined to return to the real world, observe it, and paint and write about it. More and more, man in an urban setting rather than in nature became a compelling theme for many interpreters; they came to prefer the urban over the bucolic for painting, sculpture, music, literature, and drama compositions. The din of the factory rather than the quiet of nature excited their creative instincts.

Thus Santa Fe and Taos became less attractive to artists and writers as prime places to do creative work, and each declined as a muse haven as tourist pressure escalated; as civic resentment toward colony members increased; and as the two towns, in spite of artist-writer conservation efforts, shed many of those hallowed characteristics of uniqueness in favor of "urban progress." On the eve of perceptible colony decline, artist Herbert Dunton had warned that the "coming of civilization to Taos causes pioneer artists to hear the sounding of the death knell for Taos as an artist colony." He concluded that "when these things come Taos will have lost its quaintness for which so many of our first artists endured hardships to reach."[5]

By 1940, Dunton's prophesy was consummated. Mabel Dodge Luhan, the salon-keeper of Taos, expressed melancholy at the passing of this alpine village's very special and exotic character that had charmed her since 1917. She lamented that exciting people

no longer find a haven that is peaceful and serene. Old Taos has gone; this present day Taos does not thrill the visitors as it used to. What they find here now they can find . . . in almost any state. . . . Business, business, a lot of activity ending up in nothing. The word is getting around. Taos is finished, no use to go there anymore, and so

the kind of people who came and loved it come and dislike it and go away soon.[6]

By 1942, Santa Fe was also finished as an artist-writer colony. But lamentations over the demise of these muse havens must be tempered by acknowledgment of the rich legacy that each of the aesthetic communities bequeaths, including a corpus of literature cast in the established, accepted norms for poetry, fiction, nonfiction, and drama, as well as experimental, even radical, forms. The colonies also produced an immense collection of paintings rendered in conservative, traditional form, some imbued with the essence of Romanticism, even Regionalism, as well as a critically acclaimed group struck in the mode of Modern Art (Impressionism, Cubism, Expressionism, even ultra-avant-garde Transcendentalism, that is Dynamic Symmetry). Serendipitous expressions from the colonies' creative flair also yielded sculpture, music, dance, and drama compositions, and provided impetus for ongoing productions of national stature in chamber music and the Santa Fe Opera. The literature, paintings, and cognate fine-arts expressions produced by colony members characteristically were seasoned with respect, even adoration, for the land. Their stress on environment and creativity are instructive antecedents of latter-day ecology and the "quality of life" quest. Certainly their work in cultural conservation through laboratory and museum restoration, preservation, and display become models for the nation.

No less a part of the sumptuous legacy of the Santa Fe and Taos colonies is the mystique of former presence and continuity of influence, the "spirit of personality," of the principals—Alice Corbin Henderson, Ernest L. Blumenschien, Bert Phillips, Joseph H. Sharp, Irving Couse, Witter Bynner, John Sloan, Andrew Dasburg, D. H. Lawrence, Mary Austin, Willard ("Spud") Johnson, and Mabel Dodge Luhan. Their abiding passion sensitized them to concerns larger than personal aesthetic preoccupations and frequently drew the colonies into support of local and regional, even national and occasionally international, causes. They mobilized to protect Indian and Hispanic culture and welfare and to turn back the pernicious threat of Americanization

that sought to destroy Indian and Hispanic ethnicity. And colony members created a nearly unique sense of taste, style, and sophistication that survives in Taos and Santa Fe.

Certainly the attention that colony members, through their creative output, brought to the Southwest helped to overcome the region's stigma of the Great American Desert and to bring about New Mexican statehood. And their presence and productive activities strengthened the state's economy in that the colonies became prime tourist attractions.

Erna Fergusson wrote in the mid-1930s that when the men and women painting and writing in Taos and Santa Fe "are gone" the towns will become communities of "dilettantes" unless the "artistic consciousness" of the colonies survived. It did. Although art and literature production in northern New Mexico became largely dormant between 1942–46, it increased perceptibly after the war as new immigrant writers and artists settled there. In many ways they were unlike the muse residents of the period 1900–1942. One of the most conspicuous differences was that the newcomers remained largely apart. They did not gather into a special-interest group and demonstrate the solidarity and sense of community that characterized the creative folk who lived there during the period 1900–1942. But the natural and social environment of northern New Mexico centering on Taos and Santa Fe to a degree survives, as does the "art spirit," and both nourish the new muses.[7]

NOTES

1.

1. E. P. Richardson, *Painting in America* (New York, 1956), pp. 362–65.
2. Van Wyck Brooks, *John Sloan: A Painter's Life* (New York, 1955), p. 19.
3. Richardson, *Painting in America*, p. 361.
4. A. C. Brock, "Free Air and Free Art," *The Independent* 118 (May 11, 1926):288.

2.

1. *Taos Valley News*, August 12, 1919.
2. Mabel Dodge Luhan, *Taos and Its Artists* (New York, 1947), p. 27; Mabel Dodge Luhan, "Paso Por Aqui," *New Mexico Quarterly Review* 21 (Summer 1951):146.
3. Amy Lowell to D. H. Lawrence, New York, September 16, 1922, D. H. Lawrence Collection, University of Texas Library, Austin; Claire Morrill, *A Taos Mosaic: Portrait of a New Mexico Village* (Albuquerque, 1973), p. 95.
4. *Taos Valley News*, August 12, 1919.
5. Ruth L. Barker, *Caballeros* (New York, 1931), p. 118.
6. Paul A. F. Walter, "The Santa Fe–Taos Art Movement," *Art and Archaeology* 4 (December 1916):335.
7. J. Pennington, "Taos: An Art Center on the Edge of the Taos Desert," *The Mentor* 12 (July 1924):23–28; Luhan, *Taos and Its Artists*, p. 27.
8. Howard R. Lamar, *The Far Southwest, 1846–1912* (New Haven, 1966), p. 47.
9. Eugen Neuhaus, *The History and Ideals of American Art* (Stanford, 1931), p. 316.
10. Sidney Alexander. "Suck-Egg Mule," *American Scholar* 21 (October 1952):473.
11. Barker, *Caballeros*, p. 39.
12. *Santa Fe New Mexican*, April 24, 1915; December 8, 1917.
13. Sally Sanders, "Santa Fe's New Conquistadores," *Outlook* 155 (August 20, 1930):607–609.
14. Barker, *Caballeros*, pp. 174–75.
15. *Santa Fe New Mexican*, December 8, 1917; Morrill, *Taos Mosaic*, p. 95.
16. Mabel Dodge Luhan, "Native Air," *New Republic* 42 (March 4, 1925): 41; *Santa Fe New Mexican*, January 12, 1918; March 16, 1918.

3.

1. Van Deren Coke, *Taos and Santa Fe: The Artist's Environment, 1882–1942* (Albuquerque, 1963), p. 10.
2. Laura M. Bickerstaff, *Pioneer Artists of Taos* (Denver, 1955), pp. 43–53.
3. Taos Society of Artists Book of Minutes, Taos Society of Artists Collection, Museum of New Mexico Library.
4. Ufer to Hewett, March 30, 1921, Taos Society of Artists Collection, Museum of New Mexico Library.
5. Taos Society of Artists Book of Minutes, Taos Society of Artists Collection, Museum of New Mexico Library.
6. Report of Walter Ufer, Secretary of Taos Society of Artists, 1920–21, Taos Society of Artists Collection, Museum of New Mexico Library.
7. *Taos Valley News*, September 24, 1918; March 15, 1918.
8. Walter Ufer, "The Santa Fe–Taos Art Colony," *El Palacio* 3 (August 1916):75.
9. Hartley to Hewett, Taos, January 26, 1917, Hewett Collection, Museum of New Mexico Library.
10. Henri to Hewett, Santa Fe, November 29, 1917, Hewett Collection; Hartley to Hewett, Taos, January 26, 1917, Hewett Collection, Museum of New Mexico Library.
11. Paul A. F. Walter, "The Santa Fe–Taos Art Movement," *Art and Archaeology* 4 (December 1916):330–38.
12. Ibid.
13. Coke, *Taos and Santa Fe*, p. 29.
14. Ibid., p. 30.
15. Ibid., p. 31.
16. Ibid., p. 144.
17. Oliver La Farge, *Santa Fe: The Autobiography of a Southwestern Town* (Norman, 1959), p. 224.
18. *Santa Fe New Mexican*, March 22, 1919.
19. Henri to Hewett, Santa Fe, November 29, 1917, Hewett Collection, Museum of New Mexico Library; Henri to Walter, May 10, 1919, Gramercy Park, New York, Hewett Collection, Museum of New Mexico Library.
20. *Santa Fe New Mexican*, April 24, 1915.
21. Claire Morrill, *A Taos Mosaic: Portrait of a New Mexico Village* (Albuquerque, 1973).
22. *Santa Fe New Mexican*, September 9, 1951.
23. See Coke, *Taos and Santa Fe*, p. 59; and "Gerald Cassidy and His Art," *El Palacio* 16 (May 1, 1924):135–36.
24. Herman Hagedorn, "The Peterborough Colony," *Outlook* 129 (December 28, 1921):686–88.
25. Walter, "The Santa Fe–Taos Art Movement," p. 330.

4.

1. Director's Statement, School of American Research, August 30, 1927, Hewett Collection, Museum of New Mexico Library.

2. *Santa Fe New Mexican*, January 7, 1938.

3. Paul A. F. Walter, "The Santa Fe–Taos Art Movement," *Art and Archaeology* 4 (December 1916):330.

4. Bradfield to Bloom, Hurley, July 10, 1923, Hewett Collection, Museum of New Mexico Library.

5. Walter, "The Santa Fe–Taos Movement," p. 335.

6. *Santa Fe New Mexican*, November 5, 1967.

7. Ibid.

8. Biennial Report of the Secretary of the Museum of New Mexico, 1917, Hewett Collection, Museum of New Mexico Library.

9. Ibid.

10. "The New Museum," *El Palacio*, August 31, 1919, p. 85.

11. *Santa Fe New Mexican*, November 26, 1917.

12. Higgins to Walter, Taos, March 9, 1917, Taos Society of Artists Collection, Museum of New Mexico Library.

13. Report of the Director, Museum of New Mexico, 1920, Hewett Collection, Museum of New Mexico Library.

14. Sharp to Hewett, Cincinnati, December 4, 1921; Rush to Hewett, Santa Fe, August 17, 1921; Jacobson to Hewett, Norman, August 12, 1921, Hewett Collection, Museum of New Mexico Library.

15. Biennial Report of the Secretary of the Museum of New Mexico, 1917; Report of the Director of the Museum of New Mexico, 1920, Hewett Collection, Museum of New Mexico Library.

16. Phillips to Walter, Phoenix, February 3, 1919; Berninghaus to Walter, Taos, May 11, 1919, Hewett Collection, Museum of New Mexico Library.

5.

1. *Taos Review*, June 6, 1938.

2. Dasburg died in Taos in 1979 at the age of ninety-two.

3. Claire Morrill, *A Taos Mosaic: Portrait of a New Mexico Village* (Albuquerque, 1973), p. 98; *Santa Fe New Mexican*, February 25, 1933.

4. *New Mexico Artists* (Albuquerque, 1952), pp. 119–24.

5. Van Deren Coke, *Taos and Santa Fe: The Artist's Environment, 1882–1942* (Albuquerque, 1963), p. 68.

6. Ibid., p. 66.

7. *Santa Fe New Mexican*, January 26, 1933; April 6, 1937.

8. Ibid., October 6, 1957.

9. Paul Horgan, *The Centuries of Santa Fe* (New York, 1956), p. 319.

10. *Taos Valley News*, May 9, 1935.

11. Ibid., May 18, 1920.

12. Sidney Alexander, "Suck-Egg Mule," *American Scholar* 21 (October 1952):46–76.

13. Harvey Fergusson, "Taos Remembered," *American West* 8 (September 1971):138–41.

14. E. P. Richardson, *Painting in America* (New York, 1956), p. 390; John Collier. "Red Atlantis," *Survey* 49 (October 1922):15.

15. See Coke, *Taos and Santa Fe*, for an explanation of the painting styles evolving in the Santa Fe and Taos colonies.

16. *Santa Fe New Mexican*, June 23, 1928; June 26, 1928.

17. *Taos Review*, September 15, 1938; May 30, 1940.

18. *Taoseño*, August 1, 1940.

19. *Taos Review*, May 4, 1939.

20. "What Art Did to Taos and Its Indians," *Literary Digest* 116 (October 21, 1933):19; *Taos Valley News*, October 14, 1923.

21. *Taos Valley News*, January 5, 1924.

22. Ibid., January 12, 1924.

23. Ibid., August 17, 1920.

24. J. Pennington, "Taos: An Art Center on the Edge of the Desert," *Mentor* 12 (July 1924):27.

25. Blumenschein to Hewett, Taos, August 14, 1921, Taos Society of Artists Collection, New Mexico Museum Library.

26. *Taos Valley News*, June 12, 1930; June 10, 1937; *Santa Fe New Mexican*, March 13, 1937.

27. *Taos Review*, June 1, 1940.

28. *Taos Valley News*, December 28, 1933.

29. *Santa Fe New Mexican*, February 8, 1934.

30. *Taos Valley News*, December 5, 1935.

31. Van Deren Coke, *Andrew Dasburg* (Albuquerque, 1979), pp. 126–28.

6.

1. *Santa Fe New Mexican*, October 29, 1921.

2. *Taos Valley News*, December 1, 1923.

3. *Santa Fe New Mexican*, May 2, 1938.

4. Ibid., November 24, 1931; April 15, 1936; May 7, 1936; September 17, 1941.

5. Ibid., August 10, 1932; September 22, 1936.

6. "Los Cinco Pintores," *El Palacio* 2 (November 1, 1921):111–12.

7. *Santa Fe New Mexican*, June 23, 1928.

8. *Taos Valley News*, June 16, 1923.

9. *Santa Fe New Mexican*, June 22, 1929.

10. Ibid., October 30, 1933.

11. Ibid., March 23, 1932; November 27, 1933; December 5, 1936.

12. Ibid., April 18, 1931; November 7, 1938.

13. Ibid., November 10, 1928; July 23, 1932; October 9, 1933.

14. Ibid., January 18, 1938.

15. Ibid., February 1, 1929; January 30, 1931; March 6, 1935; May 8, 1936; February 24, 1937; March 13, 1937; April 16, 1938.

16. Ibid., June 23, 1928; June 26, 1928.

17. Ibid., May 3, 1922.

18. Ibid., September 3, 1932; August 29, 1933.

19. Mechlin to Hewett, New York, September 25, 1924, Hewett Collection, New Mexico Museum Library.

20. Ritter to Hewett, Berkeley, December 3, 1924, Hewett Collection, New Mexico Museum Library.

21. Sally Saunders, "Santa Fe's New Conquistadores," *Outlook* 155 (Au-

gust 20, 1930):607–609.

22. Ibid.; and Jo H. Chamberlin, "Santa Fe Fiesta," *Scribner's Magazine* 102 (September 1937):84.

23. *Santa Fe New Mexican*, August 12, 1931.

24. Ibid., September 21, 1941.

25. Ibid., October 29, 1921; September 20, 1932; September 17, 1926.

26. *Taos Valley News*, May 2, 1935.

27. *Santa Fe New Mexican*, September 8, 1928; May 16, 1929; September 5, 1929; July 17, 1930; March 28, 1932.

28. Ibid., May 26, 1938; June 8, 1938.

29. Ibid., July 17, 1930; April 6, 1932; November 27, 1933.

30. Ibid., December 6, 1933.

31. Ibid., December 14, 1933.

32. Ibid., September 13, 1938; May 9, 1940.

7.

1. *Santa Fe New Mexican*, February 7, 1929.

2. Ibid., May 22, 1929; July 30, 1929; January 31, 1934; May 13, 1936.

3. Ibid., March 11, 1929.

4. Shonnard to Hewett, October 11, 1925, New York, Hewett Collection, Museum of New Mexico Library; *Santa Fe New Mexican*, November 30, 1941.

5. *Santa Fe New Mexican*, October 23, 1917.

6. Ibid., January 7, 1938.

7. Ibid., July 30, 1919.

8. Ibid., October 8, 1921.

9. *Taos Valley News*, March 23, 1920.

10. *Taoseño*, November 6, 1941.

11. *Santa Fe New Mexican*, January 22, 1910; July 3, 1928; *Taos Review*, December 7, 1939; *Santa Fe New Mexican*, November 2, 1941.

12. *Santa Fe New Mexican*, June 30, 1928; July 21, 1928; August 7, 1928.

13. Thompson to Hewett, Santa Fe, December 2, 1924, Hewett Collection, Museum of New Mexico Library; *Santa Fe New Mexican*, June 1, 1915; January 3, 1929.

14. *Santa Fe New Mexican*, August 15, 1916; November 18, 1932.

15. Ibid., June 8, 1932; June 1, 1935.

16. Ibid., June 11, 1929; *Taos Review*, November 9, 1939; August 18, 1938; June 27, 1940; October 17, 1940.

17. *Taos Valley News*, September 10, 1936; December 30, 1937; December 31, 1937.

18. *Taoseño*, July 16, 1942; *Taos Review*, July 30, 1942.

19. *Santa Fe New Mexican*, August 14, 1933; November 1, 1933; August 6, 1932; August 13, 1932.

20. *Taos Valley News*, September 5, 1935; *Taos Review*, September 9, 1937.

21. *Taos Valley News*, December 10, 1936; *Santa Fe New Mexican*, November 1, 1933.

22. *Santa Fe New Mexican*, August 6, 1932; May 25, 1929; January 26, 1932.

23. Ibid., January 9, 1915; April 17, 1915.

24. Ibid., April 25, 1929.

25. Ibid., July 13, 1929.

26. Ibid., March 13, 1931.

27. Ibid., April 16, 1932.

28. Ibid., November 14, 1931.

29. Johnson to Hewett, San Diego, February 16, 1925, Hewett Collection, New Mexico Museum Library.

30. *Taos Valley News*, March 28, 1925; February 20, 1926.

31. Ibid., October 25, 1934; November 1, 1934; November 30, 1934.

32. *Taos Review*, August 19, 1937; March 7, 1940; May 23, 1940.

33. *Santa Fe New Mexican*, February 11, 1929; April 18, 1933; October 1, 1933; September 28, 1941.

34. *Taos Valley News*, March 14, 1935; January 30, 1936; February 4, 1936; February 13, 1936; February 20, 1936; March 19, 1936; April 30, 1946; May 14, 1936.

8.

1. H. Wayne Morgan, *New Muses: Art in American Culture, 1865–1920* (Norman, 1978), pp. 164–66. Also see E. P. Richardson, *Painting in America* (New York, 1956); J. J. Brody, *Indian Painters and White Patrons* (Albuquerque, 1971).

2. Van Deren Coke, *Taos and Santa Fe: The Artist's Environment, 1882–1942* (Albuquerque, 1963), pp. 31–32.

3. Taos Society of Artists Book of Minutes, Taos Society of Artists Collection, Museum of New Mexico, Santa Fe; "Appreciation of Indian," *El Palacio* 6 (May 24, 1919):178; Van Wyck Brooks, *John Sloan: A Painter's Life* (New York, 1955), p. 19.

4. Robert Henri, *The Art Spirit* (Philadelphia, 1930), p. 189.

5. *Santa Fe New Mexican*, December 28, 1919.

6. Mary Austin, "American Indian Murals," *American Magazine of Art* 26 (August 1933):381.

7. Sloan to Hewett, New York, June 2, 1922, Hewett Collection, Museum of New Mexico, Santa Fe.

8. Jamake Highwater, *Song from the Earth: American Indian Painting* (Boston, 1976), p. 55.

9. *Taos Valley News*, March 12, 1918.

10. *Santa Fe New Mexican*, December 13, 1932; June 19, 1939.

11. Writers' Program (WPA), New Mexico, *New Mexico, A Guide to the Colorful State* (New York, 1940), pp. 156–57.

12. See Alice Marriott, *María: The Potter of San Ildefonso* (Norman, 1948).

13. *Santa Fe New Mexican*, August 2, 1932; August 3, 1932.

14. Laing to Hewett, Carmel, California, September 29, 1925, Hewett Collection, Museum of New Mexico, Santa Fe.

15. *Santa Fe New Mexican*, June 8, 1929.

16. Ibid., June 19, 1930; February 23, 1932.

17. Austin, "American Indian Murals," p. 381.

18. Jane Rehnstrand, "Young Indians Revive Their Native Arts," *School Arts Magazine* 36 (November 1936):138.

19. In the Elizabeth DeHuff Collection, Yale University Library, are 150 colored drawings produced by The Studio pupils.

20. Highwater, *Song from the Earth*, p. 8.

21. Ibid., p. 5; and *Santa Fe New Mexican*, July 25, 1932.

22. *Santa Fe New Mexican*, March 28, 1920; September 6, 1922.

23. Austin to Bloom, New York, March 19, 1920, Hewett Collection, Museum of New Mexico, Santa Fe.

24. *Santa Fe New Mexican*, November 2, 1931; February 19, 1932; June 15, 1932; February 8, 1933; March 11, 1938; March 27, 1938; June 11, 1938.

25. *New York Times*, September 6, 1925.

26. Laing to Hewett, Carmel, California, September 29, 1925, Hewett Collection, Museum of New Mexico, Santa Fe; *Santa Fe New Mexican*, July 10, 1936.

27. *Santa Fe New Mexican*, May 24, 1933; Austin to Bloom, New York, March 19, 1920, Hewett Collection, Museum of New Mexico, Santa Fe.

28. *Santa Fe New Mexican*, August 19, 1932; August 31, 1932.

29. Mary Austin, "Indian Arts for Indians," *Survey* 6 (1928):383.

30. *Santa Fe New Mexican*, December 31, 1928.

31. Ibid., August 5, 1932; August 13, 1932.

32. Ibid., January 6, 1934; January 24, 1934.

33. Eugen Neuhaus, *The History and Ideals of American Art* (Stanford, California, 1931), p. 316.

9.

1. Oliver La Farge, *Santa Fe: The Autobiography of a Southwestern Town* (Norman, 1959), p. 328.

2. Roland F. Dickey, *New Mexico Village Arts* (Albuquerque, 1949), pp. 116–17.

3. Writers' Program (WPA), New Mexico, *New Mexico, A Guide to the Colorful State* (New York, 1947), p. 163.

4. Dickey, *New Mexico Village Arts*, p. 12.

5. Ibid., p. 138.

6. Writers' Program, *New Mexico*, p. 164; Dickey, *New Mexico Village Arts*, p. 150.

7. Dickey, *New Mexico Village Arts*, p. 30.

8. Applegate to Austin, Santa Fe, February 22, 1929, Austin Collection, Huntington Library.

9. Ibid.

10. *Santa Fe New Mexican*, February 2, 1933.

11. Applegate to Austin, Santa Fe, March 6, 1929, Austin Collection, Huntington Library.

12. *Santa Fe New Mexican*, May 16, 1930.

13. Ibid., August 27, 1930; November 3, 1932.

14. Ibid., May 16, 1930; September 16, 1936.

15. Ibid., August 27, 1930.

16. Dickey, *New Mexico Village Arts*, p. 165; *Santa Fe New Mexican*, March 25, 1936.

17. *Santa Fe New Mexican*, August 19, 1933; February 26, 1936; also see Nina Otero-Warren, *Old Spain in our Southwest* (New York, 1936).

18. Mary Austin, "Native Drama in New Mexico," *Theater Arts* 13 (1929):438.

19. Ibid.

10.

1. *Taos Valley News*, February 16, 1939.

2. *Santa Fe New Mexican*, December 11, 1918; July 24, 1933; Witter Bynner, *Journey With Genius: Recollections and Reflections Concerning D. H. Lawrence* (New York, 1951), p. 15.

3. Elizabeth S. Sergeant, "The Santa Fe Group," *Saturday Review of Literature* 11 (December 8, 1934):352.

4. *Santa Fe New Mexican*, August 13, 1934; December 10, 1935.

5. La Farge to Johnson, Santa Fe, March 22, 1955, La Farge Collection, University of Texas, Austin, Library.

6. Bynner to Jeffers, New York, December 29, 1928, Bynner Collection, University of Texas, Austin, Library.

7. *Santa Fe New Mexican*, September 28, 1929.

8. Ibid., November 13, 1928.

9. Ibid., August 1, 1936.

10. Harvey Fergusson, "Taos Remembered," *American West* 8 (September 1971):39.

11. La Farge to Millett, New York, April 14, 1937, La Farge Collection, University of Texas, Austin, Library; *Santa Fe New Mexican*, November 9, 1941.

12. Mabel Dodge Luhan, Taos Revisited, unpublished manuscript, Mabel Dodge Luhan Collection, Yale University Library.

13. Lawrence Clark Powell. *Southwest Classics: The Creative Literature of the Arid Lands; Essays on the Books and their Writers* (Los Angeles, 1977), p. 122; Cather to Brown, New York, October 7, 1946, E. K. Brown Collection, Yale University Library; E. K. Brown Manuscript, Willa Cather, E. K. Brown Collection, Yale University Library.

14. See E. K. Brown and Leon Edel, *Willa Cather: A Critical Biography* (New York, 1953) and Elizabeth S. Sergeant, *Willa Cather—A Memoir* (New York, 1953).

15. *Santa Fe New Mexican*, November 7, 1935.

16. Sergeant, "The Santa Fe Group," p. 354; *Santa Fe New Mexican*, August 30, 1932.

17. *Santa Fe New Mexican*, May 23, 1938; March 1, 1940.

18. Ibid., September 26, 1931; October 22, 1932; September 11, 1935; January 13, 1936; July 28, 1936; March 2, 1938; February 13, 1941; February 27, 1941.

19. Ibid., April 21, 1932; August 10, 1936.

20. *Taos Valley News*, April 2, 1918; November 15, 1934.

21. *Taos Review*, June 1, 1940; July 10, 1941.

22. Claire Morrill, *A Taos Mosaic: Portrait of a New Mexico Village* (Albuquerque, 1973), p. 134.

23. *Taos Valley News*, September 1, 1928; September 8, 1928; *Santa Fe New Mexican*, June 22, 1938; *Taos Valley News*, May 9, 1935; Morrill, *A Taos Mosaic*, p. 133.

24. *Santa Fe New Mexican*, April 4, 1932; *Taos Valley News*, September 10, 1936; August 12, 1937; *Taos Review*, June 1, 1940; September 26, 1940; January 13, 1938; *Taos Valley News*, January 24, 1935; *Taos Review*, July 27, 1939.

25. See Frieda Lawrence, *Not I, But the Wind* (New York, 1934); Dorothy Brett, *Lawrence and Brett, A Friendship* (Philadelphia, 1953).

26. See Frank Waters, *The Man Who Killed the Deer* (Denver, 1942) and Frank Waters, *People of the Valley* (Denver, 1941); *Taos Review*, June 1, 1940; August 8, 1940.

27. *Taos Valley News*, August 1, 1922.

28. Jeffers to Fleck, Carmel, April 19, 1930, *Selected Letters of Robinson Jeffers*, p. 170; *Taos Valley News*, June 5, 1930; Benjamin H. Lehman, "Robinson Jeffers," *Saturday Review of Literature* 8 (September 5, 1931):97–98.

29. *Santa Fe New Mexican*, November 9, 1929; December 2, 1933; *Taos Valley News*, September 13, 1934; *Santa Fe New Mexican*, August 6, 1935; February 15, 1938.

30. *Santa Fe New Mexican*, May 16, 1929; January 28, 1933; July 3, 1933; October 17, 1936.

31. Ibid., August 7, 1930; August 13, 1935; August 15, 1935; August 5, 1936.

32. Ibid., June 28, 1938; November 11, 1941.

33. Powell, *Southwest Classics*, p. 113; *Santa Fe New Mexican*, December 16, 1933; February 7, 1935; July 7, 1936; July 20, 1936.

34. Johnson to Frieda Lawrence, Santa Fe, May 30, 1937, Willard Johnson Collection, University of Texas, Austin, Library; *Santa Fe New Mexican*, November 1, 1936.

35. Alice Corbin Henderson, "Bookseller to Santa Fe," *Publishers Weekly* 124 (August 19, 1933):494; *Santa Fe New Mexican*, December 17, 1935.

36. *Santa Fe New Mexican*, August 7, 1926; July 23, 1931.

37. Sergeant, "The Santa Fe Group," p. 354; *Santa Fe New Mexican*, July 27, 1934.

11.

1. T. M. Pearce, *Mary Hunter Austin* (New York, 1965), p. 69; T. M. Pearce, ed., *Literary America, 1903–1934: The Mary Austin Letters* (West-

port, Connecticut, 1979), p. xi.

2. *Los Angeles Times*, June 1, 1932.

3. Pearce, *Literary America*, p. 92; Austin to Hoover, Los Angeles, June 4, 1918; Pearce, *Literary America*, pp. 93–94.

4. Mary Austin, *Earth Horizon: An Autobiography* (Boston, 1932), p. 336.

5. Ibid., p. 340.

6. Ibid.; *Taos Valley News*, March 18, 1919; March 25, 1919; April 22, 1919; Walter to Austin, Santa Fe, January 17, 1920, Hewett Collection, Museum of New Mexico Library.

7. Austin to McDougal, Santa Fe, March 10, 1922, Austin Collection, Huntington Library.

8. Mary Austin, "Indian Detour," *The Bookman* 68 (1928), p. 654; Mary Austin, "Why I Live in Santa Fe," *Golden Book* 16 (October 1932): 306–307; *Santa Fe New Mexican*, October 26, 1932.

9. Pearce, *Mary Austin*, p. 54.

10. Austin to Schroeder, Taos, April 8, 1919, Austin Collection, Huntington Library.

11. Austin to Schroeder, Santa Fe, May 22, 1919, Austin Collection, Huntington Library.

12. Austin to Schroeder, Santa Fe, February 19, 1919, Austin Collection, Huntington Library.

13. Austin to Schroeder, Taos, February 20, 1919, Austin Collection, Huntington Library.

14. Austin to Lewis, Santa Fe, February 28, 1931, Austin Collection, Huntington Library.

15. Bynner to Austin, Santa Fe, May 26, 1930, Austin Collection, Huntington Library.

16. "Mary Austin," *Commonwealth* 20 (August 24, 1934):408.

17. *Santa Fe New Mexican*, April 10, 1935.

18. Mary Austin, "Sources of Poetic Influence in the Southwest," *Poetry* 43 (1933–34):153–55.

19. Pearce, *Mary Austin*, p. 62.

20. *Los Angeles Times*, June 1, 1932.

21. Brown to Austin, New York, February 28, 1911, Austin Collection, Huntington Library; Austin to Walter, Taos, March 20, 1919, Hewett Collection, New Mexico Museum Library; *Santa Fe New Mexican*, January 25, 1919.

22. Austin to Wardell, Santa Fe, May 25, 1925, Austin Collection, Huntington Library; Murchison to Austin, Worcester, Massachusetts, April 13, 1926, Austin Collection, Huntington Library.

23. *Santa Fe New Mexican*, June 30, 1928; July 7, 1927; December 1, 1928; December 31, 1928; December 6, 1930; November 6, 1931.

24. Austin to Kidder, n.p., n.d., Austin Collection, Huntington Library.

25. Mary Austin, "Folk Plays of the Southwest," *Theater Arts* 17 (1933): 599–606; Mary Austin, "Spanish-American Theater," *Theater Arts* 12 (1929): 564–65.

26. Campa to Austin, Albuquerque, May 9, 1934, Austin Collection, Huntington Library; Alvarez to Austin, Washington, August 3, 1929, Austin

Collection, Huntington Library.

27. Austin to Bloom, New York, March 2, 1920, Austin Collection, Huntington Library; Austin to Untermeyer, Santa Fe, October 13, 1930, Austin Collection, Huntington Library.

28. Austin to Park, New York, May 30, 1911, Austin Collection, Huntington Library; "Mary Austin," *Commonwealth*, p. 408; Anne Martin, "A Tribute to Mary Austin," *Nation* 139 (October 10, 1934):409.

29. Austin, *Earth Horizon*, pp. 362–63.

30. Dudley Wynn, *A Critical Study of the Writings of Mary Hunter Austin* (New York, 1941), p. 252; Mary Austin, "The Future of the Southwest," *New Republic* 42 (April 8, 1925):186.

31. *Santa Fe New Mexican*, September 18, 1931; December 24, 1928.

32. Austin to Lane, Santa Fe, January 16, 1919, Austin Collection, Huntington Library.

33. Applegate to Austin, Santa Fe, February 22, 1929, Austin Collection, Huntington Library; Meem to Austin, March 13, 1929, Santa Fe, Austin Collection, Huntington Library.

34. Burke Memorandum to All Indians, Washington, February 24, 1923, Austin Collection, Huntington Library.

35. Austin to Cutting, Santa Fe, April 22, 1930, Austin Collection, Huntington Library; Austin to Wilbur, Santa Fe, July 17, 1931, Austin Collection, Huntington Library; Austin to Wilbur, April 20, 1930, Santa Fe, Austin Collection, Huntington Library.

36. Austin to Zimmerman, Santa Fe, November 25, 1930, Austin Collection, Huntington Library.

37. Austin, *Earth Horizon*, p. 364.

38. *Santa Fe New Mexican*, August 13, 1934.

39. Wynn, *A Critical Study*, p. 356; Pearce, *Mary Austin*, p. 100; Pearce, *Literary America*, p. 12.

40. Austin, *Earth Horizon*, p. 368.

12.

1. See Mabel Dodge Luhan, *Intimate Memories* (New York, 1933), for a discussion of the early years.

2. *New York Sunday News*, December 7, 1924; Luhan to Van Vechten, New York, April 8, 1913, Mabel Dodge Luhan Collection, Yale University Library.

3. See Maurice Sterne, *Shadow and Light* (New York, 1965).

4. Luhan to Van Vechten, New York, April 8, 1913, Mabel Dodge Luhan Collection, Yale University Library.

5. Mabel Dodge Luhan, *Edge of Taos Desert: An Escape to Reality* (New York, 1937), pp. 62–63.

6. See Emily Hahn, *Mabel: A Biography of Mabel Dodge Luhan* (Boston, 1977).

7. Luhan to Austin, Taos, June 1, 1923, Austin Collection, Huntington Library.

8. Luhan to Austin, Taos, April 23, 1923, Austin Collection, Hunting-

ton Library.

9. Luhan to Millett, Carmel, April 14, 1937, Mabel Dodge Luhan Collection, Yale University Library; *Taos Valley News*, May 9, 1935.

10. *Taos Valley News*, January 12, 1924; Claire Morrill, *A Taos Mosaic: Portrait of a New Mexico Village* (Albuquerque, 1973), pp. 112–13; *Taos Valley News*, May 9, 1935.

11. Luhan to Van Vechten, Taos, March 16, 1922, Mabel Dodge Luhan Collection, Yale University Library.

12. Mary Austin, *Earth Horizon: An Autobiography* (Boston, 1932), pp. 354–55.

13. *Taos Valley News*, May 9, 1935; Luhan to Van Vechten, Taos, June 13, 1920, Mabel Dodge Luhan Collection, Yale University Library.

14. Luhan to Leo Stein, Taos, November 30, 1935, Mabel Dodge Luhan Collection, Yale University Library.

15. Dodge to Parsons, Taos, n.d., Mabel Dodge Luhan Collection, Yale University Library.

16. *Taos Valley News*, March 15, 1934.

17. *Time*, January 22, 1940, p. 80; *Current Biography Yearbook* (1940) 1:1242.

18. Christopher Lasch, *The New Radicalism in America, 1889–1963: The Intellectual as a Social Type* (New York, 1965), p. 128; Jeffers to Rorty, Taos, July 3, 1934; Ann N. Ridgeway, ed., *The Selected Letters of Robinson Jeffers, 1897–1962* (Baltimore, 1968); Wilder to Luhan, New York, June 16, 1935, Mabel Dodge Luhan Collection, Yale University Library; *Taos Valley News*, January 12, 1924.

19. Robert Lucas, *Frieda Lawrence: The Story of Frieda von Richthofen and D. H. Lawrence* (New York, 1973), p. 185.

20. Luhan to Van Vechten, Taos, March 16, 1923, Mabel Dodge Luhan Collection, Yale University Library.

21. See Joseph O. Foster, *D. H. Lawrence in Taos* (Albuquerque, 1972).

22. Mabel Dodge Luhan to Stieglitz, Taos, December 17, 1924, Mabel Dodge Luhan Collection, Yale University Library.

23. Luhan to Stieglitz, Taos, n.d., Mabel Dodge Luhan Collection, Yale University Library.

24. Mabel Dodge Luhan, *Lorenzo in Taos* (New York, 1932).

25. Luhan to Brett, Taos, December 1, 1942, Mabel Dodge Luhan Collection, Yale University Library.

13.

1. Lawrence to Seltzer, Taormina, January 9, 1922, D. H. Lawrence Collection, University of Texas Library.

2. D. H. Lawrence, "New Mexico," *Survey* 66 (May 1931):153–55; Lawrence to Seltzer, Taos, September 12, 1922, D. H. Lawrence Collection, University of Texas Library; Witter Bynner, *Journey with Genius: Recollections and Reflections Concerning the D. H. Lawrences* (New York, 1951), p. 257; Dorothy Brett, *Lawrence and Brett: A Friendship* (Philadelphia, 1933), p. 41.

3. Lawrence to Brewster, Taos, September 22, 1922; Earl and Achsah Brewster, *D. H. Lawrence* (London, 1934), pp. 61–62.

4. Harry T. Moore, *The Intelligent Heart: The Story of D. H. Lawrence* (New York, 1960), p. 301.

5. Bynner, *Journey with Genius*, p. 15.

6. See Knud Merrild, *With D. H. Lawrence in New Mexico* (New York, 1964); *Taos Valley News*, December 6, 1922.

7. Bynner, *Journey with Genius*, p. 15.

8. Moore, *Intelligent Heart*, p. 305.

9. Ibid., p. 307.

10. Lawrence to Seltzer, London, December 14, 1933, D. H. Lawrence Collection, University of Texas Library.

11. Emily Hahn, *Lorenzo: D. H. Lawrence and the Women Who Loved Him* (Philadelphia, 1975), p. 222; Eliot Fay, *Lorenzo in Search of the Sun* (New York, 1953), p. 66.

12. *Taos Valley News*, March 29, 1924; Lawrence to Skinner, Taos, April 14, 1924, D. H. Lawrence Collection, University of Texas Library; Lawrence to Seltzer, Taos, May 18, 1924, D. H. Lawrence Collection, University of Texas Library.

13. *Taos Valley News*, April 5, 1924; Fay, *Lorenzo*, p. 73.

14. Lawrence to Luhan, Questa, n.d., D. H. Lawrence Collection, University of Texas Library; Lawrence to Brewster, Questa, July 15, 1924; Brewster, *D. H. Lawrence*, p. 75.

15. *Taos Valley News*, April 14, 1925; Moore, *Intelligent Heart*, p. 341.

16. Lawrence to Brett, Bandol, November 24, 1928, D. H. Lawrence Collection, University of Texas Library; Hahn, *Lorenzo*, p. 363.

17. Robert Lucas, *Frieda Lawrence: The Story of Frieda von Richthofen and D. H. Lawrence* (New York, 1973), p. 3.

18. See Hahn, *Lorenzo*, and Joseph O. Foster, *D. H. Lawrence in Taos* (Albuquerque, 1972), p. 226.

19. Bynner, *Journey with Genius*, pp. 2–4.

20. Davey to Austin, Santa Fe, May 14, 1923, Mary Austin Collection, Huntington Library.

21. Foster, *D. H. Lawrence*, p. 278.

22. Peter S. Beagle, "D. H. Lawrence in Taos," *Holiday* 43 (September 1967):44, 86–90.

23. "D. H. Lawrence," *Saturday Review of Literature* 6 (March 15, 1930): 817.

24. C. W. Tedlock, ed., *Frieda Lawrence: The Memoirs and Correspondence* (New York, 1964), p. 444; D. H. Lawrence, "American Tradition," *New Republic* 25 (December 15, 1920):20–24.

25. Theodore Spencer, "Is Lawrence Neglected?" *Saturday Review of Literature* 15 (October 31, 1936):13.

26. See A. H. Gomme, ed., *D. H. Lawrence: A Critical Study of the Major Novels and Other Writings* (New York, 1978) for analysis of Lawrence's writings.

27. Spencer, "Is Lawrence Neglected?" p. 13.

28. *Santa Fe New Mexican*, May 22, 1933.

29. Beagle, "D. H. Lawrence," pp. 44, 86–90.

30. Claire Morrill, *A Taos Mosaic: Portrait of a New Mexico Village* (Albuquerque, 1973), p. 107.

31. *Taos Valley News*, May 2, 1935.

32. *Santa Fe New Mexican*, September 16, 1935; *Taos Valley News*, September 19, 1935; Harold W. Hawk, "The Reinterment of a Gallant Neo-Pagan: In Memoriam—D. H. Lawrence," *University Review* 3 (Autumn, 1936):11–14.

33. D. H. Lawrence, "New Mexico," *Survey* 66 (May 1, 1931):153–55.

14.

1. Jo H. Chamberlin, "Santa Fe Fiesta," *Scribner's Magazine* 102 (September 1937):84.

2. *Santa Fe New Mexican*, June 25, 1928; December 17, 1931; Austin to Cassidy, March 17, 1932, Austin Collection, Huntington Library; *Santa Fe New Mexican*, January 14, 1937; January 4, 1930; January 27, 1937.

3. *Santa Fe New Mexican*, May 20, 1930; August 7, 1930; May 8, 1941.

4. *Taos Review*, October 13, 1938.

5. Oliver La Farge, *Santa Fe: The Autobiography of a Southwestern Town* (Norman, 1959), p. 287; *Santa Fe New Mexican*, May 10, 1929; October 26, 1931; Fred Harvey Schedule for Courier Training Course, January 25–31, 1928, Ina Sizer Cassidy Collection, New Mexico State Archives; *Santa Fe New Mexican*, March 5, 1926; Paul Horgan, *The Centuries of Santa Fe* (New York, 1956), p. 319; Clarkson to Hewett, Santa Fe, March 18, 1925, Hewett Collection, New Mexico Museum Library.

6. Applegate to Austin, Santa Fe, February 22, 1929, Austin Collection, Huntington Library.

7. *Taos Valley News*, May 2, 1935; Blumenschein to Hewett, Taos, August 14, 1921, Taos Society of Artists Collection, New Mexico Museum Library; *Santa Fe New Mexican*, May 5, 1934.

8. Street to Hewett, Santa Fe, June 3, 1924, Hewett Collection, New Mexico Museum Library.

9. La Farge, *Santa Fe*, pp. 294–95.

10. Chamberlin, "Santa Fe Fiesta," p. 86.

11. *Santa Fe New Mexican*, October 2, 1915; *Taos Valley News*, September 15, 1923; *Taos Review*, October 1, 1942.

12. *Taos Valley News*, September 5, 1929; *Santa Fe New Mexican*, July 20, 1941.

13. Mary Austin, *The Land of Journey's Ending* (New York, 1924), p. 359.

14. *Santa Fe New Mexican*, October 12, 1927.

15. Martin to Hewett, Dallas, December 30, 1925. Hewett Collection, Museum of New Mexico Library.

16. *Santa Fe New Mexican*, May 22, 1915.

17. "Cultural Center of the Southwest," *El Palacio* 20 (May 1, 1926): 171–81.

18. *Santa Fe New Mexican*, April 24, 1926.

19. Ibid., April 28, 1926.

20. An Open Letter to the Federated Club Women, undated, Santa Fe, Hewett Collection, Museum of New Mexico Library.

21. Walter to Hewett, Santa Fe, May 9, 1926, Hewett Collection, Museum of New Mexico Library; Mary Austin, "The Town that Doesn't Want a Chautauqua," *The New Republic* 47 (July 7, 1926):195–97.

22. Jackson to Hewett, New York, May 11, 1926, Hewett Collection, Museum of New Mexico Library; White to Walter, New York, May 8, 1926, Hewett Collection, Museum of New Mexico Library.

23. Chairman to Martin, Santa Fe, May 5, 1926, Hewett Collection, Museum of New Mexico Library.

24. Hewett to Estabrook, Santa Fe, June 7, 1926, Hewett Collection, Museum of New Mexico Library; Black to Lutz, Chicago, May 4, 1926, Hewett Collection, Museum of New Mexico Library.

25. Alter to Doll, Chicago, May 10, 1926, Hewett Collection, Museum of New Mexico Library.

26. *Santa Fe New Mexican*, March 2, 1931; March 6, 1931; May 24, 1932.

27. Johnson to Lawrence, Santa Fe, May 30, 1937, Johnson Collection, University of Texas (Austin) Library.

28. Bynner to Lawrence, Santa Fe, November 4, 1923, Lawrence Collection, University of Texas (Austin) Collection.

29. *Santa Fe New Mexican*, April 16, 1921; August 6, 1932.

30. *Santa Fe New Mexican*, September 24, 1932; October 21, 1932; November 3, 1934.

31. Ibid., October 29, 1937; February 9, 1937.

32. *Taos Valley News*, July 2, 1936.

33. HR 2667, 71 Cong., 1 Sess., *Senate*, September 30, 1929; *Santa Fe New Mexican*, February 4, 1930.

34. *Santa Fe New Mexican*, May 10, 1933; May 16, 1933; May 17, 1933.

35. *Taos Valley News*, May 14, 1918; *Taos Review*, July 29, 1937.

36. Witter Bynner, *Journey with Genius: Recollections and Reflections Concerning the D. H. Lawrences* (New York, 1951), p. 6; *Taos Valley News*, May 17, 1924.

37. *Santa Fe New Mexican*, June 12, 1928; April 27, 1915.

38. Ruth L. Barker, *Caballeros* (New York, 1931), p. 113.

39. *Santa Fe New Mexican*, September 29, 1920.

40. Bynner, *Journey with Genius*, p. 6; Henderson to *Santa Fe New Mexican* editor, Santa Fe, October 11, 1920, Hewett Collection, Museum of New Mexico Library; Henri to Hewett, New York, December 20, 1920, Society of Taos Artists Collection, Museum of New Mexico Library.

41. Hewett to Walter, San Diego, April 29, 1926, Hewett Collection, Museum of New Mexico Library; Hewett to Walter, San Diego, April 30, 1926, Hewett Collection, Museum of New Mexico Library.

15.

1. *Taos Review*, June 6, 1938.
2. *Taos Valley News*, August 1, 1936.

3. McWilliams to Austin, March 21, 1927, Austin Collection, Huntington Library.

4. Carey McWilliams, "A Letter from Carmel," *Saturday Review of Literature* 6 (January 4, 1930):622.

5. *Taos Valley News*, October 27, 1928.

6. Mabel Dodge Luhan, Taos Revisited, Unpublished Manuscript, Mabel Dodge Luhan Collection, Yale University Library.

7. Erna Fergusson, "What Art Did to Taos," *Literary Digest* 116 (October 21, 1933):19.

BIBLIOGRAPHICAL NOTE

THE Santa Fe and Taos colonies have received considerable literary attention, largely in contemporary periodicals, with most of it pertaining to the artists and their work; colony writers have received only limited attention. And no studies have been made that explain the creative flair of the colonies extending from painters and writers to embrace poets, playwrights, sculptors, composers, and dancers, as well as Indian and Hispanic muses.

Primary source materials in New Mexico are found at the University of New Mexico, at Albuquerque, and the State Records Center and New Mexico Museum, at Santa Fe. Resources at the former include the WPA Files, detailing involvement of colony members in federally subsidized projects, the Ina Sizer Cassidy Collection for general information on the Santa Fe colony and federal projects, and the Pueblo Ceremony Investigation Files documenting attempts by federal officials to suppress Native American practices that the muses were seeking to preserve. At the New Mexico Museum Library the Donald Beauregard Collection, Ina Sizer Cassidy Collection, Dana Johnson Collection, and Paul A. F. Walter Collection are useful for supporting information, but by far the most illuminating of the research resources on colony life and development are the Edgar L. Hewett and Society of Taos Artists Collections. In addition, the Museum collections include a small number of Mary Austin letters.

Beinecke Rare Book and Manuscript Library, Yale University, New Haven, Connecticut, possess singular resources pertaining to the Santa Fe and Taos colonies—E. K. Brown Collection; John Collier Collection; Elizabeth DeHuff Collection; Oliver La Farge Collection; Mabel Dodge Luhan Collection; Fred R. Millett Collection; and Willa Cather Collection. Of these, without question the most valuable for study of the colonies are the Mabel Dodge Luhan papers.

The Humanities Research Center, University of Texas at Austin, possesses useful Witter Bynner letters, Willard ("Spud") Johnson letters, and D. H. Lawrence letters. Edmund Wilson and D. H. Lawrence collections at the University of Tulsa Library, and Lynn Riggs and Stanley Vestal (Walter Campbell) papers in the Western History Col-

lections, University of Oklahoma, Norman, provide additional supporting information on life in the colonies.

Santa Fe and Taos art-literary colonies have been explored in graduate study. Two carefully researched and well-written dissertations on this subject are James M. Gaither, "A Return to the Village: A Study of Santa Fe and Taos as Cultural Centers, 1900–1934" (University of Minnesota, 1958), and Kay Aiken Reeve, "The Making of an American Place: The Development of Santa Fe and Taos, New Mexico, as an American Cultural Center" (Texas A and M University, 1977).

Files of local newspapers, like mirrors, reflect day-to-day life in the colonies. The *Santa Fe New Mexican* and *Taos Valley News* and *Taoseño* reveal the throbbing interaction of creative folk in the colonies with nonmuse townspeople and chart changing civic attitudes toward the fine-arts appendages. They rank with the Hewett and Taos Society of Arts Collections and Mary Austin and Mabel Dodge Luhan papers as the most productive for this study.

Interviews and correspondence with knowledgeable informants often yielded strategic points for narrative construction and charming contacts as well. They include Richard Sellers, Betty Toulouse, the Gustave Baumanns, Myra Jenkins, Willard ("Spud") Johnson, Betty Kirk, Savoie Lottinville, and Michael Harrison.

Of the printed sources, periodical literature looms the most extensive, and of the hundreds of articles written about the colonies, most of them cast in a contemporary context, eighty percent are concerned with the artists and their works. Generic articles are cited in the "Notes" sections. Publications frequently carrying articles about the colonies and the members and their work include *Sunset, Overland Monthly, Outlook, Survey, Poetry, Desert, American Magazine of Art, The Nation, Contemporary Arts of the South and Southwest, Theatre Arts Monthly, New Mexico Quarterly, New Mexico Magazine, Golden Book, The Dial, Art and Archaeology, Western Artist, The Independent, The Arts, Art News, Southwest Review, Scribner's, American Artist, Literary Digest, Harper's Magazine, North American Review, The Living Age, School Arts, Creative Arts, The Mentor, Saturday Review of Literature, The Bookman, Publishers Weekly, Commonweal, Catholic World,* and *American Mercury. El Palacio,* publication of the Museum of New Mexico, regularly carried descriptive articles pertaining to the colonies and the work of members.

As in the case of periodicals, most books germane to the foregoing text are cited in the end notes. The writings of Mary Austin,

Witter Bynner, and D. H. Lawrence are brought together in several published bibliographies. Books revelatory of the quality of life in the Santa Fe and Taos colonies include Ruth L. Barker, *Caballeros* (1931); Dorothy Brett, *Lawrence and Brett: A Friendship* (1933); Van Deren Coke, *Taos and Santa Fe: The Artist Environment, 1882–1942* (1963); Oliver La Farge, *Santa Fe: The Autobiography of a Southwestern Town* (1959); Frieda Lawrence, *Not I, But the Wind* (1934); Haniel Long, *Piñon Country* (1941); Mabel Dodge Luhan, *Edge of Taos Desert: An Escape to Reality* (1937) and *Winter in Taos* (1935); Charles Fletcher Lummis, *The Land of Poco Tiempo* (1893); Claire Morrill, *A Taos Mosaic: Portrait of a New Mexico Village* (1973); and Nina Otero-Warren, *Old Spain in Our Southwest* (1936). Lawrence Clark Powell's *Southwest Classics: The Creative Literature or the Arid Lands: Essays on the Books and Their Writers* (1977) is a useful introduction to the impact of environment on creativity. And recently published titles providing fresh insight into the land as a painter's haven are J. J. Brody, *Indian Painters and White Patrons* (1971); Van Deren Coke, *Andrew Dasburg* (1979); Patricia Broder, *Taos: A Painter's Dream* (1980); Emily Hahn, *Mabel: A Biography of Mabel Dodge Luhan* (1977) and *Lorenzo: D. H. Lawrence and the Women Who Loved Him* (1975); and Alfred Stieglitz, *Georgia O'Keefe: A Portrait* (1978).

INDEX